Film Actresses
Volume 2
Shirley Temple
Documentary study

Part 1

ISBN-13 : 978-1514125939
ISBN-10 : 1514125935

Copyright©2012-2014 Iacob Adrian
All Rights Reserved.

Notice

This documentary study use historic, archived documents.

Because of this, some pages may look blurry or low quality.

Still are included in this book because they have

high value from critical, documentary, historical,

informative and journalistic point of view .

Dtp and graphic design

Iacob Adrian

**Copyright©2012-2014 Iacob Adrian
All Rights Reserved.**

Author statement

The actors and actresses are the the bricks .

The cast and crew are the plaster .

They stand on the foundation created by producers and writers and directors .

All these people creates the great palace of the art of film .

Iacob Adrian - 2013

This little Book conveys the greetings of

..

to

..

———————————————

Good Boys and Girls

Scoop! Here's a preview of Santa Claus' ledger, where he keeps the records of Hollywood stars, and decides whether or not they deserve a Christmas present

by JOHN WINBURN

GOOD POINTS	BAD POINTS	GIFTS
JEAN HARLOW. Well, you really finished that book, Jean! I like you to stick to things that way. Add good point; not letting personal problems sour her. Made her mother happy with beautiful room in new home. Lifted Bill Powell out of the dumps.	O, hum, with 115 pounds distributed like that, what are Jean's bad points? Hasn't sent the editor a copy of "Today is Tonight," her first book. Maybe he'll find one in his stocking!	A Letter from Every Fan!
CLARK GABLE. For giving us *It Happened One Night*. Being always thoughtful of others. When a friend had no place to keep her dog, he gave it a home on his ranch.	Balks at picture assignments with women stars. Drives studio frantic by disappearing between pictures, when he is wanted for story conferences.	More Dogs to Take Care of
W. C. FIELDS. For the biggest laughs of the year. For feeding that little blind duck on the pond back of his house every morning.	That fight with Baby LeRoy. GIFT: New Rattle	
SHIRLEY TEMPLE. Refuses to be spoiled by compliments. Is Mrs. Santa Claus' favorite actress. Can now spell her name and count. Invited all Hollywood (almost) to her birthday party.	Shirley, you mustn't ask for so much gum—I heard you! After all, Mama isn't *made* of gum! But I guess you've been a very good girl. GIFT: Carton of Gum Please turn to page fifty-six	

It's hard to catch Santa! Shirley Temple planned to wait up for the jolly saint but she just couldn't keep awake

JANUARY, 1935

1001 surprises!

Produced with a magnificence, magnitude and imagination unapproached in show history. Dazzling beauties...blazing splendor...amazing novelty...myriad surprises ...laughs, songs, drama, thrills, romance, ...everything!

"STAND UP AND CHEER!"

WARNER BAXTER

MADGE EVANS • SYLVIA FROOS
JOHN BOLES • JAMES DUNN
"AUNT JEMIMA" • SHIRLEY TEMPLE
ARTHUR BYRON • RALPH MORGAN
NICK FORAN • NIGEL BRUCE
MITCHELL & DURANT • STEPIN FETCHIT

**1,000 DAZZLING GIRLS! • 5 BANDS OF MUSIC!
VOCAL CHORUS OF 500! • 4,891 COSTUMES!
1,200 WILD ANIMALS! • 1,000 PLAYERS!
335 SCENES! • 2,730 TECHNICAL WORKERS!**

Produced by WINFIELD SHEEHAN

*Associate Producer and Collaborator
on story and dialogue:* LEW BROWN
Director: HAMILTON McFADDEN. Lyrics: LEW BROWN. Music: LEW BROWN and JAY GORNEY. Dances staged by SAMMY LEE. Dialogue: RALPH SPENCE
Story Idea Suggested by WILL ROGERS and PHILIP KLEIN.

6 SONG HITS!
"We're Out of the Red"
"Our Last Night Together"
"Baby, Take a Bow"
"I'm Laughin'"
"Broadway's Gone Hill Billy"
"She's 'Way Up Thar"
(I'm 'Way Down 'Yar)

HOT FROM HOLLYWOOD....

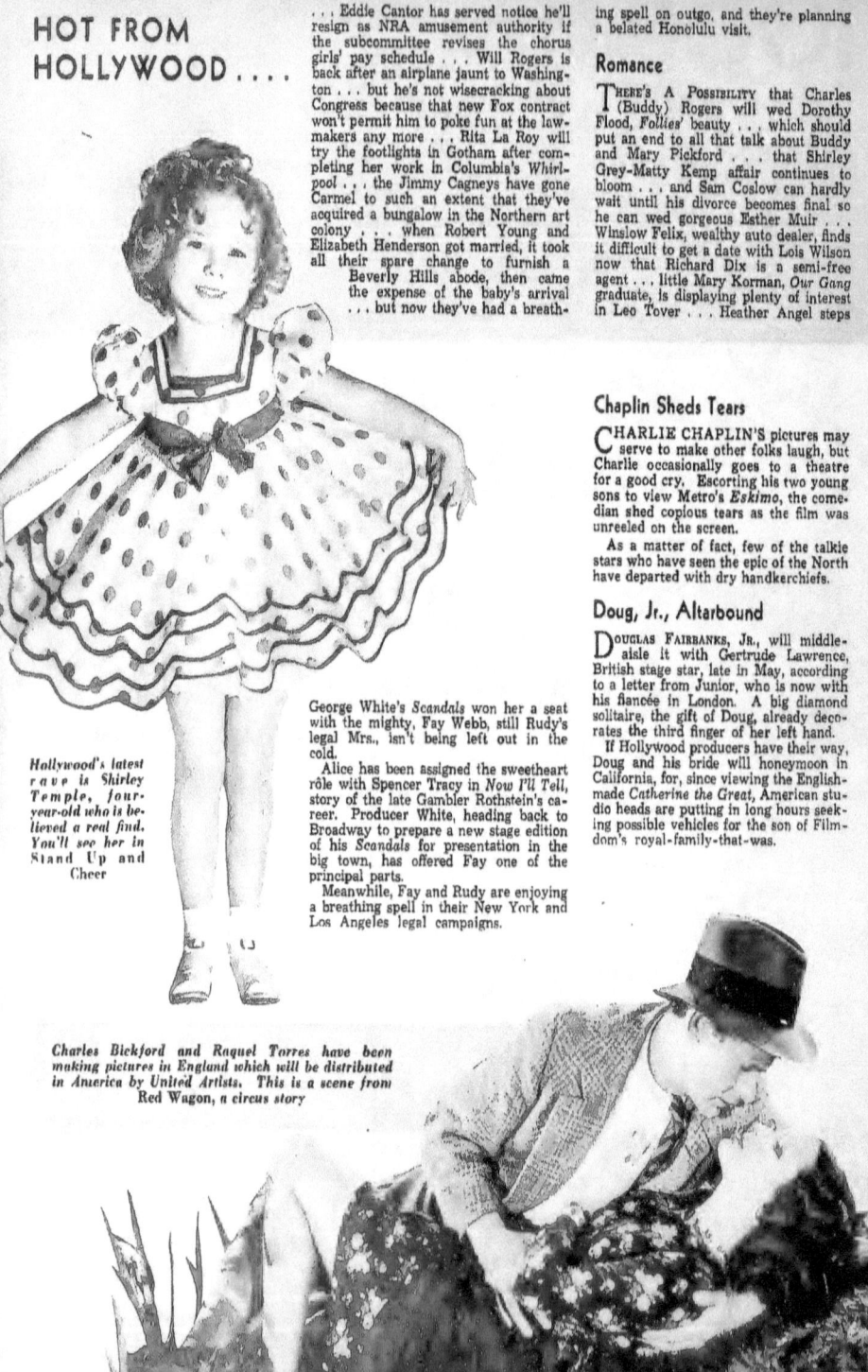

Hollywood's latest rave is Shirley Temple, four-year-old who is believed a real find. You'll see her in Stand Up and Cheer

...Eddie Cantor has served notice he'll resign as NRA amusement authority if the subcommittee revises the chorus girls' pay schedule ... Will Rogers is back after an airplane jaunt to Washington ... but he's not wisecracking about Congress because that new Fox contract won't permit him to poke fun at the lawmakers any more ... Rita La Roy will try the footlights in Gotham after completing her work in Columbia's *Whirlpool* ... the Jimmy Cagneys have gone Carmel to such an extent that they've acquired a bungalow in the Northern art colony ... when Robert Young and Elizabeth Henderson got married, it took all their spare change to furnish a Beverly Hills abode, then came the expense of the baby's arrival ... but now they've had a breathing spell on outgo, and they're planning a belated Honolulu visit.

Romance

THERE'S A POSSIBILITY that Charles (Buddy) Rogers will wed Dorothy Flood, *Follies'* beauty ... which should put an end to all that talk about Buddy and Mary Pickford ... that Shirley Grey-Matty Kemp affair continues to bloom ... and Sam Coslow can hardly wait until his divorce becomes final so he can wed gorgeous Esther Muir ... Winslow Felix, wealthy auto dealer, finds it difficult to get a date with Lois Wilson now that Richard Dix is a semi-free agent ... little Mary Korman, *Our Gang* graduate, is displaying plenty of interest in Leo Tover ... Heather Angel steps George White's *Scandals* won her a seat with the mighty, Fay Webb, still Rudy's legal Mrs., isn't being left out in the cold.

Alice has been assigned the sweetheart rôle with Spencer Tracy in *Now I'll Tell*, story of the late Gambler Rothstein's career. Producer White, heading back to Broadway to prepare a new stage edition of his *Scandals* for presentation in the big town, has offered Fay one of the principal parts.

Meanwhile, Fay and Rudy are enjoying a breathing spell in their New York and Los Angeles legal campaigns.

Chaplin Sheds Tears

CHARLIE CHAPLIN'S pictures may serve to make other folks laugh, but Charlie occasionally goes to a theatre for a good cry. Escorting his two young sons to view Metro's *Eskimo*, the comedian shed copious tears as the film was unreeled on the screen.

As a matter of fact, few of the talkie stars who have seen the epic of the North have departed with dry handkerchiefs.

Doug, Jr., Altarbound

DOUGLAS FAIRBANKS, JR., will middle-aisle it with Gertrude Lawrence, British stage star, late in May, according to a letter from Junior, who is now with his fiancée in London. A big diamond solitaire, the gift of Doug, already decorates the third finger of her left hand.

If Hollywood producers have their way, Doug and his bride will honeymoon in California, for, since viewing the English-made *Catherine the Great*, American studio heads are putting in long hours seeking possible vehicles for the son of Filmdom's royal-family-that-was.

Charles Bickford and Raquel Torres have been making pictures in England which will be distributed in America by United Artists. This is a scene from Red Wagon, a circus story

28

Hot From Hollywood

Deaths

MARY FILBIN'S mother succumbed to a heart attack . . . Fay Webb's paternal grandmother passed on at 80 . . . Jackie Coogan's uncle, J. C. Dolliver, died in Frisco, where he operated a chain of theatres . . . Lilyan Tashman died in New York at thirty-four.

Financial

RICARDO CORTEZ has incorporated himself as Zetroc, Inc., to angel the Broadway production of *Shoestring*, a crook drama . . . Uncle Sam has clamped down on Jean Harlow, Carmel Myers, Greta Nissen, Eleanor Boardman and Eric von Stroheim for back income taxes . . . Jean tops the list with $2,654 in arrears . . . Stephin Fetchit got a salary advance and paid off a $1,404 claim by an ex-landlord while court attaches were seeking him on a bench warrant . . . Conway Tearle owns no real estate and his $1,500 weekly salary is under attachment, he testified while appearing as a judgment debtor in an action brought by the executors of his late ex-wife's estate to collect $10,000 in back alimony . . . Glenda Farrell is digging into her bank account for the purchase of a San Fernando Valley ranch on which she intends to park her son, Tommy, and her Dad . . . the scheme to restore Jackie Coogan and Clara Kimball Young to the screen via a series of two-reelers has ended in the courts, with Director Eddie Cline and some of the players suing for their unpaid salaries . . . Adolphe Menjou bought a gold mine for speculation, but he's holding up it's operation because equipment will cost him $25,000, and Adolphe doesn't spend that kind of money without serious thought . . . Stuart Erwin and June Collyer have proved blessings to a crowd of artisans . . . Stu hired builders and decorators to restore one room that had been damaged by flames and ended up by having them rebuild the entire manor.

Crime

LILA LEE was robbed of jewels valued at $12,000 by an ex-chauffeur, but she didn't know it until detectives picked up the Negro in a pawn shop where he was trying to dispose of the loot . . . Sanford Roth, an actor, was arrested on charges of brutally beating Bessie Silver, an actress, while partying in a beer garden . . . Leniency pleas by Will Rogers and Walter Winchell failed to move Judge Wilbur Curtis when 25-year-old William Tannen was brought before him on drunk driving charges . . . and the scion of the famous vaudevillian, Julius Tannen, was held for trial . . . burglars looted Nacio Herb Brown's home and fled with furs and jewels appraised at $5,000.

Courts

PRODUCER SOL LESSER has asked the courts to decide whether Harold Bell Wright sold him all screen rights or merely the silent privileges on Wright's novel, *When A Man's A Man* . . . Harold Bell wants an extra fee for the talkie concession . . . Russ Columbo took time off from his romancing to sue Rusco Enterprises, Inc., for $11,452, a counter action, the corporation having brought action to collect $60,000 from him . . . the United States Circuit Court of Appeals denied John and Dolores Barrymore's priority in their efforts to collect $154,000 they invested in the now-defunct Guaranty Building and Loan Association.

Science

ANN DVORAK has dropped her study of bacteriology in favor of piano lessons . . . Margaret Lindsay is recuperating after parting with her appendix . . . Eva Tanguay, long threatened by blindness, is submitting to an operation in hopes of saving her sight . . . a method of more accurately controlling the tiny electrical particles has been found, with the result that silversheet kisses no longer will sound like the popping of a pistol . . . Lew Ayres will shortly begin the syndication of a newspaper column dealing with astronomy, a subject that ranks second only to Ginger Rogers in his affections . . . the oxygen cage for fighting pneumonia, saved the life of Director Eddie Sutherland.

Social

IT WAS a very horsey affair, that dinner party the Darryl Zanucks threw the polo set in honor of those newlyweds, Aiden Roark and the former Esther Moore . . . the producer and his frau chartered one of the better night clubs for the occasion . . . when Mrs. Harry Beaumont tendered a surprise dinner in honor of her husband's birthday, she had the candle-light cake made to resemble a stock broker's board, and listed all of Harry's stocks, good and bad alike

At the age of four Shirley Temple has progressed far on the road to fame. She has scored a big hit in Stand Up and Cheer *for Fox and is now filming* Half Way Decent *at Paramount*

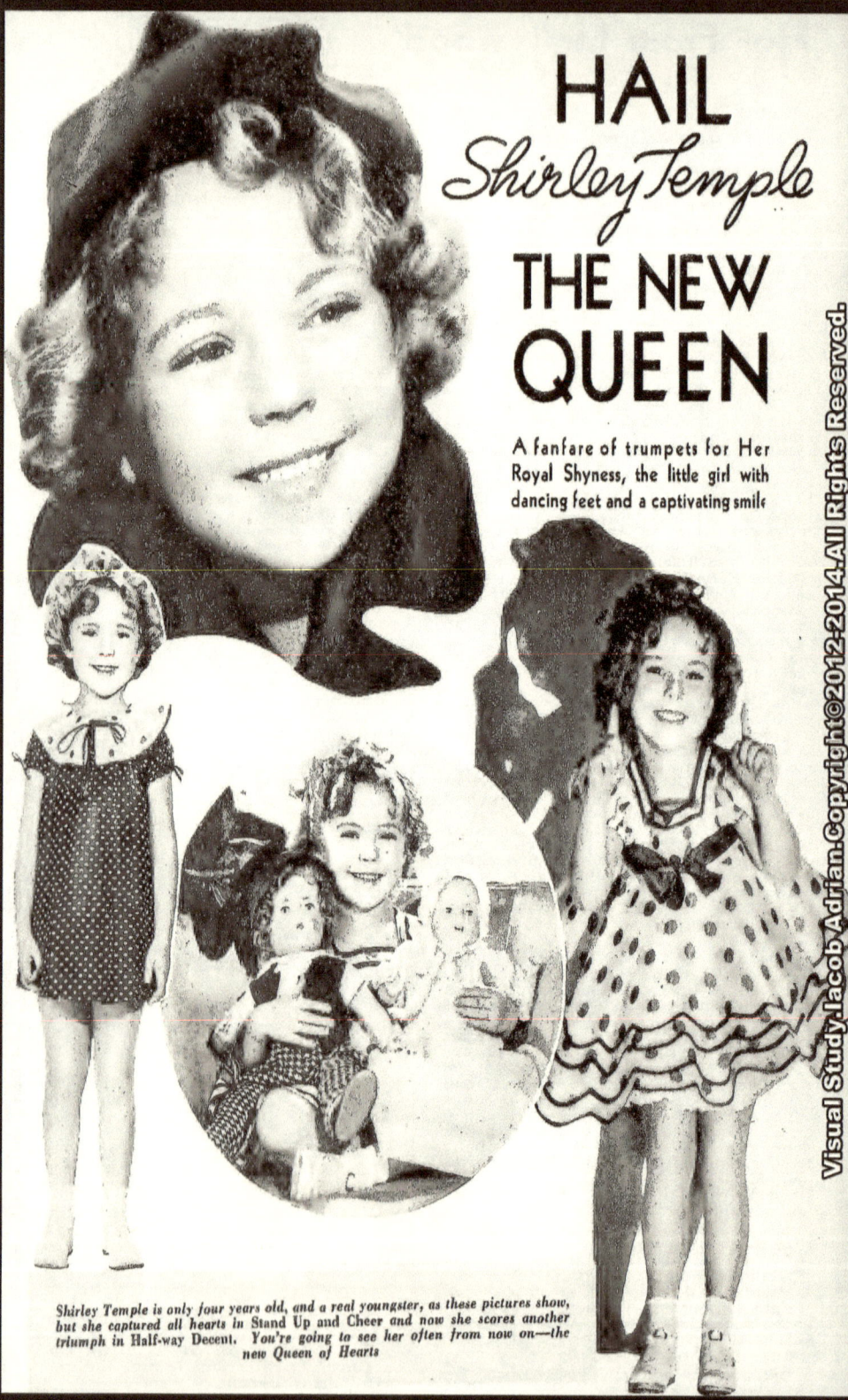

Pointed comment on cinema affairs and people
by
W. H. FAWCETT
Publisher of HOLLYWOOD Magazine

The PUBLISHER'S PAGE

Shirley's Stand-In

Shirley Temple

PERHAPS THE MOST pleasant sensation of the year was the discovery of Shirley Temple's talents and her elevation from kid comedies to featured rôles. Winfield Sheehan, Fox executive, has jealously guarded Shirley to keep her the unspoiled child beloved of all fans—to prevent her becoming the all too familiar, insufferable spoiled movie prodigy.

Recently Shirley became aware of the fact that Gary Cooper had a stand-in and immediately demanded and received one for herself. We hope this is not a sign of budding temperament that will undo Sheehan's conscientious efforts. Such talent, sweetness and wholesomeness should be preserved at all costs.

Mary Brian made the mistake of boasting she has so many luncheon engagements that she has carried a five dollar bill in her purse a year without spending it. So the other day Ned Sparks and Phillips Holmes took her out to lunch and then calmly walked out, leaving her with the check! Justice will be done!

Fields Forgot

W. C. Fields

W. C. FIELDS is in a quandary. It is well known in Hollywood that the comedian has an extremely unreliable memory. Things he should do slip his mind too easily.

Recently he forgot to attend a large function at which many stars were present, although it was his duty to be there. The next day he wondered if he had been missed and just what the result of his failure to attend would be.

Imagine his surprise and perplexity when he received a sweet note from Marion Davies thanking him for attending and doing his part to make the affair a success! Which, Mr. Fields is convinced, is the height of something or other.

A number of Hollywood actors are inventors, too. Gary Cooper has invented a calibrating device and an adjustable stirrup. Charlie Ruggles has patented an automatic egg ejector (no foolin'). But Bill Fields is the most prolific. His prize is a combination desk, lounge, bar, phonograph, ice shaver, radio, cocktail mixer and aspirin tablet.

Death Wins

Dorothy Dell

DEATH HAS COMPLETED his cycle of three in Hollywood—Lilyan Tashman, Lew Cody and Dorothy Dell. Despite its love for Lilyan and Lew, the death of Dorothy in a tragic automobile accident stunned Hollywood most of all.

Facing stardom after only eight months in pictures, Dorothy had everything to live for. Death, however, had stalked her since childhood—since the age of three, when a dog viciously attacked her, down through the years of narrow escapes and freak accidents.

Taken at the age of twenty-four, when life was sweet and full of promise for her, Dorothy might well have been spared and a less worthy person taken.

Doggy, Wot?

Donald Cook

GOING TO THE dogs in Hollywood should not be such an ordeal now that Donald Cook has opened his tony eatery for canines. The film capital has had hospitals, beauty shops and cemeteries for its pets, but not until now has there been a restaurant exclusively for them. Cook has a fleet of delivery cars which will bring the tasty food right to the tables of filmdom's aristocratic pooches. If His Highness is overweight or for other reasons needs to diet, the proper foods will be supplied. Patrons may leave their hounds at the café, where they will have private booths and may gorge themselves on the choicest of canine victuals. Truly every dog has his day—at least in Hollywood!

Jimmy Starr records Wynne Gibson's latest smart come-back thus: Eddie Welch bounced up and greeted her like a long lost brother. "Say," he said. "I haven't seen you since we started in show business together on Broadway. You've certainly passed me!" "Yeah," flipped Wynne, "and I'm at a stand-still."

Best-Dressed?

Genevieve Tobin

GENEVIEVE TOBIN HAS been nominated by Irene Castle McLaughlin as the best-dressed woman in Hollywood. The former dancer called her the logical successor to the late Lilyan Tashman as fashion dictator.

Discretion is the better part of valor, so we refrain from comment. We are perfectly willing to let the laurels rest on Genevieve's fair head, but deep in the heart of every woman in Hollywood lies the ambition to win this title, and we doubt that Irene's nomination will pass unchallenged. Who do you think should be named? Send your vote to HOLLYWOOD Magazine and we'll publish the returns.

They're telling this one on Director Frank Tuttle, whose Russian wife had a fellow countrywoman visiting her. Tuttle thought it would be sporting if only Russian were spoken at the table during her stay, and everything went fine until one meal he thought he asked for a spoon. The guest grinned, left the table and returned some minutes later leading a horse!

Play Or Player?

Clark Gable

WE'VE BEEN IMPRESSED lately with a marked increase in the number of letters from readers which stress the importance of story as against star names in motion picture productions.

For years the novelty of speaking pictures and the fabulous glamour of screen personalities held the public interest despite poor stories and weak dialogue, but novelty and glamour have had their day and the industry is being shaken down to the one great fundamental expressed in Shakespeare's famous axiom, "The play's the thing."

The public will not pay to see just Clark Gable or just Greta Garbo any more. The stars are rapidly finding out that they cannot be greater than the stories in which they are presented.

BABY LEROY'S

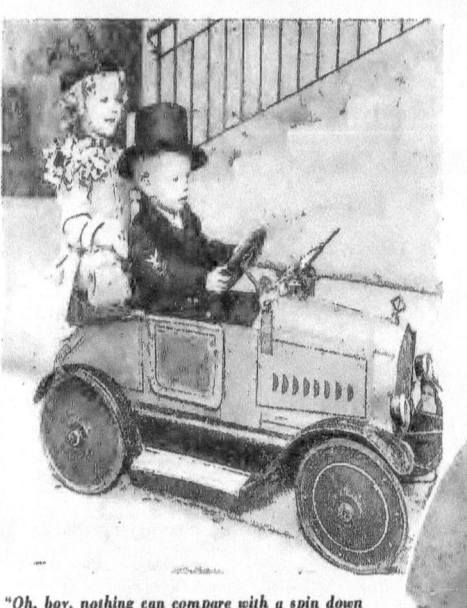

And of course Baby LeRoy chose that charming young lady, Shirley Temple, as his companion for his first fling at night life in Hollywood!

"Oh, boy, nothing can compare with a spin down Hollywood Boulevard in the moonlight with a beautiful girl like you"

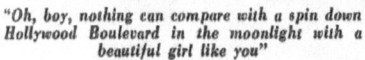

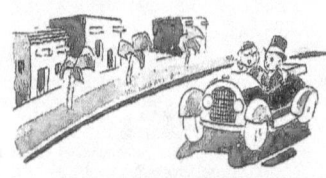

"That ride in my open roadster made me thirsty, didn't it you? Besides, there's nothing better than a drink of good old milk to help people to get better acquainted"

"Two of the best seats in the house, Mister. There's nothing too good for my girl. And after the show we're going dancing at the Cocoanut Grove"

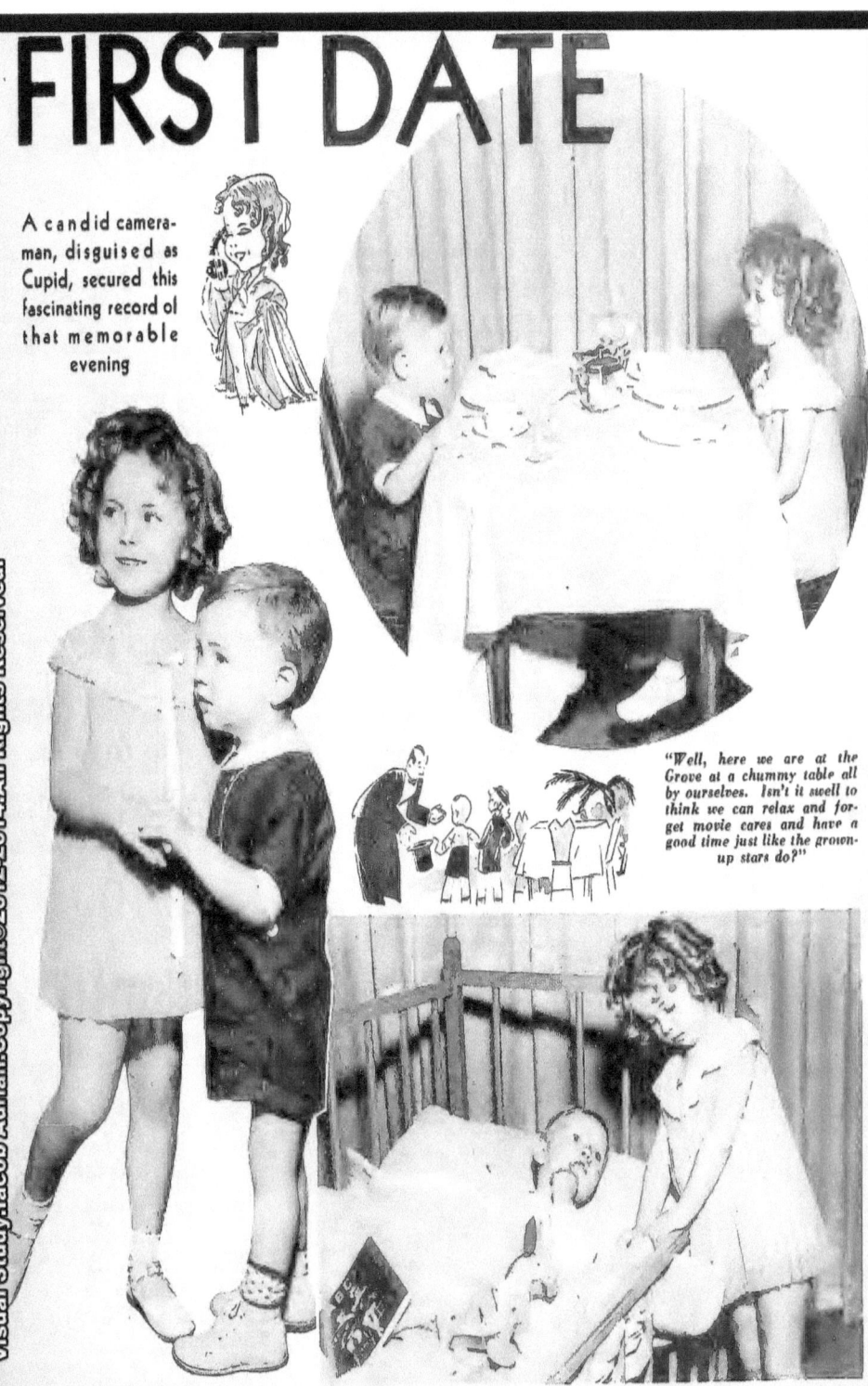

Roaming Around Movieland with the news

Loyalty's Rich Reward

WHILE MILLIONS the world over are mourning the passing of Marie Dressler—Queen Marie of the realm of make-believe—none is more deeply bowed in grief than is Mamie Cox, the colored maid who danced attendance on the beloved star for nearly twenty years.

It was to Mamie that Marie willed the bulk of her estate—wealth sufficient to keep this faithful servant and her husband who served as Marie's chauffeur, in luxury for the balance of their days.

Often in that period between the end of the world war and the start of her sensational climb to movie stardom, when Marie found herself penniless she tried to induce Mamie to seek other employment. But devotion to her mistress meant more to Mamie than weekly paychecks.

Six trained nurses were on duty at Marie's bedside on the million-dollar C. K. G. Billings place at Montecito where Marie breathed her last, yet the dominant figure in the sick chamber was Mamie, who knew every detail of the physicians' instructions and who ruled over the others with unflagging zeal.

Throughout Marie's last weeks, Mamie sat almost constantly holding the hands whose slightest gesture has caused theatre audiences to laugh or cry.

During her more than half a century behind the footlights and on the screen, Marie Dressler built several fortunes, only to part with them in aiding those less fortunate. The exact value of Mamie's inheritance will not be known until the Dressler mansion in Beverly Hills, securities stowed in safety vaults and Marie's various bank accounts have been appraised. However, there's plenty so that Mamie need never have any more financial worries!

His Lucky Day

TEN days before the stork arrived at Dixie Lee's bedside, Bing Crosby had definite assurance that the long-legged bird was bringing him twins. Yep, the modern X-ray is a miraculous contrivance.

What worried Bing after that, however, was the sex of the promised offspring. When the nurse finally brought the word that they were boys, Bing let loose a war-whoop.

"Gee, and they call Friday, the 13th, an unlucky day?"

It's All Over Now!

THAT HEATED LOVE AFFAIR—and it was real love, too—between Loretta Young and Spencer Tracy has been stored away in the cooler because marriage was not for them. Spencer still is the legal though estranged husband of Louise Treadwell. Both he and Loretta are devout Catholics, and divorce is not for one of their faith.

They're still friends, however, and they'll probably always remain that way, for Spencer is one of the truly sincere fellows in the talkie colony.

Coincidence, That's All!

LORETTA YOUNG was in the Los Angeles Queen of the Angels hospital, recuperating after a minor operation, when she and Spencer decided to call it off.

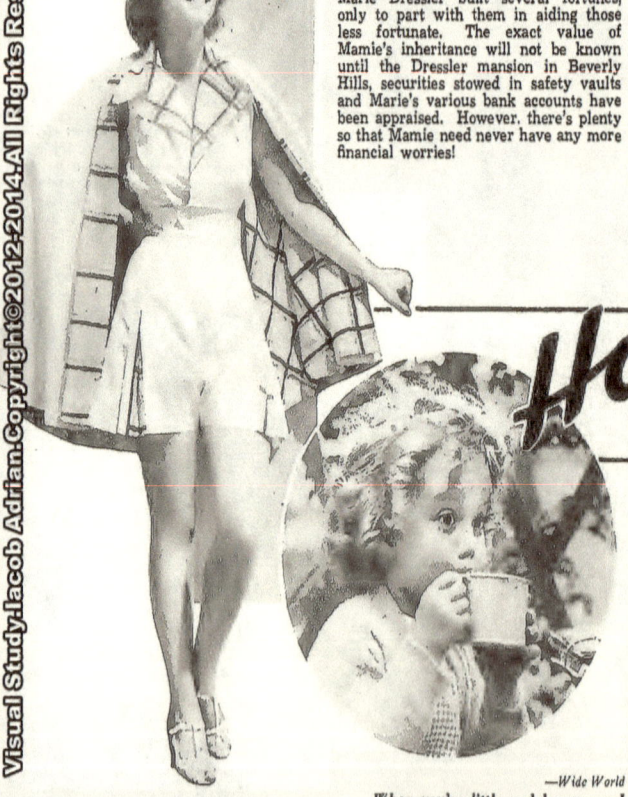

—Kling
It may be The Dragon Murder Case in which Margaret Lindsay wears this bewitching outfit, but with us it's a case of love at first sight

—Wide World
When you're little and hungry and far from home, milk tastes so-o-o-o good even out of a tin cup, according to Shirley Temple, caught by the cameraman while on location at Lake Arrowhead

Hot FROM

Romance

LEE TRACY'S ma has arrived from Pennsylvania and put her o. k. on Isabel Jewell, the girl-friend of long standing . . . so it looks like a wedding now . . . Jack Gilbert is sending his favorite red roses to Sally Blane, but he doesn't stand a chance . . . Sally and that real-life Romeo, Lyle Talbot, have decided that playing the field isn't so hot, and they've settled down into an engagement . . . Carole Lombard continues to be seen everywhere with Russ Columbo . . . even in the broadcasting station during Russ' airings . . . A visit to the preacher is all that can save Florence Rice and Phillips Holmes from spontaneous combustion . . . Back in Hollywood after a sojourn in the east, silver-voiced Lanny Ross is stepping with

Sleuth

by HAL E. WOOD

Sparkling notes on the passing show in the world's most glamorous city

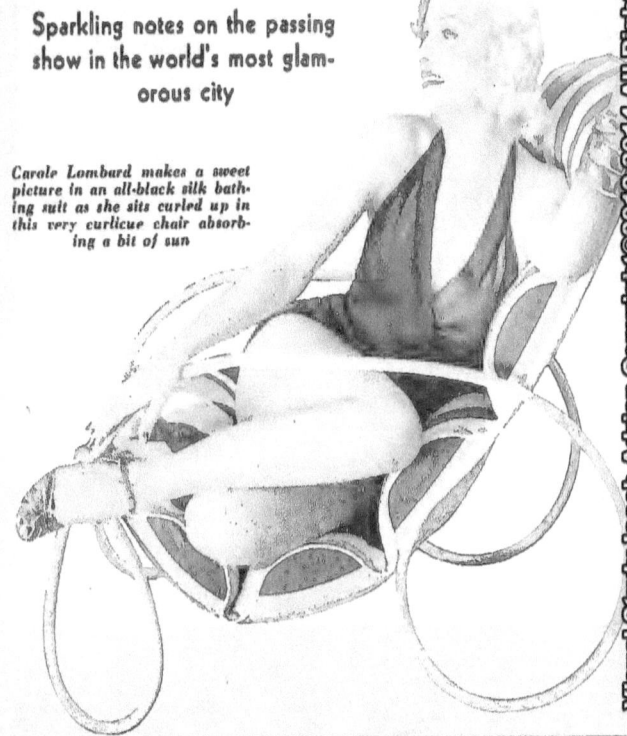

Carole Lombard makes a sweet picture in an all-black silk bathing suit as she sits curled up in this very curlicue chair absorbing a bit of sun

Perhaps it was the collapse of their romance that caused Spence to do it, but next morning he went out to the Riviera field and played the most reckless game of polo he ever has attempted. In the second chukker, with his team far in the lead because of his daring, he was thrown from his mount.

Rushed to a hospital in an ambulance, doctors found that he was suffering from a torn tendon in his back in addition to other injuries that would keep him there for two weeks.

But Spence didn't spend his bed-ridden period in Queen of the Angels. Instead, he deliberately chose Hollywood hospital!

When Romance Blooms!

EARLY IN THEIR courtship, Joan Crawford presented Franchot Tone with a Scotty pup with a pedigree longer than the trans-Atlantic cables. Franchot lives less than two blocks from Greta Garbo, and Greta, too, owns a Scotty. Daily Garbo's purp sneaks away from the Swede's estate and hot-foots down the street, where it holds a tryst with Tone's canine. Hollywood romances have started on less!

Marlene Busy Girl

MARLENE DIETRICH'S social duties are keeping her on the jump these days, what with a hubby plus five male admirers all seeking to date her for luncheon or dinner or both.

HOLLYWOOD

Late news condensed and correlated for your convenience

Patsy Daley . . . Roger Pryor is seen everywhere with Ann Sothern now that Mrs. Pryor is in Reno for the tie-cutting . . . Glenda Farrell went to New York to meet the fiance, Bob Riskin, returning from Europe . . . but she went places and places with Ronald Simins, a former flame, while she was waiting for Bob's ship to pull in . . . You'll be seeing Marian Nixon and Director Bill Seiter at the marriage license bureau before long . . . Patsy Ruth Miller, who, divorcing Director Tay Garnett, insisted love was not for her, is eating her words now that Scenarist John Mahin has come into her life . . . John Warburton's newest is a Sam Goldwyn beauty named Moody . . . Esther Ralston can't see anyone but Will Morgan . . . Henry Wilcoxon and Mona Maris have tumbled head over heels . . . And Gordon Westcott feels the same way about that newcomer, Helen Trenholme . . . Frank Melton, the lad who put Pineapple, Alabama, on the map, is keeping Gaye Mynatt, a dimpled Italian blonde, in posies . . . The Barbara Weeks-Guinn (Big Boy) Williams affair is on again . . . Wynne Gibson and Randy Scott are principals in a new twosome . . .

Marriages

CHARLIE CHAPLIN and Paulette Goddard are having a 125-foot cruiser built, and they'll circle the globe aboard the new craft on their honeymoon just as soon as they complete Charlie's current celluloid vehicle . . . however, they're very mum on the subject of marriage . . . so no one knows whether they're harnessed or plan to be soon . . . the recently divorced Corinne Griffith and Walter Morosco are plotting a second tieing . . . Richard Dix and his bride, the former Virginia Webster, are back in our midst after their New Jersey nuptials . . . and Virginia is doubling in brass, taking care of both wifely and secretarial duties . . . Ina Claire's friends are breathlessly waiting the news that she has altared it with Prince Ferdinand von Liechtenstein . . . Ralph Graves has eloped with another socialite, his second . . . the new Mrs. Graves was formerly Betty Flournoy . . . Marion (Peanuts) Byron, Georgie Raft's first Hollywood throb, is the bride of Lou Breslow . . . Margaret McConnell, 23, who came to the films via the cigarette advertisements, now signs checks as Mrs. William Pereira . . . he's a Chicago architect . . . Thelma Stevens is quitting the screen now

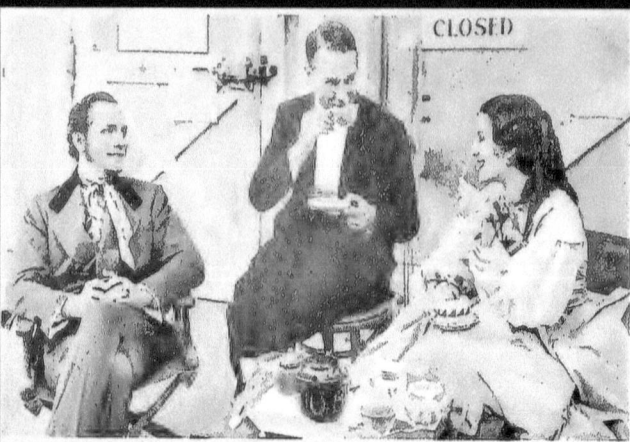

Norma Shearer makes a charming hostess at an impromptu back-stage tea party for her co-star in The Barretts of Wimpole Street, *Fredric March, and Maurice Chevalier, who dropped over for a chat*

With the News Sleuth

they insisted he come back for the Mexican première of the opus. Wally will don his Villa costume and pilot his plane to the Mexican capital for the event. During his stay there, he will be the guest of Gen. Villa's widow. After the opening, he will change to hunting attire to try out his new rifle on Mexican bear.

May Loaned Again

EVER since May Robson's tremendous hit in Columbia's *Lady for a Day*, that studio has been seeking another powerful yarn for her. Now Harry Cohn is convinced he has just that in *Orchids and Onions*. So May is being borrowed from Metro once more, and she'll be co-starred with Carole Lombard.

Natalie Starts Over

NATALIE TALMADGE, who deserted her celluloid niche when she married Buster Keaton, is planning a new try for silversheet glory. Divorced from the comedian two years ago, Natalie recently appeared in a Los Angeles court with a plea that she be permitted to use her maiden name as her legal cognomen.

A New Dance Looms

FRED ASTAIRE and Ginger Rogers, co-starring in RKO-Radio's *The Gay Divorce*, are rehearsing an original ballroom step for that vehicle. Much secrecy surrounds their trials, and the dance will be shot on a closed set. The sole clue is that the number is a variation of the Castle walk, introduced by Irene and the late Vernon Castle, which was so popular in pre-war days.

Joan May Step Down

THERE'S A POSSIBILITY that motherhood will bring about Joan Blondell's permanent retirement from the spotlight.

"I won't come back if I can find a real excuse for staying away," the blonde star confided. "I'm not going to have a youngster, then leave it in the care of nurses. I'm going to watch it grow up and see to it that it gets the proper care. I'll quit entirely—I don't care much about acting, anyway—if we find we can get along on George's salary. We'll find that out while we're waiting for the baby to arrive."

A New Screen Team

CLARK GABLE is to have a new cinematic fate. She is none other than the beautiful and talented Jeanette MacDonald. They will make their initial appearance together in Metro's *The Lady Comes to Town*, a tale of the roaring west of the '80's.

Determination Wins

FRANK MELTON, the Pineapple, Alabama, husky who hitch-hiked to Hollywood and landed the rôle of Janet Gaynor's bumpkin suitor in *State Fair*, continues to forge ahead in his new career.

During lean weeks following the completion of *State Fair*, Frank toiled long hours for little pay as a gas station attendant. Then he talked his way back onto the Fox lot, and landed a part with Will Rogers in *Mr. Skitch*. That won him a long-termer.

Then, when he heard Victor Jory, due to conflicting schedules, wouldn't be able to take the characterization of the villainous village barber in *Judge Priest*, the new Rogers' vehicle, Frank launched an annoyance campaign that continued until Producer Sol Wurtzel gave in.

Ring Travels Far

BRUCE CABOT and Adrienne Ames are back after a visit to Bruce's home town, Carlsbad, New Mexico. Bruce brought with him a ring he lost in a French seaport five years ago while working his way around the world on a tramp steamer. The keepsake was engraved with his real name, Jacques Debujac, and the finder had sent it to Carlsbad.

Stan's Back At Work

THE FIRST THING Stan Laurel did after taking upon himself a new bride was to make peace with his boss, Hal Roach. The result is that Stan and Oliver Hardy once more are emoting together, their current comedy being titled *Public Enemies*.

Gary, The Benedict

IF YOU don't believe Sandra Shaw has Gary Cooper hog-tied, matrimonially speaking, just glimpse the long, lean fellow from the Montana plains any day as he strolls down Hollywood Boulevard. Yes, sir, folks, Gary has gone in for spats, a la Odd McIntyre. And his batik neckties! Oh, boy!

Shirley Prompts 'Em

LITTLE SHIRLEY TEMPLE has painted the faces of a lot of Hollywood big shots a vivid red. The youngster not only memorizes her own lines, but those of other players as well.

Gary Cooper blew up the other day while they were emoting together in *Now and Forever* over at Paramount. Try as he would, he couldn't remember his dialogue, then Shirley put him on the spot by whispering the words in his ear.

He Takes No Chances

CHARLIE CHAPLIN never has been accused of cowardice, but the little fellow did assume a cautious attitude during the Gettle kidnaping episode.

Despite the fact that Charlie is trying to speed up production on his new picture, he remained within the four walls of his Beverly hilltop mansion, the estate surrounded by guards, during the three days and nights the multi-millionaire broker was in the hands of the snatchers. But Chaplin had good reason for playing safe. His intimates reveal that he has been the recipient of threatening communications.

Gloria Files Suit

GLORIA SWANSON has filed her action for divorce from Michael Farmer in the Los Angeles courts, and Michael, departing on a round-the-world yachting cruise, announces that he won't fight the action.

"If she wants the custody of our baby, I'll willingly grant her plea," said Mike. "In fact, I'll do anything to make her happy."

However, because Farmer is out of the state, Gloria cannot obtain her decree for ninety days. The law requires that notice of the suit be published for that length of time in view of the fact that he cannot be served with a subpoena.

It's All Over

THE romance between Gloria Swanson and Herbert Marshall was shortlived. Edna Best, Herbert's wife, is en route back to Hollywood for a picture rôle and a possible reconciliation. They do be saying that Herbert's pals talked him out of the Gloria Swanson intrigue!

—Apger

If these are the co-eds—name the college and we'll all go back to school! A typical moment between scenes with some embryo Helen Morgans in the cast of Metro's Student Tour

Beauteous Katherine DeMille at the pool on the estate of her father, the famous director, Cecil B. DeMille. She spurned a part in his spectacular Cleopatra to go it on her own in a major rôle in Mae West's new picture

shining brighter than ever before because of her stellar portrayal in *Of Human Bondage.*

With Hollywood divorce mills grinding overtime, the revival of the Bette-Harmon school day love affair comes as a sweet note in a sour symphony.

Lupe's Big Mistake?

LUPE VELEZ and Johnny Weissmuller had been battling for weeks—not one long-drawn-out fight, but too many of short duration because all of them found their way onto the front-pages of the dailies. The fan public was about filled up, and news of Lupe's legal proceedings against Johnny came as a relief to frayed nerves—of newspaper readers.

Johnny said his last farewells on a Tuesday night, and moved from Lupe's Beverly abode to bachelor quarters at the Hollywood Athletic Club. On Wednesday morning, Lupe filed her complaint with the Los Angeles courts, charging Johnny with mental cruelty, furniture-wrecking, morbidity and all the other things the average feminine star includes in such documents when she is mad clear through and love is dead.

But Thursday night found Lupe slipping into the Athletic Club and up to Johnny's apartment. Friday night saw them, hand-in-hand, at the Hollywood fights.

Did You Know That—

SHIRLEY TEMPLE, child sensation, has two brothers—one aged nine years, the other fifteen—and that neither of them ever have emoted before the grinding cameras?

Ain't Love Grand?

THE GLORIA SWANSON-HERBERT MARSHALL hearts continue to beat in unison despite the fact that Edna Best, Herbie's estranged frau, is due back in Hollywood almost any day now. Some of Herbert's English-born pals thought they had talked the soothing-voiced leading man out of la Swanson's life, but imagine their embarrassment when they read in their newspapers that Gloria and Herbie were week-end sunburning themselves aboard the palatial cruiser *Sobre re las Olas* off Catalina island . . . that they were previewing a talkie together in a Beverly theatre . . . that they joined forces to make whoopee t'other night at the King's club . . . that they—but why go on?

Heartaches for Janet

JANET GAYNOR hied herself off to Europe accompanied by the girl who dresses her hair when she is before the cameras.

Janet has had a little too much to endure of late. First, Winchell broadcast over the ether waves that she was the mother of a hidden child, the result of her union with Lydell Peck. Then came the marriage of Dr. Don Montgomery, handsome young Los Angeles dentist.

Janet and the tooth expert had been friends since before she rose to stardom in *Seventh Heaven.* He was Janet's real heart-throb before she switched her affections to Charlie Farrell, then to Lydell Peck.

Bette Davis, whose sterling work in Of Human Bondage has been getting her plenty of plaudits, takes time out to romp with her dog

—Fryer

ing him of his wife's critical illness in New York . . . he couldn't get an eastbound plane until seven in the evening so he went on with his clowning until time to flee to the airfield . . . when his cloud-ship reached Chicago another wire was delivered to him . . . Mrs. Moore had passed on.

Please turn to page forty-nine

Good Boys and Girls

Scoop! Here's a preview of Santa Claus' ledger, where he keeps the records of Hollywood stars, and decides whether or not they deserve a Christmas present

by JOHN WINBURN

GOOD POINTS	BAD POINTS	GIFTS
JEAN HARLOW. Well, you really finished that book, Jean! I like you to stick to things that way. Add good point; not letting personal problems sour her. Made her mother happy with beautiful room in new home. Lifted Bill Powell out of the dumps.	O, hum, with 115 pounds distributed like that, what are Jean's bad points? Hasn't sent the editor a copy of "Today is Tonight," her first book. Maybe he'll find one in his stocking!	A Letter from Every Fan!
CLARK GABLE. For giving us *It Happened One Night.* Being always thoughtful of others. When a friend had no place to keep her dog, he gave it a home on his ranch.	Balks at picture assignments with women stars. Drives studio frantic by disappearing between pictures, when he is wanted for story conferences.	More Dogs to Take Care of
W. C. FIELDS. For the biggest laughs of the year. For feeding that little blind duck on the pond back of his house every morning.	That fight with Baby LeRoy. GIFT: New Rattle	
SHIRLEY TEMPLE. Refuses to be spoiled by compliments. Is Mrs. Santa Claus' favorite actress. Can now spell her name and count. Invited all Hollywood (almost) to her birthday party.	Shirley, you mustn't ask for so much gum—I heard you! After all, Mama isn't *made* of gum! But I guess you've been a very good girl. GIFT: Carton of Gum Please turn to page fifty-six	

It's hard to catch Santa! Shirley Temple planned to wait up for the jolly saint but she just couldn't keep awake

JANUARY, 1935

An Open Letter
to BORIS KARLOFF

From J. EUGENE CHRISMAN

In which Gene expresses gratification to the creator of his nightmares

Dear Boris:

Perhaps you do not know it, Boris, but you are a national benefactor, fit to stand beside Washington, Lincoln, Edison, the NRA and Aimee Semple McPherson. Millions of insomnia victims from Florida's keys to Puget Sound's fogs are remembering you in their prayers because of what you have done for them.

I myself am one of those unfortunate beings who, being unable to find the favor of Morpheus, have spent my nights for years, counting sheep until a sheep became to me a thing of horror. If all the sheep I have counted were laid end to end, I have no idea what would happen but something surely would. Then I saw you in the rôle of *The Monster*, in *Frankenstein*. I returned home and when I put on the upper half of my pajamas, (which is all I have any use for), and turned in for another night of counting sheep, imagine my surprise and gratification to find a nightmare all saddled and bridled, just for me to ride. And my what a nice time I had. Instead of laying there, flat on my back, engaged in counting endless lines of sheep jumping over a gate, I was enabled, because of your talent for horror, to spend it galloping over meadow and vale, astride a lovely nightmare. Now when I am unable to woo sleep, I merely look through the list of what is showing at the neighborhood theatres, select your most recent horror effort, and return home to resume my nocturnal efforts as an equestrian. Thank you Boris and thank you for my fellow men who share these rides.

SHIRLEY TEMPLE'S MOTHER REPLIES
To J. EUGENE CHRISMAN

Shirley doesn't write so she got her mother to answer Gene's letter

Dear Mr. Chrisman:

Your open letter to Shirley was most kind and considerate. As you surmised, Shirley does not write and all she ever reads is picture-story books of the simplest nature. In view of the fact that you requested me to answer for Shirley, I will try and comply as straightforwardly as possible.

The kindly feeling shown in your letter is in keeping with the general attitude of the public. Let us right here correct any impression that people are rude toward our little girl. No one has ever been other than sweetly considerate, but naturally when we go to any public place crowds gather and stare. We try to avoid these crowds, figuring it is best for Shirley that she not become conscious too soon of the fact she is the cynosure of all eyes and therefore of greater importance than other children. We aim to keep her a plain, simple child as long as we can, and I am sure you will agree with us in this decision and endeavor.

Concerning your reflection of the short careers of other children in motion pictures and how many skyrocketed to fame and then fell equally precipitous into oblivion, there seems to be little we can do about that. Shirley will remain in public favor only as long as the public wishes. We will try to avoid mistakes and apparent pitfalls, but, after all, it is the great public that determines the fate of a child or an elder actor.

Even in the case of some, who, as you point out, shone brightly for a short time and then faded away into the great unheard-of and unsung class, we must admit they did accomplish something. They, at least, had their hour and day in a huge world that continually brings forth millions of roses to bloom and blush unseen.

If the time comes when the public

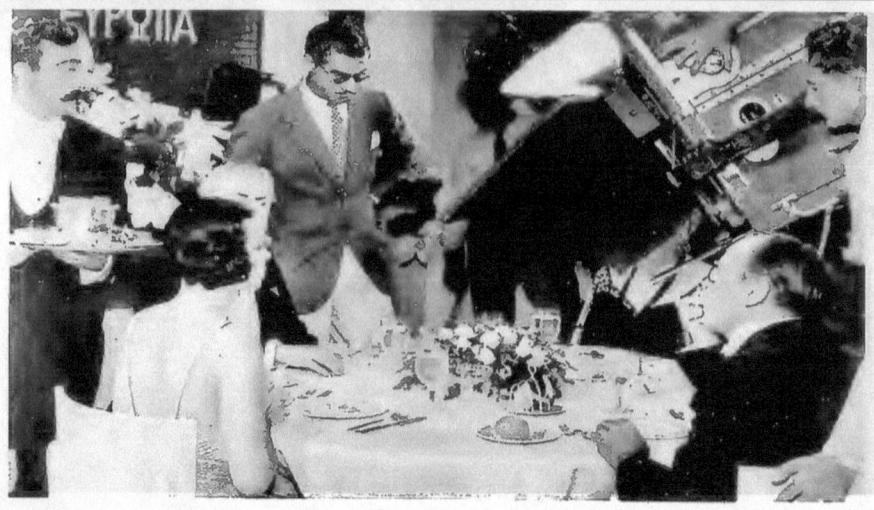

How would you like this at your dinner table? A scene in the making from the new Bing Crosby picture, Here Is My Heart. Bing is the waiter standing at left

Shirley Temple's Mother Replies

tires of Shirley Temple, I am sure she will withdraw gracefully and we, her family, will draw the curtains with her, happy and content that the day was joyful and well spent. The threat of oblivion holds no terror for Shirley Temple or her family. I am speaking in the present, for Shirley has no idea right now what it is all about. She is intense and happy and having a good time playing a new game—called motion pictures.

On the other hand, it might be possible for Shirley to continue for quite some time in her film work. If the writers can keep pace with their stories and themes to fit her changing years, Shirley may retain appeal as she grows. At present she is interesting as a child of tender years. There should be no reason why she should not be appealing in a good story of a ten-year-old girl and so on. This all revolves around the question of the public losing interest in a face or a personality.

Each day it dawns upon me more forcibly that the responsibility for Shirley's screen career is in my hands. Certainly, this is so as concerns the Temple family. All of the little girl's film affairs are entrusted solely to me. I think you can see my task is not an easy one. I can only do what any other mother would do under the circumstances—give my little girl every aid, every confidence, every wise caution and all the kindly consideration possible. Many people tell me what I should and shouldn't do. I gladly listen to all suggestions.

But, will you permit me to call your attention to the fact that Shirley Temple is really Shirley Temple? She has arrived at her present station herself. It is that indefinable "something" she has that has placed her where she is. To reach the status of motion picture stardom at an age less than six years, required personality, a certain forwardness, winsomeness and I might even say a degree of precocity, although I have come to despise the word. You must realize that there is a distinct Shirley Temple that I cannot thwart, stifle or throttle. It wouldn't be right to cover with a black cloth the light of genius. We must use keen and kindly judgment. Like you, I look at her and say to myself, "stay as sweet as you are."

As each year passes Shirley is going to have more and more to say about this. She has a mind of her own now, and this will not lessen with the progress of years.

What we must rely upon for the future is good example, development of refined and intelligent background and a solacing and proper environment.

If anyone can show me a better thing to do, I will be grateful.

Very truly,
GERTRUDE TEMPLE.

Title Changes

Red Woman (Sylvia Sidney and Gene Raymond) has been changed to *Behold My Wife*.

Limehouse Nights (George Raft and Jean Parker) is now *Limehouse Blues*.

Police Ambulance (Johnny Mack Brown and Sally Blane) is now *Against the Law*.

Caprice Espagnol (Dietrich) has been retitled *Carnival in Spain*.

One Hour Late (Morrison-Twelvetrees) has become *Me Without You*.

Broken Soil (Anna Sten-Gary Cooper) has been changed to *The Wedding Night*.

Enchanted April (Ann Harding) is being retitled but no new title announced.

Perfect Weekend (Cagney) has become *St. Louis Kid*.

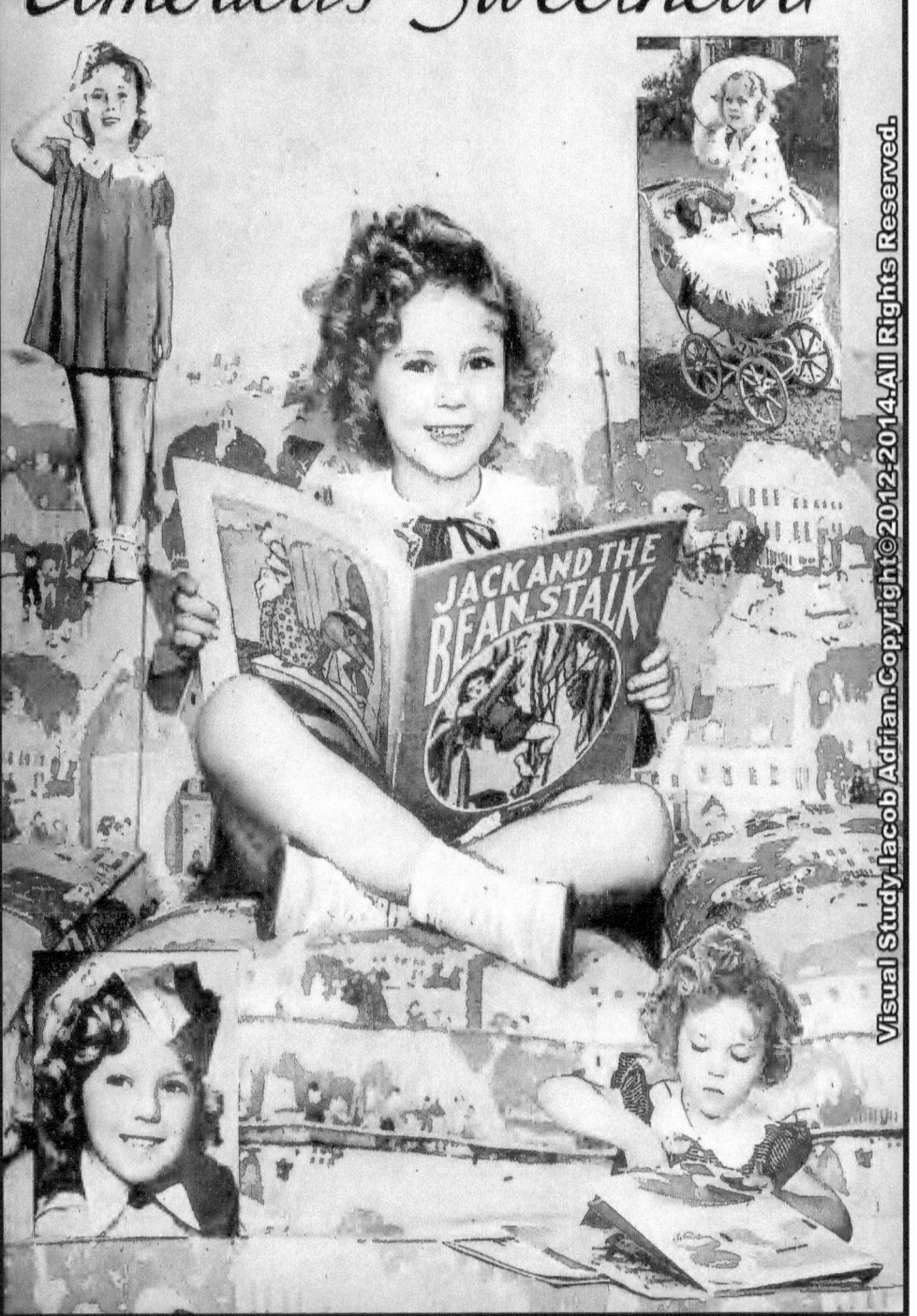

What's New

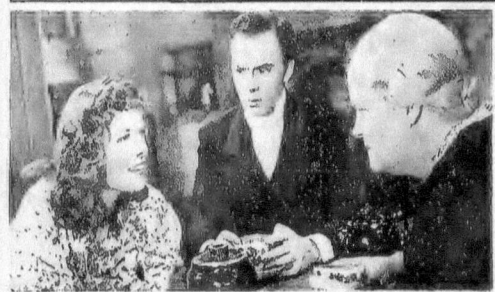

Katharine Hepburn—John Beal—Mary Gordon

The Little Minister

★★★★ The classic drama of Sir James Barrie comes to the screen as one of the truly great pictures of the year. Katharine Hepburn is overwhelming with the fire and passion of her perfomance and John Beal in the title role turns in a masterly characterization.

John Beal, a young minister in charge of his first parish, finds his life disturbed when he meets Katharine Hepburn (Babbie) disguised as a gypsy. The conflict between her passionate love and his puritanical scruples makes up the theme of this powerful play.

Lumsden Hare and Alan Hale are excellent and Andy Clyde and Donald Crisp turn in fine performances.—RADIO.

The Mighty Barnum

★★★★ Magnificent in conception and excellently screened, this film reveals the genesis of the circus.

The story opens with a flash of a modern circus, then cuts back to 1835 when it shows Wallace Beery as P. T. Barnum dreaming of owning a freak show. His wife Janet Beecher is revolted at the idea. Beery buys a negress supposed to be 106 years old and one time nurse of George Washington, and his career begins. Adolphe Menjou is assistant and guard against alcoholism.

You see Tom Thumb, The Cardiff Giant and all the freaks which made the name of Barnum famous. A great picture with not a dull moment in it.—TWENTIETH CENTURY.

Adolphe Menjou—Wallace Beery

Bing Crosby

W. C. Fields—Baby LeRoy—Kathleen Howard

Guy Kibbee—Aline MacMahon

Here Is My Heart—

★★★★ Although he is J. Paul Jones in this play, it is really our old friend Bing Crosby who, after making millions as a radio crooner sets out to fulfill all his ambitions and does so in a thoroughly enjoyable way. This is Bing's finest screen performance to date and the story is packed with laughs. Roland Young, Alison Skipworth and Reginald Owen contribute to the fun as the half-wit family of the fascinating Princess (Kitty Carlisle).—PARAMOUNT.

It's A Gift

★★★ This picture is just a series of gags. But what gags! There isn't much to the story, something about a henpecked husband who achieves his desire for a California orange grove through the death of his uncle, but it starts off with a bang and speeds right along through one continuous series of laughs. Fields carries the whole show but the romantic interest is furnished by two newcomers, Julian Madison and Jean Rouverol.—PARAMOUNT.

Babbitt

★★★ An excellent screen translation of Sinclair Lewis' epic of the small town business man, although much of the vitriol and satire has been taken out. Babbitt (Guy Kibbee) is the big real estate man of Zenith who through stupidity becomes involved in a shady deal. His wife (Aline McMahon) rescues him and he basks again in the light of his self importance. Kibbee is at his best and Aline MacMahon, Glen Boles and Minna Gombell are excellent.—WARNERS.

Advance information on newest pictures seen at Hollywood previews by our staff of film critics

on the Screen

Forsaking All Others—

● ● ● ● This is the first time W. S. Van Dyke has ever directed Joan Crawford and what a personality his direction makes of her! Clark Gable also responds to the magic of Van Dyke's direction with one of his finest films.

Joan Crawford is the girl and Clark Gable the boy who have known each other from childhood. Joan thinks she loves another boy (Robert Montgomery) but he leaves her flat and marries another girl. She then finds that it has really been Clark whom she loved. Charles Butterworth is great and Frances Drake and Billie Burke excellent. This film has everything, fine performance, grand comedy and dialogue.—METRO.

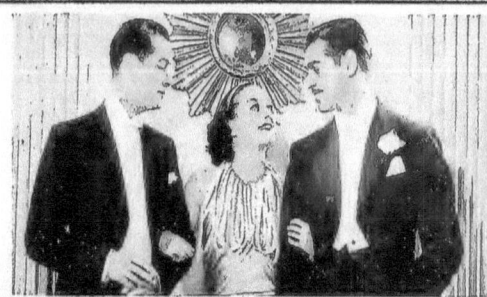

Robert Montgomery, Joan Crawford, Clark Gable

Babes in Toyland

● ● ● ● This is a movie feast for the children and for grown-ups as well for it is fantasy of the highest order presented in a superb manner.

All Mother Goose's favorites are brought to life to the lilt of Victor Herbert's March of the Wooden Soldiers. Laurel and Hardy have some very funny scenes and a real star is the character (a marionette) who looks like a twin brother to Mickey Mouse.

Other players who score are Charlotte Henry, Felix Knight, Henry Kleinbach, Florence Roberts and Virginia Karns.

Don't fail to take the kiddies to see it and while there sneak a look yourself.—HAL ROACH.

Stan Laurel—Oliver Hardy

Shirley Temple

Gato—Malibu

Francis Lederer—Ginger Rogers

Bright Eyes

● ● ● Little Shirley Temple scores again and this picture is mostly Shirley. The story starts when Jimmy Dunn adopts the orphaned Shirley. Judith Allen, the estranged sweetheart of Jimmy is slowly won back through the sweetness of the child. Jane Withers, another tiny player is the heavy of the play and she makes life miserable for Shirley. It all ends satisfactorily however with a re-union between Judith and Jimmy.—FOX.

Sequoia

● ● ● The story of a strange friendship between a mountain lion and a deer, a story of love and devotion rarely equalled even among humans. It may not sound like much but when you follow the lives of Malibu, the deer and Gato, the mountain lion through the glories of the California outdoors you will get your money's worth. Jean Parker is effective and Russell Hardie is good but the cast is really secondary to the grand animal pictures.—METRO.

Romance in Manhattan

● ● ● A grand romantic tale of Francis Lederer, a poor immigrant who dreams of being a millionaire. When he is about to starve, Ginger Rogers helps him and finds him a job as a taxi driver. Two nosey old ladies report Ginger unfit to bring up her young brother and there is lots of trouble. Finally Ginger and Lederer marry and friends arrange to get him his citizenship papers. Lederer is grand and Ginger is splendid in her first real dramatic role.—RADIO.

RATING CODE: ● ● ● ● Excellent ● ● ● Good ● ● Fair ● Mediocre Additional Reviews on page 73

With the News Sleuth

she is threatening to toss aside her stardom permanently to devote all of her energies to motherhood.

Champion Papa

IF YOU HAVE any doubts about Edward G. Robinson's fondness for that infant of his, listen to this:

When Columbia was dickering with the erstwhile portrayer of gangsters, the matter of salary and story was settled in double-quick time, then Eddie demanded that a clause be inserted in his contract providing that he would be excused from work at 5:30 daily.

"Why 5:30?" Harry Cohn wanted to know.

"So that I can get home in time to see my youngster put to bed!" he replied.

A Bride for Lyle!

NONE OF LYLE TALBOT'S many, many previous *heart attacks* ever assumed the serious proportions taken on by the one he now is undergoing. Peggy Waters, a gal from Alabama, is the cause of it all.

Shirley Loses a Curl

SHIRLEY TEMPLE truly is the poor little rich girl of the talkies.

Because a strange woman slipped up behind Shirley in a crowded department store the other day, and snipped off one of her curls, Pa and Ma Temple have ordered Shirley's governess to steer clear of mobs when she has the young star in tow in the future. They're afraid of serious injury to the clever youngster.

One at a Time, Please!

WHEN THE STORK was hovering over the Bing Crosby manor, Bing prayed that the long-legged bird would bring him twins. And his wish was fulfilled.

But Chick Chandler and wifey Jean Fontaine prefer their offsprings one at a time!

Just to prove that they are serious about it, Chick and Jean have bought one of the strangest insurance policies ever written.

It pays them $50,000 should twins come to their home, and $75,000 in case it's triplets!

Popularity Grows

ANNA STEN'S Hollywood popularity is growing by leaps and bounds, now that Goldwyn is permitting her to appear in public.

For more than twelve months after her arrival in this country, Goldwyn kept Anna in the background, while she perfected her English. During that period, the star and her husband, Dr. Eugene Frencke lived in seclusion in their Santa Monica canyon abode, the address of which was known only to studio executives.

Now that Anna has landed at the top, she and the doctor have come out of their seclusion, and every social function they attend adds to their list of friends.

HOLLYWOOD BABIES

Norman Scott Barnes (Joan Blondell's baby) aged 18 days, is pictured with his mother

And this is Sally Eilers and her nine weeks old son, Harry Joe Brown 2nd

Hollywood Chatter

Jimmy Dunn writing a story for Shirley Temple and Alice Faye.

Jack Oakie augmenting the Toluca Lake Boat Club by giving Mary Brian an eight-foot row-boat.

Marlene Dietrich demonstrating how she rolls one hundred and fifty cigarettes an hour for her rôle in her newest picture.

Myrna Loy proudly displaying the world's largest gardenia, which has been named for her.

Katharine Hepburn saving Ann Harding's "Enchanted April" set from a dangerous fire by sprinting for the fire department.

W. C. Fields joking about the time he had to leave Germany in a hurry because he started a riot in a beer garden.

Akim Tamiroff setting fire to his beard while lighting a cigarette. A property man saving the day by prompt action with an insect spray gun.

Lew Ayres going places as usual with Mrs. Ginger Rogers Ayres.

Chick Chandler stopping by the studio to take home his other suit of clothes.

George Brent puzzling over why his fan mail has doubled since his divorce from Ruth Chatterton.

Max Baer and his kid brother Buddy practicing crooning—a la Bing.

Ivan Lebedeff getting a tag for double parking while waiting for Wera Engels.

Gloria Stuart fighting the flu.

Alice Brady getting her first glimpse of a boxing match as the guest of the Busby Berkeleys.

Douglas Fairbanks showing visitors his four kinds of dress suits brought back from England.

Greta Garbo arriving one hour too late to lease the W. C. Fields home in Toluca Lake. Helen Morgan gets it.

Harpo, Chico and Groucho Marx keeping M-G-M Studio in a continuous uproar.

"Silver King," Fred Thompson's famous horse, acting as an "extra" in *The President Vanishes*.

Shirley Temple telling everyone why she doesn't like spinach.

Henry Hull and Victor McLaglen discovering that they worked in the same silver mine at the same time in Canada.

Charles Bickford trying to think of an appropriate revenge against his practical-joker manager. The manager has been pestering the life out of Charles.

Edward G. Robinson explaining why his contract states that he must be allowed to go home every day at 5:30—he likes to watch his young son being put to bed.

Adolphe Menjou, the "best dressed man in Hollywood," going to lunch unshaven and wearing a Tyrolean hat—all part of his make-up for *Thunder in the Night*.

Josef Von Sternberg dressing up the studio work crew in Spanish costume to show his actors how to act.

Margaret Sullavan handing over five dollars to the Los Angeles Traffic Bureau —charge: 43 m. p. h. in a 25-mile zone.

A Hollywood doctor advising Gloria Swanson not to wear such high heels.

Lyle Talbot still rushing Peggy Watters.

Alan Hale being very secretive about his latest invention.

Douglas Fairbanks, the Countess di Frasso, and Kay Francis dining with Mary Pickford at Pickfair.

Jean Hersholt revealing that his library of first editions is insured with Lloyds for forty thousand dollars.

Phillips Holmes cabling from England to have his car shipped over.

Gertrude Michael dining with Raul Roulien at Sardi's.

Gloria Stuart and Joan Blondell reminiscing about the time they were in a high school play together in Santa Monica.

—*Max Munn Autrey*

The world is singing the praises of little Shirley Temple, who is seen here with Pat Paterson, since she stole the show in Stand Up and Cheer. *She duplicated this success in* Little Miss Marker *and* Baby, Take a Bow

Christmas Present for Powell

JEAN HARLOW's friendship for William Powell is still taken seriously in Hollywood. Although each has a circle of close friends, they find time to go places together, and are on all hostesses lists as a romantically inclined couple.

Bill is wearing a gorgeous silk scarf with his initials embroidered in black, and makes no secret of the fact that it is a Christmas gift from Jean.

Jimmy Dunn Writing Play for Shirley

JIMMY DUNN, who has teamed with Shirley Temple in several pictures, is going to write a play for his little pal. He ran across the idea in an old book, on which the copyright has expired, and Fox studio officials think he has found a fine vehicle for the talents of the six year old actress.

McLaglen Enlarging Cavalry

VICTOR MCLAGLEN, colonel of the McLaglen Light Horse, has leased a large tract of land between Hollywood and down town Los Angeles, and is having plans drawn for a polo field, stadium, and extensive quarters for his troopers. Arthur Guy Empey, famous author of *Over the Top*, and an ex-cavalryman, is in charge of drilling the McLaglen regiment, which now numbers 300 officers and mounted men.

Jean Harlow's "Forgetter"

JEAN HARLOW has a terrible memory for everything—except her lines. While she is always letter perfect in a picture rôle, in other matters she never can rely on her memory.

Accordingly she has formed the habit of relying on Blanche, her colored maid, who never fails to remember Jean's appointments.

The other day Jean hurried into the house and saw her maid.

"Oh, Blanche," she cried, "I haven't time now, but remember to remind me that I have something for you to remind me about!"

Bellamy Back from England

RALPH BELLAMY and his wife, Catherine Willard, returned from their trip to Europe with a truckload of furniture and wrought iron for their Connecticut farm house. They visited the Leslie Howards in England, and later spent some time in France.

Baby Jane's Menagerie

BEING THE parents of a three-year-old starlet has its disadvantages, as the fond mama and papa of Baby Jane discovered when their famous infant began to build up a regular menagerie of pets. It started with twelve pigeons, then Joan Bennett gave her a Persian kitten, and to celebrate her first starring picture, *Straight from the Heart* at Universal, another fan gave her two English toy shepherd dogs. Kennels had been finally found for these frisky pups and then a Scottie arrived, the gift of her director, Kurt Neumann. And what's worse, Baby Jane doesn't want to give up any of them!

FEBRUARY, 1935

This isn't Garbo! Just a woman who has been impersonating her around Hollywood

No Spik American

VALERIE HOBSON, the lovely young English actress engaged by Universal for *Rendezvous at Midnight*, as Ralph Bellamy's leading lady, is supposed to have an American accent in the picture. So she has concentrated mightily upon an American pronunciation, paying so much attention to this bothersome detail, in fact, that when a scene came along where she was supposed to cry, she couldn't summon a tear. She sat there, in gloomy meditation, while the cast waited. Not a tear. Finally the director waved her away, saying she could go off by herself until she could think of something to cry about. She got up and started off the set, and suddenly burst into tears.

"What are you crying about?" asked the director.

"I'm crying because I couldn't cry!" Miss Hobson exclaimed weepingly.

Letters That Might Have Been True

CAROLE LOMBARD doubtless would have married Russ Columbo, had he lived. After his tragic death, it was necessary to keep the news from Russ' mother, who has been gravely ill for many months. Accordingly his brother John asked Carole to write letters to Mrs. Columbo, inventing a trip for the singer. This she has done, though obviously the writing of such letters would prove a difficult commission for one so deeply hurt by his death. And who knows—perhaps those letters might have come true—letters from their honeymoon! Close friends of Carole's say that she lost weight and suffered a near breakdown from the tragedy.

With the News Sleuth

German sausage, pumpernickel bread and —BEER!

Marlene and her mate continue to have the best understanding of any Hollywood couple. The German actress appeared at the Trocadero t'other night with the Egyptian Prince Felixe Rolo in tow, and the following evening attended the Mayfair Ball with Director Rouben Mamoulian as her escort.

Rudy was toiling at a directorial assignment.

The Way of a Woman

SHIRLEY TEMPLE STROLLED into the sanctum of Winfield Sheehan, Fox chief, the other afternoon, climbed into his lap, placed her arms about his neck and planted a resounding smack on the Sheehan cheek. And there was method in her madness, too.

Shirley wanted that Pinkie doll she used in her current picture. What's more, she got it!

Gloom for Shirley

AN UNTHINKING FEMALE has robbed Shirley Temple of her greatest pleasure—shopping.

The woman, one of a mob that was trailing Shirley and her mother on a tour of a department store, reached out and snipped off one of the star's curls. Mrs. Temple now has issued an order that she is to be kept away from crowded places.

And because he does not want Shirley spoiled, Boss Sheehan has inserted three new clauses in her contract. Henceforth, she must be in bed by eight o'clock in the evening, is not allowed to eat with the other actors in the studio commissary, and will not be permitted to make personal appearances in theatres.

He's in Demand

HOLLYWOOD PRODUCERS ARE bemoaning the fact that there is only one Robert Donat, whose American-made *Count of*

Please turn to page ten

ARRIVING

—*Wide World*

When Leslie Howard returned to America alone, the wise ones solemnly nodded and said, "Aha!" But Mrs. Howard, their daughter, Leslie, and their son, Ronald, took practically the next boat to join him. Ronald, who otherwise resembles his famous father, aspires to be a newspaperman. His F. F., who has just finished reading "Anthony Adverse," may soon start the picture version

DEPARTING

Frank Buck, who brings 'em back alive—with pictures to prove it, heads for the Malay jungle again. Mrs. Buck goes along—to the jungle's edge

HARRY CARR'S

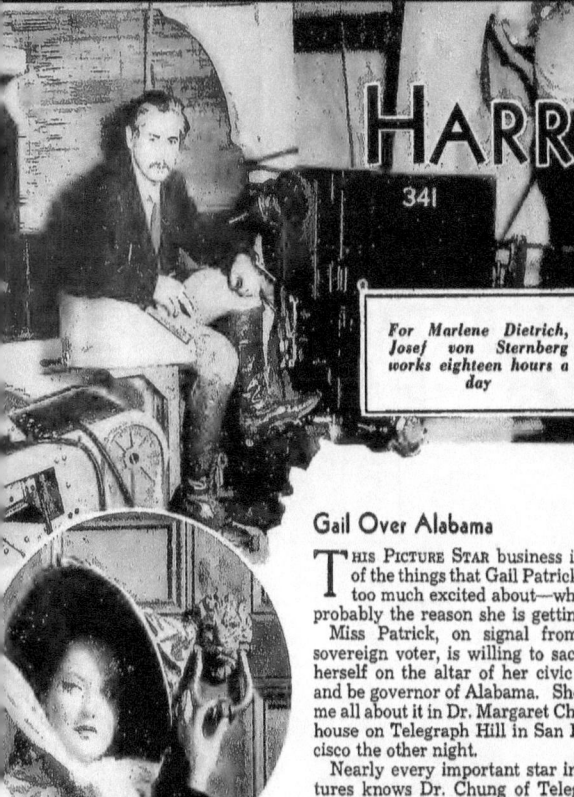

For Marlene Dietrich, Josef von Sternberg works eighteen hours a day

Who's this, knocking on Hollywood's door? England's sensation —Merle Oberon!

Every once in a while, Shirley Temple thinks, even a dance director needs sitting on. She has one who not only takes it, but likes it—Jack Donohue

Harry Carr is famous as an observer of the Hollywood scene— because he looks below the surface and behind the make-believe, and tells just what he sees

Gail Over Alabama

THIS PICTURE STAR business is one of the things that Gail Patrick isn't too much excited about—which is probably the reason she is getting on.

Miss Patrick, on signal from the sovereign voter, is willing to sacrifice herself on the altar of her civic duty and be governor of Alabama. She told me all about it in Dr. Margaret Chung's house on Telegraph Hill in San Francisco the other night.

Nearly every important star in pictures knows Dr. Chung of Telegraph Hill. Her house is a port of call for Hollywood. She is a Chinese surgeon who gives charming Oriental dinners and is the champion listener of the world—one woman who hears all, sees all, tells nothing.

Fame by Accident

"ONE OF THE things that never entered my head," said Miss Patrick, "was being a movie actress. I had just taken my bachelor's degree at the University of Alabama when a chance came for me to escort a group of contest-winning girls to Hollywood. When I got into the studio, they offered me a job acting for the screen.

"I am going to be a lawyer, but I thought this would be an amusing way to fill in the time while I rested before tackling law school. That was two years ago; and I am still acting. Give up the law? Don't ever think it. I am going to be a lawyer and I am going into politics. From the time I was a tiny little girl I have had my heart set on one thing: Some day I am going to be governor of Alabama."

I am not sure about her other qualifications, but she will be the loveliest of all Alabama's governors. She is an extraordinarily pretty girl—long and lithe, with a low voice that has thrills in it.

Josef's Other Side

I DARESAY WE should have expected this. The friends of every demanding person whisper to you to be sorry for the guy because he is shy and bashful, and that is what makes him yell at everybody.

The revelation was a long time coming; but that's what friends of Josef von Sternberg tell me now. They claim that he has struggled all his life with an appalling inferiority complex and is really issuing orders to his subconscious self.

It sounds sort of complicated. But, anyhow, they insist that he is the most charming conversationalist in Hollywood and has the most sensitive and cultured mind.

Whose Face Is Green?

I CAN'T FIND any company to admit it; but a most curious story comes from Mojave out on the desert where the finding of a bonanza gold ledge has sent thousands of people stampeding in a

Shooting Script

by Harry Carr

They're honeymooning on a movie set— Director William Wyler and Margaret Sullavan

new rush for riches. It appears that one of the companies recently made a mining picture at Mojave and went to the trouble of sinking a shaft on the very same property where the "strike" was afterward made. Doubtless the prop men shoveled out a fortune in gold ore without knowing it while they were fixing the sets.

Love Stuff

LOVE HAS HIT Hollywood in strange ways; but never did it deliver a more peculiar whack than in the case of the girl who is abandoning her promising film career to devote her time to being a step-mother.

The girl is Lucille Walker, the Fox young lady who was married recently to a cousin of U. S. Senator McAdoo. Her new husband runs a drug store in Carlsbad, New Mexico. Miss Walker has to stay on for the filming of *George White's Scandals*, but says that this will be her last picture. "My husband has a baby daughter who needs a mother's care; so I am leaving the screen."

Picturesque Weddings

THE "QUIET WEDDINGS" that the society reporters write about are not for Hal Mohr. His first one was performed on a movie set while Erich von Stroheim was making *The Wedding March*—with a whole herd of "extras" in Viennese court uniforms for audience. His latest was his airplane elopement with Evelyn Venable to Yuma, Arizona.

MARCH, 1935

Tip for Directors

THIS MIGHT HELP with all temperamental stars. In his first movie part, "Man Mountain" Dean, the gigantic, whispering wrestler, stopped the picture because he stoutly refused to wear spats. While he and Director
Please turn to page eighty-one

If it were only a case of sing or swim, Jeanette MacDonald would—b-r-rr!—rather sing

Douglas Fairbanks has seen plenty of traveling—and he's going to see some more—but the way Maurice Chevalier's dice travel is a revelation to him

HERE'S GOOD FUN— AND GOOD FOOD!

How about a "Gay Nineties" party—Hollywood style? It is easy to plan, easy to stage, famous for results!

by

Grace Ellis

HOLLYWOOD'S
Food Consultant

THEY DIDN'T SERVE SALADS IN THE GAY NINETIES!

But they served quantities of juicy fruit pickles.

You can buy spiced fruits every bit as good as theirs, or make them yourself from already canned fruit, if you like. Our recipe for delicious PICKLED FRUIT MEDLEY is ready for you, printed on one of our handy little recipe filing cards, as is the recipe for Genuine Old-Fashioned Chicken Pie.

You may have either recipe free, by sending a stamped, addressed envelope. If you wish both, include an additional 3-cent stamp for the second one.

Write Grace Ellis, HOLLYWOOD Food Consultant, 1501 Broadway, New York City, N.Y.

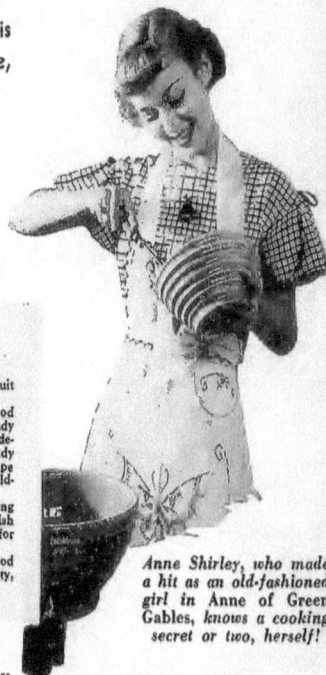

Anne Shirley, who made a hit as an old-fashioned girl in Anne of Green Gables, *knows a cooking secret or two, herself!*

HOLLYWOOD PEOPLE USED to say, "Let's have a party!" Now they say, "Let's have a Gay Nineties party!" They're throwing sophistication to the winds and having some good old-fashioned fun. And giving the rest of the world some "new" party ideas.

Mae West started it all, nearly two years ago, and the craze shows no signs of abating. Since *She Done Him Wrong*, practically every player in the movies—from Will Rogers to Baby Le Roy, and from Katharine Hepburn to Shirley Temple—has acquired a costume that could pass as 1890 vintage. And why store them in moth-balls? Why not use them? Why not, in short, have a Gay Nineties party?

And there is your cue for that party you were half-planning for February or March—whether it is to be an afternoon feminine festivity, an evening bridge group of the "mixed" variety, a special tea, or an "invitation" party. There is your cue for dragging out old sheet music, for rummaging through old trunks—two zestful occupations, bound to be fraught with re-discoveries.

But what food would you serve on such an occasion? (The "food problem" is always the biggest one at any party.) That's another enjoyable thing about a Gay Nineties party. It doesn't call for anything fancy or fussy! The food—if it's old-fashioned and good-to-eat — need be the least of your worries. Waffles, pancakes, oyster stew, chicken pie or any one of a dozen other old-time favorites would make an equally suitable main dish.

And you don't have to worry about the entertainment. Give the guests (even if there isn't an actor or actress in the crowd) half a chance and they'll provide most of it, themselves—and extemporaneously. As for the costumes —well, you can't say, of course, that everyone loves dress-up parties. I've known men who make a terrific family disturbance that usually ends in a dual regret when a "come-in-costume" invitation arrives. But even these refractory souls are apt to enjoy dressing for a "Gay Nineties" or "Pioneer Party." There's almost always a pair of pin-toed shoes or a checker-board vest about to form a nucleus for a masculine costume. As for the ladies— they can pick their ideas straight from *Little Women, Judge Priest, Belle of the Nineties, Anne of Green Gables* or a dozen other movies I could mention. In giving an unconventional party of this sort, don't let yourself be restricted to following someone else's suggestions. You'll be concocting plenty of ideas of your own, once you start working on plans.

As a send-off, I shall tell you of two recent parties that were to use a Hollywood phrase, "smash hits." The first was a "Gay Nineties" dinner, given by a young and attractive lady who isn't so helpless in the kitchen as the myths about "young moderns" would lead you to believe. Both she and her mother like to cook, and her mother enjoys particularly doing the old-fashioned dishes, so that helped tremendously.

Invitations were written on white paper, cut in the shape of a Victorian lady's hand, with a ruffle at the wrist. The eleven guests came costumed as bicyclers, auto-fans, languishing (and laced) ladies and flashy "Diamond Dicks" of the just-before-1900's—not to mention His Highness, the man on the flying trapeze! Dinner was served with pseudo elegance at a table centered with an old-fashioned castor and a pair of silver pickle-jars, and consisted of:

Chicken Pie
Mashed Potatoes Cream Gravy
Escalloped Corn
Celery (Served from a Celery Vase)
Pickled Fruit Medley
Baking Powder Biscuits Quince Jelly
Blanc Mange Layer Cake
Coffee

Each place was marked with a tiny home-made booklet titled "Autograph Album of ————," with the blank holding the name of the guest. Inside of the flyleaf of each was written a verse copied from an old "autograph album"—a relic of the days when autographs were collected for sentiment's sake, not display. Three-fourths of the hilarity of the evening was furnished by these and by the original verses written into the albums by other guests, each of whom was supposed to leave a signature and a line or two of "noble sentiment" or remembrance, on one page of the album of each other guest.

The dining table, stretched to its full length, was the center, not only of the everything-on-the-table-and-pass-the-food-around meal, but of the fun that followed. "Pokeno" furnished the evening's diversion. If you haven't played it, you must! It's the game of the moment in Hollywood. You need only a group of Pokeno cards (which you can purchase at any department store), a few poker chips and a Monte Carlo manner. Though a new game, it fitted into the "Dead-Eye-Dick-and-Diamond-Lil" spirit of the party with perfection. Losers were forced, finally,

Please turn to page

MARCH, 1935

Hollywood's Shooting Script

Victor Fleming were still arguing, Man Mountain went to San Diego and an Indian named Chief Little Wolf threw him out of the ring and into a hospital. Fleming claims it is the judgment of an outraged Providence.

De Mille Can Take It

"GRACIE," THE "EXTRA," is sure of one job—she will be in Cecil B. De Mille's coming picture of the crusades. Gracie will always be present in De Mille pictures. Her method is not recommended, however.

While De Mille was explaining a scene to the company in *Cleopatra*, two "extra" girls disturbed him by talking in the back row. He sternly ordered silence, but they kept on. At last, with frosty politeness, the great director said: "As the topic of your conversation seems to be so absorbing, kindly come up here to the loud speaker and let us all hear it." Not a whit dismayed, Gracie wended her way through the scene and came to the speaker. "Well," she said, "it was this way. I was just sayin' to my friend, I said: 'How long do you suppose that old bald-headed geezer will keep us waiting for lunch?'"

De Mille roared and Gracie has a life job.

New Hideouts

LEWIS STONE HAS started a new fad for the world-weary. He has bought an old mining claim up in the Bret Harte country.

These old claims can be had almost for the asking. The land is practically worthless; it is covered with trees, however—grown up from the stumps of the timber that went into mine shafts in the Fifties. The whole country around there is pock-marked with prospectors' holes.

The Bret Harte towns are still there—ghost towns in whose streets once dashed the six-horse stages and where the gun fights were held.

Mary 'n' Doug

IT SEEMS TO be all off again, Mary Pickford having refused an invitation from Douglas Fairbanks to go wandering around the world in a schooner he is buying in New York.

I think that the truth is that Mary's new religion has absorbed her every thought. She has even written a book about it.

Restoring Marlene

THE REAL REASON why Marlene Dietrich has gone back to work with Josef von Sternberg is to make the critics of *Scarlet Empress* eat their harsh words.

It is doubtful if any picture made by a major director ever received a worse panning.

Von Sternberg still is convinced that it was a great picture and that Marlene was wonderful. Nevertheless, the two are working eighteen hours a day on the new picture *Caprice Espagnol*, solely for the purpose of making the movie world more Dietrich-conscious than ever.

All things considered, Marlene has never been able to please the public again as she did in *Morocco*—which also showed Gary Cooper as a real actor of parts.

MARCH, 1935

Heartaches Ahead?

WHEN *The Good Earth* finally gets under way, will it be haunted by the ghost of a tragedy?

His friends tell me that Director George Hill's suicide is directly traceable to his disappointment over this picture.

Hill envisioned it an epic with an all-Chinese cast. He spent months searching China for "shots" and characters. He came back with miles of beautiful pictures and native Chinese actors and was told that the cast would be Chinese only in facial—not racial—make-up.

Over-Sold

LILIAN HARVEY Is one of the few actresses who have ever been sincere in dodging publicity men.

In a talk with a Los Angeles newspaper man, she said frankly that her career in the studios was stultified by her being "over-sold" to the American public.

After her European triumph in *Congress Dances*, she arrived in Hollywood with all the acclaim that would go to a flock of empresses.

She says that she knew at the time that it was fatal. Nobody short of Duse could have lived up the billing.

Now, without any ballyhoo, she just wants a part that will enable her to make good with the American public.

After a long rest in the hills, she quietly returns to the screen opposite Tullio Carminati in *Once a Gentleman*.

She Trouped to Conquer

HAVING TRAMPED AROUND Hollywood, eating the dust of humiliation, Mrs. Leslie Carter has won at last. She took the knocks and the disappointments without a whimper, so everyone rejoiced when the late Lowell Sherman gave her the part of Mrs. Crowley in *Becky Sharp*.

Joan Sets a Record

THE NEW CONTRACT signed by Joan Crawford and M-G-M establishes something of a record. She has been nine years with this studio. Her whole career has been within its high fences.

I am not sure, however, that this is the most unique experience of the kind. Mabel Normand must have been under contract to Mack Sennett for at least that long.

On the whole, Miss Crawford has held up as a star as well as any other woman who has ever been on the screen. And it must be a satisfaction to her to know that she has made this climb without pull or outside influence.

She has been studying singing and her next picture will probably be a musical upon which Oscar Hammerstein and Jerome Kern are working.

Years Are So Short

YOU MAY DEBATE about other stars, but anyone can measure the length of the starring days of one big box-office wallop.

In the nature of things, Shirley Temple can last for only a year or so longer. No matter how good these wonder-children are, they always grow up.

She is now at the height of her drawing power. She is among the top ten box-office attractions of the world.

THE Guide TO NEW pictures

The Check-Up of Current Pictures

These are pictures now making the rounds of the nation's theatres, which have been reviewed in HOLLYWOOD during the past two months, receiving the following ratings:

• • • •

Broadway Bill — Amusing, exciting, thoroughly human racetrack drama, directed by Frank Capra, starring Warner Baxter and Myrna Loy.

Kid Millions—Eddie Cantor in pursuit of a fortune, with Ethel Merman, Ann Sothern, the Goldwyn Girls and music.

What Every Woman Knows—Helen Hayes in Barrie's comedy about a plain, but subtle woman.

Great Expectations — Henry Hull's movie début in Dickens' famous story of a convict playing philanthropist.

The Painted Veil — Garbo, smiling, debates between Herbert Marshall and George Brent in a Chinese setting.

Music in the Air—Gloria Swanson and John Boles singing duets by Jerome Kern, against a background of hysterical comedy.

Kentucky Kernels — Wheeler and Woolsey help an orphan inherit a fortune and run up against old Southern hospitality, as represented by duelists.

The President Vanishes—Sensational, timely melodrama, with the President disappearing in a dramatic crisis.

Imitation of Life—Thoughtful, provocative drama, contrasting the lives of blacks and whites and revealing Claudette Colbert in a mother rôle.

Grand Old Girl—May Robson scores another hit as an old lady full of fight.

The Man Who Reclaimed His Head—Sensitive, startling drama exposing men who cause wars and starring Claude Rains.

The Little Minister—Katharine Hepburn as Barrie's gipsy girl, with John Beal as the earnest young cleric she bewilders.

Forsaking All Others—Joan Crawford tries comedy, with both Clark Gable and Robert Montgomery as co-stars.

The Mighty Barnum—Colorful, dramatic, amusing biography of the granddaddy of ballyhoo, played by Wallace Beery.

Babes in Toyland—Victor Herbert's operetta as a screen fantasy, interpreted by Laurel and Hardy.

Here Is My Heart—Bing Crosby scores his biggest hit in a singing version of *The Grand Duchess and the Waiter*.

• • •

It's a Gift—W. C. Fields, plus Baby Le Roy.

Babbitt—Sinclair Lewis' satire of a typical business man, minus the sting, superbly played by Guy Kibbee and Aline MacMahon.

Bright Eyes—Shirley Temple at her best — and James Dunn at his — in a sprightly little tale.

Sequoia — An unusual picture; the story of the friendship of a deer and a mountain lion, with Jean Parker also present.

Romance in Manhattan — Francis Lederer follows up his hit in *Pursuit of Happiness* with a gay comedy of a young immigrant getting used to American ways. Ginger Rogers is of considerable assistance.

I Am a Thief—Ricardo Cortez scores in another slyly clever melodrama.

Evelyn Prentice—William Powell and Myrna Loy, the co-stars of *The Thin Man*, decorate a so-so story.

College Rhythm — Musical farce of football and collegians, with Jack Oakie, Joe Penner, Lanny Ross and Lyda Roberti.

The Curtain Falls—Henrietta Crosman in a vivid character sketch of a trouper who can still troupe.

Anne of Green Gables—The famous tale of an orphan who made good, with a new story appearing in the person of young Anne Shirley.

The Captain Hates the Sea—An amusing kaleidoscope of life aboard a cruise liner. Aboard are Victor McLaglen, John Gilbert, Walter Connolly, Helen Vinson, Wynne Gibson, Leon Errol, Walter Catlett, Fred Keating.

Gentlemen Are Born—An ironic story of bright college youths battling the cold, cold world. Franchot Tone is the principal alumnus.

The St. Louis Kid — James Cagney drives a truck through the milk-strike zone, and adventure and comedy are rampant.

The Firebird — Mystery about who killed Ricardo Cortez — mother Verree Teasdale or daughter Jean Muir.

Enter Madame—Elissa Landi reveals unsuspected fire as a prima donna with a rebellious husband, Cary Grant.

The White Parade—A sensitive, dramatic, complete picture about the life of student nurses, with Loretta Young epitomizing the white-capped ideal.

Hell in the Heavens—Warner Baxter goes to war in an airplane, with romance awaiting him behind the trenches.

Can You Answer These Questions About the Picture ?

1. What season of the year is the setting for this particular scene?
2. What era is represented by the costumes of the "extras?"
3. Do the workmen outnumber the "extras," or vice versa?
4. Just where are the principals in the scene to stand—as indicated by the position of the microphone arm?
5. Where is the camera?
6. Are all the light reflectors placed in the same position?
7. Which predominate—adults or children?
8. Are there any automobiles in view?

Shirley Temple

On April 23, she will be six—and she will start her seventh year by also starting her seventh starring picture, *Heaven's Gate*. Her new accordion is a gift from its maker—a man in Italy—who had intended it for his own little girl. When she died, he wanted The World's Little Girl to have it

Portrait by Otto Dyar

What's New

A poem in grace and harmony—that is the Smoke Gets in Your Eyes dance of Ginger Rogers and Fred Astaire in Roberta—and the final fillip to a memorable and merry musical

Roberta
Astaire, Rogers, Dunne—and a Great Show

●●●● *Roberta* is one of the most lavish musical comedies ever made—and it doesn't have a single chorus number. It gives both Fred Astaire and Ginger Rogers more to do than they have ever done before, and offers the additional star-attraction of Irene Dunne, singing, among other things, the unforgetable *Smoke Gets in Your Eyes*. Their work, plus clever dialogue, amusing situations, and a spectacular, eye-filling ending, make a built-to-pattern story exhilarating.

Puckish Fred, of the flying feet, is leader of an American jazz band stranded in Paris; the gorgeous Ginger is a girl from his old home-town who has gone glamorous as "*Countess*" *Scharwenka* (her accent is devastating) and who promises to get his band a berth if he won't give away her secret; Irene is a former Russian princess, now head designer in the gown shop of *Roberta* (Helen Westley), who, in private, is the Aunt Minnie of Randolph Scott (one of Fred's gang) and wills him the shop on her sudden death. He and Irene become partners, then have a lovers' misunderstanding, and it takes Fred and Ginger, with a style-show that is real entertainment, to put over the shop.

It rates ●●●● because of the team-work of Fred and Ginger, who dance not only to the strains of *Smoke Gets in Your Eyes*, but stage a sparkling "rehearsal" number in which they "talk" to each other with their feet; because Irene's voice—while more of parlor, than concert hall quality—is silvery-clear; because Irene has never been more glamourous, Ginger never more entertainingly exotic, Fred never more clever. He even plays the piano in this one!—*RKO-Radio*.

Carl Brisson—Mary Ellis

Sterling Holloway—Will Rogers

Ann Sothern—Maurice Chevalier

All the King's Horses
Carl and Mary Race to Stardom

●●●● Much in the manner of *One Night of Love*, this musical picture steals upon the public quietly as a surprise hit and introduces another glamourous singer—Mary Ellis—to the screen. Not only that; it proves that Carl Brisson is here to stay—as a brightly shining star. Light, whimsical, gaily romantic, the story is about a king and an actor who doubles for him while he takes a secret vacation—a vacation that is a secret even from his loving queen. Besides the stars, you'll like the music—especially, *A Little White Gardenia*.

It rates ●●●● because it has sparkle, verve; and because it gives the screen two new and unusual stars.—*Paramount*.

Life Begins at 40
Will Rogers Delivers—Again

●●●● Even though the plot of *Life Begins at Forty* isn't so different from that of *The County Chairman* that the difference counts, Will Rogers rings the bell again. Not only is his part tailored to his measure, but he has such new and comical cohorts as Sterling Holloway and Slim Summerville, with Rochelle Hudson and Richard Cromwell as the young love team. This time he is a small-town newspaper publisher, forced out of business, who never gives up and makes a clever comeback—in which Slim Summerville is his particular partner.

It rates ●●●● because it maintains the high standard of Rogers entertainment; and because his supporting cast is his best yet.—*Fox*.

Folies Bergère
Meet a New Chevalier!

●●●● What can be said of Shirley Temple's latest picture can also be said of Maurice Chevalier's: it may not be his best, but in this elaborate extravaganza he is his most versatile self. He plays two rôles. In one, he is an entertainer, with curvacious Ann Sothern, at Paris' famous *Folies Bergere*; in the other, wearing a mustache and a romantic streak of gray in his hair, he impersonates a baron, the husband of exotic Merle Oberon, and is a new and unexpected Chevalier. The song-and-dance numbers are of the dazzling variety.

It rates ●●●● because of his skillful fun-making—not to mention love-making; and because of the glamourous, de luxe setting.—*United Artists*.

on the Screen

HOLLYWOOD'S Review Ratings:
●●●● Excellent
●●● Good
●● Fair
● Mediocre

(More reviews on page 54)

J. Burke—C. Laughton—C. Ruggles

Ann Dvorak—Rudy Vallée

Lionel Barrymore—Shirley Temple

Ruggles of Red Gap
They Don't Come Any Funnier

●●●● This is the funniest comedy since Chaplin's *Gold Rush*—and Charles Laughton, in the title rôle, turns in one of the greatest character sketches of all time, subtly satirical, uproariously comic, tinged with pathos. He is an English butler—lost by elfish Roland Young to a rough Westerner, Charlie Ruggles—who discovers, after many a misadventure and after falling in love with ZaSu Pitts, that he has a soul of his own.

It rates ●●●● because of Laughton, whose work inspires a fine supporting cast; because the picture hasn't a single letdown.—*Paramount.*

Sweet Music
Mark Up a Hit for Rudy

●●●● Rudy Vallée is a movie hit, and a versatile one, in *Sweet Music*—a vivid personality, a singer, a musician, and a lad with a sense of humor. It is a comedy, with music, about a radio crooner with manager-trouble and girl-trouble, in which he is assisted by Ann Dvorak (the gal dances!), Helen Morgan, Alice White, Ned Sparks, Allen Jenkins and Frank and Milt Brittons' Musical Maniacs.

It rates ●●●● because it is packed with a variety of entertainment, and because Rudy thrives on its possibilities.—*Warners.*

The Little Colonel
Shirley Outdoes Her Small Self

●●●● Shirley Temple is young for the title rôle of *The Little Colonel*, and the plot has whiskers almost as gray as those that Lionel Barrymore wears, but Shirley is the best she has ever been. Not only does she live her rôle; not only does she sing; she does two amazing dance duets with famed Bill Robinson—while hunting ways to bring her mother (Evelyn Venable) and her crotchety grandfather (Barrymore) together again.

It rates ●●●● because "the wonder child" lives up to her title in the most varied tests yet of her talent.—*Fox.*

Bellamy—Sten—Cooper

R. Montgomery—Helen Hayes

Jan Kiepura—Marta Eggerth

The Wedding Night
Sten Tills American Soil

●●●● With the beauty and sincerity of Anna Sten as the Russian peasant-girl of *We Live Again* still a vivid memory, Samuel Goldwyn again presents his million-dollar star as a peasant—this time in an American setting, and with Gary Cooper as her co-star. The story may be slighter, but her performance isn't. A girl of simple emotions, she suddenly finds life complicated by being affianced to farmer Ralph Bellamy and also loved by author Cooper. Her problem is solved dramatically, against a background of a Polish settlement in Connecticut.

It rates ●●●● because of its earthy realism; because of Sten's artistry; and because of the work of both Cooper and Bellamy.—*United Artists.*

Vanessa: Her Love Story
Kruger Steals Another Picture

●●● *Vanessa*, co-starring Helen Hayes and Robert Montgomery, tells the beginning of Hugh Walpole's colorful saga of "the wild Herries clan." It is romantic costume drama with Montgomery, restlessly adventurous, and Helen, fiercely independent, parting as young lovers—then meeting again in later years and finding that they still are in love. But Helen now is married to insanely jealous Otto Kruger, which complicates matters. She has to sacrifice either her dreams or her self-respect. An unusual story, it is also talkative.

It rates ●●● because, while the story drags, the acting is superb—with Kruger, in a difficult role, walking off with top honors.—*M-G-M.*

My Heart Is Calling
Kiepura Clicks—Singing Opera

●●● Like *One Night of Love*, *My Heart Is Calling* sells grand opera to the masses—this time with a man (Jan Kiepura) doing the singing. If it isn't such a hit as its predecessor, it won't be his fault, the fault of the music or the fault of pretty Marta Eggerth. It will be the fault of a thin, artificial story and some thin, artificial "comedy relief." As a tenor who rescues a girl stowaway from a starving operatic troupe, Kiepura, himself, clicks all the way. He's en route to Hollywood! And Marta Eggerth's trunks are also packed.

It rates ●●● because of Kiepura's singing, plus the music. You'll hear more from him.—*Gaumont-British.*

What I've Been SEEING and HEARING

Columnists can tell you some things about Hollywood, but it takes a person who is a star, herself, to give you as intimate a close-up of the starry life as this!

by

Marian Marsh

—Photo by Fraker

Even Marian Marsh's portrait above tells a bit of news—there's a new, Chinese influence in Hollywood evening dress!

I'M GOING TO YOSEMITE. That's my story, but I seem to be stuck with it. The trouble all started back in Europe, when I spent a month in Switzerland on a vacation after making two pictures in England. I met Luis Trenker, famous German actor and champion skier, with whom I later made a picture in Germany for Universal. He taught me how to ski. When I left, he presented me with a pair of skis, so when I arrived back in Hollywood last summer I could hardly wait for winter and some snow. Banish the thought of trying to find snow in summer—in California! You may hear about "June in January" here, but not vice versa....

I went to work immediately in *The Girl of the Limberlost* and when that was finished, I promised myself, "Now I'm going to Yosemite!" That's what I thought—but what happened? Well, first Columbia Pictures signed me to a contract and then I began working with Wallace Ford in a picture. To make up a little for the postponement of the skiing vacation, Howard Hughes took me to the opening of the Club Continental.

We were with Colleen Moore and her husband, Al Scott, and I felt that I had to be on my very best behavior because all of my Columbia bosses and their wives were there—Mr. and Mrs. Harry Cohn, Mr. and Mrs. Sam Briskin, Mr. and Mrs. William Perlberg. Marlene Dietrich came in with Felix Rollo and everyone had a surprise. Hollywood had fondly thought Marlene was going feminine again, under the Spanish influence of her latest picture, and yet there she was with a mannish suit on—and all the other girls dressed to kill in soft, feminine numbers!

Bill Robinson, the colored dancer, brought down the house with his stories and his routine. He had to repeat and repeat. You will be seeing him with Shirley Temple in *The Little Colonel*. Mrs. Harry Cohn and I planned a marvelous cocktail party. We set the date then and there and I dashed around to all the tables inviting people and naming the date and the place. But, alas for our labor of love! Mrs. Cohn fell ill, and on the big day I had to 'phone all the people and announce, "No cocktail party."

● Another rendezvous where you meet everyone is the Trocadero. I recently ran into Mary Pickford there with Sonny and Verna Chaliff and a party of friends. Mary looked sweet in shell-pink lace. I called over to her that I hadn't forgotten her cowbell.

I must tell you about the cowbell. It's from the barroom at *Pickfair* and Gwen Pickford, Mary's niece, loaned it

Please turn to page seventy-eight

Here, hand in hand, are the Two Inseparables—Anita Louise and Tom Brown. As Marian reveals, Anita wears a bracelet that tells a Hollywood love story

MAY, 1935

Drop Me a Line

take her at face value, and judge her by those standards.

To me, Mae West is one of the most subtle people before the public. She impresses me as having a grand time gently poking fun at life and its inhibitions, our stupid conventions and foolish vanities. I think one reason for her appeal is that she acts with an abandon with which most of us would like to if we but dared.

Also, I admire Mae West because she has the ability to wear old-fashioned clothes in a century vastly different from the one in which those clothes were created, and make them look appealingly beautiful.

I say, "More power to Mae West!" I think she is very clever, and grand entertainment.

<p style="text-align:right">MISS VERNON COX,

1956 W. 80th Street,

Los Angeles, Calif.</p>

Another Open Letter to Dick
$1.00 Letter

DEAR DICK POWELL:

In the March issue of HOLLYWOOD I read that you are fearful of the loss of public favor if you continue in "singing rôles." Please don't think this way—we like you just as you are.

Eugene Chrisman, in his letter to you, said that you have changed—that you're growing up! Your fans have noticed this, too, and they all would rather see you in the jolly way in which you have so far appeared before them.

Please, please stay "Just As Sweet As You Are"!

This may seem like a reproduction of Eugene Chrisman's letter to you, but I write to prove that your fans do want you to stay young and cheerful and keep that grand voice of yours ringing all over the country!

Do give us some more rôles like those in 42nd Street and Footlight Parade!

<p style="text-align:right">FRANCES M. FEATHER

1362 Mineral Spring Road,

Reading, Pennsylvania.</p>

Will's Popularity Secret
$1.00 Letter

DEAR WILL ROGERS:

Your pictures hold your public with their human interest. How true to life the characters you play! I, like many others, have remarked, "What good acting Will Rogers does!" However, I have come to the conclusion that you are not acting at all, but just being natural.

When a man travels across the country, paying all his expenses, to address a crowd of over four thousand people for two hours for a benefit fund, charging nothing for his address, and then slips away, leaving behind his check for $250 donated to the fund—well, he is what I call a real man. It is that spark of human interest in Will Rogers' pictures that endears him in the hearts of his public.

The only fault to find with your pictures is that they are not produced fast enough for your public. So, in closing, let me suggest a slogan: "More pictures for us and more power to you!"

<p style="text-align:right">MRS. BARTON CALDWELL,

63 E. Broadway St.,

Greenwood, Ind.</p>

(Pardon our pointing, but HOLLYWOOD is proud to present this month, on page 28, an exclusive and vivid pen picture of Will Rogers, Box Office Star Number One—by his close friend, Guinn Williams. He tells what Will, himself, might tell—if Will ever had the talking urge when reporters were around.—Editor.)

Chic, the Masquerader
$1.00 Letter

DEAR CHIC SALE:

Will you please tell where you have been keeping your "real" self, letting everyone believe you were just another "old man" playing an "old man's" part? For now HOLLYWOOD Magazine comes out with your picture, revealing to us a young man, under the caption, "The Magic of Make-Up."

No "magic of make-up" alone could ever have made the bent old man of trembling voice, who has had us first in laughter and then in tears. Why did you hide your real self, causing us to overlook so much talent and such wonderful characterization?

Now that we know, we are expecting "reel" big things of you.

<p style="text-align:right">Sincerely,

SARA DAVENPORT,

900 Gordon Street, S. W.,

Atlanta, Ga.</p>

The Favorites This Month

These are the ten women stars and ten men stars to whom the most letters have been addressed in HOLLYWOOD's "Drop Me a Line" Contest during the past thirty days. Is your own personal favorite among them? If not, why not? Did you write—try for a prize and a star's answer?

The twenty toppers:

1.	Shirley Temple	1.	Clark Gable
2.	Joan Crawford	2.	Dick Powell
3.	Ginger Rogers	3.	Bing Crosby
4.	Greta Garbo	4.	John Boles
5.	Mae West	5.	Will Rogers
6.	Myrna Loy	6.	Gene Raymond
7.	Norma Shearer	7.	Robert Montgomery
8.	Loretta Young	8.	Fred Astaire
9.	Claudette Colbert	9.	James Cagney
10.	Janet Gaynor	10.	Robert Donat

Hollywood Chatter

When *film* folks *foregather, what do they talk about?* According to a last-minute flash from Operative 7046, these are Talkie Town Topics:

Josef von Sternberg telling Marlene Dietrich about the dancing contest he once won in Flatbush.

Lee Tracy off for his new, hundred-acre ranch, where he raises melons and alfalfa.

Director Frank Borzage fighting old man "flu," and receiving many, many flowers from his numerous star admirers.

Nancy Carroll and Van Smith, who have been rumored quarreling, lunching together at the *Brown Derby*.

Dolores Del Rio and Lili Damita selecting frocks.

James Cagney kicking about the stubble he wears in *A Midsummer Night's Dream*.

Henry Armetta ordering three malted milks and downing them in quick order.

Connie Bennett and Stu Erwin at the preview of their latest picture, *After Office Hours*, and giving the small-town fans a good look at them.

Shirley Temple and her stand-in cutting out paper dolls on the set of *Heaven's Gate*.

Pinky Tomlin, who wrote *The Object of My Affections* and left the old Oklahoma homestead for Hollywood, trying to dash off a few bars of music in between shots of his first picture, *Times Square Lady*.

Will Rogers and director David Butler discussing the Hauptmann case—as who isn't?

Jean Harlow working late at night on her dance routines for *Reckless*.

Ruby Keeler playing her own hunches at the races and winning while hubby Al Jolson sits by and marvels at woman's intuition.

Tom Mix driving down Hollywood Boulevard in his new car and seeming to enjoy life in general.

Hearing about the number of prominent actors and actresses who turned down jobs after looking at the tiger in *Man-Eating Tiger* . . . Lew Ayres and Claire Trevor finally accepted the leading parts.

Fred Astaire with his hands in his pockets, whistling and strolling down the Boulevard.

Franchot Tone designing a new-style dinner jacket, in a crusade for comfort.

Spencer Tracy playing the fillies at Santa Anita and losing consistently.

Ginger Rogers' mother entertaining about a hundred guests in honor of her niece, Phyllis Fraser.

Jean Muir hunting for a house in the Toluca Lake district—one that she can remodel herself.

Kay Francis throwing a gigantic "nautical costume" cocktail party at the *Vendome* and redecorating the place to look like the deck of a ship. And then having a relapse of the "flu."

May Robson receiving two proposals of marriage in two weeks—one from a boy nineteen years old.

Fred Keating still fighting a bad cold and talking through his nose, to the delight of his friends.

Rouben Mamoulian—the only man who has directed Garbo, Dietrich and Sten—taking Gertrude Michael to the *Brown Derby*.

George McManus, the creator of *Jiggs*, the cartoon character, sketching a mighty fine picture of Tommy Lyman singing *You're the Top* at the Marcell Inn.

Hal Mohr and Evelyn Venable leaving for an air holiday in their brand-new 'plane. Reported heading for Montezuma's old hunting-ground in Mexico.

Ann Dvorak and Leslie Fenton befriending a dog that had been run over.

Henry Hull in the most grotesque make-up anybody ever witnessed.

Samuel Goldwyn still talking about making *Barbary Coast* — with Miriam Hopkins starred.

Rosalind Russell, the newcomer who has made six pictures in six months, getting away for a week-end at Palm Springs.

An anonymous admirer of Glenda Farrell's leaving a potted plant at her doorstep each morning.

How many Stars do you know?

Test your knowledge of the stars . . . Here are their *reel* names, see if you can fill in their *real* names . . . Score 10 points for each correct answer

	REEL NAME	REAL NAME	SCORE
1	ALICE WHITE		
2	CARL BRISSON		
3	MONA BARRIE		
4	NORMAN FOSTER		
5	DIXIE LEE		
6	LESLIE HOWARD		
7	MERLE OBERON		
8	DAVID MANNERS		
9	JEAN MUIR		
10	JOE PENNER		

MAY, 1935

Our Readers Write....
But write or wrong, our readers

PRIZES are awarded every month to the contributors to this department. There are two first prizes of ten dollars each to the writers of the two best letters which, if addressed to a player, will also bring you a personal answer from the individual star. These ten dollar letters are indicated on this page by four • • • •
The two next best letters win five dollars each and are marked • • • Five more letters will bring our check for a dollar each and are indicated by • • Duplicate prizes are awarded in case of a tie and the editor of HOLLYWOOD will be the sole judge. The right is reserved to print all or any part of the letters received.
Have we heard from you? Address: Editor, Hollywood Magazine, 7046 Hollywood Boulevard, Hollywood, California.

Jean Muir Aids True Love

• • • • My Dear Miss Muir:
May I be one of the many to compliment you sincerely—even at this late date—upon your beautiful performance in *As the Earth Turns*? It was a perfectly exquisite portrayal of a fine character.
I had a personal reaction to it also which I feel may gratify you. My younger sister, on my father's ranch in Oregon, had rebelled against the life and comparative hardships. I took her, by good chance, to your picture. She sat, quiet and tense, drinking in the beauty of your acting, oblivious to us all. At last she said, "Sis, thank you. You've done Jim and me a wonderful service."
A young rancher had long loved her and begged her to marry him. Fearing the life and work, she hesitated, although she knew she loved him. Your sincere work on the screen gave her new courage and in a month, they were married. Boy or girl, their first baby is to be named Jean. Their happiness is very precious to me and *you* can understand, I know, how grateful we all are to you. Very best wishes for a happy, successful life!
Evelyn Powell,
1243 Coast Boulevard,
La Jolla, California.

Fred Astaire Should Tip His "Top Hat"

• • • • Dear Fred Astaire:
Both my husband and I work, and we rarely find an opportunity to attend a show except on Sunday afternoons. We find, however, that our local theatre always runs the pictures-you-must-not-miss on Sundays, so we always get to see the very best ones. We saw you and Miss Rogers in *The Gay Divorcée* and *Roberta*, and enjoyed them both to the utmost.
When we see a picture, we expect complete enjoyment and relaxation. Your pictures fulfill this expectation to the letter.
You say your ability to dance is acquired through hard work. Well, aren't most worthwhile things in this world ac-

—Charles Rhodes Photo

Again little Shirley Temple drew more letters from readers than any other star. Here she is being hand printed in concrete for Filmdom's Hall of Fame—the forecourt of Grauman's Chinese Theatre

complished through hard work? You are certainly doing your bit by sending a host of people back to their work with a song and dance, just as you are doing for us.
Mrs. Carl Dail,
735 W. Matthews,
Jonesboro, Arkansas.

Congratulations to Claudette

• • • Dear Miss Colbert:
Congratulations on deservedly placing first in the 1934 roster of stars. Your magnificent portrayal of the girl in *It Happened One Night* was a joy to behold—a memory to be cherished. Happily, too, your sympathetic interpretation of successful working girls in *Imitation of Life* and *The Gilded Lily* amply justify the title "best actress."
These rôles, in which you exemplify splendid types of modern young American womanhood, have carved for your own bright self a permanent niche in Moviedom; and have made you the admiration and inspiration of countless plain folk in the vast outer audience.
Long may you charm a grateful public with those inimitable qualities which characterize your screen work; rare intelligence, acting ability, well-groomed femininity, kindly humor, and a vibrant personality that faces life with head up and courage high. And in bringing this happiness to others, may you thus find your own greatest happiness.
Mary Manning,
23 Hendry Street,
Dorchester, Mass.

And One Who Disagrees

• • • The Editor:
As for me, I was a bit disappointed when the awards for the best acting went to any one other than William Powell and Myrna Loy, because of their outstanding performances in *The Thin Man*. May I suggest that HOLLYWOOD conduct a department, allowing the fans to vote on the best performances according to their own viewpoint? I think this would be an interesting experiment and would of course not conflict with other judge's opinions. We would all get a big kick out of it, and give us a say, too. After all, we are the ticket buyers.
Hugh Dunton,
741 Ratcliff Ave.,
Shreveport, La.
(*Editor's note: If we have any number of seconds to your nomination, we will be pleased to start such a contest.*)

Stay as Young as You Are, Shirley..

• • Dear Shirley Temple:
I have seen every one of your pictures to date. I have loved you in each film. But, my dear "wee lassie," why do they use you only in grown-up films?
Please ask for "Fairy" or Child rôles! —How we'd all love to see you in these: *The Goose Girl, The Three Bears, The Sleeping Beauty, The Seven Dwarfs* and oh—*Cinderella*!
I don't want you in grown up films! I want you in Fairyland where you belong! Please, Shirley!
Mollie M. Smith,
Wetaskiwin, Alberta,
Canada.

And Smart Too, Shirley..

• • Dear Shirley Temple:
How is the world's famous little girl today? I know you are very fine and happy. I have never had the pleasure to see you in person, but have seen every motion picture of you that has been to Montgomery. I am twelve years old, but would still love to play dolls with you. We all love you down here, and save as many pictures as we can get of you. But we cannot understand why you are so smart, to be just five years old. I know your mother and daddy are proud of you. Who wouldn't be?
Mary Ellen Bayne,
509 St. Charles St.,
Montgomery, Ala.

..And Sweet, Myrna

• • Dear Myrna Loy:
Every "movie goer," I think, unconsciously picks out an actor or actress they admire and secretly wish they were like.
I am only a "small town" school teacher with very few advantages to see what poise, graciousness and charm there are in our old world.
I have long admired your work and recently saw *Broadway Bill* and *Evelyn Prentice*. Your charming gayety and your naturalness leaves me without necessary words to express myself, so, if you will pardon the presumption on my part, I will say, "Please, Miss Loy, stay as natural and sweet in all of your productions."
Miss H. Colen Cowell,
L. Box 373,
Pennsboro, W. Va.

Preview flashes from SHIRLEY'S greatest picture.. "OUR LITTLE GIRL"

by Jerry Halliday

"COME ON OVER AND SEE MY STATUE!"

Forgotten (for the moment anyway) are Shirley's dolls and pretty dishes. Shirley is still telling friends about the nice, fat man... (Irvin S. Cobb to you) ... who traded a bee-you-tee-ful statue for a hug and kiss! Dear little girl, I wonder if you'll ever know the happiness you bring to millions of people. Special Academy Award? That's nothing to the good wishes the whole world sends you!

She plays at being happy to rebuild a shattered dream!

CONGRATULATIONS, FANS, here comes Shirley! How you'll thrill to this human story of a child and her parents whose happiness is suddenly threatened! And how the tense, dramatic climax will stir the heart of everyone from Granddad to Junior as Shirley's love triumphs over a family crisis. A *"must-see"* picture!

If there can be anything more adorable than Shirley alone, it's Shirley with Sniff, her loyal companion.

SHIRLEY DANCES AND SHE SINGS ... TOO!

Rosemary Ames and Joel McCrea give true-to-life performances as the parents who grape in the dark shadows of misunderstanding.

You'll love Shirley's lullaby, "Our Little Girl."

Shirley TEMPLE in 'OUR LITTLE GIRL'

ROSEMARY AMES
JOEL McCREA

Lyle Talbot • Erin O'Brien-Moore

Produced by Edward Butcher • Directed by John Robertson • From the story "Heaven's Gate" by Florence Leighton Pfalzgraf

Through Hollywood's Eyes

● Although you may not know it, you invented motion picture magazines. You, the public. No editor conceived the original idea of film publications. They were the natural outgrowth of public demand. It all happened like this:

Twenty-four years ago, a New York publisher had trouble with his illustrators. He searched about for another method of presenting fiction in a magazine without benefit of artists. He found the solution to his problem in an industry then, and for some time thereafter, in its infancy.

This industry was the motion picture. It presented upon the flickering screens of tiny, deserted stores, converted into nickelodian theatres, a form of entertainment already nicknamed "The Movies."

The Movies had plots—not very good plots, I'll grant you —but nonetheless stories that could be fictionized for magazine publication. And more important still, these stories could be illustrated with photographs. No artists necessary! So was born the first motion picture magazine.

Soon after its appearance on the newsstands of the country, came an unexpected public response. Readers began to tear out pictures from its pages, and indicating certain actors with pencil marks, asked, "Who is this? Where was he born? Is he married? How old is he? What does he eat for breakfast?"

Movie actors, in those days, you must remember, were anonymous. They had no advertised identities. Stars were unthought of, for precious few of this industry's pioneers had the slightest conception of its future. It was simply an entertainment novelty that was thought to have no future.

Came the Dawn

● The response of the public to the first movie magazines was as great a surprise to the producers as it was to the publishers. Neither knew quite how to answer the demand. Actors could be hired by the gross and what possible difference would it make which actors were hired?

You decided the issue. You elected your personal favorites. The novelty of pictures that moved was wearing thin. You demanded more than novelty. You wanted personalities you could take to heart, whose careers you could follow with friendly interest.

The producers began to give names to their actors; the magazines began to interview them. Those early interviews were extremely amusing in the light of present-day standards.

The movies and the magazines devoted to them grew up together. They passed from the swaddling clothes days through an age of juvenile antics to a brief day of false sophistication. And now the movies have graduated to a new intellectual era. You have only to view the really great effort of the past six months to realize this.

Now a Word About Ourselves

● If this magazine is to serve you, who created it, we must keep apace. We must have the benefit of your advice and council. You must tell us what you like and what you dislike.

With this issue, we have made several editorial changes. We have started a new department to report the news behind the news of Hollywood. It is designed to give you a complete, unbiased and truthful account of the month's activities of your favorites. We invite your criticism.

Stories written and signed by the stars are a feature we retain. Of course, only a magazine edited in its entirety in Hollywood could present such a feature. You have told us that you enjoy these personally signed stories and unless you tell us otherwise, they will continue. I believe you can help us even further. You can name specifically the players you wish to read about each month. If you will write me personally, I will have published at least one "Command Story" every issue. Now who shall it be in July? Garbo, Hepburn, Jean Harlow, Grace Moore, Fred Astaire, Shirley Temple, John Boles, Clark Gable, Marion Davies, James Cagney, Mae West, Bing Crosby, Margaret Sullavan. Who? You are the editors. I am only working for you.

● ● ● ●

Notes at Random: Aren't you a bit weary of announcements by actors that they will never again give an interview? Leslie Howard recently made such a statement, then promptly proceeded to give a half dozen interviews upon the subject of why he wouldn't give any more interviews. Leslie, I'm ashamed of you.

Out in the San Fernando Valley, there is a sign on a vacant property which reads, "Tread lightly—This spot belongs to Walter Winchell." Imagine the heavy-footed Mr. Winchell asking others to "tread lightly." Grammatical, too.

With all of the studios picking starlets for 1935, I'd like to make a personal nomination. Miss Constance Collier, with only one minor effort, "Shadow of Doubt," to her credit, should be a reigning screen star before the end of the year —without a shadow of doubt.

Jack Grant

The Publisher Says:

Here is the biggest movie magazine for the money that you have ever seen on the newsstands—the New HOLLYWOOD at five cents a copy. Now in its twenty-fourth year of publication, it has become the truly different magazine you have always wanted. The men and women on its staff live in Hollywood. Their best and most intimate friends are the stars. That is why the stars have turned authors for your benefit. Mr. Grant, the editor, and Mr. Smalley, the managing editor, both veterans in the business, know Hollywood as few others do. Under their guidance, HOLLYWOOD will report upon every item of the colorful, intimate goings on about town, written brilliantly, concisely, constructively. If you want to know all that is happening in Hollywood, you will have to read HOLLYWOOD.

W. H. FAWCETT,
Publisher.

Today in Hollywood

- TRAGEDY STRUCK TWICE at Toby Wing when Jackie Coogan, often named her best friend, was injured in the auto accident that cost the elder Coogan his life, and three days later her father, Captain Paul Wing, crashed in a transport plane eastbound to film *Annapolis Farewell*. Toby's beautiful sister Pat (Mrs. W. Haggin-Perry) is seriously ill.

- DON'T blame MYRNA LOY for walking out of *Masquerade*; she had a salary raise coming to her. But when LUISE RAINER (see page 66) stepped in to take her place opposite WILLIAM POWELL, Myrna let herself in for some stiff competition. It may result in a new star team. "When you walked out, honey, s o m e o n e else . . ."

- GET rich quick schemes always dazzle Hollywood. The latest is the chain letter gag which has flooded the postoffice with mail. You have to spend ten cents as your part of the chain, the theory is you get back, from the widening chain, a thousand dollars. The stars are no pikers. Their chains call for a dollar apiece!

- AT LEAST six hundred Hollywood kiddies were broken-hearted when SHIRLEY TEMPLE got the sniffles and the doctor wouldn't let Shirley celebrate her sixth birthday with a big party. No one enjoyed the party she had last year more than the little hostess.

- JACK OAKIE joins the exclusive club of Picture Snatchers with his performance in *Call of the Wild*. Pretty good when a guy can steal honors from a St. Bernard, CLARK GABLE, Mt. Baker, LORETTA YOUNG and REGINALD OWEN. Jack took his mother to the preview, and was Mother Offield pleased!

- ADD Hollywood heartbreaks: CLARK WILLIAMS, striding splendidly toward bigger things after his work in *Transient Lady* with GENE RAYMOND, did an even better job with HENRY HULL in *The Werewolf of London*—only to h a v e it dumped on the cutting room floor for the sake of brevity. That's Hollywood!

Mae West's Husbands

- CANNY observers, noting the imminent release of curvesome Mae West's new film, *Goin' to Town*, and a sudden nation-wide uproar regarding a long-lost husband, might have suspected that there was a nigger in the oft-mentioned woodpile.

If some suspected a publicity stunt, they were doubtless close to the truth —as Mae herself declared when the stories mounted and expanded into a veritable deluge of husbands and rumors of husbands.

The usually good-natured Mae is authority No. 1 for labeling the blast about Frank Wallace being her husband as sheer bunk.

"I've got a sense of humor," Mae sighed, shifting into high-geared conversation, "and nobody can say I haven't. But this thing is going too far. It's a *lousy publicity stunt*, that's what it is.

"First there's a guy named Wallace —then there's another guy named Wallace, and then a fellow down in Texas, all of whom advance the notion that they were united in wedlock with me. That makes nine this year, all told."

Mae tried just denying all rumors with a pleasant grin at first when someone allegedly found a marriage license bearing her name and that of Frank Wallace. The scene was Milwaukee, the date 1911, when Mae by her own statement was still "too young to get married."

Paul Cavanagh and Mae West— "Husbands" popped from the past.

HOLLYWOOD SPOTLIGHT
Shirley Temple Talks About Her Leading Men

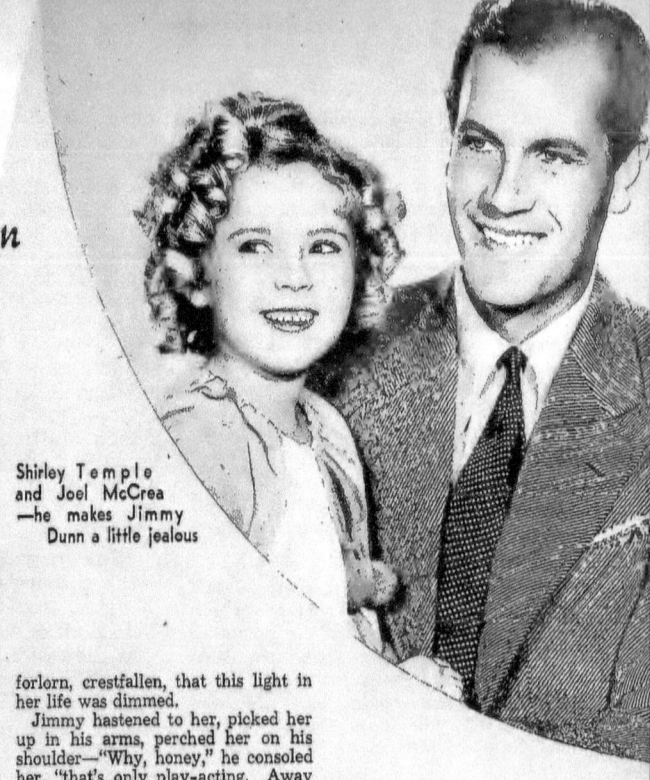

Shirley Temple and Joel McCrea—he makes Jimmy Dunn a little jealous

SHIRLEY TEMPLE looks on her leading men with the discerning eye of a child. She can tell you things about Jimmy Dunn, Gary Cooper, Adolphe Menjou, Warner Baxter, Joel McCrea and John Boles you have never known.

Her reactions, her attachment to these box office magnets is given in confidence to her mother and dad, or to her twenty-year-old brother, to whom she is not a star, but a kid sister. Shirley is not a child given to constant prattle, but is rather contemplative, a quiet morsel, whose attachments form slowly, but once formed, remain! And her reasons for her likes and her dislikes are definite.

Jimmy Dunn has played in three pictures with her. To him Shirley is a small idol, whom he worships with intensity. She has brought out all the sweetness, all the tenderness in the man obscured since his first star rôle in *Bad Girl*.

Shirley frankly considers him her own property. To her he isn't a grown-up at all. He reduces himself to her stature, mentally and physically, and they play like two kids together. Shirley crawls into his lap, snuggles close to him and they make up little songs together. The child is entranced with his vivid imagination and continually tells him—"Jimmy, I like you best because you make up such nice songs for me."

It was during the making of *Stand Up And Cheer* that Jimmy and Shirley began their era of devotion. Incidentally, that was the picture which established the Temple child, and riveted the eyes of a nation on her remarkable abilities. Jimmy was bouncing Shirley up and down on his knee as they were singing "Rockabye Baby." And simultaneously, at the end of it, they both burst out with a loud YIPPEE. It was so amusing that the director made it a sequence in the picture. And to Shirley that was marvelous. Only her Jimmy could have thought of it, and it further cemented the bond between them.

She claims Jimmy's affections as wholly her own and will not tolerate any infringement on her rights. Recently she walked on the set of *The Scandals*, where Jimmy and Alice Faye were doing an intimate scene. Shirley looked at her mother—"He has his arms around Miss Faye. I don't think he likes me any more." She was forlorn, crestfallen, that this light in her life was dimmed.

Jimmy hastened to her, picked her up in his arms, perched her on his shoulder—"Why, honey," he consoled her, "that's only play-acting. Away from the set you are still my best-beloved little girl."

When Shirley attempts to catalogue in her own limited vocabulary Jimmy's virtues, she will tell you that Jimmy never "buffs" lines. For your information an actor "muffs" when he fails to remember his dialogue. Shirley's word for that condition of amnesia is "buffing." When Lionel Barrymore played with her in *Little Colonel*, on one occasion a scene had to be retaken because that veteran slipped up on a word. Almost instantly Shirley was confiding that maybe Jimmy wouldn't have "buffed."

Then there is that matter of the wrist watch, Jimmy's Christmas present to Shirley. And she boils down her answer to the query of why Jimmy Dunn is her special pet to the simple statement that she likes Jimmy best because, after all, he *did* give her a wrist watch for Christmas.

Very recently her emotions have been complicated by Joel McCrea, her leading man in *Our Little Girl*. Joel has a child of his own. He has an understanding of children, and an inherent sensitiveness to which Shirley instantly reacted.

While on location, Shirley and Joel went walking in the woods and Joel would measure the strides of his long legs to Shirley's tiny ones. Frequently they would emerge from the forest with Shirley riding pick-a-back on Joel's broad shoulders, hanging on to him for dear life and shrieking with laughter, while Joel dog-trotted into the studio camp.

On an afternoon when scenes were being shot around them, Joel took Shirley fishing. He knew that little girls like fish-hooks made out of pins and a line out of darning thread. They returned from their excursion with the child proudly bearing a three-inch minnow and Joel downcast because he had nary a fish.

"I don't know whether I like Jimmy best now, 'cause Joel took me fishing," she told her mother. And then instantly, "But maybe I do like Jimmy best."

Gary Cooper overawed her when she first met him on the *Now And Forever* set.

"He is so high," she told her mother. And it took a bit of time before the tall star won the child. She discovered he had a facile pen which could draw entrancing animals, giraffes and elephants and lions, such as no animal book ever contained.

Shirley would sit contentedly at his side during intermissions in picture-making while he patiently taught her to hold a pencil.

The stoic Gary, the taciturn Gary, revealed a self to Shirley which no one even suspected. A gentleness and a patience which found reward when the child said to him—"You're not too high any more. When I grow up will you teach me to draw?"

He was

Shirley Temple Talks About Her Leading Men

given a special place in her heart because of his ability and his understanding that little girls *did* like to be amused with pencil and paper.

The suave and polished Adolphe Menjou was her pet for awhile because, quite unexpectedly, he revealed a talent for hide-and-seek; Warner Baxter met her casual approval because he could lift her so-o-o-o high. And now she is adding another conquest to her string in John Boles, who plays opposite her in *Curly Top*.

In each of her leading men, Shirley Temple has mined qualities not given to less perceptive eyes to see. As she grows older she will understand that, and her appraisal of her leading men will not always be in the tangible words of the child.

That Shirley Temple today is infinitely less spoiled, infinitely less self-important than the average child of her years, is a tribute to her leading men, who have amused her and loved her.

OUR READERS WRITE—
but write or wrong, our readers

The scenic beauty of 1853 along the Erie Canal was recreated at Fox studios for "The Farmer Takes a Wife." Janet Gaynor and Henry Fonda are the flower pickers

PRIZES are awarded every month to the contributors to this department. There are two first prizes of ten dollars each to the writers of the two best letters which; if addressed to a player, will also bring you a personal answer from the individual star. These ten dollar letters are indicated on this page by four ● ● ● ●

The two next best letters win five dollars each and are marked ● ● ● Five more letters will bring our check for a dollar each and are indicated by ● ● Duplicate prizes are awarded in case of a tie and the editor of HOLLYWOOD will be the sole judge. The right is reserved to print all or any part of the letters received.

Have we heard from you? Address: Editor, Hollywood Magazine, 7046 Hollywood Boulevard, Hollywood, California.

Skip From One Rogers

● ● ● ● Dear Ginger Rogers.

I want you to know how much your acting is to the deaf boys and girls, so am going to write to you through the HOLLYWOOD Magazine. I am deaf. Cannot hear what you say but get more from your pictures as they are full of pep and action. I think you are so pretty and I read in the magazines about your success. I hope you continue to advance. You show by your success your fine character and I hope you continue to be as unspoiled as today.

Someday I hope to see you and Shirley Temple dance together. I would love to have your picture. How I wish I could hear you, but can't so will be content just to see you.

Dorothy Sneath,
Indianapolis, Indiana
Care of Deaf School.

(*Perhaps Miss Sneath and others afflicted with deafness some day will be able to hear through scientific advancement. We all hope so.—The Editor.*)

To Another—

● ● ● ● My dear Will Rogers:

Gosh! Even that "Will" sounds like the country, the cracker-barrel and the crossroads. And do we, who have been ribbed and ridiculed as hay-foots and "Jakes" for all these years, love you and the way you turned the joke on the slickers and made them the saps with your rapier wit and down to the earth logic?

The home-towners and the farmers have lost all their inhibitions now, by cracky, and you're the "feller" that turned the trick! Not only that, but you've put some *good common sense* over as smart entertainment—made the public eat it up and LIKE it!

You've done more to advance Americanism than any other single force and boy! I'm not ashamed to wave the stars and stripes in one hand and my pitchfork in the other!

Let's see more of you, that's all I ask.
Barney Sollars,
R. F. D. 1, Box 404,
Sebastopol, Sonoma Co.,
California.

(*Rural enthusiasts Barney Sollars will get his wish. He will see much more of Will Rogers in the future.—The Editor.*)

How About It, Bing?

● ● ● Dear Mr. Bing Crosby:

Why do you say you are from Tacoma, Washington, when we know darn well how you and Alton Rinker used to keep people from enjoying a cool summer evening on their front porches by playing the piano and singing anything from Old

GADGET GOSSIP *from the stars' homes*

● HOLLYWOOD'S lady luminaries who have a flair for the domestic are of the opinion that you really have NEVER known all of the comforts of home until you've acquired an electric mixer. Joan Blondell is one of the most enthusiastic over the "glorified gadgets," but there are plenty of others who are crazy about them, too.

Joan's is a beauty. . . . Among the things it will do:

Grind everything from meat to peanuts; mix anything mixable; cream bananas; beat eggs; mash potatoes; whip cream; grate or shred vegetables; extract fruit juices; sharpen knives. The labor which any one of the standard makes can save marks this as an indispensable part of kitchen equipment, once it is allowed to "speak for itself. . . ."

Joan's will even pull taffy, and as for beating fudge and divinity—it is simply the last word!

● OPENING cans is no longer a chore for Lilian Bond, the reason being that remarkable contraption for the purpose which she has nailed up to the wall in her kitchen. You slip a can of whatever you choose into a round, adjustable brace that holds it firm and stationary, push on a lever and the top of the can comes off slick as anything! This gadget is called "Dazey de Luxe," formerly known as "Speedo."

No wonder Lilian Bond is smiling! She has found a new can opener that accomplishes its task without the least bit of exertion on her part

● FINE COMBS that are rather difficult to clean are made like new in a solution of baking soda and water. Place the combs in a pan large enough to allow them to lay flat, cover with water and add soda—about three tablespoons to a quart of water. Put over a slow flame and let come to a boil, watching the process off and on to see that the combs don't curl up—a misfortune which occurs only if you leave them in the water too long or let it boil too hard.

● ANY little girl likes cookies, and Shirley—the one and only Shirley—is no exception. That is the reason Mrs. Temple bought that truly remarkable gadget which has been put into use more than once in the Temple kitchen. It has various "form plates" which will cut cookie dough into various shapes. You select a plate, put the dough into the press, turn the crank and there are your cookies, all ready for the oven.

● DOUBLE-DECKER beds are quite the rage among those of Filmland who are building new beach cottages or cabins in the mountains. Far from looking like "bunks," all of them are very attractive. Of course, there is a convenient ladder for the one who sleeps aloft. These double-deckers are grand for guest rooms.

● NEWEST REFRIGERATORS, like newest homes, have built-in conveniences. Jean Harlow's has, for instance, an egg rack that slides in and out, a revolving shelf so you don't have to reach 'way back in for things, and a special vegetable compartment that also slides in and out. Moreover, the refrigerator doors can be opened by stepping on a floor lever if one's hands are full. Jean's refrigerator is white, of course, just like the rest of her house.

STRANGE *movie* FACTS

THERE must be a ruling that actors have to sing for twins in Hollywood, for the only two actors to rate 'em are the two most popular singers—Lawrence Tibbett and Bing Crosby.

Shirley Temple thinks pictures are just swell because all the clothes Paramount had made for her to wear in *Now and Forever* were given to her after the picture was finished.

Dawn O'Day, chosen to play the coveted rôle of *Ann Shirley* in *Ann of Green Gables*, is going to use Ann Shirley as her own screen name from now on.

Marlene Dietrich is spending a small fortune to have iron bars placed in all the windows of Colleen Moore's home, which she has just leased.

When Alice White entertains at dinner she furnishes her guests with the music of a complete symphony orchestra . . . you see, Alice's home is on a hilltop overlooking the Hollywood bowl and she only entertains on the nights of symphony concerts.

An Australian admirer has sent Irene Dunne a nugget of gold valued at $75 for her to autograph by etching.

Ivan Lebedeff controls his monocle so perfectly because he's had it notched all around the edge.

Buck Jones, the western hero, has more than 300 birds in his aviary.

It wasn't much trouble to secure 500 genuine Hindus when Paramount started to film *Lives of a Bengal Lancer*. Five hundred olive pickers were brought in from the Imperial valley, which is the largest Hindu colony in America.

Harry Carr's Shooting Script

is the weather—it might rain and ag'in it might not; sometimes it looks like rain and it turns out to be only a fog and anyhow we have cool nights in summer. . . .

Flops and Floppers

IT TOOK Maurice Chevalier quite a lot of words to get over a very simple idea. Going back to Paris with his reputation in shreds, he said that he did not find pictures adapted to his temperament. In other words he was a flop.

I can't think of a single instance in Hollywood where any of these footlight heroes have made good.

Fannie Brice was one of the worst payoffs in the history of films. Leon Errol and Eddie Cantor have never really hit. Ed Wynn, the Fire Chief, makes all the movie producers shudder at the mention of his name. Even Snozzle Durante has been a disappointment.

Harry Richmond and Texas Guinan were New York raves when they tried a whack at films—and left the auditors in tears. Texas, as a loving mother, mourning over a wayward son, unconsciously supplied comedy.

The stage stars who have made good in pictures have usually been those who were picked just before they were ripe; not as they were ready to fall off the tree.

The New Villain

BARTON MACLANE, who knocked them kicking in *G-Men* with the best villain stuff in years, had never played a heavy until he came to Hollywood. He had been knocking around for some years with indifferent success on the stage. On account of his work as Brad Collins in *G-Men* he is fixed for life in Hollywood. He is a quiet, rather poetic fellow who lives with his father and two sisters on a little ranch in San Fernando Valley.

High Hat

THERE IS ONE department store in Los Angeles where most of the movie stars trade. The film gels refuse to buy anything that has been advertised in the newspapers; so the store keeps a corps of special clerks with Oxford voices who telephone around to the secret telephone numbers when new nifties come in. The average price of corsets sold in this store is $90 and an average of four nighties at $125 are ordered over the phone each week.

Don't Say "Hoofer"

CLIFTON WEBB also bursts into movie fame with eighteen trunks, a contract to play opposite Joan Crawford in *Elegance*, a near-nervous-breakdown and a stern resolve to bash any critic who calls him a hoofer. He insists he is an actor or something of the kind. These new ones are coming in too fast for me. The craze for new names means of course that none of the names knocks any one over.

Spanking The Immortals

I AM CREDIBLY informed that Miss Shirley Temple, the famous movie star, is now paddled where it will do the most good ever so often. Mostly for wise cracks. Her parents are determined that Shirley will come out of the studios the same kind of little girl that she went in. If all the other Hollywood stars were spanked for wise cracks there would be no use for dining room tables; they would all eat standing up. And it would be a happier world.

Hoofer

THIS HOOFER, Wallace, can at least congratulate himself to this extent: he is the only one wearing a medal for having made a sucker of Mae West.

During his entire toe-tapping career, he has probably never before rated a nine-line item in any newspaper. For more than a month he was able to chase Hitler, the Roosevelt administration and Admiral Byrd off the front page. Huey Long and Sister Aimee McPherson are just pikers by comparison.

The Magic Formula

"IT HAPPENED ONE NIGHT" disturbs the sleep of all the producers of Hollywood. No studio can put on a picture of any kind without trying to imitate the technique of that delectable little drama.

The most obvious effort was in Jean Harlow's *Reckless*. To the towering indignation of M-G-M this picture was rather badly mauled by the critics. Jean Harlow was broken-hearted.

Where they missed fire was that they did not make the audience feel the depth and sweetness of a great love story under the frivolity. *It Happened One Night* was light, gay, jeering and had a certain insouciance; but, children, don't forget that it had the best love scene of any picture made this year—or for many years.

New Star Twinkles

M-G-M POCKETED its chagrin with philosophy—grateful that the picture gave them a new star.

Rosalind Russell is the best bet I have seen come to the screen for a long time. To me she is a good deal like Frances Dee and somewhat more vital. M-G-M sees in her another Myrna Loy.

Either way she has the goods . . . a grave, quiet girl who can get over her stuff without doing too much. When I was in the movies, actors filled me with despair because I never could persuade them to stand still and do nothing—until there was something to do.

Whether in a picture star or a stenographer, there is nothing more annoying than an insistent personality—determined to be noticed.

Miss Russell's next will be *The Black Chamber*, with William Powell, which augers well for her future. Bill has a habit of adding the final shove toward his leading ladies and there's no question about her future now.

Previewing The New Pictures

In building the sets, the largest crew ever employed was used, and the actual building covered a period of two months. A hundred thousand dollars worth of flowers, real and artificial, were entwined in every bush and branch. Several large fountains which gush forth tons of water were erected, and require two men to operate them.

Much of the shooting has been done behind barred doors. This is partly in deference to Bing Crosby, and partly due to the fact that the mechanical units require plenty of room and no crowds. Most of them would like to hear Bing sing and see Oakie cut up. Both lads add interest to any production.

The Big Broadcast of 1935 will take almost three months to complete, and will cost the pretty little sum of two and a half million dollars. "That," states Mr. Taurog, "is a conservative estimate."

Topper's Reviews

Ellis, Carminati in—

PARIS IN SPRING—(Paramount)—Is a light musical show that gets somewhere simply because it doesn't try very hard. Mary Ellis sings. Tullio Carminati capers about in a gay, sophisticated way. A sprinkling of deft and clever touches by Director Lewis Milestone lifts the film out of lurking ruts. Gordon and Revel contribute several fair tunes and the dialogue is above par. A good evening's entertainment if you don't expect very much.

Arlen, Stephens, Cabot, Bruce in—

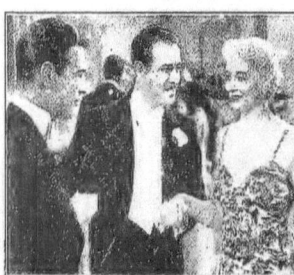

LET 'EM HAVE IT—(Reliance)—Another federal agent picture, this film deals with actual technique more than has any of its predecessors. Unfortunately, items such as suspense and interest are neglected and the film consequently misses being a major hit. There is too much Virginia Bruce and too little rip-snorting fighting. Among the lesser lights Gordon Jones and Eric Linden will please. You probably will see much more of Jones in the future—he has a definite personality.

You Can Tell By His Face

Temple, McCrea in—

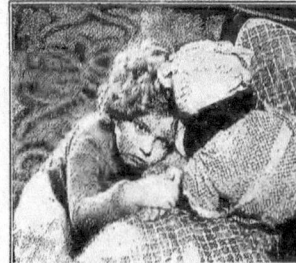

OUR LITTLE GIRL—(Fox)—Is Shirley Temple's latest production, and for that reason alone is acceptable entertainment for countless millions who worship at the child star's throne. Shirley is the small daughter of Joel McCrea, a young doctor. Story deals with her ability to keep McCrea and his wife, played by Rosemary Ames, together when his career endangers their marital bliss. Lyle Talbot is the other man in the triangle.

Ralph Bellamy, Karen Morley in—

THE HEALER—(Monogram)—Ralph Bellamy, Karen Morley, Judith Allen and a good cast try to make this picture top entertainment. They can't overcome the ancient story of the country doctor who performs the miracle man act. Nevertheless, the picture emerges as fair entertainment with Judith and Mickey Rooney grabbing major honors. Bellamy, Robert McWade and J. Farrell MacDonald turn in good performances. We've seen those forest fire scenes somewhere before.

Today in Hollywood

Was It a Prophecy?

Storm Over the Andes, an exciting South American war picture being shot at Universal, will go down in tradition as another jinx film production. Cesar Romero started the jinx off by injuring a knee. He was replaced by Antonio Moreno, who does both the English and Spanish versions.

Jack Holt

Several days later Charles Stumar, ace Universal cameraman, was shooting a dramatic headquarters scene in which a short wave radio was bringing the last gasping words of an army flier as his plane was falling in flames over the enemy lines. It was a long, tense scene, convincingly done by Jack Holt and Mona Barrie. As it ended successfully, Stumar wiped his brow and said:

"Whew! I could almost feel myself falling in that ship!"

Twenty-four hours later an airplane cracked up near Triunfo, 50 miles from Hollywood, where the company was going on location. The dead: Harrison Wiley, the art director, and ace Cameraman Stumar. Cause: The plane lost a wing in brushing a tree-top.

• •

Shirley Speaks Up

WINFIELD SHEEHAN has a notable collection of cutouts from films. The latest addition to his collection is one that has to do with Shirley Temple and John Boles. It was caught in a projection room during the running of "rushes."

It seems Boles and Shirley were having a very serious scene in the picture *Curly Top*.

Suddenly Boles blew up in his lines.

Fay Wray

Right from the screen Shirley was seen stamping her little foot, pointing a finger at Boles, and saying, "Ah! Phooey!"

• •

Fay Wasn't Fooled

WHEN FAY WRAY, who was born in Alberta, Canada, received her American citizenship papers, one of her friends invited a group in at cocktail hour to mark the occasion. Of especial significance was an American flag which the hostess hoisted in front of her home to greet Fay.

Glancing down the street, she saw dozens of flags draped in front of other homes. Turning to Fay she said, "I didn't know the good news had spread so rapidly."

"It hasn't," Fay replied cheerfully. "Maybe you hadn't heard. This is Flag Day all over the nation."

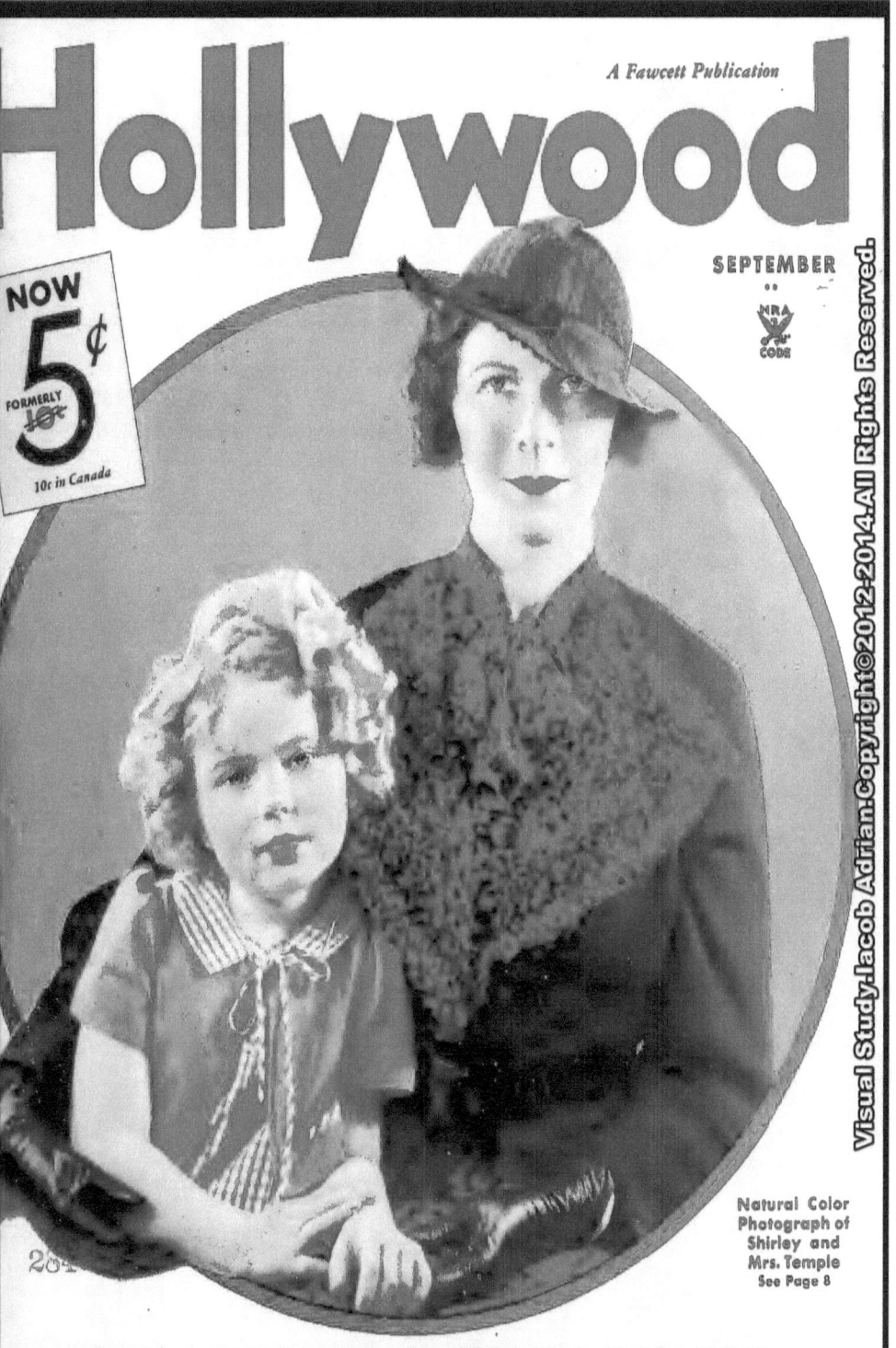

Preview

from the latest hits of

"Curly Top" is tops for Shirley! SHE DANCES AGAIN... SHE SINGS 2 SONGS in this excitingly different story!

"SURPRISE!" SHIRLEY SEEMS TO SHOUT GLEEFULLY. For what a joy package of surprises this picture will be!

"Curly Top" is completely different in story and background from all the other Temple triumphs. This time, Shirley plays the mischievous, lovable ringleader of a group of little girls, longing for happiness and a home. Once again, she dances—she sings—in that winsome way which captured the heart of the whole world.

And... SURPRISE!... Rochelle Hudson, as Shirley's faithful sister, sings for the first time on the screen, revealing a rich, beautiful voice in a song that will be the hit of the year. Her song duets with John Boles—their wealthy and secret benefactor—lead to a love duet that ends in perfect harmony!

"Curly Top" is tops for Shirley... and that means tops in entertainment *for the whole family!*

"All my life, I've had a hunger in my heart... a hunger to love and be loved."

You'll cheer these 5 HIT SONGS by RAY HENDERSON
America's Number 1 Songsmith!
"When I Grow Up"
"Animal Crackers In My Soup"
"The Simple Things In Life"
"It's All So New To Me"
"Curly Top"

Shirley TEMPLE
in
'CURLY TOP'

with
**JOHN BOLES
ROCHELLE HUDSON
JANE DARWELL**

Produced by Winfield Sheehan
Directed by Irving Cummings

"Spunky—if you don't stop sneezing, you're going to catch p-monia. You really ought to have a hot lemonade."

Flashes
your favorite stars!
by Jerry Halliday

JANET GAYNOR
AND
HENRY FONDA
IN
The FARMER TAKES a WIFE

Charles Bickford Roger Imhof
Slim Summerville Jane Withers
Andy Devine Margaret Hamilton

Produced by Winfield Sheehan
Directed by Victor Fleming
Screen Play by Edwin Burke
From Max Gordon's Stage Play • Authors
Frank B. Elser and Marc Connelly • Based on
the novel "Rome Haul" by Walter D. Edmonds

A STAR OVERNIGHT
...Henry Fonda zooms to stardom as the son of the soil who works on the canal to earn money for a farm.

JANET GAYNOR SCORES
the greatest performance of her career as the fiery canal boat girl who accuses the man she loves of COWARDICE!

YOU... who loved "State Fair"... HAVE ANOTHER TREAT COMING!

Set in a dramatic, colorful era of American life now shown for the first time . . . when the speed of the railroad doomed the picturesque waterways . . . this story is a refreshingly new, vital, heartwarming tale of simple folk on the great Erie Canal, when it was one of the world's wonders, the gateway through which civilization took its Westward march . . . when its lazy waters rang with the shouts of swaggering boatmen, bullying their women, brawling with their rivals.

Through it all threads the romance of a kissable little miss who hides her sentimental yearnings behind a fiery temper . . . while a dreamy lad, homesick for the soil, contends for her affection with the mighty-fisted bully of the waterways.

Ask your theatre manager when he plans to play it!

FOX

Hollywood's News Reel

May Try Stage

WHEN HERBERT MARSHALL finally moves his make-up kit to New York to fulfill that oft'-postponed stage contract, Gloria Swanson, his heart, will go along to give more serious consideration to the flood of Broadway offers that have come her way in recent months.

Casey (1935 model) at the bat! Billy Bakewell smacks a home run and runs the bases in a limousine . . .

The Famous Baseball Game

LEAVE IT TO BILLY Bakewell to show the local boys a thing or two about baseball with a capital "B." It was during the benefit game between Hollywood's leading men and comics. Billy was called to the plate when it came his turn to bat and while everyone waited breathlessly to see what the "great" Bakewell would do—no Bakewell appeared.

Suddenly a beautiful Rolls Royce limousine, piloted by a liveried colored chauffeur, drove onto the field and up to home base. Out stepped our hero looking as though he had just left the Trocadero. He was nattily attired in the latest in dress clothes, high hat and all. Marching up to the plate, he waited for the pitcher's delivery—then swinging mightily, he connected, driving the ball far into the outfield.

Stepping back into his conveyance, he ordered his man to drive to first base —then second — third, and finally, "home James." The first home run ever to be made in a Rolls Royce in the entire history of baseball!! And of all things—his team mates threw themselves upon him and finally Mr. Bakewell found himself standing in front of 12,000 spectators with nothing to cover his athletic figure save his shoes and shorts.

Stop It, Girls

THAT COY LOOK now adorning the Irish countenance of Pat O'Brien is caused by the flood of mash notes pouring in from feminine fans as a result of his romantic rôle in *Oil for the Lamps of China*. Pat swears they're the first missives of that type he has received in his years of histrionic effort.

• •

Multiple Adoption Scheme

TOPS IN PUBLICITY schemes is this: A publicity agent approached a famous man and wife comedy team and guaranteed to give them front page publicity in every worthwhile newspaper in the country.

"Who do you want us to kill?" queried the male of the team.

"No one," said the publicity purveyor.

And then the stunt was explained. Very simple. All the comedy duo had to do was to make formal application to the Canadian Government to legally adopt the Dionne Quintuplets!

• •

Hank's Swansong?

THAT HENRI, Marquis de la Falaise de la Coudraye, said his final adieu to Hollywood before taking his departure for France a month ago is the word being passed on by the chatterers.

ON THE COVER

HOLLYWOOD Magazine goes completely Shirley this month, with Miss Temple and her mother on the cover, and with our little star's "bringing up" discussed in thorough fashion by Miss Rhea. This was Shirley's first experience before a natural color camera, but she lost not one whit of her charming aplomb and held perfectly still as Edwin Bower Hesser directed. Mrs. Temple was somewhat harassed, however, by Shirley's active curiosity over everything that went on, and if there is a hint of a strained expression on her lovely face, remember that being the mother of a child so astonishing as Shirley is no simple matter. But how capably Gertrude Temple manages is told in detail in the story found on page 22.

Others guilty of participating in the burlesque ball game were Wally Ford, George Raft, James Cagney, John Boles, Lee Tracy. The game ended in a tie. (See story)

HOLLYWOOD SPOTLIGHTS

Indian Uprising

It had been a long, hard day for Ralph Bellamy, Chester Morris, Johnny Mack Brown and their wives at the San Diego Exposition, what with signing autographs, visiting the Hall of Fame and the hundreds of attractions. Somewhat wearily the distinguished group arrived at the Indian village for an impressive ceremony. Ralph Bellamy was to be given an Indian name and made a brother of the tribe by Chief Thunder Cloud. It was a proud moment for Ralph when he became "Chenowah," meaning warrior and poet, after a noted Sioux Chief. After the ceremonies at long length were concluded, Mrs. Bellamy plucked her husband's arm.

"Chief Chenowah," she said plaintively," can Squaw Tired-Of-Walking go home now?"

• • •

A Million For Shirley

Those who are worrying about Shirley Temple's future, and fearing that the inevitable approach of awkward adolescence may cut short all too soon her chance to earn her just rewards, may rest content. Happily enough, Shirley Temple has become a name of great magic in fields commercial, and what with Shirley dolls, dresses, cut-out books, toys, picture books and so on, royalties paid the child are reaching astonishing proportions. She is, in fact, a major industry. Thousands of people gained employment because of her popularity; in one year her revenues from manufacturers has reached $350,000, and next year should place her in the millionaire ratings of Dun and Bradstreet. A doll book paid her $15,000 the first two weeks it went on sale, making her salary of $1,200 a week look like small potatoes.

These tidy sums are thriftily put away by Banker George Temple. Shirley, meanwhile, has her own notions of finance. During the filming of *Curly Top*, John Boles gave her a nickel. Having no pocket, she had to give it to Mother Temple to keep for her. Then she approached John, whom she adores.

"Mother got my nickel," she said. "Isn't it too bad? Now I haven't any nickel." She waited. "I said I haven't got that nickel any more, Mr. Boles."

John took the hint. She got another nickel.

• • •

Familiar Eyes

They were taking tests on the Universal lot. A number of young men and women who were lucky enough to rate screen shots were going through their scenes.

Finally a petite, black-haired girl stepped before the camera and began enacting a brief scene. There was a career at stake and she was just a little nervous. She was supposed to drop her hat on an end table and her purse on a chair. She reversed the procedure, and the purse knocked off an ash tray with a loud bang.

They went through the scene again, but this time her voice cracked with nervousness. They gave her a glass of water, and she promptly romped through the scene in great style.

She was just an extra, taken from the ranks of *Storm Over the Andes*, but there was something instantly recognizable about her. Especially her eyes. Jack LaRue's eyes, unmistakably. There was the key to her identity —she was Emily LaRue, Jack's "Kid" sister. Universal thinks it has a "find."

• • •

Mundin's Mutiny

Herbert Mundin, that clever H'English comic (Barkis is willing!) is playing the cook aboard the Bounty. While the company filming the *Mutiny* was "marooned" on the Catalina isthmus for three weeks, Herbert begged and begged for permission to hire a boat and cross over to Long Beach. After a week of pestering, Director Frank Lloyd finally asked him why he was so insistent. Clark Gable and Charlie Laughton, Lloyd pointed out, were making no such demands, and they, too, were men of affairs.

Mundin finally confessed: "I want to go see a movie!"

• • •

Pie Comedy

Joan Crawford got a yen for some of that pumpkin pie her mother used to bake, and after talking about those yummy pies for several days during the filming of *Glitter*, Brian Aherne asked her why

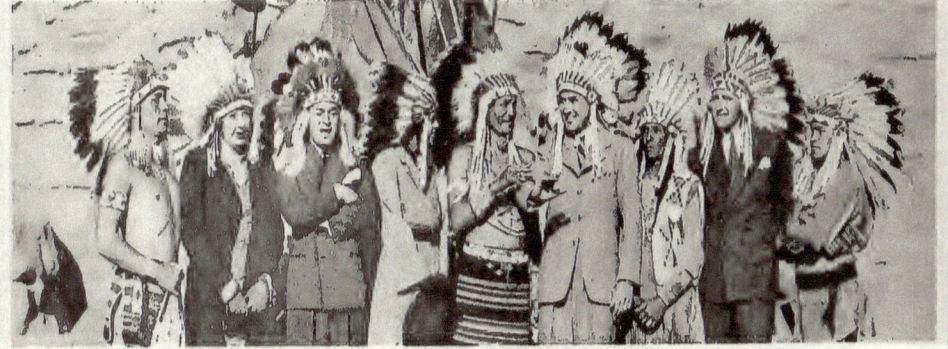

Pow-wowing at the California Pacific International Exposition in San Diego: Mrs. Bellamy, Chester Morris, Mrs. Johnny Mack Brown. Chief Thunder Cloud, Johnny Mack Brown and Ralph Bellamy

BRINGING UP

Shirley's bottle of cold milk is the drink that refreshes her during work at the studio

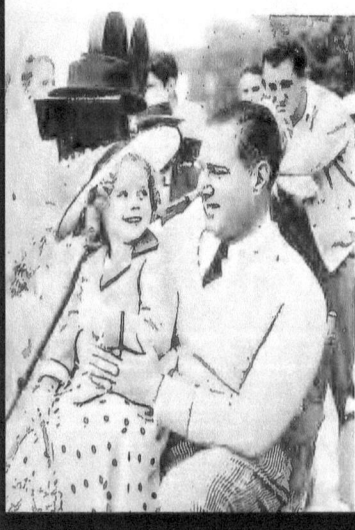

Shirley's friends find the little star good company on the set. Below, Shirley shines up to her director, David Butler

HOLLYWOOD'S Publisher, Capt. W. H. Fawcett, is not afraid to play favorites when it comes to Shirley Temple!

"YOU MAY DRINK," said Mrs. George Temple, firmly, "down to there—no farther."

"There" was marked by a row of lettering on a bottle of Coca-Cola in the hands of a diminutive, curly-headed individual nattily attired in a man's overcoat approximately eight sizes too large, a derby hat ditto, and a pair of spectacles which, for the same reason, kept sliding down over a very neat but ineffectual nose.

Came muffled tones from small lips already busy with a straw: "Yes, Mommy."

Glub. One inch gone already.... Glub. The row of letters was reached all too soon.

Glub.

"Shirley Temple! How much did I say you might drink?"

The derby-hatted one relinquished the bottle, regretfully—"You SAID only down to the letters, but I slipped a little...."

Mrs. Temple bit her lip. "I see.... Well, slips do happen, sometimes, but—" meaningly, "they must not happen too often."

"Okay, Mommy," said Miss Temple and, tilting the derby over one eye, she shuffled back on the *Curly Top* set, kicking the overcoat out behind as a duchess would her train.

There ended my first graphic example of how Gertrude Temple is bringing up Shirley. I made an entry in my notebook:

Rule No. 1: She has been taught to OBEY.

All of this happened as they were shooting that scene in *Curly Top* wherein Shirley dresses up in overcoat, hat and spectacles belonging to a trustee of the orphan home where she is living—Trustee John Boles, to be exact.

Being a Shirley Temple fan, I have seen all of her pictures, but I never have seen that kid look quite as bewitching as she did in that outfit, spectacles and all. Everyone else on the set thought so, too. Correction: Practically everyone. Shirley, herself, was more interested in an intricate picture coloring project which engaged her attention between shots, and while Mrs. Temple may have thought her daughter looked more than a bit on the adorable side, she kept the idea well to herself.

● SHE BELIEVES in doing that. "I never praise nor compliment Shirley about her work or her personality," she has told me more than once. "I want to keep her natural and sweet. I praise her for being a good little girl but that is all. She isn't vain and affected, now, and I intend to see that she doesn't become so."

At this point, I made another entry: *Rule No. 2: Shirley is not spoiled with praise.*

Mrs. Temple and I sat quietly on the sidelines a good deal during the filming of *Curly Top*. That is, she sat there all the time when Shirley was working and I when I could. We would talk casually, she and I, sometimes about the picture but usually about Shirley. Any mother likes to talk about her children. Gertrude Temple—rather tall, symmetrically built; black-haired, blue-eyed; a pleasant, unassuming person—is no exception, of course. But I don't think you can be with her an hour without realizing that her joy in motherhood is because Shirley is a winsome, healthy and happy little girl and not because she is a great screen star.

"Of course, Shirley's success in pictures has made life financially easier and more comfortable for all of us. Of course we are thrilled and proud. Of course I am glad it happened. But still, I am a domestic sort of person. I like to keep house and go to market and make my little girl's clothes and I could do it all again if it became necessary," she said on one of these occasions.

"What could make it necessary?" I asked her.

She answered quickly. "Why, Shirley's leaving pictures, perhaps." She hurried on as I started to protest against this calamity. "Don't misunderstand me. I cannot see that this will ever happen. Nevertheless, we would take her away from the camera forever if we saw her career—it seems funny to attach such a high-sounding word to such a little girl, doesn't it?—was injuring her in any way. If we saw it was threatening her health or happiness. If we saw it was making her vain or unnatural. If we saw it was de-

SHIRLEY TEMPLE

by Marian Rhea

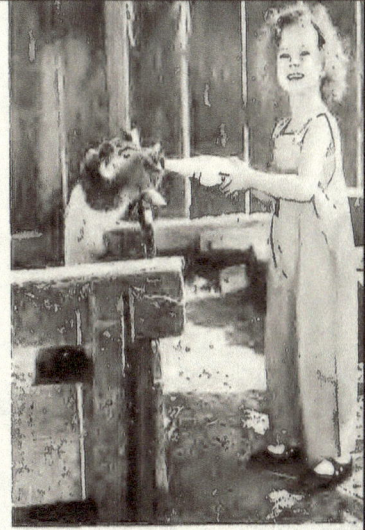

Resting for a day at a nearby farm, Shirley found the pig pen a point of major interest

priving her of her right to a normal, wholesome life. . . ."

She paused, and I jotted down Rule No. 3 for bringing up Shirley to wit: *Health comes first.*

"At present, this career is all to the good," she went on. "Shirley adores coming to the studio. Any child loves make-believe and that is all it is to her. Out there on the set—" with an eye toward a group composed of Shirley, derbied and overcoated, Etienne Girardot, playing a cantankerous asylum superintendent, John Boles, handsome as usual, and a couple of others—"they are playing a game. Listen!"

"Now, Mr. Girardot is going to pretend he is a bad old man and mean to little girls," Irving Cummings, the director, was telling Shirley.

● SHIRLEY THOUGHT that was a fine idea. "An' I'll pretend I feel bad about it," she informed him.

That's all there was to it. Cameras swung into place. The whistle blew. The game was on. In a minute, however, something happened. Shirley's glasses fell off, a mishap which tickled her funny bone smartly. Chortling mightily, she picked them up and put them on, only to have them slide off again.

She rocked with laughter. "Those ol' glasses, they jus' fall off all the time!" she informed those assembled.

"But you'll TRY to keep them on?" insinuated Director Cummings.

" 'Course I will, but I don't think it'll do a bit of good," she told him. She appeared to be right, too. Plop went the glasses on the floor again.

"Jus' can't do a thing with 'em," remarked Shirley, guilelessly.

At this point, however, Mrs. Temple took a hand.

"Shirley," she said, quietly, "aren't you wiggling your nose just the least little bit?"

Shirley considered. "I don't THINK I am," she said, judiciously.

"Well, you'd better make sure," her mother told her. . . .

The glasses didn't fall off any more.

Mrs. Temple turned back to me. "She's an awful tease," she said. "She's doing things like that all the time, the little minx. However, she really is a pretty good little girl. She always has been. She was no trouble when she was a baby and has never been destructive nor sulky nor deceitful.

"I have," she said, "a theory as to the reason for her tractability. You see, she was a wanted child. My two boys were practically grown and I longed for a little girl to care for and enjoy. So I had Shirley. I think that the basis of her unusually sweet disposition is the fact that so much affection was waiting for her.

"Faults? Her major one is that delight in teasing someone. You saw how she carried on with Mr. Cummings about the glasses. Well, she teases her brothers in the same way. She is inclined to bother them when they are studying and she wants to tag along when they are going places, much like any small sister does. They don't like it, sometimes. She's not a star to them. She's often a little nuisance.

"She has a dog, too, by the name of Roddy, that she seems to think should have the same privileges—perhaps more—than members of the family. But I disagree with her about that and so Roddy keeps his place.

"It is hard to correct her because her misdemeanors are such little ones, after all. But I know I must. I know that if she is a willful, spoiled little girl the fault is mine, not hers. I can always reason with her and the fact that she is inevitably so very, very sorry when she has been wrong makes things easier."

● THIS SEEMED to be about the time for another notation. I made it still smiling over the spectacles episode. Rule No. 4: *Shirley is not allowed to get away with anything.* Meaning she may like to tease, but she doesn't fool her mother.

I changed the subject, then, and asked about Shirley's future. "What kind of a life do you want her to have? What do you want her to do?" I queried.

She answered slowly. "You may be surprised when I tell you I haven't so many concrete plans. How can one look ahead very far in any but a general way?

"It seems to me that Shirley can go on as she is now, perhaps indefinitely—going to school here on the lot when she is making a picture, perhaps having private teachers when she is not. Of course, I don't see how we can send her to public school if she continues to be a star, because the public does not —cannot, I suppose—treat such people naturally.

"But she can get her education just the same. And she can travel, at least by automobile. To go places by train or boat is simply too strenuous. People love her and

Circus day was a big event for Shirley, but Father and Mother Temple enjoyed it, too. Below, Shirley in a scene with John Boles

Bringing Up Shirley Temple

crowd around her wherever she goes. Sometimes they try to clip off a piece of her dress or even her curls for a souvenir.

"That, of course, I cannot have. She really might be hurt. And she would soon come to think herself very important. I don't want that to happen. We are, however, taking her on a long vacation trip after *Curly Top* is finished—in the car. It is a sedan and we always let Shirley have the back seat to herself. She takes an assortment of dolls, dolls' trunks, drawing books, paints, crayons and such on such trips and has an elegant time with them.

"And when we get back, she will keep on playing in more pictures. It is all a game to her. She learns her lines easily and thinks the process is as much fun as learning a Mother Goose rhyme. Often I hear her repeating them with proper gesture and intonation to her dolls."

- A WOMAN leaned over Mrs. Temple's shoulder just then. She was an "extra" working in *Curly Top*.

"Mrs. Temple," she begged, "I wonder if you could get me Shirley's autograph?"

Mrs. Temple sighed a little but she answered that she would see what she could do.

"You know," she said to me, "this autograph business is one of the greatest problems we have. You see, it takes Shirley about three minutes to do each one. We can't take time away from work, and I don't want her to do it at home. I make it a rule not to bring her 'career' home with us, except to go over her lines with her."

Rules . . . I already had written down several which I considered all important and I was interested in knowing if there were any more. "Have you many definite rules for bringing up Shirley?" I asked her.

She shook her head. "No. Not many definite ones other than insisting she mind me promptly and be polite to people."

"Of course, you've never spanked her. . . ." This from the woman who had asked for the autograph.

"Why, yes I have," came the frank contradiction.

The "extra" gasped at such sacrilege. Shirley Temple spanked!

"What for?" she breathed.

"Why, I believe she annoyed her brother so he couldn't study," Mrs. Temple said. "I don't quite remember. It really wasn't much of a spanking. I find that, with Shirley, reasoning is better."

The "extra" looked relieved. *Lese majesty* had been on a small scale, at least. She went away, then, and Mrs. Temple and I sat watching that curly-topped mite achieving another great box office hit and having a swell time doing it.

Around her were players in grease paint, directors, cameramen, script girls, stand-ins, grips; kleig lights, cameras, sound equipment; noise, excitement, hurry. Around her was—Hollywood.

But Shirley, the center of it all, was just Shirley. Just as her round little cheeks wore no make-up, so was her child's mind unworried over close-ups, camera angles, scene-stealing; her gay little heart immune to hurt. Because this was all make-believe, anyway. Motion pictures and all of the human struggle they embrace were no more real to her than Alice's pack of cards in Wonderland.

That's the charm of Shirley.

SEPTEMBER, 1935

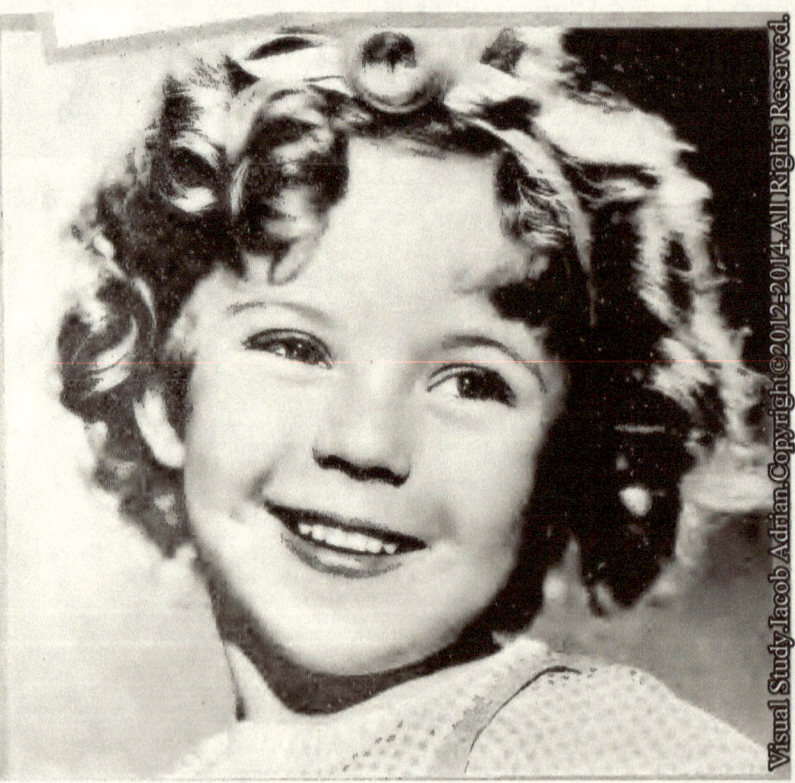

STAR GAZING IN HOLLYWOOD

Today in Hollywood

- WE filed into the corner office at United Artists, along with a dozen cameramen and newspaper reporters. Every one, even hard boiled shutterman who have snapped fires and first-nights, hangings and inaugurals, felt the drama of the scene. Here was the last of that great company of stars, all that remained of United Artists, gathered to make a public announcement. Sam Goldwyn laid aside his gold rimmed glasses, smiled with good humor. Mary Pickford touched Charlie Chaplin's sleeve, to whisper across the desk.

"Not many of us left, Charlie," she said wistfully.

There was more drama when Doug Fairbanks arrived. Even the great Fairbanks-Pickford combination is no more except as an unromantic business affiliation. They regard each other merely as financial partners.

Books were piled on the chair for Mary to sit on, for she is very tiny; Charlie crossed his legs to show the inevitable pearl colored cloth tops of his shoes, flash bulbs went off like fitful heat lightning. The announcement was brief; United Artists would carry on. Mary would become a picture producer, Charlie would direct a picture after he finished his own film. We filed out. No other movie magazine had come to what seemed to us a momentous moment in Hollywood—the last stand of the old guard.

Last stand of the old guard: Sam Goldwyn, Mary Pickford, Charlie Chaplin and Doug Fairbanks

- TIME moves on, and youth holds the spotlight for we who go stargazing in Hollywood these days. At the other end of the line, Shirley Temple comes marching. Shirley is making a scene with John Boles today, on a sound stage filled with visitors. They are enjoying a rare privilege, for Shirley's sets are closed to the public, but the guests are the county Grand Jury on its annual tour.

She enjoys company, beams at onlookers. It is a mistake to think that visitors could upset the poise of Miss Temple, or make her self-conscious. She does her scene perfectly, her entrances and speeches timed with unerring instinct. At every scene a strange phenomenon takes place—all the workers on the stage gather to watch her. This happens in no other studio, with no other star; she is a source of constant wonder and endless admiration to grips, props, juicers, all those usually blase members of a picture crew.

- ELSEWHERE on the Fox lot another youngster, a bit more grown up, is flinging her challenge to the gods that rule our fates. Rochelle Hudson is stepping into the shoes of Janet Gaynor in "Way Down East," after playing second fiddle to Shirley in "Curly Top." Like many such glorious opportunities, Rochelle's chance came from an accident. Janet's head bumped Henry Fonda's. She thought nothing of it until later in the day she fainted. After a rest she tried, like a game trouper, to go on with the show. Next day she was a very sick girl from a brain concussion, and Dr. S. A. Alter ordered a six weeks rest.

That bump cost Fox about $200,000, what with having to start the picture over again, not to mention the headaches to its top notch star, Miss Gaynor. Sid Skolsky, hearing of Janet's mishap, called her life long friend and advisor, Frances "Bobbie" Deaner, to ask what sort of book Janet might like to read. And Janet told Bobbie her preference. She wanted the Fairy Tales by Hans Christian Andersen.

- OUT at Warner Brothers studio another youngster is trying out the rickety steps of fame's ladder. He is Errol Flynn, and adventure runs in his blood. I went out to watch him make a screen test for "Captain Blood," that swashbuckling pirate who had a way with the ladies. Errol has a way with the ladies, too. Jean Muir, who was helping him with the test (she will, unless you hear to the contrary in the next few weeks, be the heroine) disclosed that Flynn is a direct descendant of Fletcher Christian, that reckless fellow who turned pirate by taking the Bounty and setting its captain adrift.

Flynn readily admitted his black sheep in the family history; his family possesses many relics of the famous mutineer. Errol himself had been to Tahiti in the course of adventurous ramblings that took him in search of gold in New Guinea, on boxing exhibitions through Australia, in search of pearls in the South Seas. Director Mike Curtiz calls them for another scene. All in costume, with elaborate sets, scene after scene from the script has been shot, just to test various actors for the roles. Miss Muir, settling back in her rustling silks, remarks: "It wouldn't surprise me if they'd discover, when they got through, that they had filmed 'Captain Blood'!"

The star gazer chats with Jean Muir as she helps a descendant of a mutineer make a screen test

- LUISE RAINER'S picture, with Bill Powell, has been unvelled and "Escapade" definitely establishes her as a star of first rank. We saw her the other day, and heard of an escapade of her own. Miss Rainer had started off for an hour's drive. She was gone five days!

In her old slacks and comfortable sweater she headed down into Mexico. By carefully guarding the fifteen dollars she started with, she financed the trip. Who says the spirit of adventure is dead?

JACK SMALLEY,
Managing Editor.

Will Rogers

IN THE BEAUTIFUL mausoleum in Forest Lawn Memorial Park in Glendale—just over the hills from Hollywood, at the moment three of the show world's most beloved personalities lie side by side in crypts. They were dear friends in life and now they are together again. . . . Will Rogers, Marie Dressler, and Florenz Ziegfeld.

OF ALL THE tributes to Will Rogers that followed his tragic death, the one out at the Cafe de Paris on the Fox lot was perhaps the most simple and yet the most touching.

For days, over in a corner where Will lunched every noon, the lone table remained vacant. Every day there was a fresh spray of flowers in a tall vase.

The little sign told it all. It said, "Reserved."

• • •

SHIRLEY TEMPLE'S ABILITY to keep a level head despite all the adulation paid her, is one of the modern marvels of Hollywood. Fresh from a vacation in Hawaii, Shirley and her mother are now busy preparing for the resumption of her screen career.

The little star left the Pacific Islands with all the little girls combing their hair a la Temple and all the boys singing "Good Ship Lollypop." On the day her boat left the dock, Shirley leaned over the railing and sang the song to a crowd of several thousand! It was all her own idea and she had no coaching from anyone.

She learned several Hawaiian words that appealed to her imagination. Her favorite expression, translated into English, meant "red stomach."

• • •

WHEN JESSE LASKY announced his production partnership with Mary Pickford, he recalled to a group of news representatives an incident that occurred between them some 25 years ago. Turning to Mary, he said, "I don't suppose you mind if I name a few dates."

America's Sweetheart laughed softly.

"I'm afraid it's a little too late to fret about age," she replied.

They sealed their contract with a kiss.

• • •

WHEN JANE FROMAN, the New York radio star, does another motion picture, it is quite possible she will stipulate that there will be no balcony scenes.

Miss Froman came west for a month's vacation and was immediately signed by Warners. Her first scene called for her to scale a fire escape three stories high and warble a tune. What the director didn't know was that Miss Froman has a phobia about high places, and the scene nearly scared her witless!

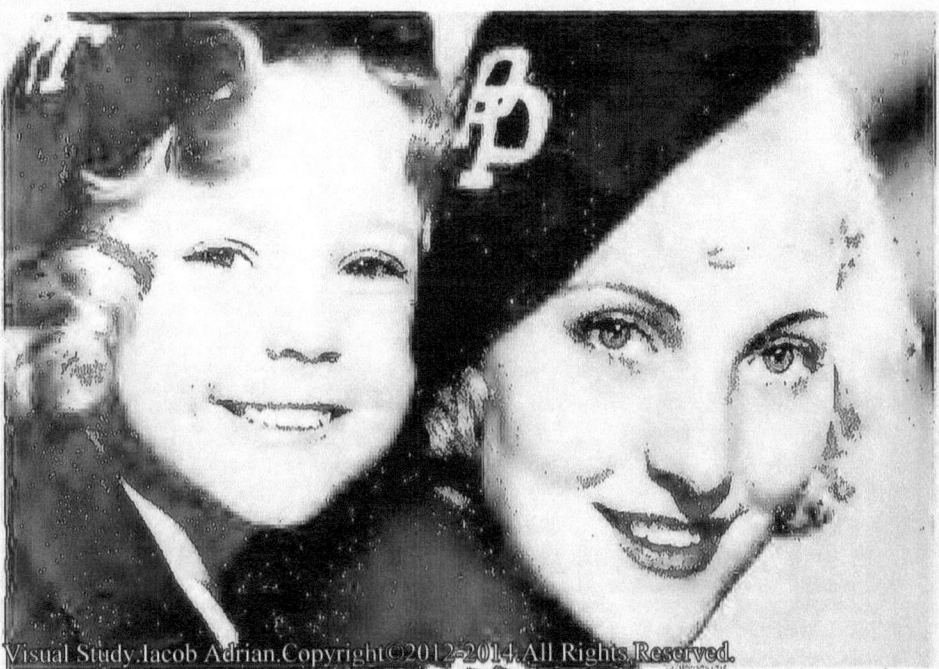

—Max Munn Autrey

The world is singing the praises of little Shirley Temple, who is seen here with Pat Paterson, since she stole the show in Stand Up and Cheer. *She duplicated this success in* Little Miss Marker *and* Baby, Take a Bow

HARRY CARR'S Shooting Script

This Is Written in Honolulu where Hollywood comes for its mad moments.

Janet Gaynor has a cottage on the Kaneohe side and never mingles with the social life of Honolulu.

Ann Harding relaxes under the tropic moon with the army people.

Dolores Del Rio comes to a cottage on the beach at Waikiki with her husband. She made *Bird of Paradise* here three years ago.

Just about every author who ever punched a typewriter has written a story here. And it's the worst place on earth to try to write. Too much tropic moon.

Shirley Temple, visiting Honolulu, was this year's biggest event in the islands. Steel cables, used to hold back the crowds, were broken in the rush to greet her.

She stands without rivalry or competition as the greatest box office puller of the industry.

And Shirley flew in the face of Providence, tradition and all experience.

I once worked in a studio where we

Janet Gaynor and Margaret Lindsay had broad smiles for the crowds that greeted them in Honolulu. But Janet, once ensconced had nothing to do with Hawaii's social life...

Hello, Hawaii! Shirley Temple and her father, George Temple, looking down from the deck of the Mariposa as they arrived in Honolulu for a long-earned vacation

were trying to put over Baby Peggy as a screen star. I grew old and wicked under the strain. Baby Peggy just didn't "jell."

As Jackie Coogan was then the child wonder, I was forced to the conclusion that the public adored little boys but had no time for little girls.

As a matter of fact, it really had no time for little boys either. Jackie never scored in but one real hit. His whole career consisted of coasting along on the success of *The Kid*. He died on his feet long before he grew up and retired.

I can't account for Shirley. The only thing that will ever stop her is that she is bound to grow up. They should have stunted her growth with whiskey when she was a kitten. She will grow and be married and I feel sorry for her husband. What he will have to live up to!

Garbo's Inhibitions

When she goes to Sweden Garbo can be her own free self again. I always wondered what she would do if she were not bound by the necessity of being a silent, mysterious figure. From the news bulletins it appeared that what her soul yearned to do was to fall off yacht masts and sprain her ankle.

Never mind, though. Greta will last forever on the screen—as long as she continues to be a mystery and does her yacht falling somewhere other than Hollywood.

Brooklyn's Wide Spaces

Harry Carey has celebrated his twenty-fifth year on the screen as a Western hero. He has outlasted them all.

The irony of it is that Carey was a young lawyer when the drammer called to him. He didn't know which end of a broncho went first and wildly protested when they cast him as a cowboy; and so far as I know has been protesting ever since that he isn't a cowhand and doesn't want to be.

On the other hand, Monte Blue, who was a real cowhand, begs and begs for chaps and a reata on the screen; but they pass him by in silent scorn when casting wild west parts. He will not do at all; he knows how to ride.

Shirley and the Harem

I learn, to my own not inconsiderable surprise, that the trade is no longer so much interested in Charlie Chaplin. They feel that the public has become so talkie conscious that it is impossible even for Charlie to remain silent and make much public commotion. If they are right, they are wrong. That is to say, they might be right in

From Pearls and Gold to Pictures

—Photo by Charles Rhodes
Errol (Captain Blood) Flynn and his bride Lili Damita, celebrated his first major rôle with a party at the Trocadero

ERROL FLYNN, A YOUNG Irishman with a flair for adventure in far places, feels the Hollywood spotlight, warm, dazzling, exciting, shining in his eyes this month. Warner Brothers, courageously disregarding the fact that he is a complete unknown, have turned him into Captain Blood, to take the lead in that swashbuckling romance of Sabatini's.

Like all the gay young blades who are setting Hollywood afire these days, Flynn is a strapping six-footer. Six feet-two, to be exact; an inch shorter than Paramount's Fred MacMurray, but the same height as RKO's Randy Scott, and two inches taller than Metro's big bet, Bob Taylor. These lads would tower over Doug Fairbanks, Dick Barthelmess and other stars of the silents.

Errol Flynn needs a build like that to carry the load of Warner's big production, although there will be, thankfully, Olivia de Havilland to rely on, and a cast of splendid veterans to ease him over the tough spots.

Flynn's tests show him to be an ideal Captain Blood, and Warners chose him over their best stars. George Brent was the closest contender, but George hates costume stuff and apparently showed it in his tests. *Captain Blood*, naturally, is a picture of such magnitude that it will be the making of Flynn. It will be one of the hit pictures of the year because it's what is known as a "natural"—it has everything from drama, setting, dialogue and pictorial values on to sure fire box office appeal.

He is a delight to copy writers, for Flynn's few years have been jammed with romantic adventures. You can spot the outdoor man by what he eats. Flynn pushed back the lace cuffs of his wine colored buccaneer's coat and tackled a big plate of fried eggs and bacon the day we sat down to lunch with him. It's the one dish a wanderer can rely on, in the bush or on mainstreet.

● A CURIOUS COINCIDENCE attends his first film adventure, which was a chronological narrative of the mutiny of the Bounty made by a British firm some years ago. Flynn, being a direct descendant of Fletcher Christian, who led the mutiny, was given the rôle of his ancestor.

Twinkling Toes » » » » » » » » Shirley Temple

Wearing her favorite pink dress, Shirley does this dance in her new Fox hit, *Curly Top*

SHIRLEY SCORES
A Bull's-eye

Cast as the Littlest Rebel of the Civil War, Shirley is set for another smash hit!

by MARIAN RHEA

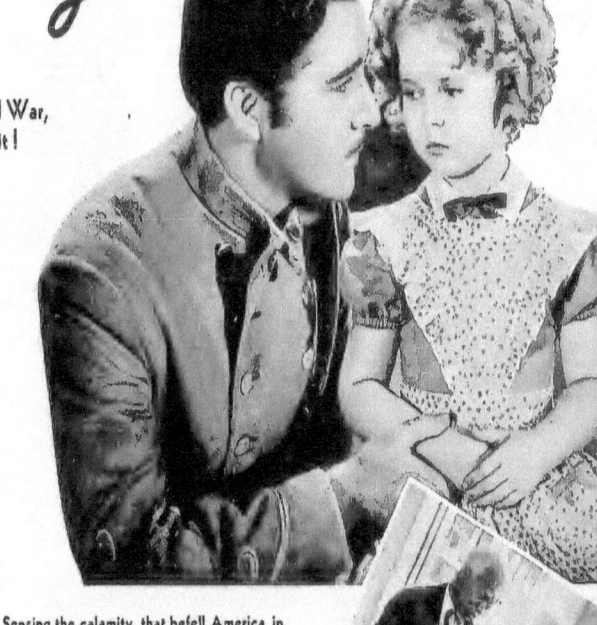

Sensing the calamity that befell America in the 60's, Shirley plays a tear-jerking rôle with John Boles with consummate ease

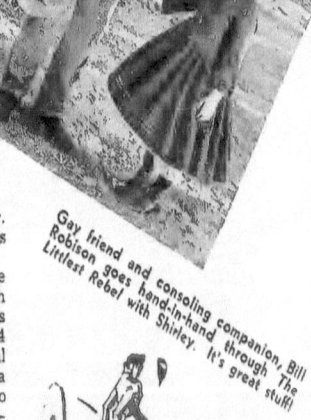

Gay friend and consoling companion, Bill Robinson goes hand-in-hand through The Littlest Rebel with Shirley. It's great stuff!

Ping! A grim-visaged gentleman on horseback, wearing the uniform of a colonel in the Union Army, turns a scowling glance in the direction whence came the pebble that hit him right smartly in the back of the neck. Ping! A miss that time, but uncomfortably close. Someone is too confoundedly handy with a sling-shot. The colonel reins in his horse. Turns and glares down at a young person in hoop skirts and pantaloons, about six years old and curly-headed, whose round countenance is as haughty and displeased as his own.

"Who did that?" roars the colonel.

"I did!" The pantalooned one's tone is fierce. She brandishes her sling shot defiantly.

"I don't like Yankees!"

"I see. You're a little rebel, then?"

"I'm not! I'm a Confederate! And I'm not afraid of YOU!"

A smile struggles with the sternness of the colonel's leathery countenance. "I'm glad of that. I shouldn't like to have a nice little girl like you afraid of me," he tells the sling-shot expert.

"Humph!"

"Okay! Cut!" yells Director Dave Butler on The Littlest Rebel set at Twentieth Century-Fox. Jack Holt (in the blue uniform) and Miss Shirley Temple (in the pantaloons and hoops) smile at each other.

"I didn't really mean I didn't like you," Shirley informs Jack.

"I know that," he assures her.

● HE DISMOUNTS AND swings her up on his shoulder. They move off to an umbrella-shaded table where Mrs. Temple is waiting. The prop men arrange the stage for another shot....

It was hot that day on The Littlest Rebel set. Late autumn, but hot. Mrs. Temple wanted Shirley to sit quietly and rest after the just completed scene— "see, like Jack is doing...." She indicated "Colonel Holt" stretched out comfortably in a folding chair.

But Shirley had other ideas. "I got to do my 'rithmetic," she informed her mother. "I'm studying take-away now an' it's very interesting."

Importantly, she sat down at the table and occupied herself with such intricate problems as 4 minus 2 leaves 2, 6 minus 3 leaves 3 and 7 minus 4 leaves 3. She had mastered several laboriously and also audibly when a diversion occurred. Bill Robinson, also in the cast, attired in habiliments indicative of what the poor but honorable colored gentleman wore in the days of '61, began operations with Shirley's slingshot. His target was the big lettering—

Shirley Scores a Bull's-eye

Stokes' Drug Store—over one of the buildings of a studio street scene.

Ping! Ping! Ping! Cheers from the gallery and a howl of glee from Bill.

"Wow! I hit the lettah 'o' right in th' nose!"

Suddenly, arithmetic wasn't so interesting to Shirley. She deserted her take-aways and joined him. "I bet I can do that, too," she remarked.

● BILL RELINQUISHED the sling-shot and she aimed carefully, drew back the elastic with practised hand.

Ping! The gallery cheered again, but more from loyalty than appreciation of marksmanship. Because the shot missed the 'o' in Stokes and hit a plate glass window. No, the window didn't break, but at this point Mrs. Temple interfered anyway.

"Shirley," she instructed, "don't you shoot that thing again!"

Ping!

Now there were those present who would swear that the second shot really got under way before this admonition, but Mrs. Temple thought differently.

"Shirley," she said, firmly. "bring the sling-shot to me!"

Shirley eyed her mother, saw she meant it . . . thought quickly. Then—

"I'll tell you, Mommy," she said, ingratiatingly, "you're a long way away and I'm kinda tired. I'll just give it to Bill. . . ." She suited the action to the word.

Mrs. Temple smiled somewhat wryly and turned back to the magazine she had been reading. "Little minx," she said. "She knows Bill will give it back to her pretty soon while I should probably keep it all day."

In the second shot of the morning, Shirley won a special bit of praise from Director Butler which with lightning perspicacity she turned to her own advantage in the matter of recovering the sling-shot. It was like this:

Shirley, dressed up in a green plaid alpaca creation with peplum, tight bodice, velvet hat tied with ribbons underneath her round little chin, appears at the ticket window of a little southern railway station in company with Bill Robinson. They want a ticket to Washington because they have very important business there. It is a matter of life and death in fact. They haven't very much money and the situation is tense. Will they have enough to buy their tickets?

"What's the fare to Washington for a colored gent'man and a little girl?" Bill asks the agent.

"Six dollars and twenty-cents for you and—" the agent looks at Shirley and considers—"I think the little girl is a bit tall for half-fare. . . ."

● IMMEDIATELY, HOWEVER, Shirley remedies that impression. Eliminating several inches from her height by scrootching down so that her little green skirt sweeps the platform, she pipes up: "Oh, no! I was standing on my toes, then. THIS is my real size!"

The ticket man laughs and promises to give them the ticket for half fare. Shirley and Bill move on. And this is where Shirley did the thing that won extra praise from Mr. Butler. As she walked away, without being told she kept on scrootching down, thus preserving the effect of smallness.

JANUARY, 1936

Butler was delighted. "That's wonderful, honey," he said. "You're a real actress. I am very pleased."

Quick as a flash Shirley, the opportunist, made him a proposition. "Then maybe you'd fix it so I could get my sling-shot back?"

Amid the laughter of all assembled, including Mrs. Temple, Director Butler "fixed it."

● IT WAS LUNCH time, then, but the afternoon found the company, or most of it, back at work—this time in a rose arbor. The setting was beautiful. It was supposed to be after the war and John Boles (who plays Captain Cary, Shirley's father) handsome in Confederate uniform, was having a friendly mint julep with his former enemy in the picture, Union Army Colonel Morrison (Jack Holt).

The scene was supposed to open with the two men in brief and pleasant conversation, after which Shirley was to "ping" Jack again with her sling-shot—this time as a friendly little joke—and then to run to him and her father (John) for a lovely finale. Well, the cameramen ultimately got the shot, but not until some two hours had been lost, together with everybody's patience. You see, the "best-laid schemes" of cameramen and director "gang aft a-gley . . ." For instance:

● THE TWO OFFICERS are sitting there quietly and the cameras are ready to roll when Jack Holt, with an accidental move of his elbow knocks over his mint julep. Time out.

Everything is ready again, when high overhead sounds the drone of an airplane.

"Hold everything!" yells Butler in disgust. "That noise won't do. Airplanes in 1865! My eye!"

More inaction until the plane—probably going two-hundred miles an hour but, to that impatient group, apparently standing still—disappears into the blue.

● The Littlest Rebel was five weeks in the making and countless interesting things occurred during that time—things out of as well as in the script. But just that one day on the set was enough to tell me I am going to like that picture. Everyone will, I am positive.

As you have no doubt gathered, it is a Civil War story and it is packed full of drama, excitement, humor and pathos. Shirley, more adorable than ever, stars as Virgie Cary, militant little Confederate who is as usual the center of things, aided by Uncle Billy, the lovable Bill Robinson. Yes, they dance together just as they did in The Little Colonel. Besides Shirley, Bill, John Boles and Jack Holt, others in the cast are Karen Morley, Willie Best, known also by the picturesque cognomen of Sleep and Eat, Big Boy Williams and Frank McGlynn, all playing important rôles. Karen is Shirley's lovely, tragic mother in the picture and McGlynn is Abraham Lincoln whom Shirley visits to plead for the lives of her beloved Daddy and Colonel Morrison. They are about to be shot—Captain Cary is a spy and Colonel Morrison for leniency toward him—but does Shirley win the president over? Well, what do you think?

TOPPER'S REVIEWS

If he waves his hat, it's grand! Otherwise—!

by TED MAGEE

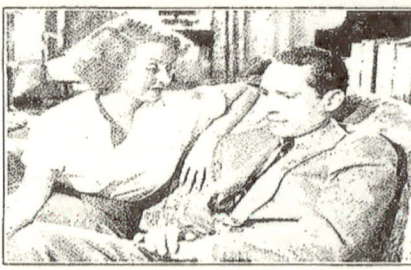

Franchot Tone becomes enamored with Bette Davis—a scene from *Dangerous*, an outstanding Warner Brothers picture

Alan Baxter and Sylvia Sidney portray young love in *Mary Burns, Fugitive*, you'll like them both! It's an exciting melodrama

MR. HOBO — (Gaumont-British) — George Arliss as a hobo may seem a little beyond your normal comprehension, yet in this film he does a beautiful portrayal of a man without a worry—until fate takes the helm! Through the machinations of a crook, Frank Cellier, Arliss becomes a bank president and the worries begin. You will like this light-hearted story. Excellent photography adds to the appeal.

THE LITTLEST REBEL—(20th Century-Fox)—Laughing, dancing and even weeping her way through the Civil War, Shirley Temple makes use of the obvious breaks and is the shining star of her newest picture. The story reflects a child's view of the American cataclysm, with the whole plot revolving around her father's secret visits home. The film makes equal heroes of John Boles as the Confederate father and Jack Holt as the Union colonel in control of the captured territory. Alongside Shirley throughout the story is Bill Robinson as the trusted old darky. His acting rates as additional salvo. Karen Morley and Guinn Williams please.

DANGEROUS—(Warners)—is a fresh love pattern that sweeps through your heart like a warm summer breeze. Technically it is a quadrangle, but the intense human interest of the story lies in the crossed-up love affairs of Franchot Tone, Bette Davis, and Margaret Lindsay. Tone and Miss Davis, holding the prize rôles, turn in magnificent performances. Miss Lindsay gets the last drop out of her lesser part. The Bette Davis of this picture is reminiscent of her rôle in the film, *Of Human Bondage*. But in *Dangerous* much of the melancholy is gone, and the players take the audience to their hearts, lifting the undercurrent of sadness to a radiant, glistening climax.

THE BRIDE COMES HOME—(Paramount)—Here you have the simple situation of Fred MacMurray, a striving young journalist, and Robert Young, a rich young blade, in love with the lovely Claudette Colbert. But you also have some gorgeous laughs, some grand situations, and a spritely air that keeps this picture at a high level of entertainment throughout. Perhaps you'll call this a goofy kind of love, but it rings true and makes this a breezy sort of comedy romance. Claudette Colbert does her best work since *It Happened One Night*.

MARY BURNS, FUGITIVE — (Wanger-Paramount)—Sylvia Sidney plays a rôle tailored to her talents, that of the honest, love-blinded girl who goes to the penitentiary because her ideal man turns out to be a crook. Her man, Alan Baxter, gives a fine performance as a young gunman with a mania for blasting people. Baxter looks good for a major film career. Melvyn Douglas sets feminine hearts a-patter with his satisfying rôle of the faithful stand-by. The picture will be especially pleasing to feminine fans.

THE GREAT IMPERSONATION—(Universal)—To properly comprehend all that goes on in this amazing film, you must take a pencil and pad with you to the theater and chart down the machinations of a great munitions ring. Plots and counterplots completely bamboozle the audience, and before you leave you will wonder if Edmund Lowe is, after all, Edmund Lowe, or whether you've been fooled all these years. Wera Engels and Valerie Hobson decorate the film with their loveliness. There's a fantastic horror mystery thrown in for good measure. If you can assimilate all these varying factors, you can call the impersonation quite satisfactory.

How SHIRLEY

She's a born actress! That's what her director, David Butler, tells you in this article

by KATHARINE HARTLEY

Director Butler usually has to explain things to Shirley only once. Above, they're shown together during the shooting of *The Littlest Rebel*. Below, Shirley does a difficult scene with Guy Kibbee in *Captain January*

Basking In The spotlight of popularity, Shirley Temple takes the plaudits of a nation unconcernedly because it's all just a lot of fun to her! She likes her dolls and crayons but when Director David Butler calls her on the set, she plays at acting like any other youngster and thereby packs a wallop.

Shirley never took elocution lessons from the neighborhood teacher, nor did she go near an acting school. She didn't need to. You see, Mrs. Temple is largely responsible for the Shirley Temple you praise so highly.

Like many another mother, Mrs. Temple always harbored the desire to act. She never achieved that ambition. So when Shirley came along, Mrs. Temple unconsciously began developing the talent that her offspring had inherited. And before many years Shirley faced the camera in a short subject and began her climb to fame.

Shirley still doesn't take lessons. What acting she knows she learned from her mother, but the disposition to act was inherent in her. And when she gets before a camera, she speaks the lines as her mother taught them. The rest of it comes naturally. She plays and it turns out to be the finest sort of child acting.

Shirley and Dave Butler are grand pals. And nobody other than Shirley's mother can tell you better about the development of her career.

● "You Can Tell the world for me that I think Shirley Temple is the greatest actress on the screen!" said Dave Butler, so sincerely and so vehemently that there could be no doubting that he meant it.

"And it's not just because I've directed four of her pictures that I say that," he continued. "Any man who couldn't direct her should give himself up. She is the sweetest, most natural, most gifted, accomplished artist that I've ever come across in all my years of movie-making—and I've directed a lot of the big ones. Shirley is instinctively an actress. It was born in her, I guess. It's just one of those things that happens once in a century —like a great race horse or a crack baseball pitcher — all born with the winning streak in them.

"Come over here to the other side of the set—I want to show you something. See that circular iron staircase?" I saw. It was the full height of the high sound stage, winding up and up, with seven or eight spirals. There's a photo with this story showing it. "The other day we had to film the most difficult shot in the world on that staircase. Shirley and Guy Kibbee had to climb up the stairs, and at the same time deliver two and a half pages of dialogue.

"The camera moved up with them on a swinging crane. Two sound men had to carry a microphone ahead of Shirley all the way up the stairs. At each turn, Shirley and Guy had to pause, face the camera at an exact angle, deliver a line or two and move on. I figured we'd have to spend two days on that one scene — it was so complicated. I explained the scene to Shirley. At first I didn't think she was paying any attention to me. She was looking at the floor, shuffling her little feet, trying out a new tap routine. I asked her if she was listening to me —did she get what I meant? She looked up at me and grinned. 'You'll see if I was listening! You wait and you'll see!' she called out gayly.

"Well, you can believe it or not. I'll admit it sounds hard to believe. But we started that difficult shot, two and a half pages of dialogue, and with all the turns, and the stopping in the right places to look at the camera, Shirley did the entire scene without one single mistake. But Guy Kibbee, veteran actor that he is, made some mistakes. That's no reflection on him, however, because nobody in the world *but* Shirley Temple could have gone through that scene perfectly the first time!

"Of course there are a lot of times when Shirley doesn't do a scene in one 'take.' But it's never because she doesn't know how. When we have to take a scene over, it's usually just because she's so full of the old mischief that she can't concentrate on acting.

LEARNED ACTING

A terribly cute thing happened one day when we were making *The Little Colonel*. It was a scene of Shirley alone, propped up in a big bed, and she had to cry, and say, 'I want my mother, I want my mother.' Well, we took the scene once. It wasn't very good. Shirley hadn't put any feeling into it. So I went over to her and used the phrase that Will Rogers always used to say after a scene—'We can do lots better acting than that, Shirley.' (Will always said it of himself, of course.) Shirley grinned and pulled me close to her. Then she whispered, 'Well, I admit there *was* a little fake in it, Mr. Butler.' Now, can you help loving a kid like that!

"The amazing thing is that Shirley not only acts in her pictures herself, but she takes a terrific interest in the acting that everyone else does in the picture. She makes the picture just as much her responsibility as it is mine. She actually helps me direct! I'll tell you how it all came about.

● ONE DAY, WHILE working on *Bright Eyes*, there was a scene between Shirley Temple and Jane Withers. While Shirley was delivering her lines, I noticed that Jane was also repeating Shirley's lines noiselessly with her lips. This is what we call 'mouthing' another's lines. I explained to Jane that she mustn't do that, and how funny it would look on the screen. The audience would see her lips moving, but hear no words. Jane apologized and said she hadn't realized what she was doing. So we shot the scene again.

"After the second 'take' Shirley came over to me, tugged at my sleeve, and drew me aside. 'I want to tell you something, Mr. Butler . . . Jane is still mouthing my lines. But you mustn't scold her, or tell her I told you, cause sometimes I do that myself. Only I just wanted to let you know not to worry, because I'll watch out for those things myself. I'll help you.'

"'All right,' I told her. 'You watch, and let me know after the scene, how it went.'

"After the next scene, I looked at Shirley, and Shirley looked at me. Her lips tightly closed, her hands behind her back, she soberly nodded her approval of that third take. Her eyes and her whole bearing plainly said that everything was jake! She still does that. After every scene she lets me know whether it was O. K. or not!

"Another time when we were doing the baptizing scene in *The Little Colonel* we had a lot of trouble with the little colored boy, whom Shirley had to baptize in the stream. You see most child actors have to be coaxed and wheedled into doing anything before the camera. (That's where Shirley is so different: you never have to coax her to do anything.) This little colored boy was feeling obstinate, and he'd always duck himself in the water, before we were ready to 'shoot' the ducking. Remember, he was wrapped in a fresh clean sheet too, before the ducking was to take place. Well, after he had used up fourteen sheets in untimely duckings, and pretty near all my patience, Shirley again called me aside. She is always crooking that little finger of hers at me, and then I bend close while she whispers.

"'Mr. Butler,' she said, 'I'm doing all I can to make him behave, but he's *so* heavy! Each time I try to hold him up till the

Tousle-headed Shirley has reason for the bright smile in the top picture. Photo was taken upon her arrival in Honolulu not long ago when she was greeted by ten thousand youngsters! Below, Shirley manhandles Director Butler, but it's all in good fun

How Shirley Learned Acting

camera gets ready, he pulls away, and ducks himself. Do you think maybe I could pinch him, so he'll behave?' Trying to keep a straight face, I advised her against pinching, but encouraged her to be patient, too, a little longer. He'd soon wear himself out, and stop being stubborn. 'All right,' she said, 'but he certainly is difficult.'

● "SHIRLEY SAYS none of these things with any air of superiority. She just simply can't understand why other children don't like to act, and don't obey a director's orders, because she herself loves it so. Maybe you won't believe me when I tell you that every day at five o'clock when we finish shooting, Shirley says, 'I don't want to go home. Please, isn't there something else we can do?'

"One of them is, that while she loves working on the set, she gets no kick at all out of seeing herself on the screen. One day I invited Shirley and her mother to see the first finished 'cut' of The Little Colonel. After sitting through the entire picture, I asked Shirley what she thought of it. 'Oh, I think it's a good picture . . . I liked it . . . it was keen!' she said enthusiastically. Then I asked her how she liked herself in it. 'Not very much,' she said. 'Why not?' I asked. She shrugged. 'Oh, I just don't like myself in pictures,' she said. That floored me. I couldn't think of another thing to say. There had been such a note of finality in her voice. She just doesn't like herself in pictures—and that was that."

I asked Mr. Butler if he thought Shirley had changed any, since he made his first picture with her almost two years ago. "Personally, not a bit," he said quickly. "The only thing that's happened to her is that she has gotten smarter. What it used to take me fifty words to explain to her, she now understands in five. Most of the time, when I am giving her directions, she anticipates what I have to say, even before I say it. Bill Robinson has had the same experience with her. He has taught a lot of girls to dance—among them, Eleanor Powell—but he says that none of them have ever learned so quickly or so easily as Shirley. One day I watched him giving her a new routine. They went through it once. Shirley watched his feet closely, and made her own follow. 'Now, let's try it again,' Bill said. 'No, let me try it first,' said Shirley. 'I think I've got it.' And by golly, if she didn't have it learned already! That's one of those things you don't explain."

● HERE'S ANOTHER example of her amazing aptitude. Everybody knows of course that Shirley has a stand-in to relieve her of standing around while we set the lights. But there are many times when the little stand-in fails to quite give us what we need. Maybe it's a direction she has failed to understand. Maybe when she walks across the floor she moves in such a stilted, schooled manner that we can't get naturalness even in our lighting. Well, when things like that happen, Shirley always offers to do it herself. She stands in for herself, and her stand-in, because nobody can do anything as well as Shirley can do it!

"Except for technical advice where the camera is concerned, nobody has taught Shirley anything. Because she has a quick observant eye, an amazing memory, and a natural talent for acting, she has learned everything herself. On the set we treat her like a twenty-year-old. I never say, 'Now come on, Shirley, darling, I want you to act very angry. Remember you're a very mad little girl, because somebody has said something about your father, and you must stamp your feet, and squint your eyes, and make a mad face. And you say your line like this—' I never have to do any of that stuff. When we are ready for her for a scene, she already knows her lines, and if her lines are angry lines, she knows how to act angry. All I ever say is, 'All right, Shirley, come on.'

● "YET, IN SPITE of the fact that we treat her professionally like a grown-up, she is still an unspoiled little girl. After a rehearsal, when there is still time before the 'take,' Shirley will say, 'All right, I can go and play now, can't I?' and off she runs to her drawing and her dolls. She plays all day long, between scenes, without a worry on her mind. She requires none of the constant coaching that so many children need."

It's obvious that Dave Butler worships his little star. When he talks about her, his eyes gleam with that mistiness that is akin to tears. And he laughs too at her pranks and her cute sayings—laughs loud and delightedly. And it's just as obvious, too, that Shirley adores him. They have wonderful times together. Dave has never once allowed her to see him become upset or out of patience with anybody. A display of anger is something that Shirley always disapproves of—and shows it to, by withdrawing from the scene with the dignity of a little saint. But just the same, when Dave puts on a "temperamental act" for her, she is delighted, and laughs till she can't laugh any more. He always does that when Shirley, in a playful mood, hides when he calls her. Of course at those times Dave usually sees her beaming face watching him from under a table, or peeking out at him from behind a part of the set, but he pretends that he can't find her, and is outraged. He paces the floor, and pounds the walls, and tears his hair, and calls her name, and Shirley giggles and giggles and giggles. Then when the game has made her tummy ache from laughing, she bounds from her hiding place, right into his arms, pats his cheek, kisses him and starts laughing all over again.

Joan Woodbury, one of the newest finds of Hollywood, appears here with William Farnum, a veteran film player, in a photo from the picture Wanted Men

DECEMBER, 1937

Shirley Temple, 20th Century-Fox star

All Aboard!
for the tour to
MOVIELAND

Hollywood Magazine's special train promises the most thrilling trip of an entire lifetime to America's most colorful and glamorous city!

How Would you like to visit Hollywood on your vacation this summer, and actually get to see the inside of a famous movie studio? Thousands of tourists annually flock to filmland, but few indeed ever see the exclusive side of the studio gates—but you can do it if you join HOLLYWOOD Magazine's economical Movieland Tour of 1936, the second annual vacation trip to the land of sunshine and stars!

Shirley Temple's home studio—the famous 20th Century-Fox company—will be your host this summer. A big special train will be made up in Chicago and begin the exciting adventure July 19.

You will get to see the colorful Northwest, with stops in the twin cities of Minneapolis and St. Paul, Yellowstone Park and Seattle. From the Pacific Northwest the train will swing down the coast, visiting San Francisco before arriving in America's most unusual town, Hollywood.

● IN FILMLAND the Movieland Tour will make its headquarters at the Roosevelt Hotel on Hollywood Boulevard, with a grand round of entertainment scheduled to make every minute of the stay in Hollywood an exciting experience.

Stars you have always wanted to see will actually be

All Aboard for the Trip to Movieland

on hand to welcome you to this most beautiful of all filmland studios! You'll get to visit every nook and cranny of the amazing lot—and that's not all! In addition, you will be feted by film notables, be taken to the famous Hollywood night spots, and not miss a thing of interest in the world's most colorful city!

At the 20th Century-Fox studios you will never cease to wonder at the marvels of making motion pictures. Within its gates broad boulevards wind through mile after mile of tremendous outdoor sets and huge sound stages such as the accurate reproduction of the three upper decks of the Liner Rex. It's the biggest dry land ocean liner ever built.

● FURTHER ALONG you will see Will Rogers' famous dressing room, where he used to write his daily newspaper column when not working in front of the camera. Down the street castles and mansions loom up into the air. You will pass the canal where Janet Gaynor made *The Farmer Takes a Wife*; on the right is the famous Cafe de Paris where the stars lunch and Shirley Temple's sky blue and white cottage where she dresses, lunches and goes to school.

20th Century-Fox has one of the biggest picture programs ever launched by a major studio, and there will be lots of activity at the lot when the tour reaches Hollywood about June 27. Right now Shirley Temple is completing *Captain January*, which will be one of her finest films. John Boles is doing the film version of the famous Spanish-American war story, *Message to Garcia*.

Then there is Warner Baxter and Gloria Stuart in the midst of *The Prisoner of Shark Island*, a huge production which will cost more than a million dollars to make.

● VICTOR McLAGLEN, who is making three pictures on this lot, promises to be on hand with Boles, Baxter, Shirley Temple, Loretta Young, Gloria Stuart, Rochelle Hudson, Paul Kelly, Simone Simon, and many other 20th Century stars.

So successful was our first annual Movieland Tour last summer that we expect the reservations to be filled long before the train is ready to pull out of Chicago for Hollywood. If you want to be certain of making this amazing trip, write now for details. Make your reservations early. You'll never forget or regret making the Movieland Tour.

For information address Mr. Joe Godfrey, Jr., Movieland Tour Manager for HOLLYWOOD Magazine, 360 North Michigan Avenue, Chicago. You will receive by return mail full particulars, showing the itinerary, costs, and descriptions of the sights to be seen. The amazingly low costs will astonish you, too!

Watch for further details in next month's HOLLYWOOD. We will tell you about the plans for the big private party to be given in your honor at the home of a star, with the names of those who plan to be present! And if, at the last minute, you find you cannot make the trip in June, a similar trip called the Movieland Special has been arranged to leave Chicago August 9th.

MARCH, 1936

Here's an airplane view of 20th Century-Fox studio, which will open its gates to members of the Movieland Tour. Reading down from the top are some of the stars who will greet the visitors: Shirley Temple, Warner Baxter, Rochelle Hudson and Ronald Colman.

Hollywood Spotlights

—Photo by Charles Rhodes

Aboard ship? Well it would seem that way. Hugh Herbert rings the dinner gong. Frank McHugh is the stoker. Mr. and Mrs. Pat O'Brien lend "class" to the setting

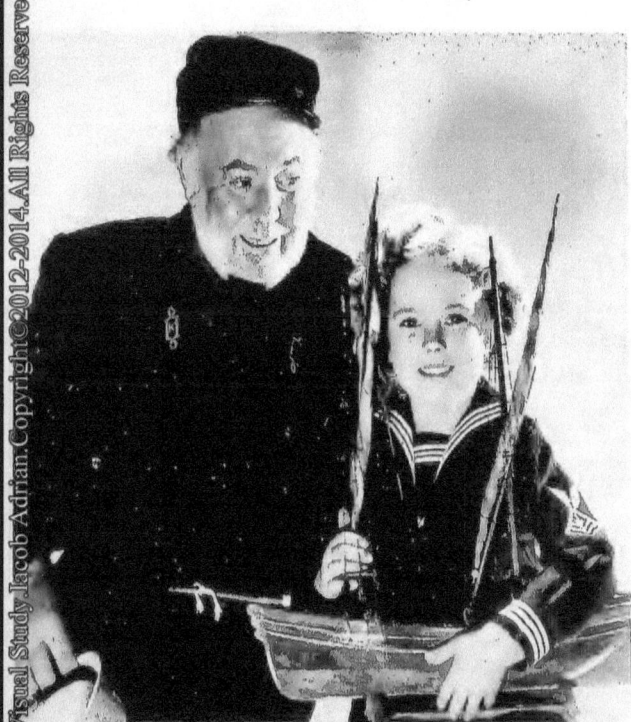

The cutest picture yet of beautiful Shirley Temple! This time she's shown with Guy Kibbee in a scene from *Captain January*. The model boat is Shirley's favorite toy since she has become sea-minded

Donald Woods

NEXT TIME Donald Woods goes about at odd hours in turtle neck sweater, unpressed trousers and tennis sneakers, he'll be sure to have documentary identifications with him.

Thus garbed, Don had an amusing tussle with John Law on his way to the studio one morning. Woods parked his car, an expensive model, at Cahuenga and Sunset, where Mrs. Woods was to pick it up later, and started for the bus station at Hollywood boulevard.

Suddenly a police radio car drew alongside, and two officers demanded to know who he was, where he was, where he was going and, if he owned the car, why he was parking it miles from the studio. Not satisfied with his replies, they asked him to "get in!" and drove to the studio.

After the gateman assured the police that Don was no auto thief, the police started away—but not until the actor thanked them for the three mile lift to the studio!

* *

Grace Moore: Business Expert

Grace Moore

WE HAVE JUST heard a marvelous story about Grace Moore, one that demonstrates how and why she is going to retire with a nice life income. Once upon time, not many years ago, Grace was financially very flat. No more, and here's another good reason why: A gentleman representing an English concern flew to Hollywood. His object: to get Grace Moore to make ten electrical transcriptions at almost a fabulous price.

The famous diva was under the weather. She refused to see the agent. Days passed. Miss Moore was fully recovered. She knew the agent was being urged to return home as quickly as possible. But always alert to drive a shrewd bargain, Miss Moore still refused to see him.

Came the day when the agent was ordered home. The word reached Singer Moore. She sent for the agent, drove home a hard bargain hinged on his anxiety to plane eastward. The result: only six recordings at twice the original price!

The bewildered agent accepted her counter offer in a rush, then grabbed the nearest plane for the east. You can depend on it that Grace Moore will retire with sufficient funds for old age! She's a good model for the whole colony.

YOUR HOSTESS in Hollywood

Old Faithful in action

You'll see wild animals

Lounge under palm trees

Enjoy gorgeous mountain scenery

Visit movie studios

PAULA STONE, one of the famous "Stepping Stones" who made stage history, invites you to a cocktail party at her home in Hollywood! You'll meet all her friends, among whom are the most noted stars in Hollywood. Fred Stone, her father, will act as host, and her two sisters, Dorothy and Carol, will help entertain you.

Doesn't it sound thrilling! And it's just a sample of the wonderful entertainment Fawcett Movie Magazines have arranged for those who join the second Annual Movieland Tour. To give you an idea—here's a day's schedule: Start with a trip through 20th Century-Fox studios, where you'll see pictures being made, meet the stars working on the sets. You'll meet Shirley Temple in person, talk with Janet Gaynor, Warner Baxter will come up to say hello. In the afternoon, a tour through Beverly Hills, seeing the homes of the stars. That night, a big party at the Blossom Room of Hollywood's Roosevelt, at which many of the movie people will be present. Other highlights of the four days in Hollywood ... bathing at Santa Monica Beach, a trip to Catalina Island —magic spot in the Pacific, Paula Stone's cocktail party, a large dinner party at the famous Cocoanut Grove.

This is the kind of vacation an ordinary traveler could never hope to have. But under the sponsorship of Fawcett Movie Magazines, all doors are open to you. Briefly, the plan is this—we've organized a complete, all-expense vacation trip of two weeks, from Chicago to Hollywood and back. We'll see some of America's most wonderful scenery—we'll go through Yellowstone Park, see Old Faithful, the world's biggest geyser, visit British Columbia. We'll travel in luxurious special trains, have first class accommodations everywhere. But by getting group rates, the entire cost of the trip will be absurdly small. One sum includes everything—transportation, meals, hotels, entertainment.

Two Movieland Tours are planned, limited to 200 people each. One leaves Chicago July 19th, the other August 9th. Fill in coupon now for booklet giving complete details.

I GUARD

It's a tremendous job safeguarding the little star! The man who does it takes you behind the scenes for one brief glimpse of the child's complex life

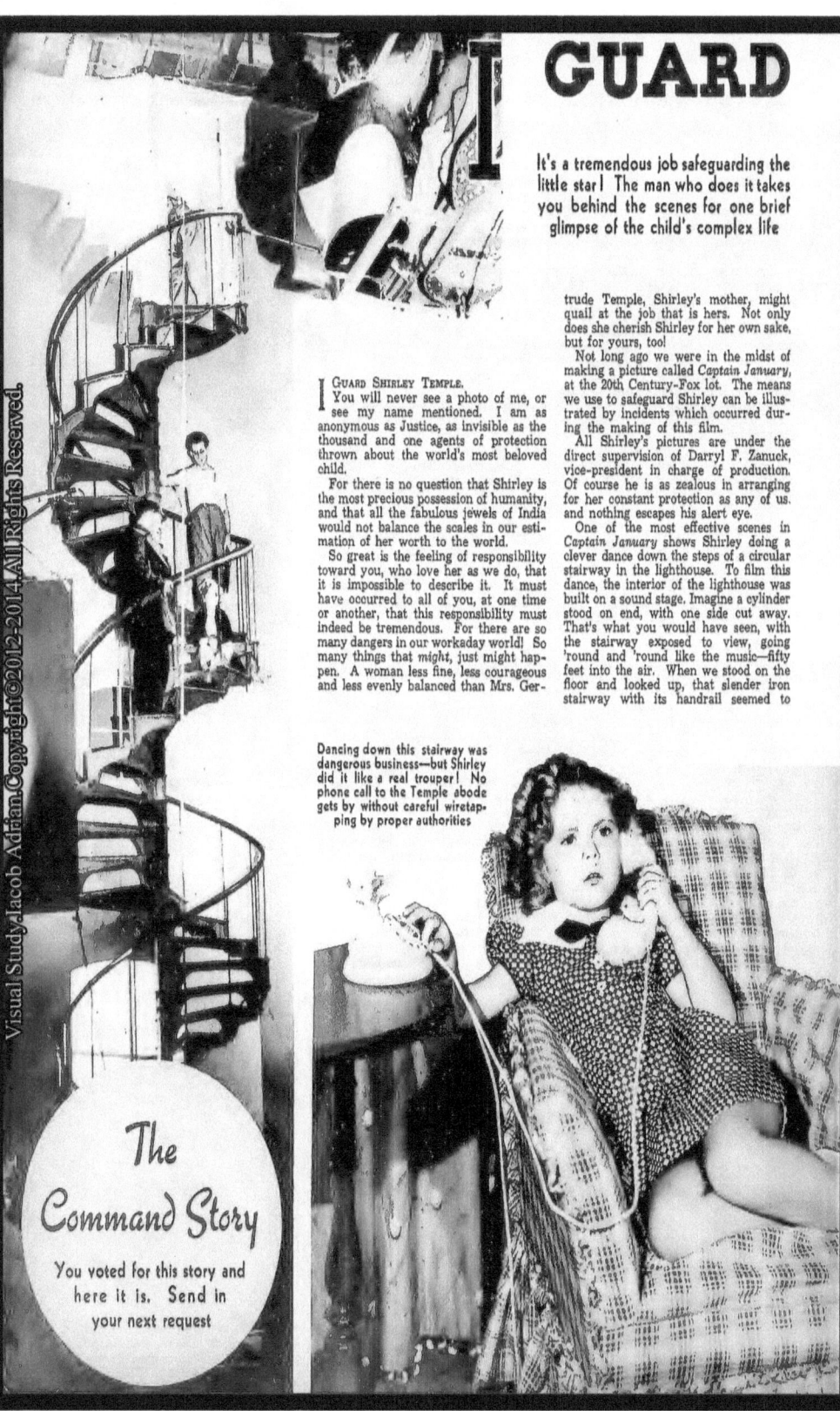

Dancing down this stairway was dangerous business—but Shirley did it like a real trouper! No phone call to the Temple abode gets by without careful wiretapping by proper authorities

The Command Story

You voted for this story and here it is. Send in your next request

I GUARD SHIRLEY TEMPLE.

You will never see a photo of me, or see my name mentioned. I am as anonymous as Justice, as invisible as the thousand and one agents of protection thrown about the world's most beloved child.

For there is no question that Shirley is the most precious possession of humanity, and that all the fabulous jewels of India would not balance the scales in our estimation of her worth to the world.

So great is the feeling of responsibility toward you, who love her as we do, that it is impossible to describe it. It must have occurred to all of you, at one time or another, that this responsibility must indeed be tremendous. For there are so many dangers in our workaday world! So many things that *might*, just might happen. A woman less fine, less courageous and less evenly balanced than Mrs. Gertrude Temple, Shirley's mother, might quail at the job that is hers. Not only does she cherish Shirley for her own sake, but for yours, too!

Not long ago we were in the midst of making a picture called *Captain January*, at the 20th Century-Fox lot. The means we use to safeguard Shirley can be illustrated by incidents which occurred during the making of this film.

All Shirley's pictures are under the direct supervision of Darryl F. Zanuck, vice-president in charge of production. Of course he is as zealous in arranging for her constant protection as any of us, and nothing escapes his alert eye.

One of the most effective scenes in *Captain January* shows Shirley doing a clever dance down the steps of a circular stairway in the lighthouse. To film this dance, the interior of the lighthouse was built on a sound stage. Imagine a cylinder stood on end, with one side cut away. That's what you would have seen, with the stairway exposed to view, going 'round and 'round like the music—fifty feet into the air. When we stood on the floor and looked up, that slender iron stairway with its handrail seemed to

SHIRLEY TEMPLE

reach to the rafters. A huge camera boom, like some prehistoric monster, held the camera and crew in its outstretched jaws, ready to swing them through the air as they photographed the scene.

Mrs. Temple came from the dressing room with Shirley. We had all in readiness but the more we looked at the stairway the more worried we became. Suppose Shirley should fall?

● SHIRLEY WASN'T the least bit afraid. But imagine her mother's feelings; on her shoulders rests a crushing responsibility. In the last analysis, of course, it is not Shirley the star we are protecting, but Shirley the beloved daughter of the Temple family. No picture could be worth any risks for Shirley.

So one more safeguard was planned. A huge net was sent for, and erected under the stairway. Men stood ready, just out of reach of the camera, in case she should slip.

Mrs. Temple touched her child on the shoulder, and Shirley smiled up at her.
"God is watching over you, darling," Mrs. Temple murmured.
"I'm not afraid," smiled Shirley.

Her little legs twinkled past the iron rails as she climbed to the top. She seemed like a tiny cherub climbing up to heaven, as we watched her progress. The signal was given, and Shirley did her job without the slightest hitch. Down the stairway she danced, to music, while whiskered Guy Kibbee as the old sea captain, played the scene with her.

Every member of the crew, everyone on the set, stops work to watch Shirley when she does a scene. Hundreds of eyes are upon her. On no other set does this happen, but Shirley is one star who holds the attention of all who work with her. She seems never to make a mistake. We call her "One Take Temple," because only one take of a scene is necessary with her.

On all studio sets there is a confusion of electric cables lying about, connecting the lights, cameras, mikes and so on. But on a Shirley set, every cable must be moved aside to give her clear progress to the place where she is to enact her scene.

● WE WHO GUARD her go ahead, trained to watch for any object that might be in the way, ready to move anything that might fall. She is not allowed to step over any cable.

Another part of the picture calls for Shirley to dance along the wharf with Buddy Ebsen, that gangly, nimble-legged lad you saw with Eleanor Powell in *Broadway Melody of 1936*. The wharf juts into a lagoon on the lot; from it you can see the canal boats used in *Farmer Takes a Wife*, and the steamer being filmed in *The Country Doctor*.

During rehearsals for this sequence, we noticed that some of the planks were rough. These were planed down or covered so that Shirley's toes wouldn't trip.

Shirley took an impish delight in going over to the edge of the wharf and teetering there, just to draw gasps from us. Her mother and school teacher, however, aren't easily put upon, and Shirley has to behave when business is afoot. She has plenty of time to play.

Not long ago she announced, when things had grown tedious during rehearsals, that she was going to play. And play she did! The actual making of the picture finds her always interested, never wearied.

"Is it a take?" she'll ask. If it is, Shirley "gives." If it's just practicing, she loses interest. Like a bright child in school who grows bored if she has to mark time for duller students, Shirley rebels against too much rehearsal or fussing around. She always knows her lessons, you see, even when grown ups stumble or forget.

Mrs. Temple knows a responsibility far and away more pressing than the average mother. She is the most important of the safeguards erected about Shirley. She cannot lead the normal woman's life—shopping, bridge, puttering about the house while the kids are at school or down the block playing.

● MR. ZANUCK MUST RELY chiefly on her for protecting Shirley from any accident, for one must remember that even a tummy ache or a scratched knee becomes serious when the most important trouper in the cast is the victim.

I have often been asked if Shirley resents her safeguards. As a matter of fact, these do not intrude upon her life. The closest she ever came to questioning us was with the remark—"Why must Mr. ——— drive us, when Daddy can drive just as well?"

Other children quite naturally stand in great awe of Shirley, which makes them shy playmates. But children are adaptable; that shyness soon wears off and she will romp and tussle with other kids just as your daughter would. She likes boys, and boys' toys. A bicycle was her first choice of Christmas presents. Shirley is husky and glowingly healthy.

Which means that her diet must be watched lest she over-eat. Other children may get away with an extra piece of cake or too much candy, but Shirley can't eat more than is good for her.

Crowds are always a problem in safeguarding so famous a child as Shirley. On that vacation trip to Hawaii, the Temples took a suite which had access to a private promenade deck. They couldn't stroll the main decks because people would form such crowds that they could not move. Shirley, however, adores people and lots of 'em.

● A RULE HAD TO be made against her eating in the main dining room of the famous Cafe de Paris at 20th Century-Fox, because players and visitors simply had to touch and caress her. A near riot would start when she appeared. Accordingly she usually lunches in her dressing room, or in a private dining room at the café. One day she wanted to go through the main dining room, and turning to her mother said: "Please, can't I? I won't be 'spicuous!'"

Never for an instant do we relax our vigilance, even though Shirley takes us for granted and forgets we exist. Even a phone call to her dressing room has two connections.

Lest you think that all these precautions might be

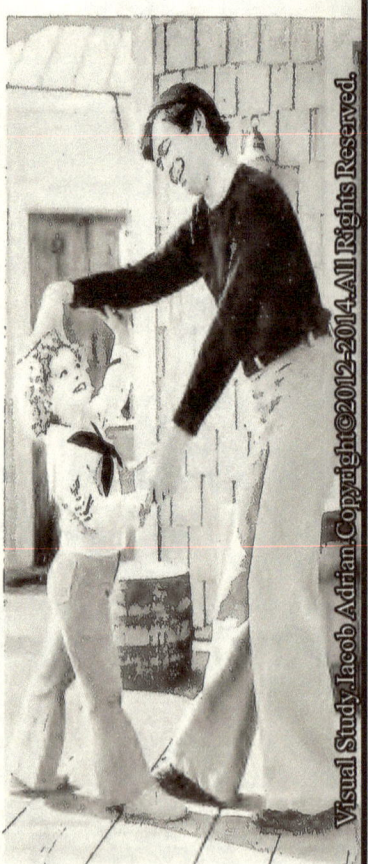

Shirley had to be nimble-footed in this sequence with Buddy Ebsen, a scene from *Captain January*. Despite careful precautions, it was difficult and dangerous

I Guard Shirley Temple

so unusual as to cause Shirley to live a hemmed in and restricted life, let me assure you that such is not the case. Precautions are the usual, rather than the unusual thing, in Hollywood, and our work of safeguarding her is accomplished so quietly and unostentatiously that she never suspects.

Hollywood, in fact, is the best protected wealthy city in the world. There have been threats, but never the successful accomplishment of a crime against a picture celebrity, other than the petty sneak thievery which sometimes results in the loss of jewels or valuables.

Each studio has its own police and detective organization, all bound together under a general group. These groups in turn are allied with the District Attorney's office of Los Angeles. Formerly, Blayney Matthews was head of the special squad of investigators assigned by the District Attorney to protect Hollywood. He is now the chief of police at Warner Brothers studio. Matthews knows more about the stars than they do themselves.

DECEMBER, 1937

What They're Filming

DANCING PIRATES
(Pioneer Pictures)

● Next big technicolor picture to make the nation color conscious will be *Dancing Pirates*, produced by Jock Whitney at United Artists, and which is expected to boost Jock's technicolor stock another notch or two. Since unfortunate *Becky Sharp*, color technique has leaped many obstacles. This film, to judge from rushes we saw, will be as warmly colored as life, escape from picture-postcard garishness. Talking with Robert Edmond Jones, Jock's color expert, we learned their plan—to match color to music. When music is soft, colors are soft; when sound reaches a crescendo, so will the colors.

Profiting also from *Becky*, the Whitney crowd has found a story of great charm and well adapted to color. *Dancing Pirates* is based on an actual happening in early California. A captured pirate was condemned to hang by Santa Maria villagers, but the alcalde, discovering the pirate's ability as a cabinet maker, offered him a job making a chest. The easy going mayor put off hanging the pirate until the chest was finished. The pirate never finished the job he had in mind, and neither did the villagers. The chest to this day can be seen—still unfinished.

From this idea is derived a plot for *Dancing Pirates*. A dancing master, accused of piracy, is permitted to live long enough to teach the mayor's daughter how to dance. Needless to say, he never decides she has learned all he can teach her of dancing—and love. This engaging romance is filmed entirely on one stage, with gorgeous fiestas to enchant the eye, many clever actors to sustain the tale.

Most remarkable feature of the cast is Charles Collins, unknown to film fans, destined to be another heart throb. He was dancing with his wife, Dorothy Stone, in New York when talent scouts nabbed him. He has that rare quality, expressed in Hollywood lingo as *umph*, more specifically as *personality*. Steffi Duna, one-time

STUDIO CALL SHEET

San Francisco (M-G-M)—Clark Gable, Jeanette MacDonald, Spencer Tracy. Nearing cutting room stage. Looks like a winner.

The Good Earth (M-G-M)—Paul Muni, Luise Rainer. Barely under way with long schedule ahead.

Princess Comes Across (Para)—Fred MacMurray, Carole Lombard, Alison Skipworth. This is the one George Raft nixed.

Mary of Scotland (RKO)—Katharine Hepburn, Fredric March go historic. Just started.

Road to Glory (20th Century)—Fredric March, Warner Baxter, Lionel Barrymore in war story. A major film nearing cutting room.

Poor Little Rich Girl (20th Century)—Shirley Temple, Alice Faye, Gloria Stuart. Long schedule ahead. Summer release.

Florence Nightingale (Warners)—Kay Francis, Ian Hunter, Donald Woods. Opening scenes look promising. Long way to go.

Dracula's Daughter (Universal)—Otto Kruger, Marguerite Churchill. Nearing completion.

friend of Francis Lederer, is the girl, and such scene stealers as Frank Morgan and Luis Alberni enrich the cast.

THE KING STEPS OUT
(Columbia)

● Grace Moore, Joseph von Sternberg, Franchot Tone and 1472 other actors have been working for weeks on this film and it's about ready to be shown you. No one has seen more than small bits of the picture; it is still in the cutting room. But the rumors run rife that here is Grace Moore's finest work and we're ready to believe it!

They did the last scene first, the first scene last. Pictures just aren't shot in proper sequence in Hollywood—for technical reasons. We want to tell you about

Most important trio at Columbia... Franchot Tone, Joseph von Sternberg and Grace Moore, filming *The King Steps Out*

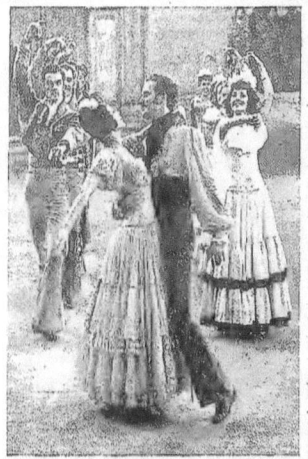

Here's an elaborate dance scene from *Dancing Pirates*, the next big Technicolor picture. Steffi Duna and Charlie Collins dance

Star Gazing IN HOLLYWOOD

by JACK SMALLEY, Managing Editor

● Two MAMMOTH BRAIN-WAVES sweep Hollywood about this time of year. It's hard to say which brings on the biggest headache—how to avoid handing everything over to the income tax collectors, or who will win the annual Academy awards.

Snows of winter are just turning to the slush of spring when the momentous announcement revealing the vote on the best this and that of 1935 is made at the Academy dinner. It is conducted at the Biltmore, while stars, directors and writers stare at their plates and try to look nonchalant.

Last year it was all very embarrassing; Columbia Studios gathered in all the four main prizes for *It Happened One Night*—Claudette Colbert, Clark Gable, Frank Capra and the studio each carrying home a gold statue.

Our Own Nominations

● IN A BENIGN spirit of helpfulness, your Stargazer has compiled his own list of awards, which so far he has neglected to mail to the distinguished Academy. Let 'em read it in HOLLYWOOD. That's if they

Here's the famous dinner scene from *Alice Adams*. Who can forget Fred MacMurray, Hattie MacDaniels and Katharine Hepburn in this picture?

have a nickel left after paying income taxes.

Best Picture of 1935
The Informer—RKO-Radio
Best Actor
Victor McLaglen, in *The Informer*
Best Actress
Katharine Hepburn, in *Alice Adams*
Best Director
John Ford, for *The Informer*

That looks like a grand slam for RKO-Radio, and if the Academy follows my advice there'll be a gold statue in every corner of that excellent studio. Bitter accusations of prejudice will be filed against me from Metro-Goldwyn-Mayer for not naming *David Copperfield*, from Paramount for failing to nominate *Hands Across the Table*, for overlooking *Midsummer Night's Dream* at Warners. Perhaps so—if they dig up my past they'll find I was one of Victor McLaglen's sergeants in his Light Horse Cavalry, that I have a wife who is hounded at previews by autograph hunters insisting she is Miss Hepburn, and that John Ford and my publisher are close friends. But that's my list and I'll stick to it.

Honorable Or Otherwise Mention

● MISS HEPBURN WON the prize two years ago, so it's hardly fair to heap more laurels on her comely head when I so yearn to see Greta Garbo get a prize just once, or witness the recognition of that superlative address, Carole Lombard. I waver, too, over the talents of Jean Harlow, who so ably portrays on the screen characters the opposite of her own. Bette Davis, most consistent performer, may be the Academy choice for 1936.

In awarding honors for acting, one should remember that simply playing yourself on the screen is no indication of great genius. Among the men who, for real *acting* rate high honors, I would nominate Wallace Ford (*The Informer*) Charles Laughton (*Mutiny on the Bounty* and *Ruggles of Red Gap*) Henry Fonda (*I Dream too Much*) William Powell (*Escapade*) Basil Rathbone (*Copperfield*) Fred Stone (*Alice Adams*) Claude Rains (*Crime Without Passion*) Fred MacMurray (*Hands Across the Table*) and Edward Arnold (*Diamond Jim*).

Other "Bests" Of The Year

● THE ACADEMY Is entirely too impersonal in its list of awards. I would give a copious number of other prizes, some of which are herewith tendered. (Applause!)

Most beloved star: Shirley Temple.
Most popular woman: Claudette Colbert.
Most popular man: William Powell.
Best host: Leo Carrillo, master of Santa Monica rancho.
Best hostess: Mary Ellis, and you must see her soon in *Brazen*.
Most alluring voice: Ginger Rogers (listen to it on the phone!)
Best combination of talents: All together, now—FRED ASTAIRE!
Most progress in 1935: Virginia Bruce (watch her this year!)
Most progress for man: Henry Fonda.
Best comedian: Jack Oakie (that goes for in films and out)
Most independent: Connie Bennett, and she won't give a hoot if I say so.
Happiest family: Paula, Carol, Dorothy and Fred Stone.
Biggest feminine thrill: Clark Gable, of course.

The Ten Best Pictures

While I'm sticking my neck out, I'll go the whole hog and name my choices for the ten best films of 1935: *The Informer, David Copperfield, Alice Adams, Mutiny on the Bounty, Lives of a Bengal Lancer, Top Hat, Hands Across the Table, I Dream Too Much, Ruggles of Red Gap, Naughty Marietta.*

And what a struggle to eliminate *Thanks a Million, The Scoundrel, A Night at the Opera,* and *Les Miserables!*

Onward and Upward in 1936!

No question remains that several young ladies will be definitely placed with the fans as toppers in 1936. Merle Oberon, for *The Dark Angel*, might even rate for the '35 awards, but certainly this year's *These Three*, film version of *The Children's Hour*, will make the name of Oberon famous.

Another girl with one fine picture, *Broadway Melody of 1936*, is headed for glory. That's Eleanor Powell. And if we are to hear much more of Elisabeth Bergner, whose *Escape Me Never* was a

Victor McLaglen did his finest role in *The Informer*. Here he's shown with Margot Grahame in a scene from that film

smash hit, doubtless she'll be up among the winners this year. Her habit of nibbling cookies, apples, or nuts in every scene didn't make her appealing to me in *Escape Me Never*.

I Told You So Department

Almost a year ago I saw the screen test of Luise Rainer, and wrote in this department: "Luise Rainer will, before very long, be a new star, adored, popular, her name a byword, her face as familiar as your own neighbor's." Those who saw her in *Escapade* with Bill Powell wrote in to agree. Now we've just seen her in the rushes of *The Great Ziegfeld*, again with Powell. Luise plays Anna Held, and once more we make the prediction—Luise Rainer is tomorrow's great star.

Fanagram Contest

Win Shirley Temple's Doll!

SHIRLEY TEMPLE offers one of her big, life-like dolls to this month's winner of the FANAGRAMS contest, and the field is wide open to everyone! Moreover, Shirley has autographed the doll personally (see accompanying photo).

If you didn't get in on last month's opening FANAGRAMS contest, try your luck this time. Here is a new and brilliant contest that is all fun and no work—a new diversion entirely free from the strain of cross word puzzles!

As we explained before, a Fanagram is an appropriate, interesting or amusing phrase created by rearranging the letters contained in the name of some movie star. As an example we cited the name of MAUREEN O'SULLIVAN, which by rearranging the letters, forms the phrase ON A UNIVERSAL MULE. No letters have been left out, nor have any been added.

Here are additional samples of Fanagrams: MAURICE CHEVALIER rearranges to read I HAVE A MIRACLE CURE. HOOT GIBSON becomes BIG SHOT? O NO! You can rearrange MARLENE DIETRICH to read I'M CLEAR IN THE RED, a fitting phrase for any movie star around income tax time. GEORGE RAFT can be changed into GREAT FORGE.

Shirley Temple's doll is going to the person who submits the entry which, in the opinion of the judges, best fulfills the potentialities of the Fanagram game. Here are the requirements:

First: You must take the phrase "In walks his troops" and re-arrange it to make the name of a movie star.

Second: You must take the names of GARY COOPER, BING CROSBY and CHARLIE CHAPLIN, rearrange each so that it makes a Fanagram just as illustrated above.

Third: Create three original Fanagrams of your own, choosing whatever names of film stars you please. (Here enters the biggest point on originality and cleverness.)

This is the contest in a nutshell—and the cleverest contestant is going to receive

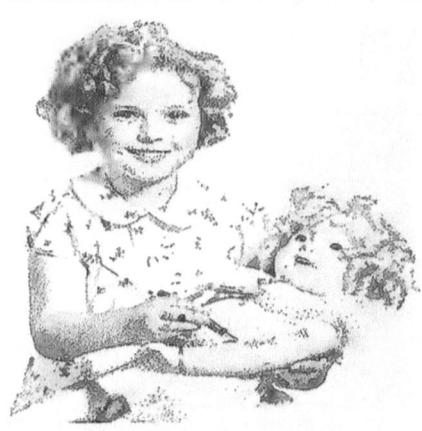

Here's the Shirley Temple doll that HOLLYWOOD Magazine offers this month, nestled in the arms of Shirley herself. Try to win it

Shirley Temple's life-size doll, autographed by her own little hand.

Remember that fancy decorations won't help you win the contest. The judges demand only neatness and cleverness. The person who does the best job of creating new Fanagrams and solving the ones given above is going to walk away with the Shirley Temple doll! There are no blanks to fill out, no complications whatever. When you have worked out your solution, mail it in to the Fanagrams Editor, HOLLYWOOD MAGAZINE, 7046 Hollywood Blvd., Hollywood, Calif.

Fanagrams was created largely as an entertaining game for your own amusement. Then we decided to add zest to the game by offering a monthly award. Play it for the sheer fun of the game, then send in your contribution. It may be the prize winner!

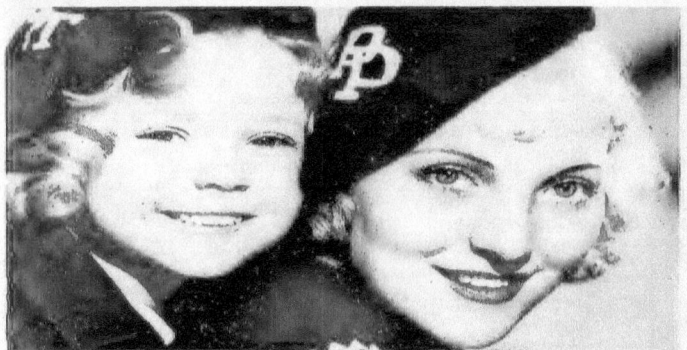

—Max Munn Autrey

The world is singing the praises of little Shirley Temple, who is seen here with Pat Paterson, since she stole the show in Stand Up and Cheer. She duplicated this success in Little Miss Marker and Baby, Take a Bow

Movieland Tour

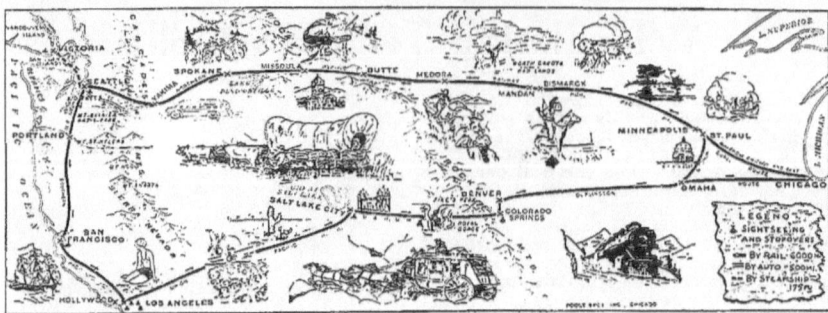

H OLLYWOOD Magazine's second hegira to Hollywood gets under way from Chicago July 19, with all details completed for two weeks of travel and sightseeing in filmdom. So popular is this plan of a Hollywood houseparty that a second group will make the same tour from Chicago starting August 9.

Idea originated when fans asked for some means of seeing Hollywood under auspices that would permit visits to the usually barred gates of studios, and at a cost within reach of the average pocketbook. From this basis the Movieland Tour has grown to include parties, banquets, and special entertainment, of which the following is but the bare outline:

Paula Stone

After crossing the country (see map) the first group of 200 guests arrive in Hollywood Sunday, July 26, and will embark immediately for Van Nuys, to be guests of Ken Maynard for a viewing of his circus. Maynard, one of the top notch cowboy stars of filmdom, is preparing a circus for a national tour. Lunch will be served from the cook wagons, and then the party will watch Ken and his circus perform. Then in to Hollywood, where luggage will already be disposed of in rooms allotted our guests at tour headquarters, the Roosevelt and affiliated hotels a few blocks from Hollywood Magazine's offices.

In the evening the houseparty goes to the famed Brass Rail for a surprise party with special entertainment devised. Here, and at all our functions, stars will be guests of honor. On Monday a trip through 20th Century Fox studios is scheduled, and Shirley Temple's home lot will take charge of our visitors. Souvenirs of the visit with famed 20th Century-Fox stars (Ronald Colman, Gloria Stuart, Victor McLaglen, Loretta Young, Rochelle Hudson, and others) are being prepared.

● FOLLOWING THE STUDIO TOUR, we'll visit the homes of the stars in Beverly Hills. Not to waste a precious moment of the Hollywood visit, the evening will be given over to a banquet at the Biltmore Bowl, rendezvous of the stars in downtown Los Angeles. Here dining and

Ken Maynard, above, will be one of the hosts on the Movieland Tour. Consult the map for a complete story of the many wonders to be seen on this annual pilgrimage

dancing to music of Jimmy Grier's orchestra, with big floor show and many stars as our special guests is planned.

Tuesday will be the highlight—a big cocktail party at the home of Paula Stone, Warner Brothers player, and daughter of Fred Stone. Paula is inviting dozens of friends to be there from the film colony, so bring kodaks and autograph books! You'll want snaps of yourself with the stars to show the home folks.

Paula is celebrating a big success in her latest Warner film—better see it before you leave. It's called *Treachery Rides The Trail*. Wednesday brings a trip to gorgeous Catalina Island, and Thursday the tour is homeward bound.

● TOUR NO. 2, ARRIVING here August 16, will enjoy the same program, except that Universal Studios, where *Show Boat*, *Sutter's Gold*, and *Love Before Breakfast* have recently been completed, will be our host. Be sure to see these films, as sets for these productions will be points of interest on the

Stars' Favorite Recipes

Try Shirley Temple's Diet in Your Home

Shirley leads a strenuous life, eats sensibly, and is amazingly free from illness! Here's why

By Dorothy Dwan

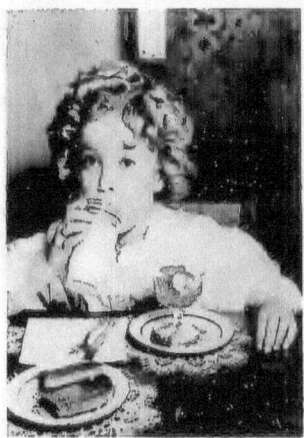

One of the first things Shirley learned to like was milk. She's always glad to get a glass of it to refresh her

"GOOD MORNING! You are Miss Dwan, aren't you?" Shirley Temple greeted me composedly. "Please come in."

It almost took me off my feet. The poise and cordiality of the child! I suddenly felt six—she acted grown up!

"Is your mother in?" I stammered, about to add Miss Temple.

"Mother is in the projection room looking at yesterday's work," Shirley told me. "I am allowed to answer the door and telephone this morning, as my lessons were perfect all week."

Miss Barkley, Shirley's teacher introduced herself, and asked if I would like to look through the studio bungalow.

Would I!—wild horses couldn't have kept me out. I was as thrilled as any one of Shirley's millions of fans would have been.

The tiny house is like the child herself—fresh, quaint, and cheerful. Dainty white organdy curtains flutter at the many windows. The furniture is white, but bears, elephants, ducks—all the animal kingdom peeks out at one from the upholstery.

As we entered the playroom, Shirley rushed over to show me a doll. "Look," she invited, shaking the doll back and forth. "Hasn't Letitia the funniest eyes?" And Letitia performed for me, rolling her orbs in a very droll fashion.

Miss Barkley explained Letitia happens to be Shirley's favorite name at present, and is her esteemed doll. "The name was Jacqueline last week," she added.

So you see, Shirley is just a little girl after all, loving dolls and the more fancy the name, the more fascinating to her.

● THEN MRS. TEMPLE arrived. One could sense immediately that she is a most capable mother and businesswoman combined. Yet, busy as she was at the moment, she was so sweet and unassuming, one felt at ease. Incidentally, Mrs. Temple has as much charm and beauty as many of our stars.

Knowing that mothers all over the globe would be interested in little Shirley's daily routine, I asked Mrs. Temple about her diet and how her hours were arranged.

"If Shirley is working in a picture, we have to be at the studio by nine," explained Mrs. Temple. "If she just comes to the studio for rehearsals or her lessons, we arrive at ten. Naturally, the time she arises is governed by these circumstances. Upon awakening, I see that she has a large glass of orange juice, as I believe any of the fruit juices are most nourishing.

"When bathed and dressed, she has her breakfast, and it is amazing how much a child will consume! There is always a cooked cereal served, also stewed fruit, milk, and now, boiled eggs.

● MRS. TEMPLE continued, "As Shirley eats nothing during the morning, she is ready for her heavy meal at noon. Usually this consists of soup, meat, vegetables, and bread and butter, not to mention a glass of milk and dessert."

"I suppose she has a light supper?" I asked. "I know doctors advise this for children."

"Soup, vegetables, a light salad, and more fruit," agreed Mrs. Temple. "At night Shirley usually has a malt drink for a change from plain milk."

During this conversation, Shirley and Miss Barkley had been in the school room tussling with spelling. It seems that morning they were on the "ing" words, and her teacher said all sixteen of them were perfect.

I asked Mrs. Temple to give me a few of Shirley's favorite dishes and the way they were prepared so I could pass them on to you.

BAKED BANANAS

Peel the bananas, cut lengthwise, and place in buttered casserole. Sprinkle with a little brown sugar and pour a tablespoon of water for each banana over them, and a little lemon juice. Bake in a moderate oven until a golden brown.

BLANC MANGE

½ cup cornstarch
¼ cup sugar

AUTOGRAPHED RECIPES FROM THE STARS

Looking for something different in food for the dinner table? Well, here you are—write now for the kitchen tested recipes, printed—like all our leaflets—on a punched leaflet to fit a standard collegiate notebook!

Here's your chance for a modern file of the very finest recipes. Select one or a dozen, and enclose the necessary cash. Remember, the recipes are all tested by Anna Belle Lee, noted home economics expert in the Hollywood Citizen-News building!

Mona Barrie's Favorite Soups	5c
Tuna Recipes from James Cagney	5c
Leftover Surprises from Sally Eilers	5c
Mae Clarke's Favorite Cakes	5c
Adrienne Ames' Apple Recipes	5c
Raquel Torres' Mexican Dishes	5c
Heather Angel's Salads	5c
Andy Devine's After Dinner Snacks	5c
E. G. Robinson's Honey Cakes	5c
Margaret Sullavan's Tasty Puddings	5c
Raisin Recipes from Noah Beery, Jr.	5c
Pinky Tomlin's Favorite Hot Breads	5c
Valerie Hobson's Casserole Dishes	5c
Cottage Cheese Delights from Binnie Barnes	5c
Savory Ham Dishes from Gloria Stuart	5c

Address your letters to Dorothy Dwan, Hollywood Magazine's Food Editor, 7046 Hollywood Blvd., Hollywood, Calif. NO LETTERS ANSWERED UNLESS A STAMPED AND ADDRESSED ENVELOPE IS ENCLOSED!

Shirley Temple loves gag pictures! Note here how she fits in the spirit of the thing—waiting for the hen to lay an egg so she can fry it!

Tim McCoy is another who is well liked over here. He is called "McCoy" by the boys and "Tim" by the girls. Tom Tyler is becoming a favorite.

Most of the boys over here have read Zane Grey's books and loved them, but they are utterly disappointed when they see a Zane Grey film, for the simple reason that it is not like the book.

So will some man who understands the west with all its glory, its forests, its mountains, please make a western and please us all?

But before I close, I want to give a vote of thanks to those who keep on riding, no matter what rotten stories they get.

Adios,
 D. Hoath,
 Portland Road, East Grinstead,
 Sussex, England.

• •

Keep The Songs New?

Dear Editor:
When I go to a movie I want to get new ideas and new songs. Lately, it seems that every time I go to the show, the songs are the same ones that have already been played to death. They are the same tunes that we hear over the radio a dozen times a day. Isn't there some way to prevent the songs from being old and worn out by the time the picture gets to town? I wonder if other moviegoers object? Does it take away or add to the enjoyment of the picture—for others? I'd like to know how other people feel about this situation.

In all sincerity,
 Nancy Jo Cotton,
 1504 Georgia Avenue,
 Tampa, Florida.

• •

A Rose—But No Posies

Dear Editor:
A rose by any other name still smells. So do western pictures, and *Rose of the Rancho* is just a dressed up horse opera. I was terribly disappointed in it because I expected so much of Gladys Swarthout—and she never had a chance. And although Willie Howard is funny, he certainly was a jarring note in the film. There is no use commenting on John Boles. The point is, can't all three of these people do much better if given half a chance?

 G. M. G.,
 Tulsa, Okla.

Paramount worked overtime on *Rose of the Rancho* trying to save it from obvious distress. The picture was considerably improved in the cutting room, but struck a psychological snag: audiences everywhere expected something sensational with Swarthout's screen début and the story simply did not have enough for the "hit" ranks.—Editor.

A Welcome For Janet—and Bob

Dear Editor:
I was glad to read in HOLLYWOOD Magazine that Janet Gaynor is soon coming back to the screen. She has always been one of my favorites and I know lots of others feel the same as I do about her return. So I guess it's a "lucky accident" for us all that she fell on her head and thereby got better screen roles.

Sincerely,
 Margaret Lewis,
 Boston, Mass.

• •

Dear Editor:
I see in Mr. Smalley's story that Bob Taylor will play opposite Janet Gaynor. Hooray! I think he's one of the finest young actors on the screen. He is my very, very favorite since *Magnificent Obsession!*

Sincerely,
 Mildred Sumosky,
 Cleveland, Ohio.

Bob Taylor's rise to screen prominence has been one of the most remarkable developments of the last six months. At M-G-M hundreds of letters arrive each day from devoted Taylor fans, and already the studio is making plans to advance Taylor to highest stardom.—The Editor.

• •

Praise For Lovers

Dear Editor:
Next Time We Love, to my mind, was a magnificent picture. I was particularly pleased with James Stewart, since I had never before seen him on the screen. I think he has a great future. One cannot praise Margaret Sullavan too highly for her acting. She has an astonishing personality and a naiveté that is most pleasing.

 Randall Jones,
 Chicago, Ill.

• •

We Knew This Was Coming

Dear Editor:
Who said Joan Crawford was stuck up? We "fair and stormy weather" fans deny this without a second's hesitation. You large number of "finder faulters" need a good kick—yes, out the front door.

Joan, the envy of every feminine movie fan since her marriage to Franchot Tone, is naturally the target of numerous sarcastic remarks. It isn't fair! Feature yourself the new bride of your "dream man." You'd rather spend your time doing things of no interest, would you? Of course you wouldn't! Then why criticize our innocent Joan?

 Mary Wilcox,
 Elysian, Minn.

WIN MARGARET SULLAVAN'S WEDDING RING

Hollywood

5¢ a copy

JUNE

5¢

Natural Color Photo of **SHIRLEY TEMPLE**

IS SHIRLEY TEMPLE A POOR LITTLE RICH GIRL?

Hollywood Newsreel

Bon voyage on the ship of matrimony! Jack Oakie plants a kiss on Venita Varden, the gal who put him on the water-wagon—and kept him there. They were married when the train reached Yuma

Marjorie Lane, the little lady in white, sang at the Trocadero until M-G-M gave her a contract! She's shown with Allan Jones and his girl friend, Irene Franklin, who is said to be wearing a *special* ring....

FAN MAIL COSTS Dick Powell $480 a month for postage, to say nothing of his time, stationery and stenographic fees.... Buster Crabbe has purchased a Lake Arrowhead apple orchard as a site for a boys' school.... Blonde Marion (opera star) Talley has gone red-head for her rôle in *My Old Kentucky Home*.... Ethel Merman has within the last three months tapped the stock market for sufficient profit to keep her in luxury the balance of her days.... W. S. (Woody) Van Dyke, now Hollywood's highest salaried director, began his movie career as messenger boy for David Wark Griffith when the latter was megaphoning *Intolerance*.... Kay Linaker's favorite sport is fencing.... Glenda Farrell sheds her golden tresses and becomes a "brownette" for her next rôle.... Edward G. Robinson inhales twenty-five cigars a day when he's emoting, cutting to twelve when he's between pictures.... Robert Taylor is taking swimming lessons from Johnny (Tarzan) Weissmuller.... Dolores Del Rio and hubby, Cedric Gibbons, will house-guest it under U. S. Ambassador Ruth Brian Owen's embassy roof while they're in Denmark.... Leo Carrillo spent two weeks on tour with Tom Mix's circus, donning a clown's make-up twice daily.... The Donald Woods are expecting.... James Stewart's hobby is collecting model airplanes.... Anita Louise is left-handed in everything except writing her name.... Fred Keating, a crack pianist, plays only by ear....

• •

Gifts Come To Shirley

WHEN LORD AND LADY CAVENDISH (Adele Astaire) took their departure after a sightseeing sojourn in Hollywood, they dispatched a costly jeweled clasp to Shirley Temple, who had won their hearts during a luncheon at 20th Century-Fox studio. "Isn't it beautiful!" gasped the curly-topped star as she opened the package.

Two days later, however, came a gift from Texas' chief executive, Gov. James V. Allred, including a document commissioning Shirley as a member of the Texas Rangers and the gold badge that goes with the honor.

"That's the most beautiful thing I ever saw," commented Shirley as she fondled the emblem of authority. Then turning to her mother, she handed her the Cavendish clasp.

"You better put this away for safekeeping," she told the mater. "I think I'd rather wear this badge!"

• •

Elegance To Return

ADOLPHE MENJOU, whose sartorial elegance has long decorated the screen, will soon return to his public. Menjou's career has been interrupted frequently by illness; a few months ago he suddenly underwent a major operation. Doctors now pronounce him cured.

• •

Isabel's Secret Fear

Isabel Jewel, notified by a Cairo shipping firm that a huge crate is en route to her, does not appear to be overly-anxious to see the cargo. Indeed, she appears a bit apprehensive.

Not long ago Isabel took Englishman John Philip Romleigh on a tour of Paramount studios just before he sailed for Egypt.

He asked if he could repay the favor by sending her some little memento from the land of restless sands. Flipped Jewel: "Sure, send me a camel."

Hollywood Newsreel

More fun than fishing! Homeward bound, the crowd contented itself with tall stories. From the left: Capt. Bob Oeffinger, Evalyn Knapp (hostess of the day), Editor Ted Magee of HOLLYWOOD, Editor Eric Ergenbright of MOVIE CLASSIC, Paul Kelly and Mrs. Kelly.

Burglars Take Warning

RISING FROM A HILL in Brentwood, a suburb of filmland, Irene Dunne's new home will have every modern development including adequate magic eye burglar alarms. Lovely Irene, one of the most reticent persons in Hollywood, nevertheless has been something of a favorite with burglars. Since coming to Hollywood she has been held up twice, had her home robbed once.

• •

Barn Dance Favored

PALM SPRINGS, the small metropolis of the desert, boasts plenty of varied night life, including hay rides and steak suppers of the old fashioned sort. Lured by the fun of barn dances were such personages as these: Constance Talmadge, Townsend Netcher (her husband), Clara Bow and husband Rex Bell, Robert Woolsey and Amos 'n' Andy.

• •

Pons vs. Moore

JOYS AND GRIEFS of stardom are all in the point of view, Lily Pons, Metropolitan warbler, suggested almost simultaneously with Grace Moore's temperamental outburst on cows and music. The latter diva, you may recall, was burned over the necessity of milking a cow all day while singing a tune in her new picture. Grace intimated she could get along without Hollywood if such things were necessary.

Spoke up tiny Lily: "I am asking your Uncle Sam to make me a legal citizen of the United States. Gradually I shall retire from grand opera and devote all my efforts to the films. The talkies are harder work than opera, but much more fun!"

He was mistaken for Will Rogers so often that A. A. Trimble, Cleveland map salesman, was urged to appear in M-G-M's *The Great Ziegfeld* as a tribute to the comedian.

ON THE COVER

This month's natural color photo of Shirley Temple, made by Edwin Bower Hesser, portrays with utmost fidelity the charm and simplicity of the child star.

Shirley wanted to hold a vagrant cat in her arms for this picture, but the feline failed to appreciate the signal honor and simply would not hold still. Shirley's next choice was a bouquet of flowers which she carefully selected herself.

Mr. Hesser took three pictures of Shirley and all proved perfect. He gave all the credit to the little star who knows more than many an adult about correct pose for "still" shots.

HOLLYWOOD SPOTLIGHTS

Lovely Marlene Dietrich's stock has soared in the wake of her fine work in *Desire*. She'll do *Garden of Allah* next for Selznick, then go to England for one film

Freddie Faces Fate

THE SMOKE OF LEGAL BATTLES over little Freddie Bartholomew makes the young star heir apparent to the title of Poor Little Rich Child provided it doesn't go to Shirley Temple (see page 28.) When Freddie was too small to care, his mother vested the legal guardianship of the child in Millycent Bartholomew, his aunt.

The years, proving good to them both, brought happiness and contentment to little Freddie, kindly Aunt Millycent. Coming to America, Freddie gradually developed his acting genius under her care. Now, with the child old enough to be nearly Boy Scout age (twelve), mother Lillian May Bartholomew opposes final guardianship papers.

Things Hollywood did not consider favorably: (1) rumors that the whole Bartholomew clan might migrate from England to filmland; (2) Lillian May's sensational disappearance for a week after reaching the U. S.; (3) any court order that might go against Freddie's own wishes.

How Gable Slays Them!

LEO CARRILLO TELLS us something interesting about Clark Gable's shooting prowess. Gable, as you may have heard, has something of a reputation for hitting the bull's-eye when he lifts a gun.

Recently he and Carrillo went duck hunting. They regarded themselves as pretty evenly matched when they started out. They came back with an equal number of ducks. But all the same, Carrillo thinks Gable had an unfair advantage.

"All I got were male ducks," Carrillo said. "And I had to shoot practically perfect to nail them. But Gable—ah, that man is lucky! All he had to do was stand there and show himself. And all the lady ducks came squawking right over in front of the fellow. He couldn't have missed them with a sling shot!"

How's that for putting your charm to work?

Old Hat Still Fits

ONE OF THE MORE cheering of the recent Hollywood tales revolves around Fred MacMurray, whose rise to screen fame—and popularity—has become the sensation of the last twelve months.

Studio executives seeking to show Fred all possible consideration, took him to look at the lot's prize dressing suite—a suite constructed for Pola Negri, remodeled for Clara Bow and renovated and enlarged again for Sylvia Sidney.

Fred strolled through the spacious quarters, including living-room, dining-room, dressing-room, kitchen and bath. The chieftains breathlessly awaited his comment. It came:

"Thanks a lot," he said, "but I'm an actor, not a social butterfly. If you don't mind, I'll stay where I am!"

And with that the star hied himself up two flights of stairs to the cubby-hole that has been his since the day he arrived in Hollywood!

Groucho in Name and Fact

So YOU THINK the professional comic fairly drools with a sense of humor! Listen to this.

A newspaper reporter was sent out to the studio to interview Groucho Marx. Groucho, in the event you scramble 'em, is the one with the black mustache and big ceegar. Arriving at the studio late in the afternoon he was told that Groucho would see him at home.

"Wait a minute, though," exclaimed one of the publicity men. "You look quite a bit like Groucho yourself. Suppose we have the make-up man make you up as Groucho before we go over."

"Okey doke with me," quoth the scrivener, "if you'll do likewise. There's that mad look of the Groucho on your pan, too."

So off the two dashed to that department where miracles occur, whence they departed half an hour later looking for all the world like Groucho and his twin.

They rang the doorbell of the comedian's home. Mrs. Marx met them in the hall and immediately waxed hysterical.

The publicity man entered the library, where Groucho awaited. "What's the meaning of this?" he demanded, without the trace of a smile.

Already feeling rather foolish, the interviewer went in. "You'll have a hard time getting that mustache off," Marx told him, glumly. "What's the idea?" he asked. Groucho may be able to dish it out . . . but apparently he can't take it. Such a prank would have been greeted by the majority of comedians with a hearty guffaw and chortle, but apparently Groucho Marx doesn't always travel with the sense of humor he is supposed to possess in goodly measure.

Sew? Certainly! The star of *Poor Little Rich Girl* learns fast, but still she hasn't learned that she *is* comparatively rich

Acting has never been work for Shirley. It's all just a game to her. Therefore her playmates treat her as a regular pal

Shirley likes her dolls, like any other normal youngster. Here she plays with her Shirley Temple doll named "Sweetness"

Is Shirley a Poor Little Rich Girl?

by KATHARINE HARTLEY

Shirley never lacks things to do. When she isn't playing with other children, she's apt to be tending to her knitting, aided by Michael Whalen

IF SHIRLEY TEMPLE had never seen a movie studio . . . if she had never drawn a salary . . . if her closet weren't full of adorable dresses . . . if every mail weren't laden with presents . . if her weekly earnings weren't close to $4,000 . . . still Shirley Temple would be the richest little girl in the world!

Her wealth is a wealth that can't be measured in dollars and cents. It's a strange and wonderful kind of wealth: it can't be dissipated, it can't dwindle. The more she spends of it, the more she has! It's happiness, of course—the kind that comes from an abundance of love, and sweetness. It shines in her eyes, glows in her skin, tinkles in her laugh, and overflows her heart. As anyone who knows her will tell you: Shirley Temple is the happiest little girl in the world!

But why shouldn't she be? you ask. She has everything she can ever need or want for all the rest of her life! Yes, but believe it or not, those things mean nothing to Shirley. Except for the five dollars she gets every week—four of which she spends on gifts and "treats"—she doesn't even know what money is! Once when she held a five dollar bill in her hand, she said:

"Is this my salary, Mummy?"

"Oh, no, you make quite a bit more than that, but Daddy is saving the rest for you so you'll have it when you grow up."

"Will it be a lot?" Shirley asked.

"Quite a lot! Why do you look so worried?" "Because will it be enough for me to buy a vegetable market? That's what I want to know!"

"Oh, yes! Yes, I'm sure there will be

A Poor Little Rich Girl

enough for that," said Mrs. Temple, smiling. And Shirley looked so relieved!

● ALL THAT WAS A MONTH or so ago when Shirley looked forward to making vegetables her life career, and to being a vegetable woman. There was one she liked very much at the market where the Temples shopped. One day Shirley watched her, with her green sprinkling can, watering the purple beets and the yellow carrots and the crinkly lettuce and the little red radishes—and right then and there Shirley knew that that was what she wanted to be!

The vegetables smelled so good and fresh, like field flowers, and they were such pretty colors! And Shirley loves colors—gay ones best of all, and especially red. Also, if she were a vegetable woman, then she could always save the freshest vegetables specially for her mother.

Of course this phase has passed by now, and more recently Shirley has decided to become a hair-dresser.

Watching one evolve a new coiffure for Alice Faye the other day, Shirley was overcome with this new and more artistic ambition!

She's as simple and unaffected as that. And as naive. And so, if you have visions of her flipping through magazines and pointing to first a Rolls Royce and then a Castle on the Rhine and then a pony and then a dog cart, and so and on, saying "I'll buy that someday, and that, and that, and that!" then you can just take your visions right back and save them for some other, more precocious, more materially-minded young star. Shirley just hasn't the least idea of what millions are!

● OF COURSE, NO FOND UNCLES and aunts and no doting parents ever showered more gifts on a child than fans have showered on Shirley. The children of Tillamook sent her a prize-winning calf. A little boy in Belgium sent her a real Belgian hare. From Switzerland came a trained Saint Bernard. From Ireland enough Irish lace to trim an entire trousseau and edge all the linen in a hope chest. From China, dolls. Dolls from every country of the world, as a matter of fact. Yet these gifts don't come first in Shirley's heart—not by any means.

Last Christmas Eve afternoon, the Temple car was parked in front of one of the executive bungalows on the 20th Century-Fox lot, and parked on the running board was Shirley. "Hi, Shirley, what did you get for Christmas?"

"Oh, lots of nice things, I guess. Of course, I don't know for sure. I haven't opened anything yet. But look!"

She pointed, and I looked inside the back of the car. The seat was completely snowed under with red, white, green packages. "But why *don't* you open them? At least some of them?" I was remembering my own early Christmases, and couldn't imagine why it hadn't been done before!

"Well, I don't feel like it right now," she said apologetically. "Oh I know they're nice and all that, but I just wouldn't like them now. You see one of my bunnies is sick. He has to be fed every three hours and we're late now. And if Mummy doesn't hurry pretty soon, I don't know what might happen." And then I saw that her little forehead really was wrinkled,

The man behind the glasses is Robert Riskin. Of course you recognize the fair lady as Carole Lombard. They're hurrying to the Riviera to watch the polo games

and that her eyes were anxious and worried. "Oh I do wish she'd hurry!"

● THERE, THAT'S SOMETHING for the believe-it-or-not man! A six-year-old to whom a sick bunny means more than Christmas presents!

But then everything is "believe-it-or-not" about Shirley. Out here, we who know her often wonder how much of what we write about her is really believed, and how much is tossed off as just hooey! We admit that on paper she sounds almost too perfect.

Not long ago I went on to the set to see Mrs. Temple about plans for Shirley's seventh birthday. As we talked Shirley had her nose buried in a drawing book some few feet away, and apparently wasn't listening at all. But in the course of the conversation, I happened to mention that Harry Brand, head of the publicity department, was celebrating his birthday that day.

Then, a half hour later as I started back for the publicity department, where I had left my things, Shirley thrust a piece of paper into my hand, gave me a big wink, and said, "Please, will you leave this for Mr. Brand?" and skipped off. After I got back to his office, we unfolded the paper, and there in precise, inch-high letters we found the laboriously pencilled words:

Happy Birthday to Mister Brand,
with love
from his little friend,
Shirley.

What better proof of her innate, unprompted thoughtfulness!

● A FAMOUS WRITER ONCE SAID that there were really only two kinds of people in the world: those who give, and those who take. Shirley is definitely of the first category. So many children have to be entertained every hour of the day ... so many are always begging and whining, making exorbitant demands for attention. And usually movie children, more than others, are guilty. That's because they know they're important ... they sense that they're breadwinners, and they're sure they can get what they ask for! Yet Shirley makes no demands, ever. Her happy disposition is a part of her great wealth. She never cries or whines or begs or argues about anything.

We all know people who sit back and say, "Now make me laugh!" But Shirley is the one who leans forward and does make you laugh! She is a natural born little hostess, and adores gathering her friends and co-workers around her, even if only for a tick-tack-toe game on the set. Not because of any selfish desire to be entertained herself. But because she wants them to enjoy her game too!

● DURING THE LAST TWO YEARS, the years of Shirley's screen fame, I have only known her to become perturbed twice—neither of these perturbances could in any way reflect on her own sweet, sunshiny disposition. Both of them had to do with—you should have guessed this!—with her beloved rabbits. Once someone slighted them with some disparaging remark. Again the gardener or somebody gave them the wrong kind of food and made them sick—and on both occasions Shirley was mad and didn't mind saying so! Why not, and who could blame her? It was quite a righteous kind of indignation!

Another thing. Unlike the poor little rich girls of fiction fame, who have all the material advantages but very few friends of their own choosing, Shirley makes friends where and with whom she pleases.

The rumor that she is not allowed to mix with "ordinary" children of her own age is entirely false and foolish. Mary Lou, the little girl who stands in for Shirley on the set, may be just a stand-in in the eyes of the other players in the picture, but as far as Shirley is concerned, she is her playmate. All of picture making is just one grand and glorious game to Shirley, and when she's in front of the camera, then it's just her turn to play, and when Mary Lou is called upon to pose for the lighting, then that is Mary Lou's turn! No question of star and stand-in there!

Then there are the playmates she meets at Sunday School, and the little friends she has known all her little lifetime at Santa Monica. And Shirley also has three "best friends" in the Harold Lloyd children. When she isn't working she spends many of her afternoons there.

Still, all in all, Shirley does seem to prefer most grown-ups to most children. But that is only natural. She is more at home with grown-ups. The grown-ups she knows don't stare at her as children do.

Incidentally perhaps you have wondered, as I did, what Shirley's reaction is when people stare at her as they are bound to do everywhere she goes. Mrs. Temple tells me that when Shirley first asked her about it, she explained it this way: "They look at you, darling, for the same reason that you like to look at a pretty flower, or another nice little girl.

"You enjoy looking at something or somebody who is always sweet and good. People know that you're trying to be a good little girl—and that's why they like to look at you." Now Shirley doesn't ask it any more. Staring people no longer

JUNE, 1936

We thought we knew him despite his attempts to pass incognito. It's Al Jolson's and Ruby Keeler's attractive little youngster

Hollywood Newsreel

Awaiting their turn at the microphone... Claudette Colbert and Jesse L. Lasky had ringside seats for the South American radio broadcast in which they participated

An unusual group candid camera shot! Jackie Cooper, Jeanette MacDonald, Jack Oakie, Jean Hersholt and Fred MacMurray ...Jeanette rolls her hose... Oakie sneers

upset her. She thinks of them as friends who appreciate how hard she is trying to be good.

● YET IF YOU HAVE ANY IDEA that Shirley's "goodness" is forced on her, or that she is motivated entirely by parental or studio "do's" or "don'ts"—then that is an error too. "Don't" is one word that isn't in the Temple vocabulary.

If Shirley wants to do or eat something (the latter is most prevailing!) then Mrs. Temple reasons with her, and merely suggests something else. I have often heard Shirley say, "I was going to do so-and-so, but Mother had a better idea!" And she will be just as enthusiastic about Mother's new and better idea as she was originally about her own. Except on one occasion which comes to my mind:

It was while they were making The Littlest Rebel. In one of the earlier scenes of the picture, Shirley, and several other children had to eat ice cream. Of course "had to" isn't quite the right phrase for it. They were adoring it. But after the second "take" Mrs. Temple suggested that from then on Shirley should only pretend to eat the ice cream. Shirley was only luke warm about that suggestion. But she obliged.

Incidentally, part of her allowance every day is spent on one bottle of soda pop or some other such drink—yet Shirley never drinks more than half the bottle. Another one of Mother's suggestions which she has adopted.

Shirley's greatest wealth is in her abundance of talent, however. Not only is she a natural born actress, but she has a great love of music, and a real flair for drawing. Then, too, she is studying French and Spanish now, and making great headway with them. These are the talents that will carry her along to success in almost any field ... if and when she does leave pictures as its most famous child star.

About most child stars you can say, "But how terrible when they are not child stars any longer!". That can't be said of Shirley. There will never be any such terrible time for her. Even if she does outgrow her youthful stardom, she will keep on finding happiness in anything else she might do.

More than that, she will keep on *giving* happiness. She can't help it. It's that kind of wealth! And that's why Shirley can never be classed as a poor little rich girl. She's just a lucky youngster having the time of her life playing, scarcely aware that she is getting rich doing it!

JUNE, 1936

Life Loses Its Quest

CHECK OF RECENT studio orders governing outside activities of the more important players while they are "on call" for picture duties reveals the talkie capital as the home of don't-do-it.

Here are a few of the more recently applied check-reins:

Warner Baxter must forego hunting trips on which guns and ammunition are carried, Errol Flynn is ordered to stay off jumping horses, June Lang is not permitted to travel via air, Shirley Temple and Alice Faye must stay out of the sun to safeguard their blonde beauty, John Boles must give up speed-boating, Victor McLaglen may ride only on bridle paths and must hold his mount to a walk.

For Men Only!

CLARK GABLE'S extensive preparations for continuance of his current bachelorhood have failed to dampen ardor of the Hollywood chatterers, who persist in weaving a romance around his friendship for Carole Lombard, whom he squires to spots where the lights are brightest.

Wearying of life in the cramped hotel quarters that have been his since his separation from Ria Gable, the big fellow has taken a long lease on a six-room place in the Brentwood sector, which he is converting into a male paradise, with guns and fishing tackle supplying the decorative motive, and sans any feminine touch whatsoever.

Baby Marie Comes Back

GINGER ROGERS, hearing that a small part was about to be cast, went to the powers-that-be and asked that the rôle be assigned her stand-in, Marie Osbourne.

For two hours she argued, and finally won her point. Against her flowery oratory even the hard-boiled officials were forced to give in. And so, Baby Marie Osbourne is embarked for the second time on a screen career. For Ginger's stand-in is the former baby star, the Shirley Temple of her day.

Finders No Keepers

IN HOLLYWOOD, WHERE big money usually brings thoughts of millions, it is understandable that few people heard of a $29,000 cash loss.

Nevertheless, Ernst Lubitsch, up-again-down-again producer, discovered in sudden alarm he had lost a wallet containing that sum of currency. A short time later a U. S. employee in the Revenue department found the wallet, nearly swooned over its contents. Back to Mr. Lubitsch went the missing money, but no reward was paid.

Had this occurred in Iowa, Producer Lubitsch would have been forced to part with $2,900, in accordance with Iowa's 10 per cent reward statute. Validity of the state law was upheld only recently by the U. S. Supreme Court.

Has-Beens and May-bes

WM. S. HART'S court victory over United Artists may ultimately bring him $85,000 ... he spent $300,000—his entire personal fortune—making his last picture in 1925 ... Bill Robinson, re-signed by 20th Century, must also coach Shirley Temple in four dance routines for her

FAN MAIL

20th Century's younger set gathered one night for a party. We snapped this picture of Alice Faye, John McGuire and diminutive Dixie Dunbar at the festive board

Where Do the Writers Cash In?

Dear Editor:
Something has bothered me for years. I never thought it was any of my business before, but now that I am determined to become a writer, I feel that I must ask my question.
How do writers for movie magazines get paid? Does the star pay them? Or does the writer pay the star? Or does the studio pay? Or does the magazines pay?
Please don't think me a nit-wit—others I have talked to are as much in the dark as I am.
Grace Larson,
Bellham, Wash.

The magazines pay the writers. The stars, through the publicity department of the studio, gives the interview to the writer. They do not charge for such an interview because they are only too happy to permit their readers, through the fan writers, to know more about them.

• •

Not Temple Tempered

Dear Mr. Magee:
I agree with you and all the writers and publishers and editors who tell the world over and over again that Shirley Temple is NOT being a spoiled little girl. And no doubt, it has taken the place of the "Santa Claus won't come" bribe in order to get little children the world over to be good.
But, Mr. Editor, I'm grown up! And I get plenty tired of hearing that Shirley Temple is NOT spoiled. If you must fill your magazine with children, can't we please have a change of diet? Tell us a bit about Freddie Bartholomew, Jane Withers, Cora Sue Collins, Spanky McFarland, Eddie McManus, Sybil Jason—or that beautiful little girl that played in "Alias Mary Dow."
Yours in patience,
Patty Drane,
Spartanburg, S. C.

• •

The First Barrymore

Dear Mr. Magee:
When are we going to have a big, big story on Lionel Barrymore? Year after year he turns out about him. The studios, and the magazines too,

I guess, just seem to take it for granted. What does he have to do to get a story—make a flop?
The papers are full of Ethel, John and Ariel, and they can't hold a candle to Lionel when it comes to acting—either on or off the screen. I admit he isn't flashy, doesn't get into trouble or make scenes off the screen, so maybe he isn't good copy, but I'll bet he'd be grand reading, so bow about it?
John Huhert,
Elheron, N. J.

Correct you are! Mr. Lionel Barrymore has yet to give an inadequate screen performance. On the stage, he was always considered "the Third Barrymore" but he is now the "First Barrymore" of the screen.—The Editor.

• •

A Club for Hollywood

Dear Editor:
I thought you might like to know that I belong to a club here, called "Hollywood Magazine Club," and every month, each member of the club must read Hollywood Magazine from cover to cover and report on a story which appeared there. It's swell fun!
In that way we thoroughly cover the magazine, carefully criticize every feature of it.
Jennie Garr,
51 Rockwell Ave.,
Long Beach, New Jersey.

Thank you, Jennie Garr, and all your fellow members for your interest in HOLLYWOOD Magazine.—The Editor.

• •

Horrible Horror

Dear Editor:
Why cannot horror films be made with the same serious care as the other kind? The present system of heaping one absurdity upon another, and thinking nothing too nonsensical, is only treachery to the canons of art. Horror story writers agree that to write such a story requires the highest genius and technical skill and I can see no reason why this rule should not apply to film production.
Let us have more subtlety and restraint and then these films will really do what they promise, instead of the most perfect of performances and yet no stories

Brief Guide

best. You'll love Guy Kibbee. Slim Summerville.
Desire—(Paramount)—Bogs down in spots, but all in all proves grand entertainment with Marlene Dietrich and Gary Cooper stand-outs.
Strike Me Pink—(United Artists)—Eddie Cantor fans will consider this his best one. Fun in an amusement park.
Every Saturday Night—(20th Century)—Family stuff—the same thing that happens in your own home—only here it is great entertainment.
Follow the Fleet—(RKO)—Ginger Rogers and Fred Astaire continue their hit parade. Swell songs, swell dances, and a new discovery named Harriet Hilliard who will catch your eye.
Just A Girl—(G-B)—Meet Jessie Matthews, the new British sensation, in a girl-imitates-boy rôle.
Ceiling Zero—(Warners)—The best Cagney-Pat O'Brien film in ages. Funny, dramatic, dynamic. Pretty near sensational.
Passing of the Third Floor Back—(G-B)—Conrad Veidt deftly handles the rôle of the Stranger who straightens out tangled lives.
Rendezvous — (M-G-M) — William Powell, Rosalind Russell in a World War spy story.
Frisco Kid—(Warners)—James Cagney, Margaret Lindsay, Donald Woods in a Barbary Coast story.
O'Shaughnessy's Boy — (M-G-M) — Wallace Beery and Jackie Cooper pluck at your heart strings in a circus picture.
Barbary Coast—(United Artists)—Miriam Hopkins, E. G. Robinson and Joel McCrea in a thrilling Barbary Coast yarn.
Big Broadcast of 1936—(Paramount)—Oakie, Crosby, Roberti, Burns and Allen broadcast. You just listen and applaud.
I Live My Life—(M-G-M)—Joan Crawford glistens. Brian Aherne and a swell cast add to the fun.
Shipmates Forever—(Warners) — Annapolis story with Dick Powell and Ruby Keeler. You may be a little tired of the song by now.
The Clairvoyant—(G-B)—Claude Rains in the title rôle joins with Fay Wray to make this a superior seer picture.
Ariane—(British International)—Elisabeth Bergner scores a triumph. The problem: marrying a kept girl.
The Crusades—(Paramount)—Henry Wilcoxon, Loretta Young and a grand cast in a DeMille spectacle.
Three Musketeers—(RKO)—Presenting Walter Abel in a new interpretation of the famous classic.
She Married Her Boss—(Columbia)—Claudette Colbert, Melvyn Douglas, Edith Fellows in a rollicking film.
Dangerous—(Warners)—Franchot Tone and Bette Davis co-star in a marvelous love story.
Littlest Rebel—(20th Century)—Shirley Temple captures the film as usual. Secondary honors to John Boles, Jack Holt, Bill Robinson.

Here's one British star you are going to hear a lot about! Madeleine Carroll's American debut will be in *The Case Against Mrs. Ames*, with George Brent

Hollywood Spotlights

Margaret Sullavan: An Armbreaking Interview

WE HAVE BEEN intending for a long time to have a heart to heart talk with Margaret Sullavan, whose delightful madness makes *The Moon's Our Home* one of the more appealing pictures of the season. And by that we do not intend to slight Henry Fonda, her ex-husband, who played brilliantly the leading male rôle. This simply isn't Henry's story.

As a matter of fact, we should like to have discussed this Fonda business with Miss Sullavan, but by the time we had finished our interview with her, it seemed wise and proper we rather ignore the ex-husband business, and the current rumor that Henry is still very madly in love with our fair star.

Margaret's sudden separation from William Wyler, whom she married after she and Henry decided it was no go, probably has had a lot to do with current gossip. In any case you can safely wager your mortgaged home Margaret simply won't talk about such things.

We waited for an auspicious moment to approach irrepressible Margaret, decided that the present time was logical and safe. You see, she is carrying around a broken arm in a sling, the result of some tomfoolery on the set and a stubbed toe.

● IT WOULDN'T BE MARGARET SULLAVAN if the broken arm mended without incident. And of course, it hasn't. For instance, the doctor has just finished lecturing her regarding a narrow escape at a preview a few nights ago. Margaret insisted on attending the affair despite her arm-in-sling condition. Regardless of all precautions, she was jostled around by the crowd. Result: the cast was broken but her injured arm escaped with only minor damage. She is behaving herself in slightly better fashion now.

Incidentally, her injury completely stopped production on *I Loved a Soldier*, a sort of jinx picture ever since its first version in 1926. At that time Pola Negri starred in the film, under the title of *Hotel Imperial*. In the middle of production Rudolph Valentino died; Pola fled the set and rushed east to his bier. Then, a few months ago, Marlene Dietrich began doing the new version, walked out on the studio after two weeks of shooting. Margaret's arm break completed—we hope—the cycle of ill luck.

● AND SO IT CAME TO US that this, of all times, was the proper occasion to face the unpredictable Margaret Sullavan, the lady who was known as death to interviewers.

We mentioned this latter fact to her as we sat down—and promptly started her off on a discourse that never once mentioned Henry Fonda. Just why, you shall see!

"Hollywood people come under two main categories," Miss Sullavan began.

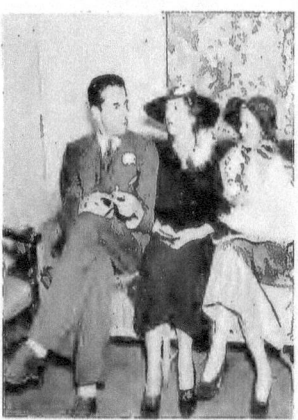

—*Rhodes Photo*

Before—and after. Miss Sullavan is pictured in the top photo with her ex-husband, Henry Fonda, as she looked before the disastrous spill. Below she's shown with Fonda and Margaret Hamilton, both of whom appeared with her in *The Moon's Our Home*. The game arm is conspicuous

"Those who are meek as angels, the elect class, and then the other extreme, those who think enough of themselves to fight for principles. The last are considered hard to handle.

"For two years I have occupied a place in this second group—a person presumably difficult to fit into the well-cut grooves of the film business. Now I don't know whether to accept this classification as a compliment or as a knock, and frankly I'm not worried. My personal philosophy is to enjoy whatever life has in store for me. If someone hands you a lemon, rejoice and make lemonade. Isn't this an easy way to soften most difficulties?

"As a consequence, I don't take my reputation seriously. And I say that realizing that perhaps I am hard to handle.

Palm Springs—and Shirley Temple is about to catch the big ball, but—

There's many a slip, and this looks like a neat one for Shirley! It's true that

Whatever goes up comes down, and here's our favorite star surveying the ruins!
—*Photostory by Charles Rhodes*

BEHIND THE SCENES

How a Casting Director Gets His Star!

ALL THE ROLES but one in Shirley Temple's *Bright Eyes* had been filled. There remained only the selection of The Brat, Shirley's nemesis in the story, before the picture could go into production.

In the office of Producer Sol Wurtzel, Director David Butler and Casting Director James Ryan sat closeted with their chief. Two days now had passed without so much as one satisfactory candidate being suggested for the part.

"She must be a year or so older than Shirley," Butler repeated wearily, for the fiftieth time. "She must be larger and so convincing as the brat that the public won't be conscious even for a second that she's acting."

The group adjourned, and Butler went into a story conference, while Ryan returned to his office.

Several days rolled by without an inspiration in Ryan's fertile brain. He combed his files containing every child actress in Hollywood and sent out word for talented unknowns. On the afternoon of the third day, his secretary phoned in to him.

"There's a lady with her little girl waiting to see you," she announced. "She might fit the part we're looking for."

● USHERED INTO HIS OFFICE, the child immediately intrigued the fancy of the casting director. Yes, she had had practical experience, both in pictures, on the stage and over the radio. She was the right age and the correct height. And she looked the part. Taking her by the hand, Ryan hastily broke in upon Butler, and left her with the director.

An hour later, as he emerged from his office, he found mother and daughter in his waiting room.

"Jane would like to show you several of her impersonations if you can spare a few minutes," the mother halted him. Realizing the futility of refusing the demands of a determined parent, Ryan complied.

Following the young one's "take-off" on ZaSu Pitts, Greta Garbo, Maurice Chevalier and others, he asked:

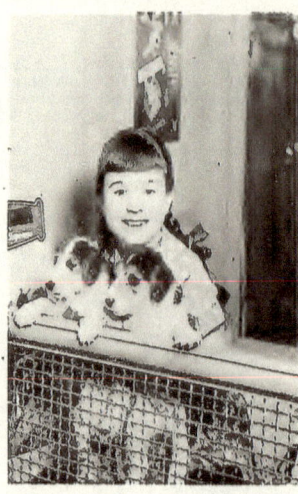

Jane Withers... being a brat meant fame...

"Did Mr. Butler see these impersonations?"

"No," came the reply. "He just looked at Jane and took her name."

"Come on, then," Ryan shouted, and fairly ran to Butler's office again. Once inside, he commanded, "Go ahead."

"The part's hers," the director exclaimed, five minutes later, after many a chuckle. "She's wonderful." He drew Ryan aside. "Sign her up, quick."

That is how Jane Withers, now one of the outstanding juvenile favorites on the screen, was discovered ... and illustrates how characters in a film sometimes are cast.

● PERHAPS NO OTHER ASPECT of motion pictures holds more mystery for the layman than the subject of casting. To the average theatre-goer, it merely signifies the choosing of actors and actresses to portray the various rôles in a screen play, or picture ... without carrying a realization of the many perplexing problems that confront the casting director on every side in his search for talent. Actually, casting constitutes one of the most vital and complicated phases in picture-making, tied up as it is with the discovery of new personalities and new faces.

Where the selection of Jane Withers for the part of The Brat required a number of days to locate a child who would adequately fit the rôle, ordinarily the casting director is called upon to suggest a player at a moment's notice. In his mind's eye, he must visualize between twenty and twenty-five hundred different faces, and memorize their names, their physical descriptions, salary and at least two pictures in which they have appeared.

● TIME AND AGAIN HE'S called upon to perform feats of mental gymnastics that would be positively amazing to the common man. Almost out of thin air he must be able to produce the proper person to enact any part, irrespective of type, and not infrequently this individual is one who has never appeared on the screen. Without his expert assistance, no film could be perfectly cast, for no other in the studio possesses his unique knowledge of actors and their peculiar attainments.

By far the most difficult task in casting lies in the choice of the important figures in the screen story. The perplexities confronting the casting director here seemingly are without end, for new situations arise daily.

A leading lady may not do her best work opposite a certain male star ... they simply do not "click" ...

The one player best suited for a role may be under contract to another studio, and may not be borrowed at any cost ...

The very actor to undertake a character may be temperamentally unfit to work with the director, or vice versa ...

He may decline to appear in the film because, even though his stipulated salary will be paid without question, he does not deem the part of sufficient worth for one of his standing ...

He may be booked up for a number of pictures, which would not permit him accepting another assignment for at least six months ...

His salary may be too high to meet the budget of the picture, and he may be appearing on the Broadway stage ...

Harriet Hilliard was nailed by a talent scout. She proved a real hit in *Follow the Fleet*

James Stewart's real rise started with Margaret Sullavan in *Next Time We Love*. The casting directors knew their man, gave him good breaks in succeeding rôles

HOLLYWOOD INSIDE

When Illness Hits Hollywood

A RECRUIT NEVER had more grief getting into the army than he would crashing a good film rôle in some studios these suspicious days! A candidate for a substantial picture assignment hasn't a secret left by the time the doctors get through thumping his chest and double checking all accessories, with anything worse than pink tooth brush and athlete's foot receiving an official glare.

And there is a good enough reason. Stories of illness and death in Hollywood occasionally break into print, but few people realize that these items constitute one of the greatest unpredictable expenses the studios have to meet.

That's why Columbia studios, for instance, require a complete physical examination before actors are definitely assigned rôles in productions. And if there is one little sour "ah" in response to chest thumping, the victim isn't an actor, he's a patient!

● ACCIDENTS COST LESS than illness in Hollywood, but you never saw a town more careful than this one. For instance: Shirley Temple was having her picture taken in natural color photography. She wanted to play with the cat that was wandering by. Mrs. Temple eyed the cat's sharp claws apprehensively, then succumbed to Shirley's pleading look. Mrs. Temple apparently was paying no attention to Shirley and the cat, but so was that attitude was intended only for Shirley's benefit. Not only was Mother Temple keeping a sharp eye on the cat, but so was the big, good-natured chauffeur who never strays far from Shirley's side.

One flash of the claws could have cost the 20th Century-Fox thousands of dollars had those sharp instruments struck Shirley's face. It would have taken only one deep scratch to stop the cameras grinding on her new picture, *Poor Little Rich Girl*, and keep expensive supporting players awaiting her recovery.

So important is Shirley to the studio's treasury that she is insured for $2,000,000. Another good reason for the close guard kept over this precious child. (See HOLLYWOOD, April 1936.)

20th Century already has had one bitter blow from adversity. Besides losing one of its most beloved characters, the studio lost nearly 40 per cent of its annual profits when Will Rogers was killed in Alaska last year. And Shirley is even more valuable to the company!

● AS A MATTER OF RECORD, sickness and death cost the studios millions of dollars every year. Delays in production and rearrangement of film schedules are the most costly items. During the last year, such extra costs ran more than $4,000,000 in the industry in tangible costs. Count-

When 20th Century decided to film *Under Two Flags*, sleek Simone Simon was assigned the leading feminine rôle

This is how Simone looked in costume. She might have made a signal success—IF illness hadn't come her way

With Simone under the weather, 20th Century gave the rôle to Claudette Colbert, a box office cinch. Then Claudette fell ill . . .

less other extra items could be charged off to this source of trouble, rocketing the total even further.

Illness affects practically every contract player sometime during the year. Experts estimate the average loss of time to be four days per person. Considering that filming costs run more than $1,000 per camera hour, it is easy to see how the total reaches unexpected heights in no time at all.

Insurance such as Shirley Temple's has cost the studios a terrific sum. United Artists had Merle Oberon insured. She became ill and delayed production on *These Three* for nearly a week, at a cost of $15,000 per day. Lloyd's, who issued the policy, had to take the rap after the initial $5,000 loss. But you can bet your hat Samuel Goldwyn paid a dear premium for this protection!

Probably no studio has been hit more than 20th Century by illness. For instance, when they cast *Under Two Flags*, Simone Simon, the French importation, was scheduled for the lead. Then she fell before a local influenza epidemic and was forced out of the picture. Darryl Zanuck sent a riot call to Paramount for Claudette Colbert to take the leading rôle. The arrangements were all made and the cameras were set up. Then Mr. Zanuck's phone rang one morning.

"Hello, Mr. Zanuck." He couldn't recognize the voice on the other end of the line. It was hoarse, shaky.

Big-nosed W. C. Fields only recently was able to resume his career with the picture, *Poppy*. A long illness brought great losses to him and Paramount

Hollywood Newsreel

newspaper, is reported secretly betrothed to Patricia Ziegfeld, Billie Burke's daughter and a playmate of his childhood days. They are said to be plotting marriage as soon as Pat completes her education at the University of California at Los Angeles. Meanwhile, Bill has made her movie editor of his Beverly Hills newspaper.

* *

Shoe Doesn't Fit

A STAR MAY be a star—and a glamorous one, at that—but in a darkened theatre she's Rosie O'Grady.

We chanced to sit next to Barbara Stanwyck a few nights back, at a preview ... and the moment she sat down she slipped off one shoe and sat on her foot throughout the run of the film.

* *

Sally Dons Makeup

FAN-WAVING SALLY RAND, who was a silversheet satellite before the film industry hooked up sound, causing her to set out on a career as No. 1 exponent of nudism, is returning to her first love via an important rôle in Cecil B. DeMille's *Calamity Jane.*

It all came about when Sally, in Los Angeles for a holiday, dropped in on the famous director, for whom she toiled when she was rated as one of the colony's most beautiful ingenues. The social visit ended in a test and a contract for her.

Sally will be fully clothed for the rôle.

* *

It's An Ill Wind, etc.

DOCTORS' ORDERS that temporarily retired silvery-throated Dick Powell from the screen and air waves while he rested his vocal cords following an operation, didn't make the crooner too, too sad, for the respite from toil provided him with freedom in which to press his courtship of Joan Blondell, whose divorce from George (cameraman) Barnes becomes final in August.

Unless something unforeseen arises in the interim, this popular pair will ankle it altarward early in September, according to pals in a position to know.

* *

Shirley Dips In

CHILDREN ARE PRETTY much the same, whether they be gilted talkie stars or just plain run-of-the-mill kids.

When the Governor of Tennessee and a group of Shirley Temple fans in Nashville banded together and shipped the curley-top a 50-pound cake on her seventh birthday, Mamma Temple unwrapped the package, and placed the frosting-laden gift on the Temple dining table.

"Now Shirley," warned the *mater*, "you mustn't touch it until dinner, then you'll be allowed to cut it, and have a piece yourself!"

Mrs. Temple left the room, but returned in time to find a hole in the side of the cake and Shirley's mouth and one hand coated with chocolate!

When Illness Hits Hollywood

"This is Claudette Colbert speaking (believe it or not.) I'm dreadfully sorry, but the doctor says I have influenza and he won't let me out of bed. . . ."

That's one reason why Producer Zanuck spends 14 hours a day trying to keep the studio's affairs straight!

Here are some more reasons:

Mary Astor fell victim of influenza on a location trip, spent a week in bed while Columbia footed the bill. Illness comes high in Hollywood when the camera is grinding

Zanuck borrowed Rosalind Russell from M-G-M to play in *It Had to Happen.* The picture was all set to go when the old bogey, laryngitis, came along and Rosalind couldn't talk for three days.

While filming *Captain January* Shirley Temple was out for four days with a bad cold—and the studio cannot afford to take chances when their valuable players are under weather.

During the shooting on *Professional Soldier*, Freddie Bartholomew sprained his ankle and was unable to do any long shot scenes. After the first day he was able to go ahead with close-ups.

Plans had all been made for doing *Ramona*, locations selected, and the cast tentatively drawn up. Then Loretta Young had a long siege of illness and the picture had to be delayed.

● THE DEATH OF THELMA TODD cost Hal Roach a big sum, for she had nearly finished a rôle in *Bohemian Girl.* When Sam Hardy died, United Artists found a lot of scenes in *Strike Me Pink* without value because Hardy hadn't finished his rôle. Further delay was caused on the same film because Jack LaRue smashed a finger in a car door and couldn't wear a bandage.

Over at Paramount a big source of revenue was suddenly shut off when W. C. Fields became ill. Only because he was a swell trouper did W. C. Fields finish *The Man on the Flying Trapeze.* He was ill and worn out during much of the picture. Only recently was he ready to resume his career with the picture *Poppy.*

The illness of Joan Bennett's famous father, Richard Bennett, caused her to fly east to his bedside during shooting on *Thirteen Hours by Air.* The company managed to re-arrange its schedule and proceeded to shoot around her. But if Joan had failed to get back on the prescribed date, production costs would have dug deeply into the profits.

When Binnie Barnes went to Metro to appear in *Rendezvous*, her sudden illness caused many an executive to sharpen his pencil and get gray hair. The production was delayed two weeks pending her full recovery. It was cheaper than trying to replace her and shoot everything over.

● HOLLYWOOD REALLY DOES NOT have more than a normal share of illness. Most of filmdom's players try to keep themselves in good physical shape. But if illness breaks out during a production, it is apt to get more than one person because of the trouper instinct to keep on to the last ditch. By that time—if the illness should happen to be contagious—it may sweep through half the cast before it is stamped out.

Many players dislike being loaned out to another studio because they have learned the tricks of their home sound stages, and can't predict unexpected draughts in others.

Irene Dunne is a good example. At RKO she knew just how much clothing to wear while in production, and how to avoid vagrant winds that sweep through the big structures. But when she went to Universal she failed to consult the weather man about strong sea winds sweeping through the valley, and she promptly caught cold on one of the sound stages during the shooting of *Magnificent Obsession.*

That's what worries all the studio executives. Illness is unpredictable, and no matter how they try, they can't stamp out the causes.

Location trips are especially troublesome. Mary Astor and Elliott Nugent, on location near Lake Tahoe for the picture, *And So They Were Married*, both got influenza due to the extreme frigidity of the climate. Accustomed as they were to Hollywood's warm sunshine, deep mountain snows were an official terror that completely stopped production for a week. The company slid its way back to sunshine, sent Miss Astor to bed pending recovery. The delay was so costly that the company had to rush to nearby Big Bear Lake district to finish on time.

Rochelle Hudson, doing *The Country Beyond* for Fox, also in the Tahoe country some 600 miles from Hollywood, had a narrow escape when a landslide went awry. Had she been injured in filming the scene, it would have cost 20th Century vast sums of money to hold up production.

● THERE'S ANOTHER tremendous cost that every Hollywood actress has to consider when she marries. Blessed events! They come costly in filmland! Who can say, for instance, how much box office revenue and personal salary was involved when Norma Shearer decided to have her second child? There's big money involved in a year's retirement from the studio.

Or take the case of Sally Eilers. When she had her child, husband Harry Joe Brown thought it was swell. So did Sally, but they paid dearly. It was a full year

Hollywood Newsreel

to be Conrad Nagel's fiancée, are on the verge . . . Peggy Fears is all set to Renovate the ultra-rich A. C. Blumenthal before taking another whirl at the studios . . . Hal (cameraman) Rosson, Jean Harlow's No. 3 ex-mate, is all set to listen to wedding bells with Mrs. Yvonne Crellin, Paris and Beverly Hills socialite . . . James Blakeley, blue-bookish thespian, has reason to worry now that Paul Mitchell has arrived from London, intent upon claiming Mary Carlisle as his bride . . . Jane Eichelberger of the New York and Memphis social registers, became Mrs. Weldon Heyburn three days after a Los Angeles judge granted Greta Nissen an annulment from the actor . . . Margot Grahame and hubby Francis Lister have patched things up, and Margot is going to toss away her Hollywood career unless Francis agrees to quit England for California . . . Marjorie and Douglas Fowley have called quits to their marriage . . . when Dixie Dunbar continued to dodge his daily mail proposals, George King, Atlanta, Ga., long her boy-friend, journeyed to Cinematown to wage a personal campaign for her heart . . .

• • •

Baubles and Bugs

HOLLYWOOD STARS who read their fan mail never find the task monotonous if one is to judge by recent experiences of Gary Cooper and Errol Flynn.

Unwrapping a small package bearing a postmark, "India," Gary found an exquisite and expensive cigarette case in onyx and gold with a card bearing the inscription, "From the children in the Sir Khurshid Jah Palace."

After wading through ten pages of scrawl from a palpitating heart in Spain, Errol sighed as he neared the end, but there was a postscript, in which the lady asked him:

"Please excuse the handwriting because I am suffering from smallpox!"

FANAGRAM WINNERS

Miss Gail Purdy, 184 Elmlawn Road, Braintree, Mass., wins the big life-like Shirley Temple doll which has been personally autographed by the star herself!

The winning Fanagrams: Alison Skipworth—In walk his troops; Gary Cooper—O! Pay grocer; Bing Crosby—Cry, big snob; Charlie Chaplin—He'll chip in a car; Freddie Bartholomew—A bird tole me how, free; Gertrude Michael—Cute dream girl, eh?; Charles Butterworth —Let her watch, or burst.

Many of the Fanagrams were exceedingly clever, and a careful study of them had to be made by the judges. The winner of Margaret Sullavan's Wedding Ring will be announced next month.

Join in this fascinating game and win a prize!

Jane Withers blows some of her allowance for a ride on the elephant at the L. A. Zoo. She's atop Anna May, who in her own way is also a star, toting Tarzan through many a thriller

Business Woman

JANE WITHERS has her own ideas about earning money. Jane, you may or may not know, receives over one thousand dollars salary every Wednesday from the studio . . . but that's a different matter.

The ten-year-old actress wanted to give her mother a birthday party . . . with ice cream and cake and things. But her $2.50 weekly allowance wasn't sufficient to pay for everything she wanted to buy.

S-o-o . . . instead of asking her mother or father for more money—even for an advance on her next week's allowance— Jane started a store on her latest picture set and sold everything she could find. When this still didn't amount to enough, she found some chairs and rented them to Slim Summerville, Irvin Cobb and others in the picture for so-much a day . . . in the shade. And, to further swell the exchequer, she rented out nails to the members of the company to hang up their coats.

Don't worry about Jane Withers' future . . . she'll NEVER starve!

• • •

The Cash Rolls In

WHILE MARY PICKFORD has laid aside her screen make-up box, temporarily at least, her current income far surpasses the huge earnings that were hers in the heyday of her flicker stardom.

In addition to the flow of wealth from her highly successful talkie producing business, her radio contracts and her literary efforts, she is adding fat figures to her bank account through disposal to major studios of stories and plays she used as stellar vehicles in the silent era.

Mary has just sold 20th Century-Fox the talkie rights to *Kiki* for a cool (or should one say "cold") $60,000!

FAN MAIL

Gangway—the wild gas wagon roars by! Jean Harlow and Franchot Tone, in a scene from *Suzy*, give the local lads a thrill with their new car

has been raising horses. He doesn't conduct a riding school or anything like it, but he did teach Johnny Mack Brown all his riding tricks for *Billy, the Kid*. He also gave Clara Bow her first riding lessons, and made her so ranch minded that she bought a ranch at Searchlight and lives there most of the time.—The Editor.

* *

Guy Kibbee's Case

Dear Editor:
I think you give entirely too much space and credit to stars and forget all about the character players who, after all, make the picture good or bad.
My praise is for Guy Kibbee, that chubby little man with the popping eyes and smiling face. He has saved so many pictures, through his comedy when all the time he really was a tragedian instead of a comedian.
I am so glad that he has come into his own at last and I am willing to forgive the producers for being so blind to his talents for so long.
Mary Weisse,
Waco, Texas.

Being "typed" is about the most tragic thing that can happen to a screen player because it often spells death to their real talents as it did in the case of Guy Kibbee. He is indeed fortunate to have been rediscovered before it was too late.—The Editor.

* *

Picture With Value

Dear Hollywood:
Well, at last a picture that shows the Great American Home for just what it is—a series of conflicting minds and emotions.
I refer, of course, to *Too Many Parents* and hope that the producers will see the real value back of such pictures and continue to give us a treat now and then.
A Parent,
Spokane, Wash.

* *

If Winter Comes

Dear Hollywood Magazine:
Recently I read something that distressed me very much. The article said that nearly all of our old screen favorites are broke—that the studio casting directors had gotten together to see that they had work.
What a tragedy! Can't something be done about it? Can't they be forced, I mean all screen stars, to establish a trust fund? It isn't fair to us who supported them so sincerely by giving them our every thought during the days they were in the money—not to mention our hard earned nickels and dimes.
Are all the favorites of today going to wind up broke too?
Anxiously,
Olive Thompson,
Los Angeles, Cal.

There is never any great loss without some gain—to someone. The young players of today are profiting by the mistakes of the old favorites and are investing their money in property and securities. HOLLYWOOD readers should be reminded that while many old-time stars are destitute, others like Ruth Roland have preserved adequate fortunes—The Editor.

* *

Scenarios From Unknowns

Dear Sir:
In HOLLYWOOD Magazine, I read an article concerning the ban on purchase of scenarios from unknowns. The studios must remember that if it were not for the unknowns there wouldn't be any need of a studio. Our dimes and quarters, no matter how small they seem, pay the salaries of actors, actresses, directors, etc.
How are the unknowns to get in touch with a responsible agent. I have several outlines of original stories I wish to submit. I am a faithful reader of HOLLYWOOD Magazine. I haven't enough money to consult an attorney, let alone start a lawsuit.
I suggest a contest; say a two-hundred-word outline of a story, each entry to become the property of the sponsor of the contest. This would avoid lawsuits if a story used later would resemble an entry. This would give unknowns a chance.
I am submitting a story for Shirley Temple to suggest what I mean, I'm on the level, please believe this is no trickery. This story should be of interest when Shirley loses a front tooth.
Thank you,
Vivian Slingerland,
1010 E. Ruth St.,
Flint, Michigan.

Fawcett Publications will consider Reader Slingerland's contest suggestion.—The Editor.

* *

Reader's Recommendation

Dear Editor:
Never before in my life have I seen such a well done motion picture epic as *La Maternelle*, the French language picture now showing at various houses throughout the country.
I took my family to see it. Subtitles running with the action make the picture understandable to every person in the audience. We not only enjoyed the picture but it brought all of us closer together in the sweet understanding portrayed on the screen.
Madeleine Renaud of the Comedie Francais is the leading lady, but the real star is a little child, not more than 10 years old, Paulette Elambert. She is not "pretty" like Shirley Temple. There is nothing "cute" about her. Even her shape is scrawny. But that child can ACT as no child star ever seen in an American made film can act. She is a "natural," and she is lovable without more than three smiles in the whole picture.
It is a picture that deserves more attention than it is receiving in America . . . and I am writing this letter because as a father I think it SHOULD be shown, as a CRITIC I think it is better than any American film I ever witnessed, and as an average theatre goer I think it *is* entertaining.
The recording is poorly done, the only fault, probably due to inferior sound recording equipment in France, but after the first few moments even this small defect is forgotten so intense is the drama which unfolds for all to understand and admire . . . and remember for years afterwards.
Cordially,
Gilson Willets.

* *

"Color" for Color Blind

Dear Editor:
Bing Crosby *can* arrange to determine all colors correctly if he wishes to do so, by the use of color filter glass or transparencies of other types. (Enclosed is a report from the Transactions of Ophthalmology of the American Medical Association.)
Sincerely,
Vernon A. Chapman, M. D., F. A. C. S.,
Hollywood, Calif.

Dr. Chapman's suggestion is an outgrowth of an article on Bing Crosby's notorious color-blindness (June HOLLYWOOD, p. 26). To enable Crosby and others similarly afflicted to determine the difference between red and green traffic signals, safety spectacles have been developed. The upper half is red-free filter glass; the lower part clear glass. When a driver peers through the filter, a red signal appears black, a green light remains its usual shade of gray.—The Editor.

* *

More Clubs for Your List!

VICTOR JORY—Eastern Branch, Frances Grady, 11 West St., Bangor, Maine; Western Branch, Betty Bass, 524 N. Elena St., Redondo Beach, Cal.
RIN TIN TIN, JR.—Lou Heshrot, Wassookeag School-Camp, Dexter, Maine.
RALPH BELLAMY—Jeannette Mendro, 4939 Gunnison St., Chicago, Ill.
MOVIE FAN FRIENDSHIP CLUB—Chaw Mank, 226 East Mill St., Staunton, Ill.
CESAR ROMERO—Chaw Mank, 226 East Mill St., Staunton, Ill.
GEORGE BRENT—Helen Henderson, 162 Highland Ave., Kearny, N. J.
TOM BROWN—Ebba Ebraue, Jr., 45 West 45th St., New York, N. Y.
JACKIE HELLER—Virginia Gilliland, 5321 Kimbark, Chicago, Ill.
JOE PENNER—Sidney Vousden, 34 Strathmore Blvd., Toronto, Ontario, Can.

Hollywood Spotlights

The Nightmares in Margot Grahame's Exciting Career

IF YOU'VE EVER wondered what a star dreams about, Margot Grahame is a good one to ask. She has dreamed better plots than ever were written for the movies. And as for her nightmares . . . !

The luscious blonde star of Columbia Studios has reason to believe that dreams mean something. When she wakes up she can remember them vividly, and some of those visions cause her brow to knit with thought.

She dreamed about money one night. It was counterfeit, as unreal as a figment of the imagination. The next she knew she was in *Counterfeit* with Chester Morris. Usually Margot (the "t" is silent as in cranberry) plays the rôle of a lady of the evening, for she is the knee-plus-ultra in sex appeal. In *The Three Musketeers* she was a courtesan of high degree and nothing less than rubies won her favor, but in *The Informer* a shilling was sufficient.

Success Without Riches

● HER MOST ASTONISHING adventure followed hard on the heels of a vision of her mother's. It is a Cinderella story almost beyond the bounds of magic.

Margot Grahame was living in London, in a rather attractive apartment and with no money to pay for it. While she had enjoyed considerable success and no small amount of renown as an actress on the stage and screen, there was no denying that now she was broke. Here and there along the street she owed a bill or two, and her wardrobe was getting frayed at the edges. Her fiance, Francis Lister, was having just as much a struggle in New York, with the ocean between them.

"If only something would happen!" she exclaimed to her mother.

"The phone will ring in a moment. It will bring good news," her mother remarked placidly. Some uncanny prescience has always guided Mrs. Grahame. Margot was impressed.

But a few moments later when the phone did ring and a voice said: "How

A WESTERN SONG · · · · · · · SHIRLEY TEMPLE

To be a cowgirl! That's one of Shirley Temple's many ambitions, and she practices every time her mother takes her to the desert

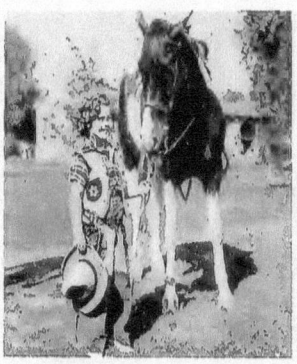

The pony is tame and friendly, but then—who wouldn't shine up to little Shirley? She's not only able to ride the animal, but she also—

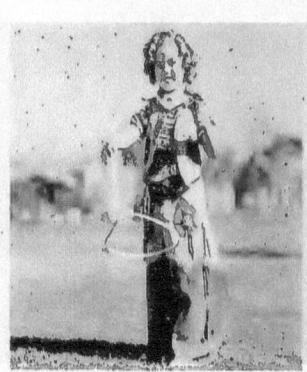

can toss a rope around in several directions. Shirley is going to learn to lasso from a horse as soon as she can convince her elders it's safe!

Margot Grahame's Nightmares

would you like to earn 400 pounds and a trip to New York on the *Berengaria?*" Margot thought she was being spoofed. "Your joking, whether you know it or not, is in very bad taste," she retorted.

Rags to Rolls Royce

● ONLY A CALL in person from the executive of a big London paper convinced her that this was no pipe dream. The proposition was simple—British shipping had been feeling the competition of French boats and wanted some important star to cross on board the *Berengaria* for a publicity stunt. The paper was in on the deal with the steamboat company. All Margot had to do was pose in various shops with luggage, gowns, coats and so on, and the stores would all advertise. She must go and return on the *Berengaria* without a stopover, so that on getting back to London the paper could publish her own account of the trip.

Margot set out the next morning in a Rolls Royce that called at her door, and she was still wondering if she wouldn't suddenly wake up. The Rolls whisked her into traffic and came to Yagers. A most exclusive store. Margot was outfitted, photographed, and prepared to leave. "But the costume is yours—keep it on," she was told! In a daze, Margot next went to Selfridge's. Gordon Selfridge was a friend. And he personally presented her with a gorgeous traveling outfit. Shoes, stockings, negligées, coats —everything came her way. The Rolls was filled with gifts when she came back to her apartment.

The Battered Bride

● BUT THAT WAS only the beginning of the adventure. Outward bound they hit a terrific storm, and Margot slipped, turning her ankle. It was nothing, but the publicity man aboard ship did not waste his opportunity. The radio flashed back word of the accident. The paper headlined it—the other newspapers played it big.

Then someone thought of the crowning touch. Why not get married while she was in New York?

Well, and why not? Margot was game. She could bring her husband back with her. What a lark this had turned out to be! The radio sputtered, and of course Francis Lister was thrilled at the prospect of becoming a bridegroom. Neither had dreamed of the possibility before all this happened.

They had but one day in New York, and poor Margot and Francis thought they never would be able to contrive a wedding ceremony. With everything arranged, they suddenly realized they had no ring! Back to Fifth Avenue they hied, and rushed to a jewelry store. The clerk was busy withdrawing his precious gems from the window. The store had closed. Frantically, Margot rapped on the window. She went through the motions to show she wanted a ring. If you ever tried that in sign language, you can imagine the problem. Finally the clerk understood and Francis Lister purchased the ring.

By this time, of course, the London paper was extending itself. It was indeed a grand story, and typewriters pounded right merrily in a dozen news rooms in dear old London. More, Margot had acquired a slogan. *The Battered Bride of the Barengaria!* Headlines told of the Battered Bride's Return, of her Landing, of her Life Story.

And naturally, the movie makers were at the dock waiting for a chance to sign such a famous person, even if she was a bit battered.

Other Nightmares

● THAT'S WHAT ONE vision did for Margot. She couldn't have dreamed a more exciting adventure. She has tried to equal it since in Hollywood, but her dreams here, fortunately, did not come true.

When she is up against some difficult problem, her dream is usually about trying to knock somebody on the jaw, and failing to get any steam in her punches. The frustration dream, however, is of the common, or garden variety which everyone, almost, experiences now and then. Usually Margot's dreams are of much better stuff.

Margot has gone back to England, but not to dream. She will be a busy girl over there, from all reports, but if she does find time for a few choice nightmares she has promised to let HOLLYWOOD Magazine know. Oh, yes, she does *not* talk in her sleep.

—JOHN WINBURN

JOSEPHINE HUTCHINSON

JOSEPHINE HUTCHINSON is a surprise ... a complete contradiction to her screen rôles ... Very, very young ... vivacious ... hair of sparkling titian ... determined ... a dust of freckles across a pert nose ...

Few people are aware of the fact that she made her screen début as early as 1923 ... when she played a child rôle in Mary Pickford's *The Little Princess* ... Has been an actress all her life ... following in the natural footsteps of her mother ... Leona Roberts ... still well known on the New York stage ... Josephine's greatest stage hit was the creation of Alice in *Alice in Wonderland* ... She was disappointed in the screen version ... Is a great fan of Shirley Temple's ... and considers her the logical Alice for films ... If somebody doesn't do something about it pretty soon ... may get out herself and sell the idea of an all-color production of the famous classic ... with Shirley the star ...

She is married to her manager ... James Townsend ... It wasn't a case of love at first sight ... far from it ... They disliked each other very much ... so much they thought the less they saw of each other the better ... but business wouldn't allow it ... they had to spend so much time discussing jobs and contracts ... they soon forgot to be personal ... understanding turned to admiration ... and so they were married ... in Las Vegas, January 12, 1935 ...

Their home in Beverly Hills is as light and gay as their lives together ... white Monterey ... with roses 'round the door ... and a patio ... filled with Josephine's strangest of all Hollywood collections ... potted plants which she has collected since a child ... and packed across country a dozen times ... Her other prides and joys are her pets ... A Scotch Terrier named Puck ... and a Persian cat named Padda ... both are red heads ... and like to scrap ... so does Josephine when anyone mentions sweetbreads or persimmons ... they're her principal aversions along with gossipy people ...

Is a good cook ... her husband says so ... most expert at making soups and that's a real art ... she says so ...

Shirley Temple and her stand-in, Mary Lou Isleib, compete with each other at the studio school

Reviews of the Previews

able side of the ledger is Claude Rains, whose Napoleon rôle is something to rave about. Charles Ruggles, Edward Everett Horton and Arthur Treacher are supposed to be a comedy trio. They succeed in their efforts at intervals. This picture lacks neither big names nor fancy decorations to make it a hit; that it misses the mark is regrettable. Nevertheless it cannot be brushed aside as insufficient entertainment. To many *Hearts Divided* will prove pleasing and worthwhile.

Poor Little Rich Girl—Michael Whalen, Shirley Temple

POOR LITTLE RICH GIRL—(20th Century)—Shirley Temple's newest offering steps right out and keeps pace with her best. Shirley, daughter of a soap magnate, gets lost one day, calls it a vacation. She falls in with a pair of ham troupers (Alice Faye and Jack Haley.) They take an audition for a radio program, land a contract on Shirley's merits. Inevitably, the sponsors are rivals of Shirley's film father, Michael Whalen. Gloria Stuart enters the picture as proper love interest for Whalen's loneliness. Shirley's acting is beyond criticism. Next in grabbing honors is Alice Faye, who needs to watch her alarming increase in weight. Haley and Miss Stuart are good, but Whalen's performance misses through coldness.

AND SUDDEN DEATH—(Paramount)—The highly exploited title of this picture (thanks to *Reader's Digest*) should give hope that here is something unusual and of value in recent productions. The film does not measure up to its potentialities. It presents Randolph Scott as the traffic director; Frances Drake as a reckless young beauty; Tom Brown as her equally reckless brother. It is obvious from the first that Scott will fall in love with Miss Drake, that she will become involved in a serious accident. With poor handling of preachments whatever merit this picture has must be found in the story. If Scott, Drake and Brown provide these elements, you may possibly conceive this as satisfactory entertainment.

PALM SPRINGS — (Wanger-Paramount)—Frances Langford, Sir Guy Standing, Ernest Cossart and a radio find, Smith Ballew, are the principal features of this sprightly picture. Obviously a story of the famous California resort town where dollars roll over the tills and hills, the picture portrays the love affair between rich Frances Langford and cowhand Ballew. David Niven, cultured lad with no ambition, vies for her interest, prodded along by his aunt, Spring Byington. You will find the story bolstered by a good cast doing good work. Ballew looks like good material in this first picture, possessing a homespun sincerity and unaffected straightforwardness.

YELLOW CARGO—(Pacific-Grand National)—presents Conrad Nagel likewise in the rôle of a government undercover man out to break up a smuggling ring. Smugglers, acting as independent movie company filming a Chinese picture off the coast, take out white actors in make-up, bring back boatloads of Chinese aliens. Nagel's rôle is substantially portrayed. You will find Vince Barnett capable as the dumbbell news photographer, Eleanor Hunt as a girl reporter and Jack LaRue as a gunman click nicely.

THE WHITE ANGEL—(Warners)—This is the story of Florence Nightingale, and her valiant efforts in launching the movement which was eventually to become the Red Cross of the civilized world. With the title rôle portrayed by Kay Francis, this picture becomes a moving, poignant story cleverly unfolded by the expert direction of William Dieterle. Sticking close to fact, it takes spectators behind the scenes in the Crimean War (1854-56). Miss Francis plays her rôle superbly, is given able assistance by an excellent cast which includes Donald Woods as the suitor, Donald Crisp as the head army surgeon, Ian Hunter, Nigel Bruce and many others.

EARLY TO BED — (Paramount)—Charles Ruggles and Mary Boland are married again—cinematically speaking—in this uproarious comedy. They have been engaged for 20 years before the knot is finally tied and Ruggles carts her off to a sanitorium where he hopes to sell a large order of glass eyes to a big business man (George Barbier). Complications revolve around Ruggles' suppressed sub-consciousness. As a sleepwalker he gambols on the lawn, becomes involved in a murder mystery. The entire situation gives Ruggles full use of his favorite comedy routines. It's a funny picture, sure to draw guffaws from all but the most morose.

Poppy—W. C. Fields, Rochelle Hudson

FURY—(M-G-M)—Sylvia Sidney and Spencer Tracy have the leading rôles in this powerful story of mob action and its consequences. Suspected of being kidnapers, the two barely escape being burned alive in a jail when the mob runs wild. It is Tracy's part to suddenly evolve from a tolerant, quiet individual into a madman of raging fury over the mob's action. Both Tracy and Miss Sidney bring their characterizations to a skillful, emotional climax. With hysteria as a background, this picture quite possibly can prove too strong a thing for many theater patrons. On the other hand it represents consummate artistry for its own type of drama, well worth your attention.

* * *

What Price Love

Dear Editor:
I have just read in HOLLYWOOD Magazine that the most expensive ingredient in the making of a motion picture is *love*. But *love* is what I spend my quarter for (yes, I sit in the balcony—I'm a working goil), and I wish Metro-Goldwyn-Mayer would invest $4,000.00 more and give me a break by letting Mr. Gable and Miss Crawford do some real emoting in their next.
However, at $4,000.00 a kiss I can understand why, much to my disappointment, the screen says "The End" just before the final clinch.

Georgeane White,
723 West Capitol,
Little Rock, Ark.

Shirley Shows Off?

Dear Editor:
I wish they wouldn't let Shirley Temple do "show-off" things like the opening scene of *Captain January* where Shirley, upon awakening, goes into a song, jumps up, jazzes around the room, washing and brushing her teeth in time to music, and tapping professionally while dressing.
When the picture unfolded, Shirley took her part with the others and was as sweet and dear as always. Her dance with Buddy Ebsen was fine, and her operatic "trio" was a riot. It is only when Shirley is allowed to strut, that we fans feel sorry for what they are doing to her.
We hope that in the future, Shirley will be allowed to do only natural, childish things and the precocious posings be eliminated.

H. Stappenbeck,
3171 Sacramento St.,
San Francisco, Calif.

Petrified not a Fraud

Dear Sir:
I resent the letter from Mrs. Hill saying that the picture *Petrified Forest* was "a vast fraud and so evident."
I live in a small town which lacks many of the intellectual opportunities afforded by a large city so I welcome a picture with an idea that stirs the audience out of its lethargy and makes them really think.
Petrified Forest had a deeply stirring message. It tried to show us what we live for and how we can live a life of value to mankind. It was as good as a sermon and the acting was splendid.
Sincerely,

Winifred Seward,
420 Oak St., Roseville, Calif.

In its references to time and space, *Petrified Forest* could reasonably be criticized. In this film, bandits dashed over vast spaces of the Southwest as if they were moving from suburb to suburb. And while some people will tend to criticize the film, others will join Reader Seward in praising its spirit and purpose.—The Editor.

Will Rogers' Doubles

Dear Editor:
A. A. Trimble, Cleveland map salesman, I'll admit does look very much like the late Will Rogers, but does he talk like him? If Trimble's "looks" and Stuart Erwin's "voice" could get together, the beloved spirit of Will could stage a comeback.
And, by the way, if Stuart Erwin would eat less, he could run Trimble a close race as to looks, too.
Sincerely,

Rebecca Lawrence,
714 Eighth Ave.,
Hickory, N. C.

Miss Lawrence refers to the man who was asked to appear in *The Great Ziegfeld* as a tribute to Will Rogers. Mr. Trimble's picture appeared on page 10 of June HOLLYWOOD.—The Editor.

TOPPER'S FILM REVIEWS
HIS HONEST FACE TELLS THE STORY

LIBELED LADY — (M-G-M) — When Jean Harlow, William Powell, Myrna Loy and Spencer Tracy walk gaily across the screen as the headliners of a picture, one may with some impunity call the feature a four star product. In *Libeled Lady* we have them all cavorting for us, and if the picture isn't quite a four star film, it's close enough to get in under the wire.

We have: Jean, the bombastic blonde in love with Spencer, managing editor of the daily paper; William Powell, debonair wanderer who must inevitably fall in love with America's richest young lady—Myrna Loy. Spencer's paper libels Miss Loy, who files suit for a mere $5,000,000 damages. To save the day Spencer contrives a plot: Powell marries Harlow, then plans to compromise Loy. In the midst of the compromise Harlow is to enter and become the indignant wife ready to sue for husband-larceny. So naturally Myrna dismisses her suit to avoid further scandal, that is, assuming all goes well with the plot.

All does NOT go well, however. Hence we have an amusing, sometimes rough and tumble comedy which does justice to all participants. Jean Harlow, faced with the necessity of returning to her shouting rôle, drops bombs all over the enemy and acquits herself very neatly. But Jean, if we may address you personally, we would rather see you in rôles like those you rarely get—where eyes and

Four stars—in a great comedy! William Powell, Jean Harlow, Myrna Loy and Spencer Tracy are featured in M-G-M's film, *Libeled Lady*

curves and suppressed emotions do more talking than your voice. In *Libeled Lady* your part was not the best break, but you did handle it fully as directed.

And Bill, we thought M-G-M made your rôle exactly to fit. You were as charming as ever, and very, very amusing. It must be fun, falling in love so frequently with Myrna on the screen. Congratulations to both of you for your excellent performances.

And now, Spencer. As the fourth member of the troupe you made a better managing editor than your newspaper reflected. It was a rather cheesy looking sheet, what we saw of it. But you - you were swell!

It would not be fair to finish this review without a word of congratulations to Walter Connolly who plays the rôle of Myrna's rich father.

We have been talking to the stars somewhat in this review, but this much we say to the world: *Libeled Lady* is light, frivolous comedy, intended to be taken with salt and a laugh. As such it provides around 100 minutes of hilarity with very little to slow it down. If you leave the theatre buoyed with the thought that life is easier if not taken too seriously, *Libeled Lady* will have been not only good entertainment, but will have served a purpose of no small importance.

LADIES IN LOVE—(20th Century-Fox)— Whatever else may be said of this picture, it is at least an interesting experiment. Loaded with star names, the story attempts to deal satisfactorily with four separate love affairs, carrying them through to logical conclusions. The attempt is not entirely successful.

Janet Gaynor, Constance Bennett and Loretta Young move into a fashionable apartment together and the stage is set. Janet becomes housekeeper for a magician (Alan Mowbray) while a physician (Don Ameche) yearns his heart out for her. Connie falls in love with a rich playboy from South America (Paul Lukas), Loretta's love goes to a titled young gentleman (Tyron Power, Jr.)

Director Edward Griffith is faced with the proposition of handling these three love affairs simultaneously, plus the complication of Simone Simon, who enters the scene to steal Connie's boy friend from her. Handling such a story is not an easy task, but the director has achieved a moderate sort of success at that.

If the rumors of great bickering among the four stars during shooting of the film are true, they at least do not show up in the final version. Janet Gaynor captures a good measure of sympathy because her love affair eventually works out with the doctor. Best actress probably is Loretta Young, although we may be taking our life in hand by saying so. Miss Bennett's performance is satisfactory but scarcely sparkling. As for Simone, the girl who made such a solid hit in *Girls' Dormitory*, one cannot muster up the same enthusiasm for her present work. Here she is a shadow of her previous self, portraying a similar rôle without half the opportunity or self-ambition offered before.

To Alan Mowbray goes considerable credit for playing his magician's rôle with unlimited enthusi-

asm. He makes a ham actor supreme of himself, apparently delighting in doing so. As a result, he garners up practically all the laughs that can be found in an otherwise unfunny picture.

THE GAY DESPERADO — (Pickford-Lasky)—Gay, satirical and romantic, *The Gay Desperado* proves to be, in racetrack parlance, a "sleeper" of the first order. Little heralded because no one as quite sure what Miss Pickford and Mr. Lasky would evolve as their last production effort this picture emerges as one of the distinctly finer films of the winter.

Nino Martini is billed as the star, and deserves it because of his many fine songs in the picture, but Leo Carrillo as the gay Mexican bandit leader plies his trade well, steals scenes promiscuously. Carrillo, the "most worst bad man in thees country," twists dialogue and plot into delightful knots for 85 minutes while Martini serenades the cacti in the moonlight and Ida Lupino considers romance with Jimmy Blakely.

Gay Desperado is particularly enjoyable because it runs liltingly along a path seldom followed by Hollywood films. Entrancingly melodic, it combines farcical fun and genuine excitement with light opera.

You will like every member of the cast. All have contributed to the success of the film. Watch for the scene where Mischa Auer, as one of the bandits,

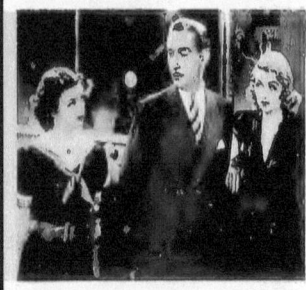

Ladies in Love, following the current trend, offers plenty of stars for your entertainment. Here we have Simone Simon, Paul Lukas, Constance Bennett. And to your right—

Others in the *Ladies in Love* cast: Don Ameche, Janet Gaynor, Loretta Young! But for all its star names, it isn't the world's best picture

breaks his heroic silence to offer his resignation when romance is at stake.

Songs you will like: *The World is Mine Tonight*, the lovely *Estrellita*, *Celeste Aida*, *Adios Mi Tierra*.

Gay Desperado's fine qualities make all the sadder the parting of Jessie Lasky and Mary Pickford, for in this final picture they have demonstrated the worthiness of such a partnership. To them and to Director Rouben Mamoulian goes much credit for the success of the production. Mamoulian, who did not get along with the cast any too well will probably find them all in a forgiving mood by now.

DIMPLES—20th Century-Fox)— Given ample opportunity to display her wares of wistfulness and charm, little Shirley Temple unerringly captures the high spots of *Dimples*, makes this film another smashing success for her studio. The story is concocted of simple things; a little harmonica-playing orphan living with the "Professor" of debatable ethics (Frank Morgan), meets a dowager (Helen Westley) who would like to adopt her for her own.

FLASH REVIEW!

CHARGE OF THE LIGHT BRIGADE—(Warner Brothers)—Into the valley of death rides the noble six hundred, and across the screen in the year's best action film—a picture that will thrill you from start to finish. Once again we have the ingredients that made *Captain Blood* such a smash hit the world over. Errol Flynn wears dashing uniforms, makes love to the beautiful Olivia de Havilland, defies death with that reckless smile that has carried him to stardom. Not is it all Flynn's picture, for Patric Knowles, Henry Stephenson, Nigel Bruce, David Niven, Spring Byington and a host of others have vital parts in the film. C. Henry Gordon as the native leader, Surat Khan, plays one of the outstanding rôles of his career.

Charge of the Light Brigade is great not only because of the inherently fine production itself, but because it brings to life the immortal poem of Tennyson, gives you a vision of the thing that inspired the masterpiece. Director Michael Curtiz creates a symphony of action with charging horses, flying banners, booming cannon, with enough love interest to offset the sheer drama of battlefields. This picture merits the attendance of young and old, men and women. We heartily commend it to your attention.

TOPPER'S FILM REVIEWS

Nino Martini, Leo Carrillo and Ida Lupino provide the main attraction in the Pickford-Lasky smash feature, *The Gay Desperado*.

The dowager's nephew (Robert Kent) deserts her fireside to produce stage plays. The lonely aunt fails in her efforts to adopt Shirley but loans the Professor a thousand dollars in exchange for a worthless watch he maintains once belonged to Bonaparte. The money is quickly turned over to the nephew to produce "Uncle Tom's Cabin," starring Shirley. Learning of the deception, the aunt is about to jail the Professor but relents when she sees Shirley doing Eva's death scene.

Shirley amply satisfies the young fans and manages to capture with her usual ease most of the elderly hearts. Where she fails at this, Morgan and Miss Westley step in and complete the job. *Dimples* has pathos and comedy and enough story to make it worthwhile. Even the most skeptical must admit that Shirley continues her amazing pace unabated, heading for another season of top box office records.

BIG BROADCAST OF 1937—(Paramount)—Loaded down with all the necessary elements to make it a smashing success, the latest annual edition of *The Big Broadcast* is on the way to your theatre with 94 minutes of entertainment. Built around activities in a radio studio, the picture sizzles with good gags, splendid showmanship. Jack Benny fully deserves the top billing he rates.

By way of glancing through the cast you may behold: (1) George Burns and Gracie Allen, with Gracie featured; (2) Bob Burns as the yokel radio aspirant; (3) Martha Raye as Benny's secretary—and she will wow you! (4) a supporting cast which includes lovely Shirley Ross, Ray Milland, Benny Fields; (5) Benny Goodman and his swing music; (6) believe it or call us a liar—Leopold Stokowski symphony.

With this setup *Big Broadcast* couldn't miss—and didn't. We commend it to your attention, feeling certain that if musical shows can please, this one will click nicely.

POLO JOE—(Warners)—The basic formula of *Polo Joe* is, of course, that of *The Hottentot*. This time Joe E. Brown comes from China, with Skeets Gallagher as his gentleman's gentleman. In order to win Carol Hughes, Southern belle, Brown is forced to boast of his polo-playing ability and to arrive in time for the seventh chukker of the big game and turn victory into defeat for the opposing team. Brown knows nothing about polo, is allergic to horses (they make him sneeze). He sneezes intermittently throughout the picture, substituting only occasionally his famed whoop for the sneezes. The cavern-mouthed comedian keeps the audience in an uproar with his attempts to familiarize himself with polo.

Carol Hughes, with her "you-all" directed at one person, drew snickers from the Southerners in the audience who resented the misapplication of the word. Miss Hughes is entirely ornamental.

Fay Holden plays the fluttery, doting relative capably. She gets her share of the laughs, and registers well.

Polo Joe will undoubtedly appeal to Brown fans. It is a typical Joe E. Brown comedy, and for those who like him, it is worth the price of admission just to hear him sing a Chinese song in a high-pitched voice.

ADVENTURE IN MANHATTAN—(Columbia)—Crime detection takes the stage in this picture, but proves such an undependable vagary that *Adventure in Manhattan* does not make its way into the top notch class of fall pictures.

Joel McCrea is presented as the eccentric newspaperman whose sole serious interest in life is specializing on crime cases. Given an unusual ability to analyze motives and trace their outcome, McCrea proceeds merrily through life chasing clues.

While thus occupying himself he meets Jean Arthur, leading lady in a theatrical troupe. At this stage of the game the vagaries begin to sneak into the story and we shall leave the picture to tell itself. McCrea and Miss Arthur do what they can with their roles. Reginald Owen as the stage producer with just a touch of villainy, lends strength to the film.

THE MAN WHO CHANGED HIS MIND—(Gaumont-British)—Boris Karloff, who had rather hoped to get away from horror pictures for awhile, resumes the grind in this film which tells the story of a deranged scientist experimenting with a world-shaking discovery. Specialist Karloff, after a life study of his subject, learns the secret of transferring the mind of one living being to the mind of another.

With this none-too-unusual cinematic situation, Karloff summons lovely Anna Lee as his assistant and soon turns his discovery to evil ends. Too much of the bizarre is introduced in the picture, with the consequence of turning it into a thriller instead of a pseudo-psychological study. But although the film borders on the naive, it unquestionably will prove exciting and thrilling to the not-quite-mature mind or to the horror picture fans.

15 MAIDEN LANE—(20th Century-Fox)—Jewel thieves, millions in gems and murders all center around 15 Maiden Lane, the largest jewel headquarters in the world. From this block-long street, guarded night and day by special police, a 50,000 dollar diamond is stolen in broad daylight. The audience is taken behind the scenes and shown the workings of the jewel thieves and how they recut gems. Claire Trevor, Cesar Romero, Douglas Fowley, Lloyd Nolan, Lester Matthews, Robert McWade and others.

THANK YOU, JEEVES—(20th Century-Fox)—Taken from the P. G. Wodehouse character, this film makes a fairly amusing comedy. Arthur Treacher as Jeeves turns in a neat performance as the gentleman's gentleman. His master, David Niven, has a modern knight complex, always hunting for a lady in distress. Finally his complex leads him into several entanglements in rapid fire order with Jeeves rushing to the rescue each time. When you see this one watch Treacher mix his salad dressing. You'll love it!

BEHIND THE SCENES

They Who Lead Double Lives

EVERYTHING changes with time—even the route to stardom.

It used to be that anyone aspiring to a movie career felt, "If only I could get on as an extra some famous director would see me on the screen for just one impressionable minute and—success!" Quite a few made the grade that way, but now an increasingly popular route to the top is via the stand-in road.

This is interesting because stand-ins are never photographed. But they consider themselves very lucky and as one of them explained it:

"The contacts we make while working on a picture are far more valuable than a fleeting glance of our faces on the screen out of focus.

"If we show any ability whatever, some of the directors will let us rehearse the stars' lines, which gives us a grand opportunity to prove that we are potential stars.

"And if we succeed at rehearsals, the directors call us for bit parts and if we make good in them it is just a question of hard work and a smile from Lady Luck before we have our own stand-ins."

Another break that a stand-in has over the extras is that the stand-in work is much more steady, therefore more lucrative. And another very important and expensive detail—the wardrobe department furnishes them with clothes while the extras have to supply their own outfits.

Resemblance Not Mandatory

A stand-in doesn't necessarily resemble a star, but should be approximately the same height. However, this is not essential. Harry Coinblath stands in for Fred Astaire, Edward Everett Horton, Bob

So amazingly alike in appearance that it's hard to tell who's which! Edward Arnold, on the left, looks over a script of his new film, John Meade's Woman, with stand-in William Hoover

Adalyn Doyle, above, previously was stand-in for Katharine Hepburn. She stuck the job out until she got a chance of her own to act!

Woolsey and Randy Scott, who are all different heights, but that doesn't worry Harry. A pair of trick shoes which he designed himself does the work. His height is regulated with a lever and can be raised or lowered for a range of several inches.

Victor Sabuni, who stands in for handsome Francis Lederer, is shorter than his star, so he has to have thick wooden soles and heels to make him taller. He hasn't fallen down in them yet but it wouldn't surprise him if he did. Sometimes the stand-ins are too tall and then they take off their shoes to make themselves shorter, because the difference of even an inch or so can completely throw off the lighting of a star. It isn't essential for a stand-in to have the same color or style of hair dress as the star, for it is simple enough to substitute a wig.

Mary Jane Irving, a young lady of twenty, has naturally blond hair, so when she stands in for Lily Pons and Janet Gaynor she has to wear a dark transformation.

"Baby" Marie Osborne, who was once a star in her own right, now poses for Ginger Rogers and when she is working has to cover her black hair with a red wig. And of course Harpo Marx's stand-in must wear a replica of his inimitable wig.

However, some of the stand-ins do bear a striking resemblance to their stars. Sonia Day has James Dunn to thank for her job. He saw her in a drug store wearing dark glasses and went over and spoke to her, thinking she was Marion Marsh, with whom he was about to start work on a picture. Sonia took off her glasses and showed him his mistake, but instead of

Bob Whittaker (left) came to Hollywood and won a screen job on a street corner. A talent scout picked him up to become Gene Raymond's stand-in. This scene was taken during the filming of Lily Pons' new picture, as yet untitled

This photo of Miss Hepburn shows the remarkable resemblance between herself and Adalyn Doyle, the stand-in who made good

They Who Lead Double Lives

being embarrassed Mr. Dunn took her back to the studio, where she has a steady job as a stand-in for Miss Marsh.

William H. Hoover looks so much like his star, Edward Arnold, that they are mistaken for brothers. And just to make the resemblance complete, Arnold and Hoover are both left-handed.

Bob Whittaker, who came to Hollywood on a visit, was spotted by a talent scout while he was waiting at a street corner for the light to change, and now his visit has become permanent while he stands in for handsome Gene Raymond, who is engaged to Jeanette MacDonald.

Buddy Roosevelt is another stand-in who looks amazingly like his star, Ronald Colman. It is surprising, but none of the stand-ins feel that their resemblance to famous stars hinders their personal careers in any way. They logically think out that clothes and make-up make the personality.

She Gets Advanced

One example of this is Mary Jo Ellis, who was Ann Shirley's stand-in. Now, thanks to Miss Shirley who coached and helped her, Mary Jo is playing an important part in *Make Way for a Lady*, in which her former star is the leading lady. Seeing them on the screen together you would never suspect that Mary Jo was once Miss Shirley's stand-in.

Adalyn Doyle is another stand-in on the road to fame unhandicapped by her

Here's Cary Grant with his stand-in, Bob Johnson. They scarcely look alike, but the resemblance is close enough to suffice

likeness to a star. A talent scout discovered her while she was working for Katharine Hepburn and signed her up for a long-term contract. Adalyn is now in the East being groomed for her screen début, while her sister Patsy stands in for the brilliant Hepburn. Carmen La Roux, who comes from Durango, Mexico, the same town as Dolores Del Rio, and who has been working as the beautiful Dolores' stand-in, has just signed a contract with Ramón Novarro to appear in several Mexican pictures which he will produce.

But not all the stand-ins are looking forward to a motion picture career.

Kasha, who is Joan Crawford's substitute, spends her spare time writing lyrics and music and if her latest song, now being sung and played by Wayne King and his orchestra, is a success, she will leave Joan and the movies to devote her entire time to song-writing.

Slim Talbot who came down out of the Montana mountains with Gary Cooper to play cowboy parts in the movies, and ended up by being Gary's stand-in, is perfectly happy in the background, just being with Gary and acting as official spokesman during interviews.

Rollo Dix is a matinee idol of the stage who works with Edmund Lowe in pictures while he recuperates in the California sun from a serious illness. When fully recovered he hopes to go back to his first love, the stage.

Shirley's Old Friend

Little Mary Lou Isleib has known Shirley Temple all her life—Shirley's mother and Mary Lou's mother are old friends—so

when Shirley became a famous little star and needed a stand-in Mary Lou, who has the same features and coloring, was asked to be her stand-in. Now Shirley and Mary Lou can be together all day long.

Bing Crosby and his stand-in, Leo Lynn, went to college together. As time passed and Bing and his crooning became popular he sent for Leo to help him answer his fan mail. And when Bing went into the movies Leo naturally went with him. When the question of a stand-in arose Leo obliged by stepping into the part.

However, it isn't always so easy to get the rôle of a stand-in. Katherine Doyle (another one of the Doyle sisters) decided she wanted to be an actress like Barbara Stanwyck, and taking the advice of her two stand-in sisters, went to Miss Stanwyck and asked for the job. But charming Barbara had a stand-in of whom she was very fond, so she told Katherine she was sorry, but she would keep her in mind. Five months later Katherine was given the job.

And then there is the story of Kathryn Stanley. She was first brought to Hollywood by a talent scout, but for some reason didn't click, so she went back to the business world. One day she saw Irene Dunne on the screen and resolved to be Miss Dunne's stand-in, even if she couldn't be a star. So she came to Hollywood again but still her battle wasn't won. For three long years she worked as stand-ins for other stars before she finally was given the opportunity to work for La Dunne. She also substitutes for Jane Wyatt and taught her how to play the

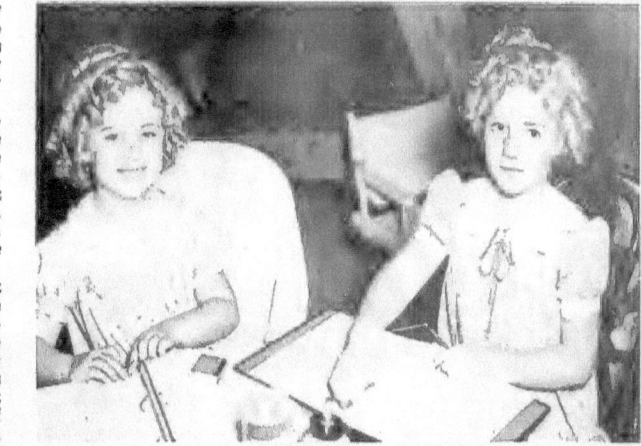

Shirley Temple and her stand-in, Mary Lou Isleib (right), are playmates during their spare moments. Each enjoys the work she has to do

violin for a part in one of her recent pictures.

A Family Affair

There are two husband and wife teams among the stand-ins. "Cracker" Henderson works for Jack Oakie, and Helen, his wife, stands in for Mae West and occasionally for Madeleine Carroll. Marilyn Kingsley, who substitutes for Eleanor Powell, and Tom Sale for James Stewart,

met while they were working on the *Born to Dance* set. They fell in love and were married just in time to work on the love scenes in the picture.

The stand-ins apparently come from everywhere and for a wide variety of reasons. Helen Parker of Chicago came to Hollywood after winning a beauty contest and now she is working with Ann Sothern, who recently married Roger Pryor, that popular orchestra leader from Chicago.

Hollywood

FEBRUARY

HOLLYWOOD 5¢

Win Fred MacMurray's Candid Camera
DARING THE GODS OF DEATH

$1,000 In Cash Awards

Choose Your Favorite Star!

PRIZES
First Prize
Second Prize
Third Prize
Fourth Prize
Fifth Prize:
Ten Prizes of
Sixth Prize:
Fifty Prizes of

You STILL HAVE time to write those 20 words of special value that may win our SCREEN STAR POPULARITY CONTEST, but if you want to share in the $1,000 to be distributed in an effort to discover who deserves top rating in the screen world, your entry will have to have a postmark during March, for the contest closes April 1.

Selection of America's No. 1 film favorite is in your hands and to learn who in the minds of filmgoers heads the list ONE THOUSAND DOLLARS IN CASH will be paid. There never has been a more simple contest. All you have to do is ballot FOR THE PLAYER YOU LIKE BEST, not for the ONE YOU THINK THE MOST POPULAR. When the ballots, now pouring in and those to come, are counted, the world will know who really IS the most popular player on the screen. The final tabulation will be a true cross-section of fan reaction because the winner—man or woman—will have gained that distinction through the ballot of those who are the life blood of the box offices—the reader fans of the world.

None can foresee who will be named the top choice. It may be someone not now in the BIG NAME CLASS. The winner will be chosen on the basis of individual favor, not because of expensive advertising campaigns put behind him or her, but because the man or woman has "that something" which makes his or her work register better than any other.

The requirements for balloting are simple. Use the ballot provided for you in this magazine, NAME YOUR FAVORITE, tell in TWENTY WORDS OR LESS why you prefer your selection and then mail your ballot to SCREEN STAR POPULARITY CONTEST EDITOR, 7046-H Hollywood Blvd., Hollywood, Calif.

For example you might say: "I vote for ———— because he or she gives sincerity to every role played." Of course, that quotation cannot be used, but the most cleverly worded reason advanced by a contestant will take the capital prize of $300. The final standing of the player to which the best reason applies will have no bearing on awarding prize.

The second best reason advanced for voting someone a favorite will take the second prize of $200. The third best expression will win a $100 prize and so on down through the list until SIXTY-FOUR PRIZES have been awarded.

Shirley Temple

Clark Gable

Remember, elaborate entries will not enhance your chance of winning. Cleverness of expression will be the basis for judging the entries.

Read the following rules carefully, then go out to win some of this EASY MONEY. If you can give your reason for your vote in 15 words and it should win first prize it would represent $20 a word. Rather good pay for a bit of your effort. Everyone who enters will be interested to learn who is America's No. 1 screen favorite measured by the fans' yardstick. Be sure you have some part in it.

CONTEST RULES

1. To enter this contest it is only necessary to name your favorite screen player

(man or woman) on the coupon published for that purpose, and tell why in twenty words, or less, you voted for this star.

2. Prizes will be awarded those contestants supplying the best and most novel reasons (in twenty words or less) for voting as they did, regardless of final standing of their choice after all votes are counted. The entry chosen as the best by the judges will receive the $300 first prize; the second best entry will receive the $200 prize, etc. In case of ties, duplicate prizes for the amount named will be awarded tying contestants.

3. Contestants may enter and thus vote for their favorite, as many times as they desire, but each entry must be printed, written or typed on a ballot coupon as published in this magazine.

4. Editors of Fawcett Publications and Motion Picture Publications are judges in this contest and their decisions shall be final. No correspondence will be entered into regarding entries in this contest. Entries will not be returned.

5. No employes of Fawcett Publications, or Motion Picture Publications, or members of their families, are eligible to compete.

6. This contest will close April 1, 1937. Entries postmarked later than that date will not be considered. Elaborate and bulky entries are discouraged. As prizes are to be awarded for reasons given for voting for your favorite screen player, your chances of winning will not be enhanced by sending in an elaborate entry.

7. After you have filled out the coupon, send it by mail to SCREEN STAR POPULARITY CONTEST, 7046-H, Hollywood Boulevard, Hollywood, Calif. You may paste your entry blank on the back of a postcard, or send it in an envelope, first class mail. It is not necessary to accompany your ballot with a letter.

DECEMBER, 1937

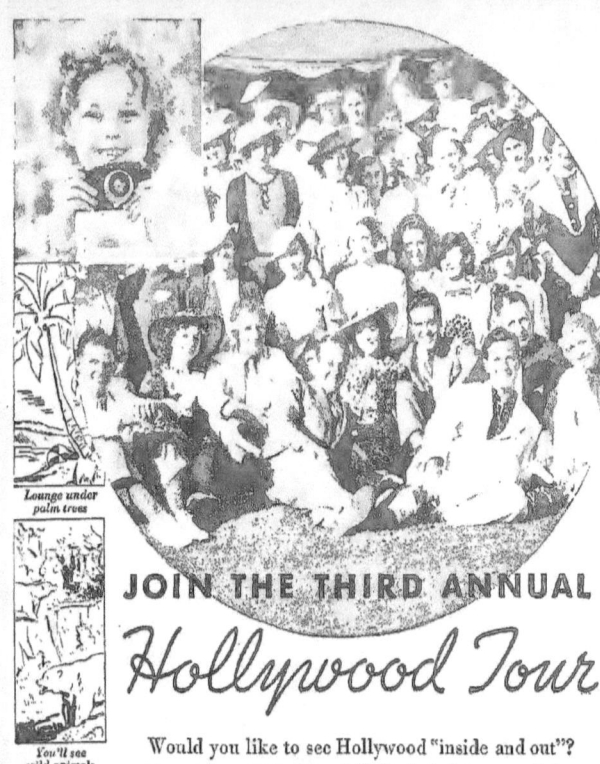

Lounge under palm trees

You'll see wild animals

Enjoy gorgeous mountain scenery

Visit movie studios

JOIN THE THIRD ANNUAL
Hollywood Tour

Would you like to see Hollywood "inside and out"? See and meet the stars? Visit their homes and the big studios?

You are invited to enjoy these rare pleasures with Fawcett Publications. We are taking two tour parties to Hollywood. The first leaves Chicago July 11; the second on August 8.

Plan your vacation to fit these dates. Two weeks on a traveling "house party" with us will give you a perfectly grand vacation. We circle the West on the Burlington, Northern Pacific, Southern Pacific, Union Pacific and the Royal Gorge Route. We see *all* of the Pacific Coast—not just California alone, but Washington, Oregon and California—all three!

In Hollywood, gates will open to welcome you, if you can join us. Send for our free folder describing the trip. Read it over. Decide for yourself. No obligation on your part whatsoever. Ask questions, please. The very low cost from your home city for the complete two weeks vacation trip will surprise you.

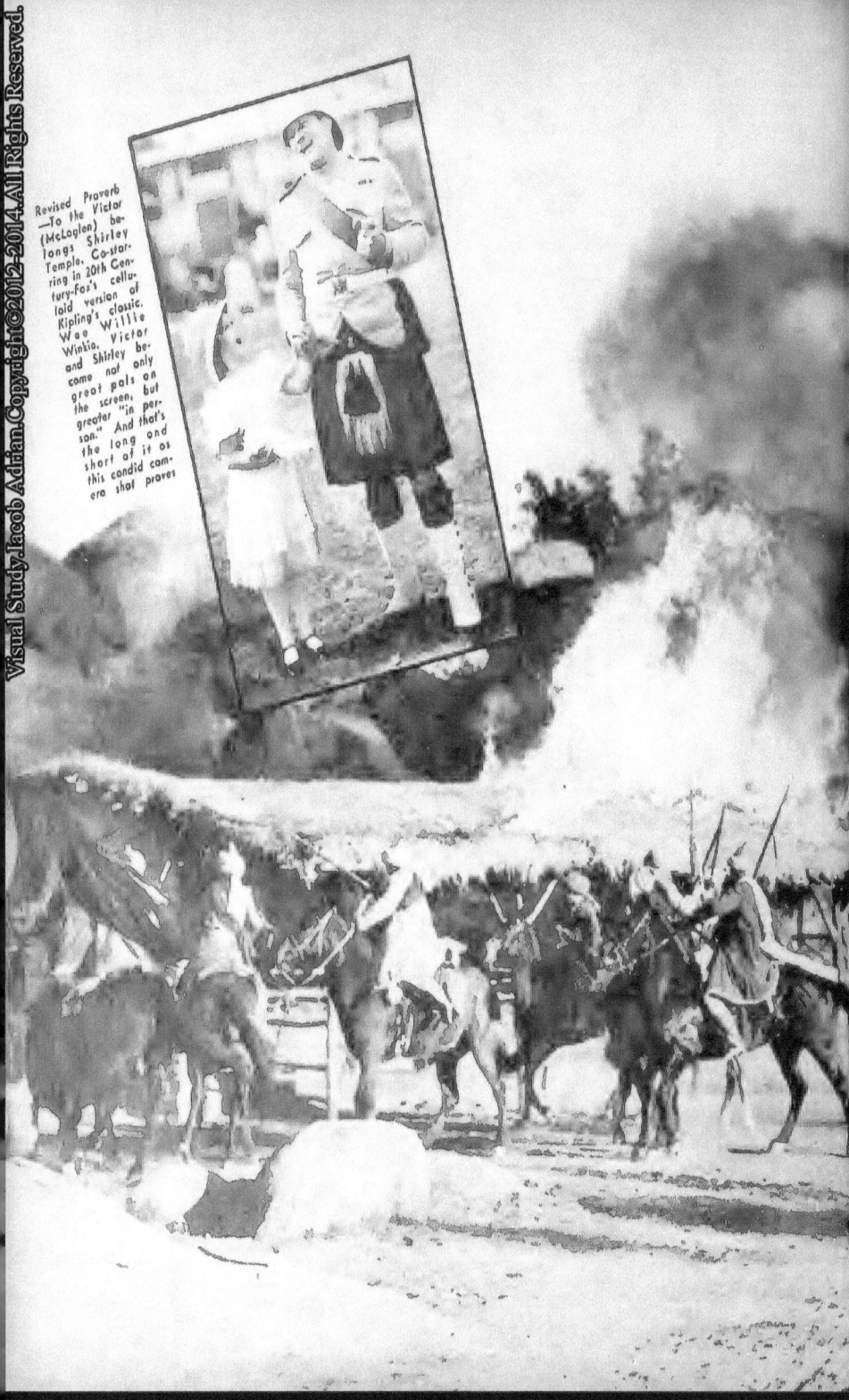

Revised Proverb—To the Victor (McLaglen) belongs Shirley Temple. Co-starring in 20th Century-Fox's celluloid version of Kipling's classic, Wee Willie Winkie, Victor and Shirley become not only great pals on the screen, but greater "in person." And that's the long and short of it as this candid camera shot proves

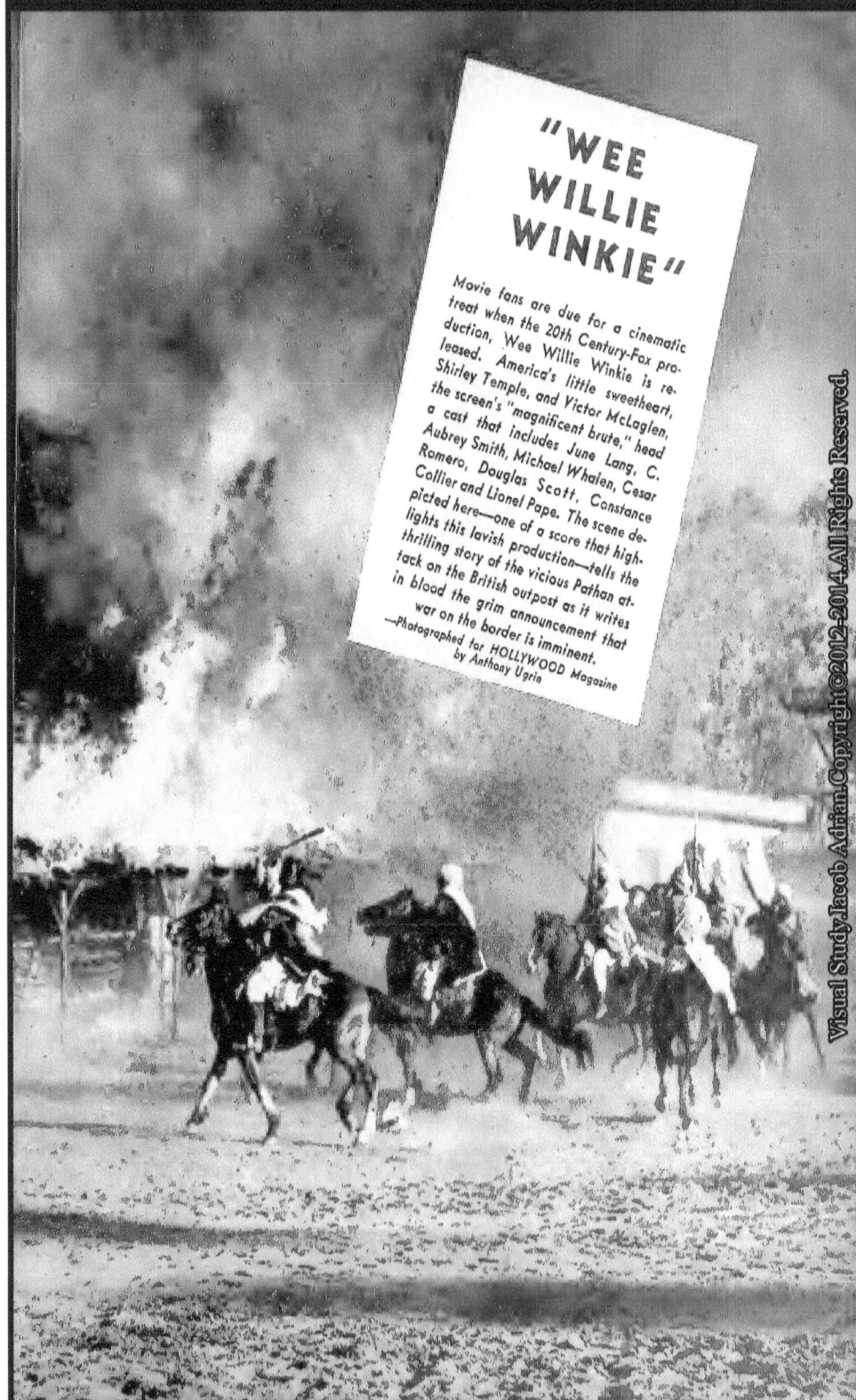

"WEE WILLIE WINKIE"

Movie fans are due for a cinematic treat when the 20th Century-Fox production, Wee Willie Winkie is released. America's little sweetheart, Shirley Temple, and Victor McLaglen, the screen's "magnificent brute," head a cast that includes June Lang, C. Aubrey Smith, Michael Whalen, Cesar Romero, Douglas Scott, Constance Collier and Lionel Pape. The scene depicted here—one of a score that highlights this lavish production—tells the thrilling story of the vicious Pathan attack on the British outpost as it writes in blood the grim announcement that war on the border is imminent.

—Photographed for HOLLYWOOD Magazine by Anthony Ugrin

Shirley's Favorite Comics

Shirley Temple, good little girl of the movies, admits that those tough little youngsters of the comic sheets—the *Katzenjammer Kids*, please her most

By P. C. MORANTTE

THERE IS SOMETHING significant in Shirley Temple's taste concerning the comic strips in the newspaper Sunday supplements.

When I asked Shirley what particular feature appealed to her, the eight-year-old cinema star replied, "Oh, I like the Katzenjammer Kids very much."

"Are they your favorites?" again I queried.

"Uh-huh," she nodded, her curls splashing gold about her head.

This was a surprise to me. For a survey I made disclosed the fact that out of ten children in my neighborhood, ranging in age from six to eleven, not one picked the Katzenjammer Kids as first choice. Not that they did not like this particular strip, but simply that they happened to prefer other features, like Skippy, Flash Gordon, Ella Cinders, Peter Rabbit, Mickey Mouse, Popeye, The Gumps, and others.

Of course Shirley admitted that she loves Tarzan also and sometimes prays for him before she goes to sleep—that is, when Tarzan is in a very precarious situation.

But this only shows that her imagination, like the imagination of all children about her age, absorbs the spirit of adventure and invests the story heroes with realism. And also, she does not want to miss Dinglehoofer und His Dog, Mickey Mouse, Orphan Annie, Bringing Up Father, Tim Tyler's Luck, Henry, Always Belittlin', and others.

"But can you understand the Katzenjammer Kids?" again I asked her.

"Oh, yes, I can," she said without hesitation, her eyes sparkling with enthusiasm. "I know Hans and Fritz."

She knows Hans and Fritz! Why, it takes experience to know Hans and Fritz. These two famous comic-strip characters are constantly devising the most outrageously clever plots to annoy their Father, the Captain, and most of the time they get away with it. Invariably they are either in trouble themselves or making troubles for others. But underlying the obvious comedy of their pranks there is a current of adult philosophy.

"Can you understand the words in the Katzenjammer Kids?" I asked Shirley, believing that her enjoyment must be confined to the mere pictures.

"Oh, yes," she answered promptly, "the way they are written."

"But," I commented, "they are such queer words and often so mixed up."

"I can understand them and read them, though," she declared, leaning against the couch beside me.

"How do you like the wordings in the Katzenjammer Kids?" I asked them.

"Oh, I don't understand them many times," said a ten-year-old boy. "But I sure understand the pictures and like the Kids, too."

"I don't read the words, because they're hard," said another, a girl of ten. "I just look at the pictures because they are funny. I like Tim Tyler best."

"The words ain't right," commented another.

"Yeah, they ain't so good," was another remark.

"Oh, yes," said an eleven-year-old girl, "I can understand some of the words. Sometimes all of them, because mother explains them to me."

These answers may not be typical. The training and environment of these children may account for the response I got from them and thus make comparison between them and Shirley Temple somewhat unfair. At any rate, ask your own child how he or she likes the words in the Katzenjammer Kids cartoons. The reply will provide you a basis for comparison between the intelligence of your kid and that of America's little sweetheart, Shirley Temple.

DECEMBER, 1937

Shirley Temple, 20th Century-Fox star

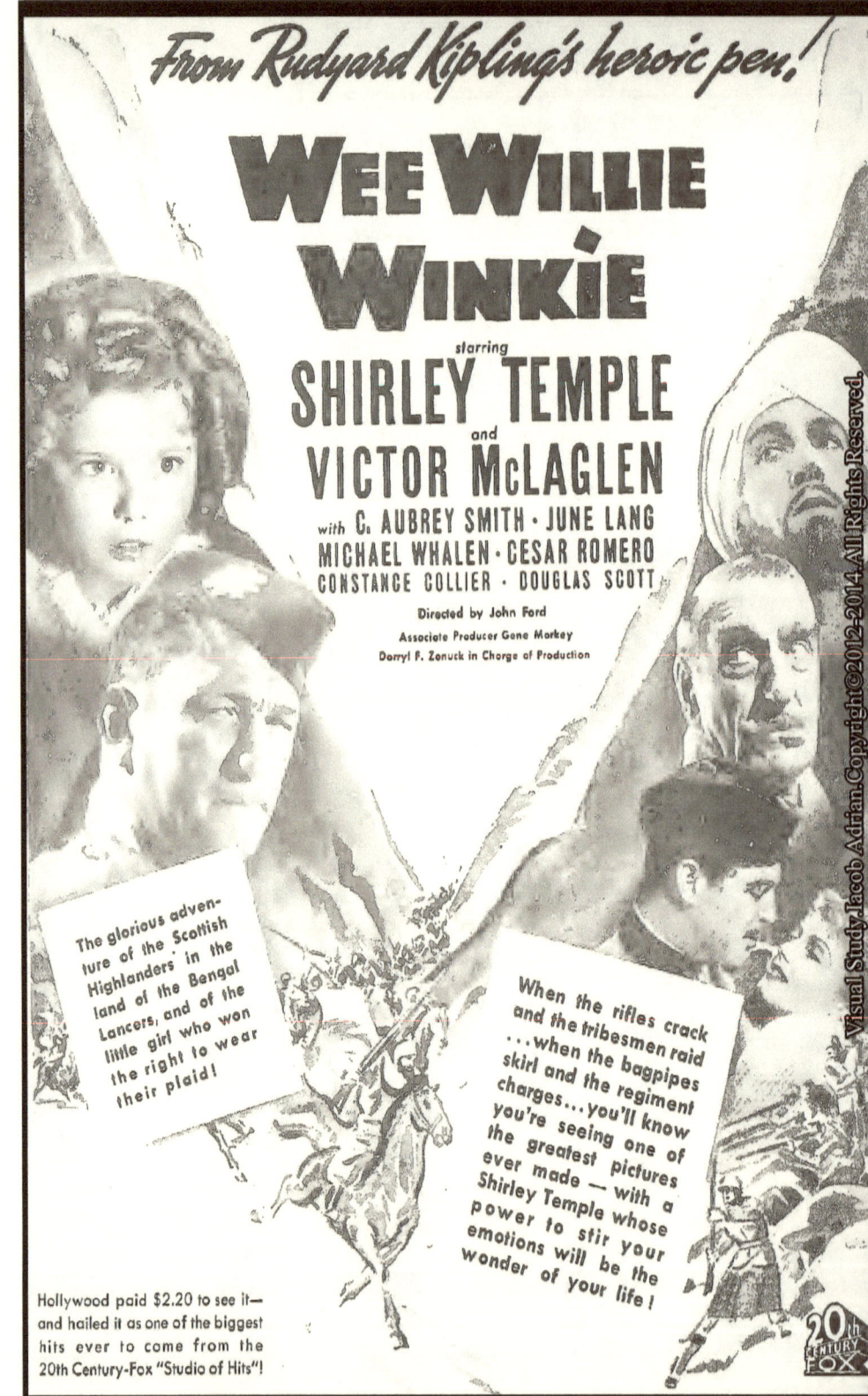

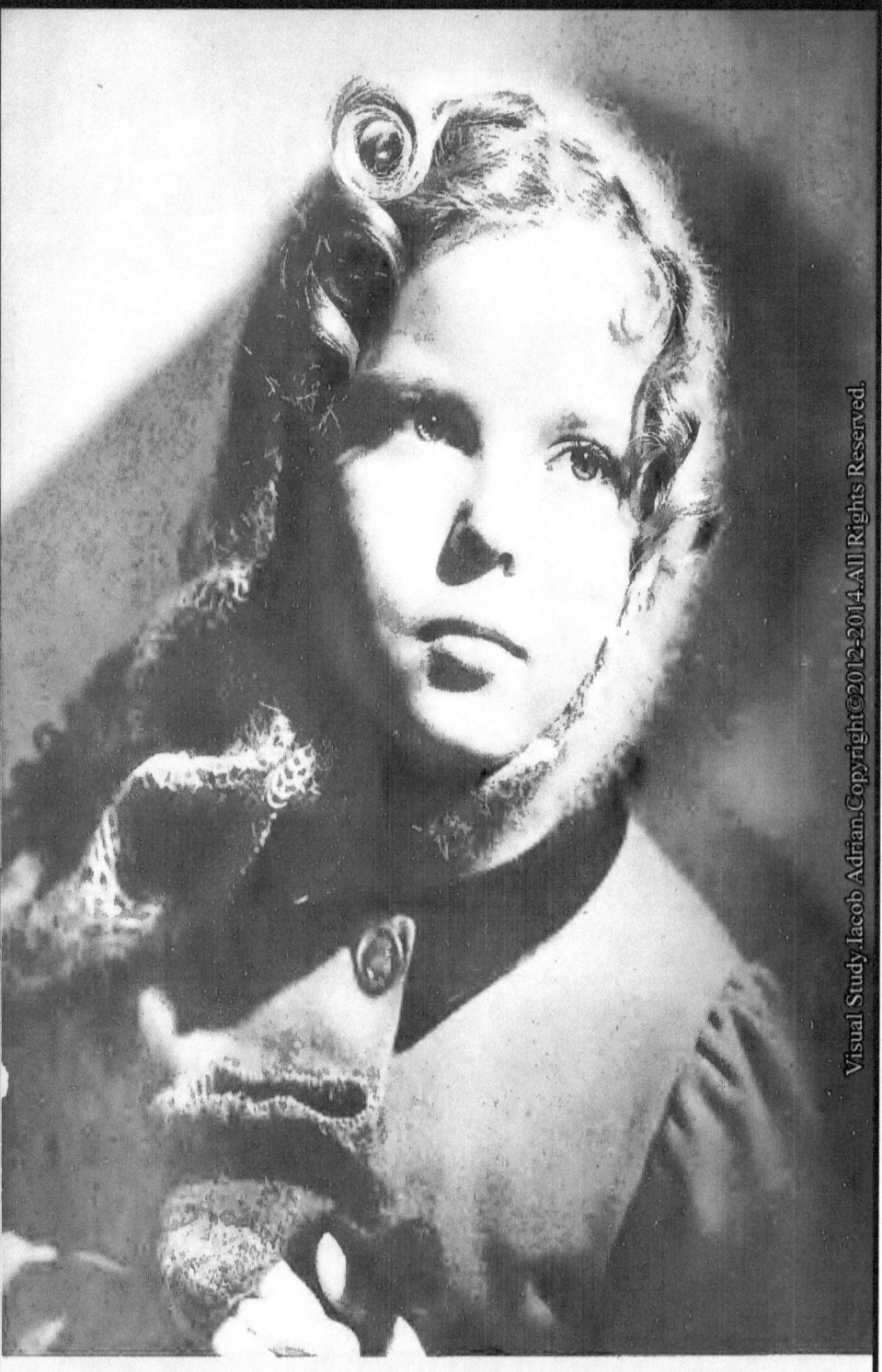

SHIRLEY TEMPLE — America's top ranking star brings *Heidi*, beloved of generations of children, to the screen as her contribution to the holiday season

Hollywood

A FAWCETT PUBLICATION

5¢

MARCH
NSC

GARBO
DRIVEN FROM TWO
HOLLYWOOD HOMES!

SHIRLEY TEMPLE
Starred in "Rebecca of Sunnybrook Farm"

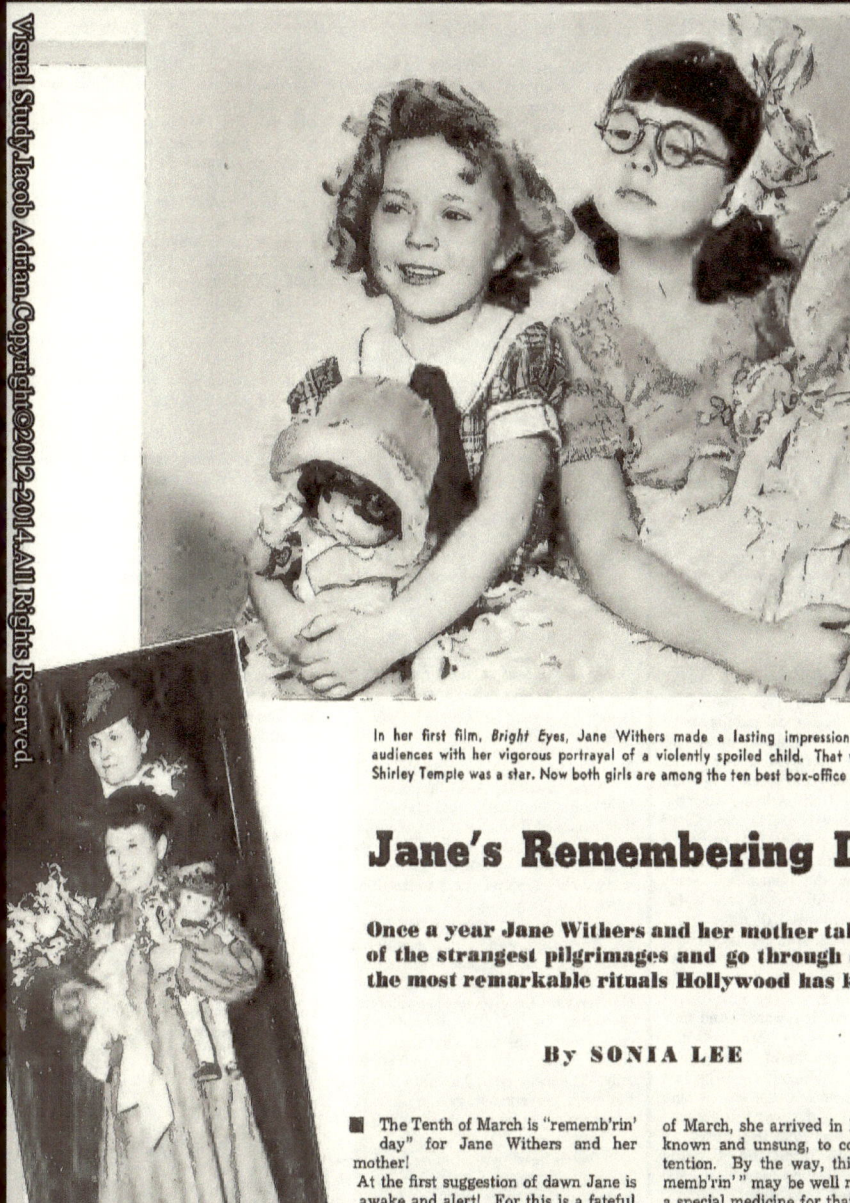

In her first film, *Bright Eyes*, Jane Withers made a lasting impression on movie audiences with her vigorous portrayal of a violently spoiled child. That was before Shirley Temple was a star. Now both girls are among the ten best box-office attractions

Jane's Remembering Day

Once a year Jane Withers and her mother take one of the strangest pilgrimages and go through one of the most remarkable rituals Hollywood has known

By SONIA LEE

This is the way Jane and her mother looked when they returned to Hollywood recently from a trip ... very different from the people who stepped off the train from Georgia a few short years ago

■ The Tenth of March is "rememb'rin' day" for Jane Withers and her mother!

At the first suggestion of dawn Jane is awake and alert! For this is a fateful date, and worth considerable celebration, as well as remembering. It is the high spot on Jane's calendar of every year!

For on the Tenth of March, Jane Withers, with the help of her mother, puts aside all the trappings of Fame to become again little Miss Nobody. After all, what good is it to be important and rich if you've forgotten how it feels to be obscure and relatively poor?

"Rememb'rin'," Jane with childish wisdom points out, "is awful good for people." All the glamour gals and boys might learn a thing or two from this youngster who doesn't fail to remember that on the Tenth of March, she arrived in Hollywood, unknown and unsung, to court a little attention. By the way, this game of "rememb'rin'" may be well recommended as a special medicine for that disease known as "Going Hollywood." Peculiarly enough, it attacks only those who've become stars overnight and suffer a strange lapse of memory about their humble beginnings.

■ This March day is a day of pilgrimage for Jane and her mother. The routine is well established. This is the one morning on which she is permitted to forget her fruit juice and her cereal, if she is so minded. Jane can wear anything she chooses. She can even show marked signs of impatience, like wiggling in her seat at the table and tapping her foot, which Mrs. Withers as the well-bred mother of a well-bred little girl never permits on other days.

Jane's Remembering Day

But special days have their special rules—and Jane for the next eight hours is not the greatest child character actress in this or any other year, and sixth among the ten top ranking stars, but the Georgia Peach, come to Hollywood for a break in the movies!

Somewhere around seven o'clock Jane and her mother are sitting on the corner bench nearest their house, waiting for the next bus into Los Angeles proper—something like twenty miles away from their present home in Westwood. But don't you mind the mileage. That's a mere stone's throw as distance goes in California.

The bus driver throws these two a casual glance. Undoubtedly he thinks to himself that they are shopping-bent—and his practical mind registers that it's awful early to take a youngster out.

The bus whirls down the road and the turning of the wheels is punctuated by Jane's excited, "Do you remember this, Mummy?" or Mrs. Withers' equally excited, "Look, Jane, there's the house with escalators!"

■ Right through Hollywood, and into Los Angeles they ride. Their destination is the Union Pacific Station, and they must reach there not a minute after eight-forty-five. That is the fateful hour. For at that very exact moment on March 10th, 1932, a train arrived from Atlanta, Georgia. Among the passengers was five and a half year-old Jane, the Pride of Atlanta, to begin that hunt for Fame.

From here on the rememb'rin' game flourishes! Mrs. Withers and Jane watch while the train unloads. Then they walk through the station, strangers again in a strange city. They stop at the taxi-cab stand and pause to remember that on that first March Tenth they asked a cab-driver how far it was to Hollywood. And they seem to hear him say— "Are you in a hurry, lady, to get there? It's quite a ways." And then dubiously— "The taxi fare will be almost four dollars. It ain't good business, but if I was you and not goin' anywhere particular in a hurry, I'd walk down to the Terminal Station and get a street car. It's just a few blocks and it'll take you there for a dime."

■ So, as if it were that morning, Jane and her mother walk that goodly stretch to the heart of downtown Los Angeles.

Right past restaurants who feature enormous slabs of roast beef in their windows and indifferent table linen. Past all the second-hand stores, the stationery shops, the windows which enticingly advertise that everything can be bought on "easy" payments.

Almost to the street-car station, Jane discovers an important landmark. "There it is, Mummy, it hasn't changed much. Only, their windows are painted blue this year." So in they go to a tiny, tiled restaurant, which simulates the rustic spirit with its log-cabin walls and low-hung ceiling.

The Withers ate lunch here on the fateful day of arrival. And Jane today, as then, is permitted the forbidden, and orders a sandwich with a strange concoction as filling.

Once inside and perched on a stool, Jane is much too polite to remember audibly, but her eyes bob up and down in excitement.

In 1932, sandwiches were six cents and an enormous glass of milk was a nickel. Now, rising restaurant prices interfere with the re-living to exactitude of that first March day. Sandwiches are up to fifteen cents, and a glass of milk is a dime.

■ At the Terminal, they board the Hollywood street-car, and are soon at the hotel in the heart of movie-city, where they spent the first two days of their Hollywood sojourn.

In the lobby Jane and her mother have a half-hour of real rememb'rin'. "Do you remember how lost we felt, Jane?" her mother asks. And Jane crinkles her inimitable nose and replies in the very self-same tone and words as she did then. "I'm lonesome for my daddy. But we'll be all right, Mummy."

From there on rememb'rin' day is a matter of visits. To the places and the people they knew in their first obscure and lonely months, when their tattoos on Hollywood studio gates didn't make the sound of a dropped pin.

■ First, there is that visit to 5555 Hollywood Boulevard—to the one-room, kitchenette and bath apartment which they occupied during the first months of their struggles. Apartment 202 has now become a place of distinction—mothers bring their youngsters here to instill ambition into them.

Out into the yard Jane and Mrs. Withers go. This is the scene of the now defunct "Gilmore Circus"—a Jane Withers enterprise of those days. The neighborhood children were the cast—the show, informal specialties by all the playmates Jane could round up—and admission 2c for sitting place, and 1c for standing room only. The memory of Jane's undertaking has been perpetuated by the apartment house manager, who to this day refers to the back yard as "The Circus."

In Jane's heart several other neighborhood places are immortalized. The Five and Ten Cent store, not far from this apartment house, where Jane regularly did her shopping. It is the sort of a place where clerks and cashiers have a lifetime job and practically all of them remember Jane long, long before her name was in lights.

She knows them by name, too, and she goes from counter to counter saying "Hello" and, as usual, does some shopping. She is their little girl, and next best to being themselves in the movies, they'd just as soon it were Jane. Isn't this for their Jane?

■ From the ten cent store Jane trots down to a nearby pressing shop. This is the incubator of her first business experience. At the ripe age of six she lent a friendly hand to the proprietor on busy afternoons. Her penmanship wasn't very legible, but she would insist on writing down the names of customers. The fatherly gentleman would smile benignly and re-write the slips after Jane left. He wouldn't hurt her feelings for the world by doing so in her presence. Or have her lose faith in the perfection of her first A B C's.

On rememb'rin' day, Jane gives him samples of her hand-writing to show the considerable improvement, and he pats her on the head, and declares in all good faith, that some day she'll be learned enough to go to college.

■ The corner drug-store is next on the list. Her visit is fittingly inaugurated at the fountain with a double chocolate soda, topped off with an extra helping of whipped cream.

A close inspection of the lollipop situation is now in order, and lime is the choice. "You always did like lime best," beams the boss. "We take extra care to have lime for you every Tenth of March, Jane."

From here on, by bus and street-car, Jane and Mrs. Withers make the rounds of the Studios! They walk slowly past RKO, Warner's, Paramount and the others, and very, very carefully look again on the once forbidden gates. They remember them best by the fact that in the old days they couldn't get through!

■ One more call Jane and her mother make, and that is to the home of Mrs. David Neville in whose apartment house they lived for a few weeks during those early days. The Withers and the Nevilles are now close friends. They see each other frequently. But this is a very special visit, with particular thought given that army blanket Mrs. Neville loaned Jane for play purposes, and which she promptly converted into a tent. The small fact that she cut a piece a foot square out of it to make a window is now laughingly mentioned, but it wasn't discussed then.

"After all, you can't scold a child for having imagination," Mrs. Neville at that time explained to the horror-stricken Mrs. Withers. "I can't think of a better way to make a window in a tent than by cutting it right out."

And so the day is done! The day of rememb'rin'! The Tenth of March—a red-letter day on which Jane never works, but spends in retracing her first discouraging steps to Fame!

At last the bus deposits Mrs. Withers and her small daughter at the corner where it picked them up early in the morning.

■ As Jane and her mother walk towards their present home in fashionable Westwood—a charming farm-house surrounded by extensive grounds—they contrast it with that one-room apartment.

And they look at each other! And there is more than young understanding in the eyes of the child. There is deep gratitude in the eyes of the older woman!

"Aren't we lucky! We must never forget that!" says Mrs. Withers.

Wordlessly they pledge themselves never to cease their rememb'rin'!

HOLLYWOOD NEWSREEL

By WHITNEY WILLIAMS

■ FLASH: Alfalfa, crooner de luxe of Our Gang, isn't THAT way about Constance Bennett any more. She allowed him to sing for her in her dressing room for nearly an hour . . . and rewarded him with only two dishes of ice cream. SIX always has been Alfalfa's price.

■ Annabella, the new French star, hasn't been long of Hollywood . . . but already she's firmly implanted in the affections of the hamlet.
Learning that her English stand-in, the one she employed in London, wanted to come to Hollywood, Annabella arranged for her to be brought to America, all expenses paid. Why, the new employer even gave her a house near the studio!

■ So it's fun to be a star! Consider the case, then, of Norma Shearer.
For her new picture, *Marie Antoinette*, Norma must wear thirty-four different costumes and eighteen wigs. You may have read this before. But here's something you probably never heard before . . .
For the past four months, the star has spent from four to five hours daily three or four times a week for fittings! And the end is not yet in sight. Still convinced that a star's life is a merry one?

■ Funniest sight of the month was a tough-looking egg holding a pastel-colored lady's umbrella over him outside the Republic studios, while the skies unbosomed themselves . . . he looked surprisingly like Bull Montana . . . remember him? . . . Maureen O'Sullivan sent all her friends in Hollywood English plum puddings, while in London on location for *A Yank at Oxford* . . . Joan Blondell's brother, Ed, has a daughter the perfect image of Joan . . . and speaking of likenesses, Gloria Somborn is a dead-ringer for her famous ma, Gloria Swanson . . . she's about sixteen, now . . . Jane Wyman, for all her doll-like face, throws a poker game every Saturday night, and whips up a mess of Spanish dishes herself . . . she and her husband live in a white modernistic flat . . . how's this for luck—Melvyn Douglas appears with THREE leading ladies in *There's Always a Woman*, for Columbia . . . Joan Blondell, Mary Astor and Frances Drake . . . mebbe THAT will erase that cold calm of his . . . Stuart Erwin, who once thought himself quite a tenor, has named his new Doberman Pinscher "Elsa of Lohengrin," because of her deep "contralto" voice . . . George Raft is building a new house, near Kay Francis . . . there's nothing niggardly about Fernand Gravet . . . he's already talked to his mama in Paris to the tune of more than $2,500 telephone toll, and his picture isn't half finished . . . if you know of a six-footer who can plunk the banjo melodiously and can talk like Andy Devine (the s-f, NOT the banjo), get in touch with Nat Pendleton . . . he wants him for a stooge . . . ADD GOOFY BET —Leo Carrillo and Victor Fleming, the director, have wagered an Arab steed on who can raise the highest oats in the shortest time on their ranches south of Hollywood . . . believe it or not, but 'tis said that at Palm Springs during a Santa Claus parade all the town kids followed Shirley Temple—instead of Santa—when Shirley's parents decided it was time for her to return to her hotel and marched her home . . . Francis Lederer defies superstition by walking under ladders, throwing his hat on the bed and whistling in his dressing room . . . honest! . . . you'll be seeing him as "The Lone Wolf" . . . Bert Lytell originally was seen in this character years ago . . . and now it's Gene Raymond who has gone cowboy in a beeg way . . . the blond debs' favorite week-ends occasionally at the B-Bar-B Ranch near Palm Springs, and appears resplendent in loud plaid shirt, chaps and wide sombrero . . . whoopee! . . . wot luck—Claudette Colbert must drink at least five glasses of milk and cream daily to keep up her weight . . . Bert Lahr hosted a ragamuffin party, and winner of the first prize was no less than nobility . . . the Earl of Warwick . . . you'll see him in *The Buccaneer* under the name of Michael Brooke . . . George Brent is a full-fledged American now . . . he recently obtained his final citizenship papers.

■ Stars garner colossal salaries, but not all of it goes into the banks. Within a few days of each other, Ginger Rogers acted as hostess to five hundred orphans at a matinee of *Hansel and Gretel* at the

The opening of *Snow White* at the Carthay Circle in Hollywood was the outstanding event of the show season. When Shirley Temple arrived to see the faery tale, the seven dwarfs were waiting to help her find her seat

Walt Disney and his wife, happy over the brilliant gathering of stars on opening night, had a hard time getting past eager cameramen, even with the aid of one of the loyal little dwarfs

Minnie, Mickey and Donald Duck gamboled in the fore-court and helped to emphasize the party spirit that marked the evening when all of Hollywood turned out to pay tribute to the magic of Walt Disney's pen

IMPORTANT PICTURES
By LLEWELLYN MILLER

No, we did not get the pictures mixed. This is *Rebecca of Sunnybrook Farm* in the middle of a song and dance routine. Shirley Temple brings her own especial magic to the 1938 version

REBECCA OF SUNNYBROOK FARM
(Twentieth Century-Fox)

Life is full of surprises, so don't be startled when *Rebecca of Sunnybrook Farm* opens with a scene in a radio station. Don't become uneasy, and ask the usher if you are in the right theatre. Just sit still, because you'll probably have quite a good time with the picture, even though you won't see the dear familiar tale of little Rebecca who went to live in the red brick house with Aunt Mirandy and Aunt Jane.

Aunt Jane is gone completely, and Aunt Mirandy (Helen Westley) turns up astonishingly with a comic suitor (Slim Summerville). Gone is Mr. Cobb. Gone is Adam Ladd. Gone is the hateful Minnie Smellie and the sweetly dull Emma Jane Perkins. Gone, for that matter, is Rebecca, herself, leaving Shirley Temple the undisputed center of attraction. And, after all, what more does anyone want in a Shirley Temple picture?

Time and again, audiences have demonstrated complete satisfaction with the studio's efforts, so long as Shirley has plenty of songs and dances. As the New Rebecca, Shirley plays a radio performer caught by the recession. Her manager-stepfather, believing that she has flopped (oh, traitor thought!) at a tryout, turns her over to Aunt Mirandy who hates show people. In the meantime radio station officials (Randolph Scott, Jack Haley) are searching frantically for her. By happy chance, they occupy a house right next door to Aunt Mirandy's when they go to the country for a rest. So the next thing you know, Shirley is running back and forth across the lawn to go on the air behind Aunt Mirandy's back. She dances with Bill Robinson, she aids the romance of her cousin (Gloria Stuart) and she sings a generous number of songs with that exact showmanship which enchants a huge audience.

Beyond any doubt, *Rebecca of Sunnybrook Farm* is an immensely successful picture, but besides that, it blazes the trail for an entire new group of dramatic properties in which Miss Temple might be starred. The imagination is fired by the possibilities... Shirley Temple in *The Taming of the Shrew!* (Suggested plot: Shirley as an orphan cajoles an evil-tempered aunt into marriage with a lonely tap-dancer)... Shirley Temple in *Camille!* (Suggested plot: Shirley's widowed father suffers terribly from hay-fever until Shirley gets him a job on a transatlantic liner and introduces him to the captain's lonely daughter)... Shirley Temple in *Carmen!* (Suggested plot: When Shirley's widowed mother is too ill to go to work as a cigarette girl in Child's restaurant, Shirley takes her place, meets a lonely musical comedy producer and puts over his show)... Shirley Temple in *Beau Geste!* Shirley, the only survivor of a shipwreck off the coast of Africa, becomes the darling of the lonely Foreign Legion, and cajoles the blood-thirsty natives to

Important Pictures

a peace pow-wow with her song, "Give a smile a trial before you shoot!"

Well, it's nice to know that there is no danger of Shirley retiring because of lack of suitable stories. This department would miss her terribly.

BLUEBEARD'S EIGHTH WIFE (Paramount)

Michael (Gary Cooper) believed firmly in marriage. He respected women, and when he proposed he meant nothing less than honorable wedlock. That is how he happened to have married . . . and divorced . . . seven wives.

Then he met the lovely Nicole (Claudette Colbert), daughter of an impoverished but still hopeful French nobleman (Edward Everett Horton). It was love at first sight for both of them, but it takes eight reels of rousing comedy before they realize it.

Nicole consented to become Michael's eighth wife, but only on a coldly commercial basis. Then she began a campaign of heckling designed to take her with all possible speed to the divorce courts.

How she uses real and fictitious rivals, phoney notes and spring onions to enrage her stubborn spouse, and how he retaliates is something that you should investigate for yourself. You'll be sorry if you miss this one.

EVERYBODY SING (M-G-M)

This is another tale about one of those nit-wit, run-around-and-act-crazy families, so popular at the moment.

The mother (Billie Burke) is a star who cannot stop acting in the home. The father (Reginald Owen) is a temperamental playwright. Bankruptcy stares them in the face until the cook (Allan Jones) puts on a show in which the youngest daughter (Judy Garland) makes a hit. But before that happens, Fanny Brice, Reginald Owen, Henry Armetta and Lynne Carver have opportunities to add comedy and drama to make the story seem a little different.

For some reason, not entirely clear to me at the moment, I keep thinking about what would happen if Miss Judy Garland could be cast in a film as the sister of Miss Martha Raye. Wow!

HER JUNGLE LOVE (Paramount)

All alone on a wildly beautiful South Sea Island lives Tura, an exquisite native maiden in a seductively cinched-up sarong.

Into her tropic paradise crashes a plane carrying Bob (Ray Milland) and Jimmy (Lynne Overman). After their first moments of frightened suspicion, Tura (Dorothy Lamour) settles down to a happy life of learning English, bandaging the injured Bob and singing songs.

But comes the evil day when natives from a nearby island arrive for the yearly ceremonies of sacrifice to Tura whom they worship as a goddess. Led by an embittered Eurasian (J. Carrol Naish) who cherishes a gnawing hatred for all white men, they enter a vast subterranean cave where blood-thirsty crocodiles crawl in horrid swarms, waiting for human sacrifice.

The film follows the familiar pattern of most jungle romances, but on a quite stupendous scale. Where other such films have been content with a dozen crocodiles, this one has hundreds. The sacrificial cavern is as big as all out-doors. It has not only stalagmites, stalactites, but little bubbling volcanos, and when it collapses in an opportune earthquake just when everyone you like in the cast is right on the verge of being sacrificed, it comes down like the Grand Canyon caving in.

Technicolor adds greatly to the tropic splendors of the background. The late lamented Jiggs, most talented of all screen chimpanzees, has an important role, and you'll find yourself planning a vacation in the South Seas, if you don't watch out.

FOOLS FOR SCANDAL (Warners)

Persistence must be a prime virtue in the gentle art of romance, if we can believe all we see in the movies, for so many tales show a determined young man laughing off vicious rebuffs until the heroine grows weary of insulting him, and melts into his waiting arms.

Such a one is *Fools For Scandal*. Fernand Gravet, as a broke but very well dressed Marquis is having a hard enough time without adding foreign entanglements when he sees a beautiful American brunette (Carole Lombard). Then his troubles really start. Her mysterious actions are explained by the fact that, under the dark wig, she is a blonde movie star on vacation. But that is not discovered until the Marquis follows her to London, and insists upon taking seriously her offer of a job as chef.

Ralph Bellamy and Allen Jenkins add greatly to the comedy content, which is very high. The whole affair is featherweight and very funny.

JEZEBEL (Warners)

Miss Julie was willful and wayward and stubborn. But Miss Julie was mighty fascinating, and she knew it, and she was at some pains to keep others from forgetting it.

Not since *Of Human Bondage* has Bette Davis had such a strong role, or such a difficult one. She has to gain, if not sympathy, at least understanding for the headstrong girl whose chief pride lay in showing her power over men. Gentlemen of the old South did not beat up their loved ones, in the manner so popular in modern movies, but they had other ways of evidencing displeasure. And before the end of the film, Miss Julie experiences rigorous discipline for her ruthless way.

ONLY 5 CENT MOVIE MAGAZINE IN THE WORLD

HOLLYWOOD

A FAWCETT PUBLICATION

(Reg. U. S. Pat. Off.)

DECEMBER
5¢

SPECIAL HOLIDAY NUMBER

Shirley Temple

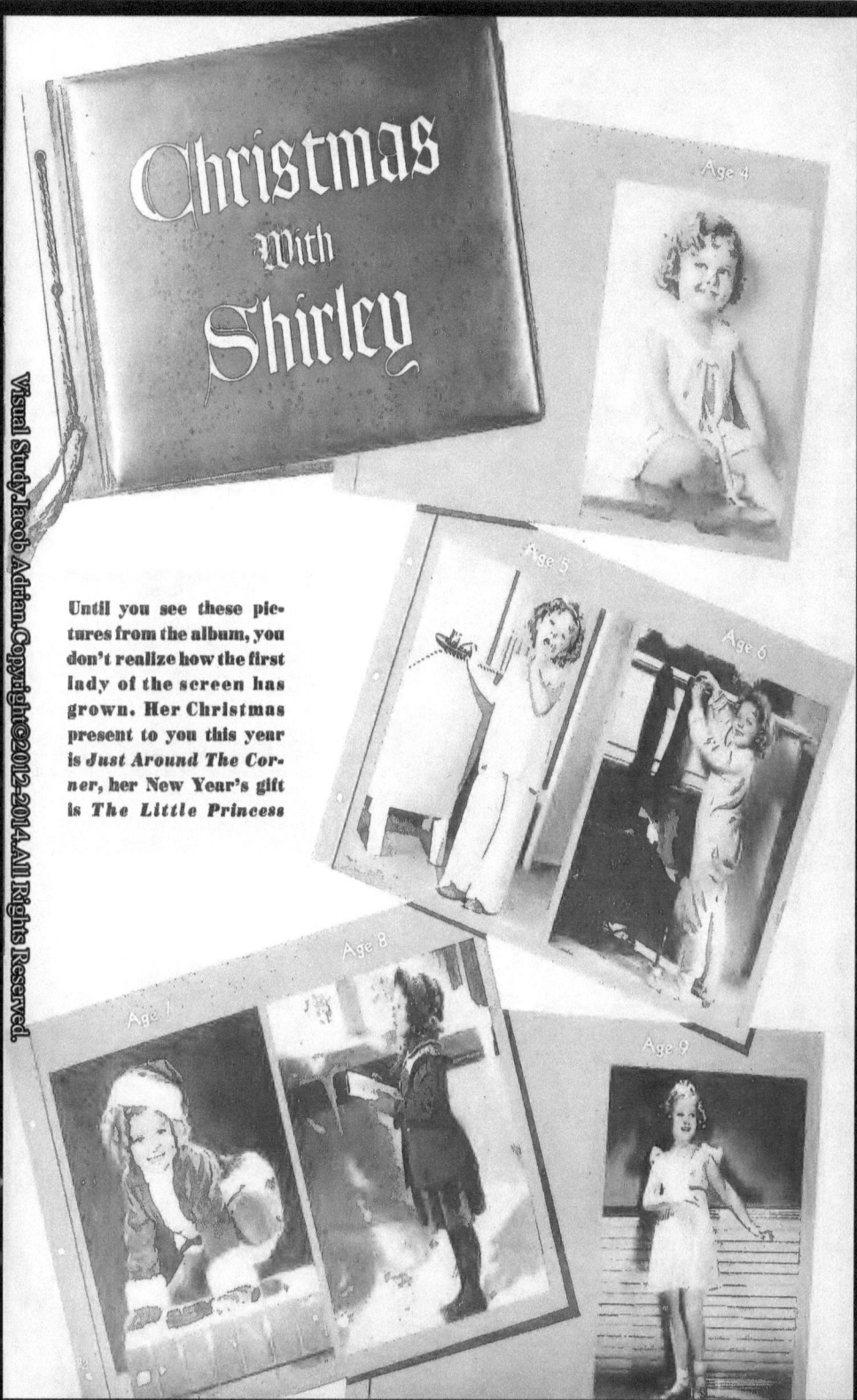

Hitting the Come-Back Trail

Charles Farrell has been on the top, the most sought-after young leading man in Hollywood. He also has seen the time when parts were poor and very far between. His story, between his last success and his part in Shirley Temple's film, *Just Around the Corner*, is absorbing

By ED JONESBOY

■ Way back in the bleak, black days of the First Depression, tall, likeable, and handsome Charles Farrell, the Cape Cod boy who made good in Hollywood, stood at the top of the movie ladder of fame, a celluloid king of all he surveyed.

More stories were being written about him than about any other actor in the business. His fan mail had grown to such huge proportions that it was a big headache to the postoffice department. He had an airtight contract with Fox Film that called for a weekly salary of $3,000. He had, as we backwoods folk so drolly put it, the world by the tail and a downhill pull. His pictures with Janet Gaynor were making so much money that the studio had to hire extra help to cart it to the bank and Fox executives were wearing those 'smiles that won't come off' as they figured on future profits.

And then it happened!

Charley Farrell, Cape Cod boy who had made good in Hollywood, decided to call the whole thing off and before a director could say "cut" he tore up his contract that was worth $100,000 if it was worth a cent, and said he was through being a party of the first or second part in pictures if he had to play those sappy, sugar-sweet roles he'd fallen heir to.

Well, the ripping of that contract made a sound that was literally heard around the world. Charley was smothered by fan mail that said he must be more than slightly 'teched in the haid' to commit such a movie blunder. Other studios offered him big important money if he'd reconsider and sign on the dotted line for roles similar to those he'd been playing, but to all enticing offers Charley turned two deaf ears. The chances are that if he'd had six he would have turned them, too, being just that stubborn about the whole thing once his mind was made up.

He was, so he calmly stated to all and sundry, definitely through with all sugary parts that tabbed and typed him as a "walk-in, walk-out" sweetheart. From now on, he said, his movie diet would consist of one

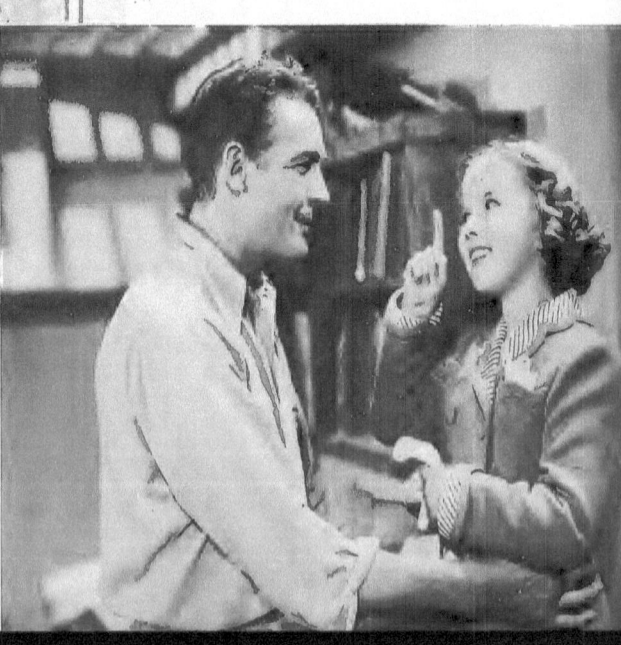

Hitting the Come-Back Trail

hundred per cent roast beef—or else. Otherwise he was through—and very definitely.

Well, movie history proves that when all was said and done, "through was the word for Charley."

Eight long and idle months passed by before he got the "nod" from a studio for camera work. He'd had plenty of offers to play the same type of role that had contributed to his fame, but he had turned them down as fast as they had come along. During those eight long and camera-idle months Charley read scripts, studied hard, and in between times acquired a tan, a fishing boat, some horses and small pieces of property. He appeared more confident, more enthusiastic, more sure of himself and his future, and a hundred times happier than he'd ever been despite his self-maneuvered eclipse. And he showed it, too, in his first comeback picture, *A Girl Without a Room*, for Paramount, and later in *Aggie Appleby* for RKO, and still again in *The Shakedown* for Warners. It began to look as though the shrewd Cape Cod boy had at last vindicated his judgement of himself, and the comeback trail began to smooth itself out to accommodate the long, sure strides of the young man who had bet a $100,000 contract against the success of his second career in pictures.

And then he began to backslide. He popped in and out of a few pictures, each one, so he says now, worse than the other until he finally discovered that if he kept it up he'd most likely win the Hollywood title of the official Keeper of the B's—not overlooking the C's and the D's.

■ By now a lot of water had passed under the movie bridge since the eventful day he had been co-starred with Janet Gaynor in *Seventh Heaven*, the picture that had shot them both, as unknowns, up into the higher reaches of stardom. Over-the-fence gossips began to pass the good word around that Charley's voice was so high-pitched that it was and always would be unadapted to the "mike" and these rumors, piped into the elaborate front offices of the powers-that-be, began to have their effect. Picture committments were soon infrequent, and Charley, smarter by far than a hundred other actors who had failed to see the handwriting on the wall decided to call the whole thing off.

And he did, save for one brief return to the Fox lot in 1934 when he was assigned the leading male role in *The World Is Ours* in which he was reunited with Janet who had been going it alone and doing pretty well for herself in such films as *Adorable*, *State Fair*, and *Paddy, the Next Best Thing*.

Although she wasn't aware of it, nor anyone else for that matter, it was about this time the movie moving finger began to write the history of her gradual decline —a descent from greatness that almost carried her down and out of the Hollywood scene. Almost, but not quite. Thanks to *A Star Is Born*, her return along the comeback trail last year has been in a blaze of glory and her name once again is one to be reckoned with when "important people" are mentioned in the film factories.

But back to Charley.

■ For a boy who had been so liberally sprinkled with star dust, Charley took his defeat without a whimper. What hurt him the most were the wounds inflicted by his "fair weather" friends who began to give him the cold shoulder and the icy stare as only Hollywood fair weather fellows can give it, but he managed to take this "chill" without much complaint.

"It all hurt a little," he admits honestly, "and I'd be an out-and-out liar if I said it didn't, but strangely enough it failed to ruin my life. I bought myself some polo ponies and learned how to play saddle golf with Big Boy Williams. I had a nice home, a lovely wife who refused to let me mope, a little money in the bank and a philosophy that somehow just wouldn't let me turn sour on either the world or myself. I traveled around a bit and made a few pictures in Australia, England, and Germany. When I wasn't doing that I was deep-sea fishing and when I wasn't deep-sea fishing I was playing tennis and when I wasn't doing that I was looking around for good real estate investments."

Now we're getting somewhere.

■ Playing tennis and looking around for good real estate investments brings us right down to the Mojave Desert in general and Palm Springs in particular where Charley has made himself a sizeable fortune in a few short years.

"I used to go down there," he says, "just for the ride and to play a little tennis during the winter months. It was usually for the ride because what tennis I could play had to be played on the hotel courts when the guests weren't busy bouncing the ball back and forth. It finally got so that the guests were playing all the time which didn't help my game any, so after a bit of looking around, I bought a sandlot or two, interested a friend or two in my idea of forming a tennis club, and in a month or two had established what is now known as the Palm Springs Racquet Club. It's turned out to be quite profitable although we haven't declared any dividends as yet, preferring to turn all earnings back into improvements."

Charley is as modest about the Racquet Club as he is about everything else. Any time a young man can work up a membership in a tennis club from 100 to 750, have a waiting list almost as long as the home stretch at Santa Anita, while running the business only four months a year, has something that puts him in the plutocrat class. It took a different kind of sand that goes to make up the Mojave Desert to start it—and Charley has plenty of it.

■ The Racquet Club has been a fortunate investment in another way, too, because to it goes the credit of getting him back into pictures.

Irving Cummings, 20th Century-Fox director, walked into the club not long ago, spied Charley, the genial host, and almost sprained both ankles getting to him. "Listen, you old fossil and Peter the Hermit, where have you been hiding? And why? Don't answer. All I want you to tell me is that you'll take the nice part I've got for you in Shirley Temple's new picture—tentative title, *Lucky Penny*. Don't say no and don't say yes. Just think it over for a minute. I'll wait. Okay then, it's all set."

Charley finally managed to squeeze in a mild protest. "Listen, you old liar and so-and-so, don't try to kid an old desert rat. You know as well as I do that Fox would never take me back. Maybe you don't remember the battle I had getting out of my contract."

Irving said he remembered ALL about it, told Charley to stop worrying, and went to a nearby phone and put in a call for Darryl Zanuck and when the connection was made told 20th Century Fox that he wanted to make a test of Farrell. Zanuck, being pretty quick on the verbal trigger, wanted to know what was holding him back.

Two weeks later Director Cummings made the test and when Zanuck saw it he said: "You know, Irving, the best thing I like about that guy is his voice!"

"Which just about knocked me for a loop," Charley says, "because it was my voice that put me on the shelf."

■ It turned out that Charley had been his own voice teacher without knowing it.

"We installed a microphone at the Racquet Club and in time I got to be a 'mike' bug. At night, when the place was crowded, it was difficult to be heard, but I discovered that if I lowered my voice the sound of it seemed to penetrate through all the noise. A month or two of that and I found myself talking in a low-pitched voice whether I was near the mike or not. Fortunately for me, it got to be a habit good enough to win a screen test and a picture contract on the lot where I had made my first great success, *Seventh Heaven*. In the good old days I starred with Janet who turned out to be America's Sweetheart—and here I am again, starting over with Shirley Temple, the present-day America's Sweetheart. A good omen, don't you think?"

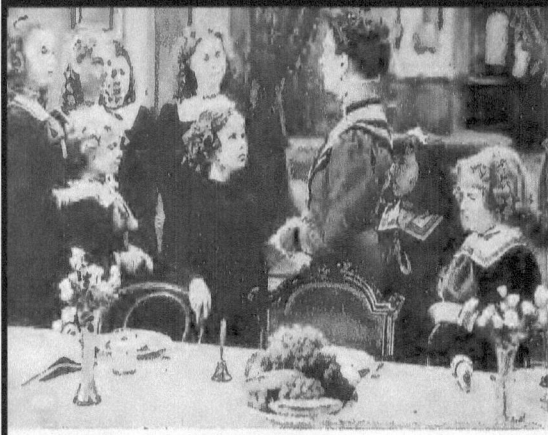

Shirley Temple as *The Little Princess* finds that the world is cruel to a little girl alone in the world

The little princess finds a friend (Arthur Treacher). Right, with her father (Ian Hunter) before trouble came

Getting Away From It All

Stars have to pay dearly for privacy. Here is how Shirley Temple gets a little peace and quiet when she is between films

By
JESSIE HENDERSON

And now Shirley Temple has a "hideout!" Yes, the nine-year-old star needs to get away from it all occasionally, the same as her older stellar sisters. When Shirley takes a vacation from the limelight, she takes it where not a ray of limelight can penetrate—in the entire list of Hollywood hideaways, hers is the most effective.

So whither do you suppose the screen's Number 1 Box Office Allure betakes herself in the intervals between films? A cave somewhere in the mountains where she can play Injun? A Pacific island rich in pirate lore? Or, since Shirley's favorite radio program is "Gang-Busters," some isolated spot where G-men might keep secret lookout for marauders?

No, indeed. Shirley goes to the desert.

Behind a high wall and a defensive grouping of trees, half a dozen acres of ground stretch out behind an hotel building. Her "hideout" has a swimming pool, tennis courts, archery range, croquet grounds; and scattered bungalows. Shirley occupies one of the bungalows with her mother and father, chauffeur and his wife, and sometimes a visiting friend.

Since the hotel doesn't specialize in stars, it doesn't draw crowds of curious bystanders. Moreover, even if crowds collected to watch for Shirley, it wouldn't do them much good because nobody can get past the iron gates except for some legitimate reason. Since most of the other guests are there for peace and quiet, they respect the privacy of the others. These bankers and society people thoroughly enjoy watching Shirley, but they don't go bounding across the lawn to ask for her autograph.

As a matter of fact, Shirley needs a sheltered retreat for her vacations even more than most of the stars and socialites who seek one. She is in the formative years when a slice of normal holiday with normal playtime is essential.

Not that Miss Temple becomes a hermit when she reaches the desert. If you could see beyond that wall about the "hideout" you would see a youngster in a blue play-

With Sybil Jason in the exciting scene when the miserable attic rooms are magically changed to cosy little boudoirs

The little princess shows Arthur Treacher how they do native dances in India and shocks the sedate English school

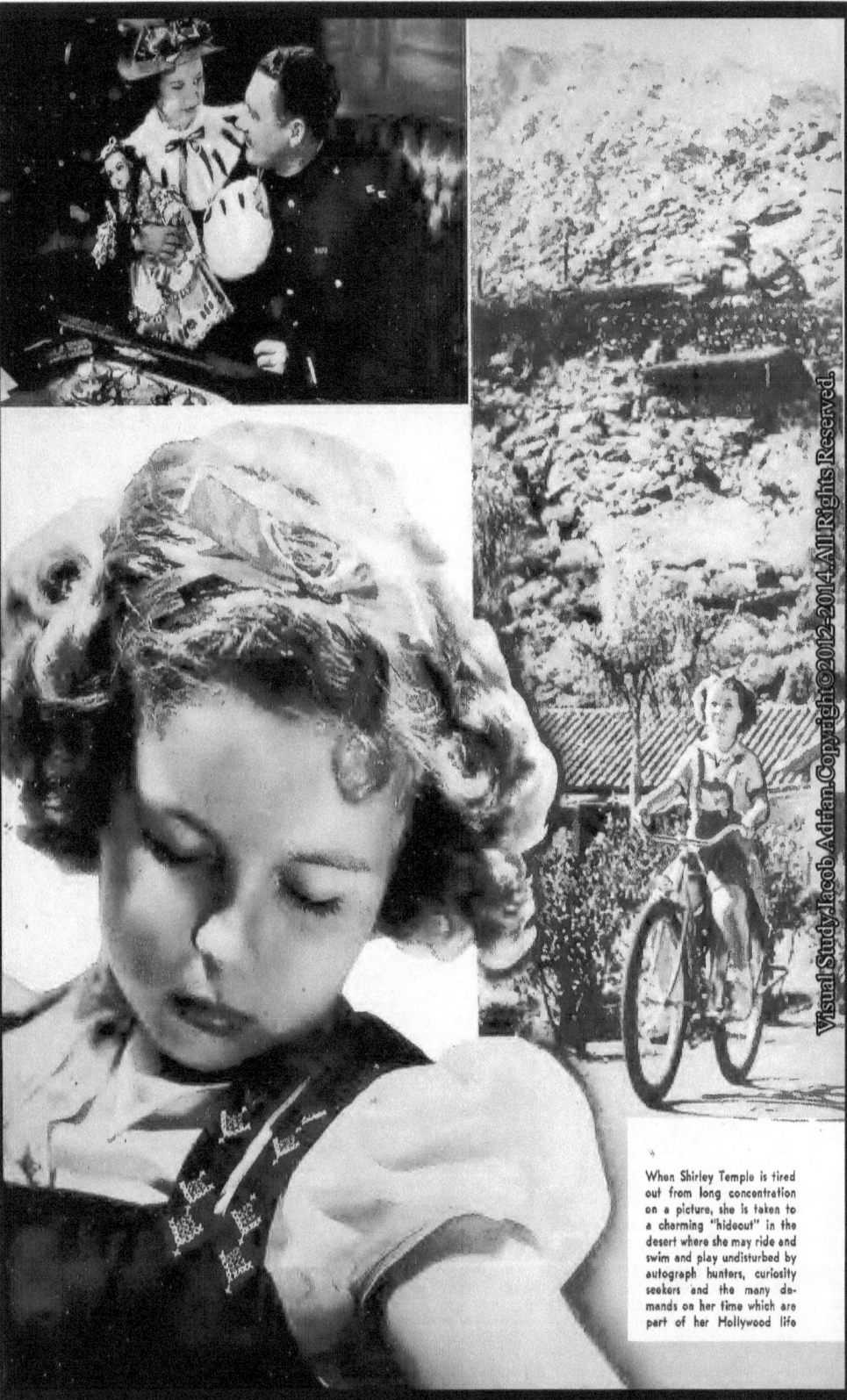

When Shirley Temple is tired out from long concentration on a picture, she is taken to a charming "hideout" in the desert where she may ride and swim and play undisturbed by autograph hunters, curiosity seekers and the many demands on her time which are part of her Hollywood life

Shirley's "Uncle" Bill

He is "The Boss" in Harlem. They called him "Mikado" at the Fair, but he's proudest of his title "Uncle"

By JOHN R. FRANCHEY

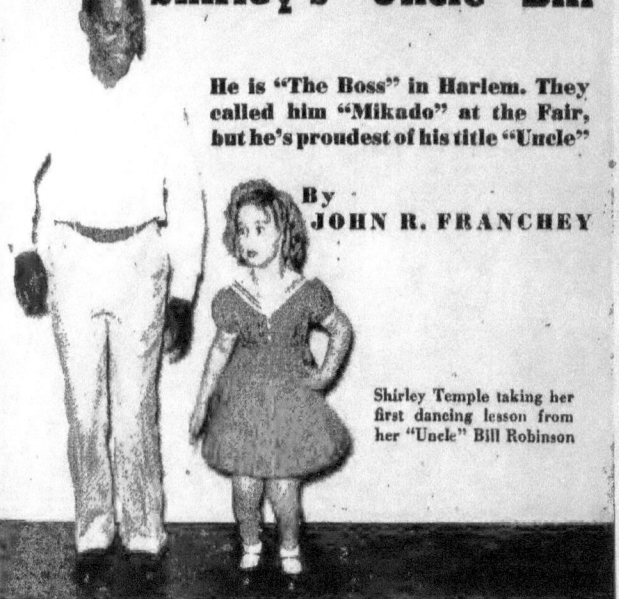

Shirley Temple taking her first dancing lesson from her "Uncle" Bill Robinson

A little more grown up, but still having fun in intricate numbers for *Lucky Penny*

All dressed up and having fun in a number for *The Little Colonel*

Going to town in a fast routine designed by "Uncle" Bill for *The Littlest Rebel*

Truckin' on down the road for one of the scenes in *Rebecca of Sunnybrook Farm*

Not every little lady just turned ten can have an "uncle" who is a Mikado. Shirley Temple has one, and she's real proud of him.

On duty, he wears a brown, spangled uniform with gold braid, an immense silver chain around his throat and the largest ermine collar you ever saw on one man. For a hat he sports a brown derby from which there sprout ostrich feathers, lush and flamboyant, and if he is actually the Son of Heaven, as his subjects swear he is, it's all on account of his wonderful winged feet.

Blow, bugles, blow! All hail Bill Robinson, lord of tap, who reigned as "The Hot Mikado" over Grover Whalen's colossal festival known as the World's Fair last summer and who now is making a peaceful conquest of the country as the show begins a winter tour.

No wonder Shirley's proud of him, but not merely because he's boss of a sepia Nippon. He was her "Uncle Bill" long before Mr. Whalen began dreaming of Tomorrow. It's an old friendship, hers and her Uncle Bill's. It goes back to the time Shirley was hardly six and 20th Century-Fox decided to bring the two together in *The Little Colonel*. Right from the start Shirley decided to adopt Bill Robinson and make him an uncle. Nothing ever pleased him as much—at least, nothing that happened in Hollywood.

No young lady could have a more devoted adopted uncle.

Every other Saturday or so he picks up the telephone in New York and calls Hollywood just before Shirley's bedtime. When Shirley recognizes "Uncle" Bill's voice, she lets out a war whoop.

Then the two settle down and talk. Inevitably the conversation gets around to dancing, and Shirley is off for fair. This is where Bill's eyes light up. It brings to mind all the grand fun he had on the lot showing her routines, for Shirley was a model pupil. She learned fast. And what a grand little trouper she was!

Take those moments in rehearsal when her wise teacher would notice that the little feet moved a trifle reluctantly. She was tired but wouldn't admit it. That is when Uncle Bill would call time-out. Together they would sit on the floor and play jacks. Or maybe he would draw with a pencil outlandish animals never seen on land or sea.

Then, after his little pupil had rested, he would confide a terrible secret: he had, of all things, forgotten the step he had been teaching her! Would she show him how it went? Please? Up in a flash, she would go into her buck and wing, hand in hand with Uncle Bill, now beaming

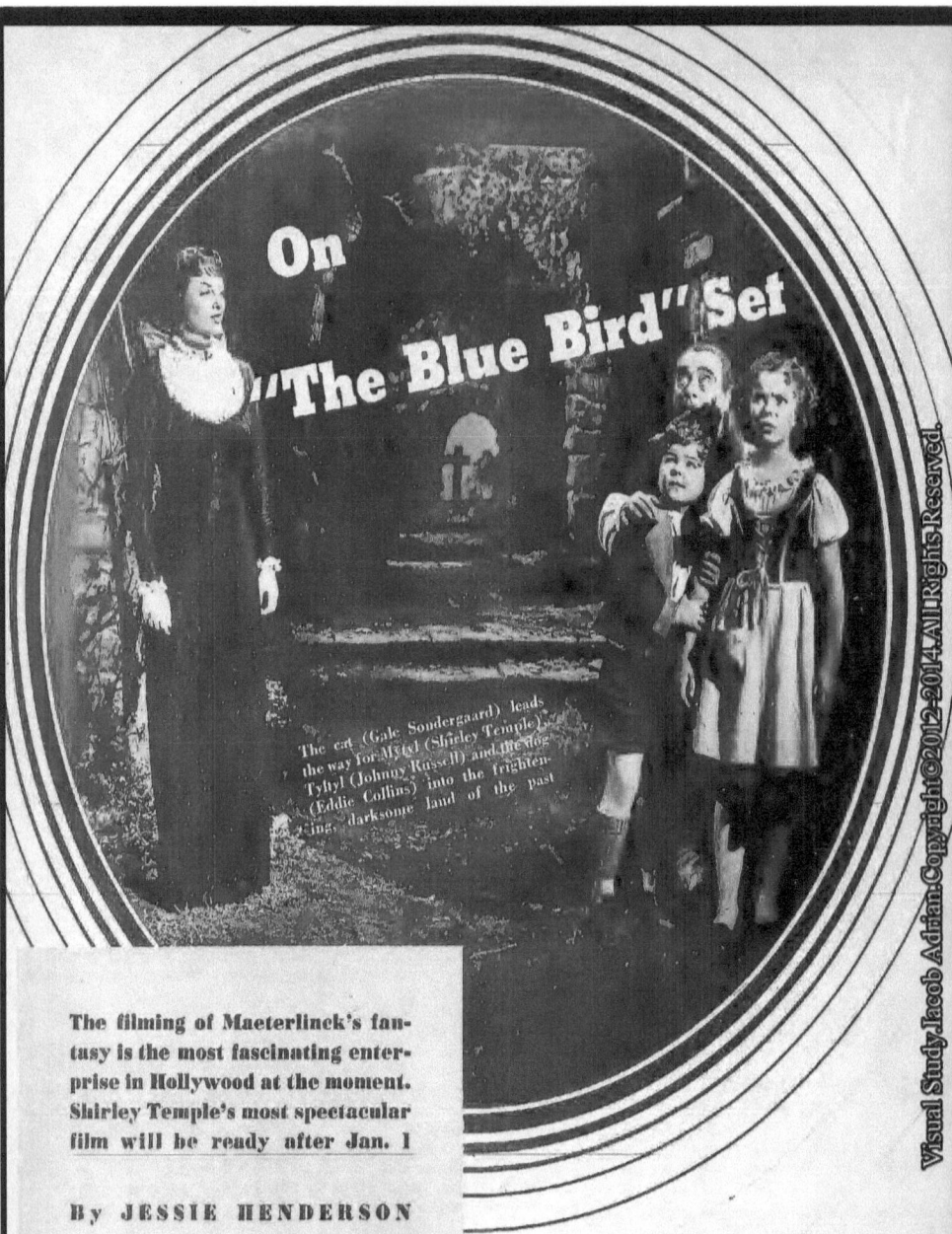

On "The Blue Bird" Set

The cat (Gale Sondergaard) leads the way for Mytyl (Shirley Temple), Tyltyl (Johnny Russell) and the dog (Eddie Collins) into the frightening, darksome land of the past

The filming of Maeterlinck's fantasy is the most fascinating enterprise in Hollywood at the moment. Shirley Temple's most spectacular film will be ready after Jan. 1

By JESSIE HENDERSON

Over the hilltop with the vast, moonlit sky behind them came Shirley Temple and Johnny Russell, hunting for the Blue Bird. They were bound for the region of their first search, the Land of the Past—and here it was, right at their feet. A graveyard!

Perhaps the hesitation with which Johnny followed Shirley under the archway of a crumbling chapel and along the path that wound among ancient, lichen-crusted tombstones, wasn't wholly acting. Johnny is only six, and the slanted stones with their blurred dates shining pale and silent from shadows where the moonbeams did not penetrate looked so real you couldn't believe the set had been tossed together by the property department just for Maeterlinck's story.

Tylo, the dog (Eddie Collins in a brown fur suit) ran away scared. But Tylette, the black and white cat (Gale Sondergaard), simply loved it and went gliding around the graves with a smug smirk. She's the villain of the piece, forever trying to get Mytyl (Shirley) and Tyltyl (Johnny) into trouble . . . and generally succeeding. On velvet paws she softfooted about the monument with the Greek figure, and the small grave that

Mytyl and Tyltyl return from the forest with a thrush, but refuse to give it to the little lame girl, played by Sybil Jason

Mytyl and Tyltyl stop complaining of their poverty when their mother (Spring Byington) and their father (Russell Hicks) face the fact of war

The selfish children are suspicious when a Fairy gives them the help of Light (Helen Ericson) for their long journey

The Blue Bird is not in the Land of the Past, though the visit with grandparents (Cecelia Loftus and Al Shean) is happy

And the Blue Bird is not to be found in The Land of Luxury, though the children enjoy their glimpses of wealth

The cat plots the death of the children with the spirits of the forest, who quite naturally expect harm from the woodchopper's children

Home at last, and with the Blue Bird!

had the little angel with a broken wing to watch above. ... A bad 'un, Tylette.

This graveyard set, which occupied an acre of sound stage, afforded a nice technicolor contrast in gentle greens and grays washed by silvery blue moonlight to the sets full of richer hues in which the film abounds. There are, by the way, no horizons in the scenes through which the Blue Bird search wends its eventful way. Only the great sky is roundabout, giving an effect of floating in air and lending a dreamlike quality, a Maxfield Parrish atmosphere, in harmony with the story itself.

Briefly, the story is this. On Christmas Eve of the year 1809, Mytyl and her brother Tyltyl return home with a thrush which they have trapped. Their home is a modest cottage in the Tyrolean village. Twentieth Century-Fox Studios built the village on the back lot with such faithfulness to detail that a real Tyrolean would start yodeling at first sight. On their way up the village street they look enviously into shop windows full of toys and lament the fact that their father, a wood chopper, isn't rich. You see, they are two very self-centered youngsters. From her bed at the window, ailing young Angela (Sybil Jason) begs Mytyl to give her the thrush. Mytyl selfishly refuses.

This is the first time Shirley has played a meanie. She entered into the role with zest, and found it all the more fun because at the end of sequences in which she was hateful the picture crew hissed her, whereat she laughed heartily and hissed them right back. It's the first time she's had her million dollar curls pulled, too—but more of that later.

At supper, Mytyl complains of the food, of their poverty, until her whining is subdued by news that father must leave tomorrow for the army, since war threatens. After she and Tyltyl are in bed, imagine their surprise when Fairy Berylune routs them out to go search for a Blue Bird. Berylune sends Light (beautiful Helen Ericson in snowy robes and long flaxen hair) to help them, as well as the dog and the cat, transformed into a stocky man with a bulldog jaw and a slim, sinuous lady in black with white gloves, a big red bow on the

On "The Blue Bird" Set

back of her neck. And so begins one of the loveliest tales ever spun, packed as full of subtle symbolism as a good plum pudding with raisins.

At the outset of their search, the children discover at shivery midnight in the graveyard that there are no dead. Passing by the headstones of their grandparents, they see grandpa (Al Sheean) and grandma (Cecelia Loftus) asleep before their cottage door. They rouse to wakefulness as the children's thoughts turn toward them. But, in spite of a splendid visit at grandma's, Mytyl and Tyltyl do not find the Blue Bird in the Land of the Past.

Straying away from Light, they go with wily Tylette, the cat, to the Land of Luxury. No Blue Bird. Thence, still under wicked Tylette's guidance, to the Forest—where, during an electric storm, the forest catches fire and Tylette perishes.

Light meets them beside the lake at dawn, and points them toward the Land of the Future. This is the exquisite cloudland of blue and pink and fleecy white where the unborn children live. Here, for example, they meet the little sister who will, in course of time, come to join their family. They are watching a galley with silver sails take away the children to be born on earth next day.

On Christmas morning they awake, home again. Tylo, to their astonishment, is plain dog again. And they can hardly believe their eyes when they behold Tylette demurely lapping milk . . . apparently she lost only one of her nine lives in the forest.

Glancing with appreciation and contentment at the familiar faces and the familiar home brimful of love, Mytyl sees that the thrush captured the day before is no longer brown. It is the Blue Bird!

Joyously she seizes the cage and hurries down the street to present the bird to invalid Angela. Strengthened by happiness, Angela leaves her sickbed to receive the gift. The two little girls want to hold the Blue Bird in their hands, and thus Mytyl learns the final lesson—happiness cannot be confined nor commanded; it must be free. The Blue Bird escapes. But Mytyl tells Angela not to worry—they can always find it again! And so the picture ends.

■ Of all the 15 sets, which Richard Day and W. B. Ihnen designed, the biggest and most imposing is that for the baroque palace of Mr. and Mrs. Luxury (Nigel Bruce and Laura Hope Crews). Twenty-four draughtsmen worked 4 weeks on plans. A large proportion of the 5000 items of set furnishings built for the picture by the prop department were used in the Luxury's home.

Shirley reveled in that home, figuratively and literally. In the first place, the hallway had a double staircase with wide, smooth, marble balustrades down which it was a pleasure to slide. As a matter of fact, Mrs. Luxury slid down a balustrade, landing on a huge silken cushion at its foot, when she came to greet Shirley. Mrs. Luxury's gown was a marvelous velvet affair, and she was so bedizened with necklaces and chains and ear-rings and whatnot that Shirley stared open-mouthed.

Dear, dear, Mr. and Mrs. Luxury were all a-flutter at thought of adopting a boy and girl. Shirley got out of her sweet little peasant costume, a purple cloth skirt, a crisp blue apron, a white puffed-sleeve blouse with a laced black bodice, and into a velvet gown nearly as imposing as Mrs. Luxury's. Johnny was put into white satin knee breeches. Waiting for a "still" closeup in these clothes,

Nelson Eddy spends his time between scenes for *Balulaika* (that accounts for the Russian blouse) with his new hobby, modeling portraits in clay

Shirley shoved Johnny, and Johnny shoved her, and she shoved him again . . . Shirley's at the slightly tomboy age, and cuter than ever. Perhaps she was getting into training for the fight.

■ That fight! It occurred after the Luxurys gave the children a pony. Johnny wanted to ride it, and Shirley (that is, as Mytyl, you know) wanted to ride it first. Shirley pulled Johnny off the horse and Johnny got a firm clutch on Shirley's curls, and they rolled over and over in an ecstasy of rough-and-tumble, both having the time of their lives. Afterward, they were supposed to be mad at each other, but in rehearsals they kept tickling each other and bursting into giggles when they were expected to look angry.

At the age of 10, Shirley felt very motherly toward Johnny, who is four years younger. She was worried especially about a turtle somebody had sent him. She advised Johnny as to the critter's diet. "And don't drop it on the floor," she added, "account of concussion."

As for Johnny, he's the son of a New York newspaper man and somewhat precocious. They were discussing Hitler. "I don't think," said Johnny in his careful English, "that he's a very desirable person." A few minutes later he pulled one that halted production. After gazing solemnly at pot-tummied Eddie Collins (the dog Tylo), he observed: "When you laugh, Mr. Collins, your whole body lights up."

Poor Tylo's whole body didn't light up, however, in the Luxury's palace. They banished him to the doghouse and both Mytyl and Tyltyl selfishly forgot him while they slept in beds of incredible ornateness. But Shirley climbed from her lonesome, gigantic bed with its brocaded canopy, and pattered into the bedroom of Mr. Luxury to tell him she was homesick.

When Shirley came to the threshold of Mr. Luxury's room, she paused. And no wonder. It's a purplish red room. There's a colossal red and white rug on the floor. The woodwork is white and gold, carved within an inch of its life. The silver bed has heavy, creamy satin draperies. There's a fireplace the size of the Grand Canyon, of white marble, with alabaster urns full of big pink, purple, and garnet flowers beneath a mirror as big as a skating rink. A great crystal chandelier, too. Restful? That bedroom is so restful it would knock you unconscious, merely to look at it.

■ Before Shirley made her appearance there had been a flurry of activity. Nigel Bruce sat on the sidelines, being given the gout by the make-up department by means of yards and yards of bandages around his left foot. Meanwhile, his stand-in sat in a satin easy-chair wearing a replica of Mr. Luxury's costume—a white dressing gown brocaded in gold and edged in sable, plus a white nightcap with a lavender tassel, and an ebony cane with an impressive gold knob. The stand-in is famous in his own right. He is Captain George Hill, a friend of the Bruce family, formerly Chief Inspector of Police in Edinburgh, Scotland, and decorated by King George V for thirty years of brilliant police service.

Finally, Nigel Bruce hopped clear across the bedroom on one foot, to keep the white bandages from getting soiled, took his place in the armchair, and the scene began. Mytyl, though wearing a beauteous pink nightgown of satin trimmed with lace, was crying. (Shirley can cry whenever she pleases. Real tears.)

They decided to take an extra crying scene, just for the sound track; just in case. Shirley sat on the gorgeous bed and sobbed until your own eyes watered. Right in the middle of a heart-breaking

sob, she paused to look up at Director Walter Lang and inquire mischievously through tears streaming down her face: "How'm I doing?" before she resumed her lamentations. If there's one talent better than another which Shirley possesses, it's her sense of humor.

■ After the crying sequence was over, and Shirley had received the bottle of soda pop which she has every afternoon, the picture advanced to the scene where Tylette conspired against the children with the old Oak Tree in the Forest. Tylette, you understand, hadn't wanted to leave the Land of Luxury, and she didn't want to go home where she'd turn back into a cat that couldn't talk. Before she slipped off by herself, however, Tylette had a run-in with Tylo the dog. She curled her white-gloved fingers into claws and went ps-ss-t-tt! at Tylo. Tylo thrust out his lower jaw in such an exact imitation of a bulldog and growled so fiercely that Shirley and Johnny laughed right out, and had to be warned to quiet down so that the cameras could roll.

When the cameras started, and the children with the dog climbed the steep path leading to the Forest, Tylette took a shortcut across the fields in order to reach the Forest first. It was a pretty sight to watch Director Walter Lang showing Gale Sondergaard how to slink over the fence and tiptoe through the grass. He succeeded in looking so much like a sinuous cat full of crafty enterprise that you wanted to yell, "Scat!"

A few seconds later, strange sounds issued from Shirley's dressing-room. Possibly inspired by the Tyrolean village on the back lot, Shirley was practicing the art of yodeling. It sounded a bit as if she were seasick.

■ With Shirley still yodeling, the company moved over to the north lot for the forest sequence. This was a really terrifying scene. The studio had taken every precaution so that neither of the children would be hurt, and so that during the forest fire not so much as one hair of a million dollar eye-lash should be singed. Just the same, you kind of cringed as the heavy branches lashed out at the youngsters during the wild wind-and-thunder storm, and as the fire crackled and roared.

The special effects crew built both a large lake and a forest of 1,000 trees. They wanted conifers with big trunks and with foliage something like cedars, and the easiest way was to whip up a batch of them in the plaster and carpenter shop. The tree they invented would do credit to Luther Burbank. In fact, it went Burbank one better because it was equipped with mechanical gadgets which allowed an inflammable liquid to run out and catch fire—and to be turned off when necessary. Though the children seemed to rush through the conflagration, they were protected by screens and half a dozen other safety devices. A scene of splendor, this: the dark green forest twisted by the tempest, lit by the vivid lightning and the gush and billow of orange and crimson flames.

The forest fire raged to the accompaniment of stirring music, arranged under the leadership of James O'Keefe. As in the other sequences, the music was written especially for the picture, since the Humperdinck score (written for the stage play) was not used. In certain episodes, such as the Land of the Future and the Land of the Past, a full symphony orchestra was augmented by electrical instruments, invented by the studio sound experts, which are said to produce tonal effects beyond the capacity of ordinary musical instruments.

It was after the last note, after the last crackle of the forest fire had died, after the escape of Mytyl and Tyltyl and the dog, that Shirley—once more in the pretty blue and purple peasant costume—approached Eddie Collins, the dog's impersonator. She held forth a small, paper-wrapped package, her eyes a-twinkle.

"Thought you might be hungry, after all that racing around," she said.

Collins unwrapped the package. It contained a bone.

"Somebody out on the lot got it away from Lynn Bari's dog," Shirley explained with a chuckle.

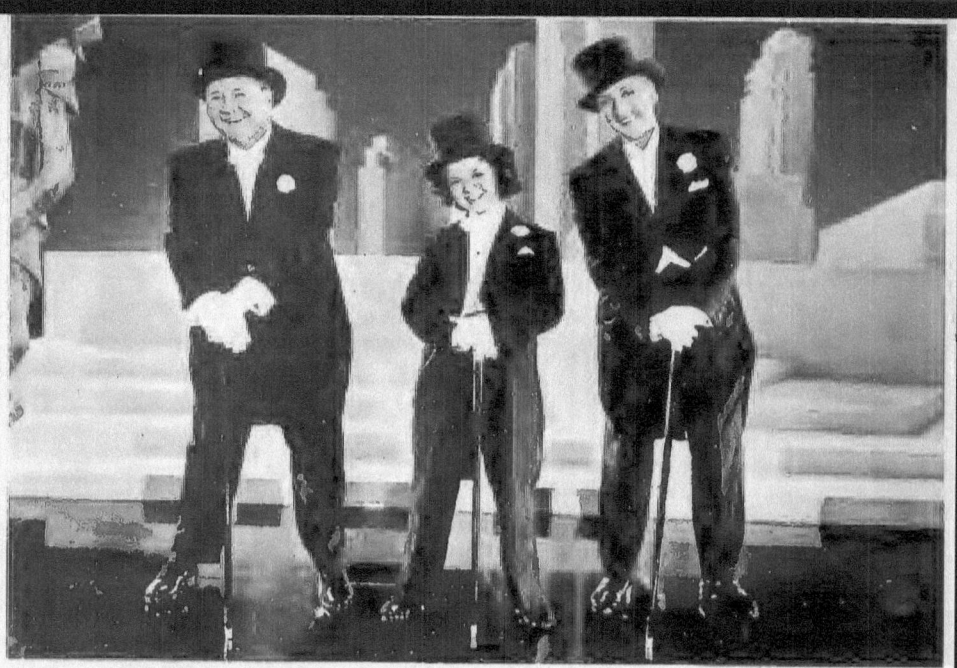

Getting tall is Shirley. Here she is shown with Jack Oakie and Charlotte Greenwood in a scene from *Young People*. Oakie also is in Charlie Chaplin's *The Dictator* in which he plays one Benzino Gasolini, and sticks his chin out like guess who?

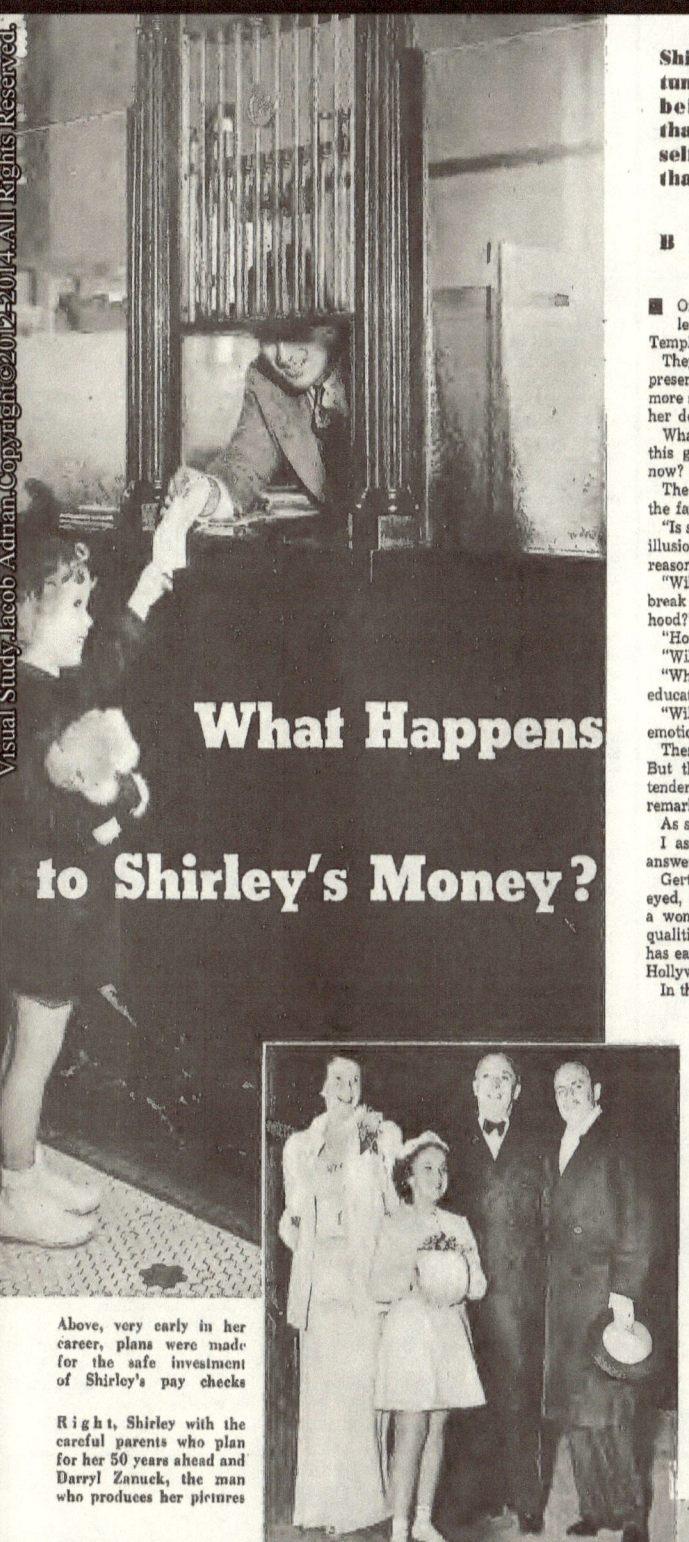

What Happens to Shirley's Money?

Above, very early in her career, plans were made for the safe investment of Shirley's pay checks

Right, Shirley with the careful parents who plan for her 50 years ahead and Darryl Zanuck, the man who produces her pictures

Shirley Temple makes a fortune every year. What is being done to safeguard that money, and Shirley, herself, against the hazards that menace the child stars?

By SONIA LEE

■ On my desk are more than a hundred letters asking questions about Shirley Temple.

They range from inquiries about her present and possible future wealth, to the more searching and human questions about her destiny as a woman.

What will happen to the miracle child of this generation, say five, ten years from now?

The letters ask: "How will Shirley escape the fate of other wealthy girls?"

"Is she destined for unhappiness and disillusionment in the motives of people by reason of her wealth and her position?"

"Will fortune-hunters seek her out and break her heart when she arrives at womanhood?"

"How is her future being protected?"

"Will she continue in pictures?"

"What provision is being made for her education?"

"Will she have difficulty in making emotional adjustments as she grows older?"

These are not questions of idle curiosity. But they are the result of real interest, tender anxiety and love for the world's most remarkable child.

As such they deserve careful answers.

I asked Mrs. Gertrude Temple for the answers. She gave them.

Gertrude Temple is a poised, twinkly-eyed, exquisitely groomed person. She is a woman of wonderful insight. She has qualities as a mother and as a woman which has earned Hollywood's awed respect. And Hollywood is hard to awe.

In the adjoining room Shirley was taking her French lesson. And frequently, as Mrs. Temple and I talked, she stopped to listen, calculating the progress by the tempo of her child's voice seeping through the closed door.

■ As wealth is considered today, Shirley Temple will never be enormously rich. By the end of the next five years, when she is fifteen, she will have approximately a million dollars in her own right.

This estimate is based on her present Twentieth Century-Fox contract which covers this five-year period. Also on other commercial contracts.

Adventurers, fortune-hunters, spongers—that fraternity which considers a wealthy and beautiful young girl fair prey—will find slim pickings in Shirley's vicinity because her parents have planned

What Happens to Shirley's Money?

her financial future carefully and well. Let's first consider what has been done to safeguard her fortune.

Shirley, Number One juvenile actress, is reputed to earn in the neighborhood of $750,000 a year. This is income from her picture-making and the various endorsements of foods, toys, dresses and allied commercial products.

Not one cent of the money she earns is touched by her parents, although by law they are entitled to a goodly percentage of it. Mrs. Temple is paid a studio salary for her very important contributions during the making of Shirley's pictures. Her father, earns a substantial income as banker and business counsellor. Not even the income from Shirley's investments is spent. That, too, is re-invested.

With a yearly income as great as this, it is natural to question why Shirley will have only a million dollars at the end of her current studio contract. But as Mrs. Temple explains, the days of great fortunes are past. Taxes take an enormous slice of any six-figure earnings.

Shirley's money is invested in a variety of ways. She has a number of trust funds, many gilt-edged securities.

The trust funds are staggered, so that they will mature over a long period of years. Shirley will be fifty before she receives the benefits from the longest term fund.

There is a secret board which sits in consultation over Shirley's many affairs. This board consists of a famous lawyer, a banker, and Shirley's father. The three men must share the same opinion regarding the soundness and advisability of an investment before it is made.

There are provisions to perpetuate this board. In case of unforeseen eventualities or death, the two remaining members will choose the third. A lawyer and a banker will always be on this guiding committee.

Shirley's oldest brother, by many years her senior, will replace his father eventually. He will know enough of Shirley's affairs to be able to advise her, guard her, and guide her, if she requires his help.

With material affairs for Shirley's future well in hand, there is still another safeguard which her parents have provided.

The human factor is tremendously important in the life of any spectacular child.

"After all," Mrs. Temple points out, "Shirley will not have the emotional problems that so many wealthy children have. She has not been raised by nurses and governesses. She has not led a secluded life. She has had, and I say this advisedly, a completely normal childhood.

"In traveling, I've seen many wealthy mothers and their children. The youngsters dine with their governesses, are forbidden contact with strange children usually, are carried along as so much precious but troublesome baggage.

"I've heard many mothers boast that they never fail to spend half an hour a day with their youngsters.

"That isn't possibly enough time in which to give a child mental and emotional health. It isn't enough time to build a foundation of love for the years to come. It doesn't give a child the reserves of stability needed later on in life.

"Shirley has never lacked love. We've given her an abundance of it. When she was even a tiny baby, and her bedtime was seven o'clock or earlier, I would frequently keep her up a little later, if Mr. Temple was delayed in coming home. For I felt that Shirley was entitled not only to my companionship and my care and my love, but also to the companionship and the love of her father.

"In the old days, Shirley was given her supper early, and then the two boys and Mr. Temple and I had our dinner. Afterwards, Mr. Temple and the boys would do the dishes while I got Shirley ready for bed. But the lights were never out in her room until her father came up to help tuck her in.

"I am not trying to prove that we're perfect parents. There are millions of children who get exactly the same care and love that Shirley does. I only want to emphasize the fact that Shirley has never been deprived of that personal attention which seems the inherent right of the average child, and yet is frequently denied to the child of wealth.

"There is such a thing as a mother and a child being together too much. I have tried to avoid that by occasionally leaving Shirley to her own devices for a whole afternoon. She draws, she reads, she helps the cook bake cookies. This absence from each other is good for both of us.

"Shirley has had all the love and care parents can give, but we have never robbed her of her right to be independent, free, and self-reliant.

■ "Mr. Temple and I recognize that there are peculiar problems which parents of a child star, face. Those problems are primarily concerned with companionship and friendships of children her own age. I think the friendships a person makes in childhood and which continue through life, are vital to happiness. It gives us a sense of solidity for which there is no substitute.

"I, personally, feel that my own life has been enriched by the friends I've had since I went to school. I want Shirley to have that, too.

"Keeping this well in mind, we have looked forward to our weeks in the Islands. We've been going to Honolulu for several years, and Shirley has met the children of the permanent residents there.

"With these youngsters Shirley has formed firm friendships, and I'm quite certain they will continue through her entire life.

"I feel it necessary that Shirley have a great deal of contact with children who can quickly forget that they have seen her on the screen. Fortunately, they don't think of her as a motion picture star, but as Shirley Temple, who plays in the movies. They're very casual about what she does in Hollywood.

"During our weeks on the Island we keep week-end open house. Dozens of children, of all races and creeds—ranging in age from two to eighteen years—spend all day Saturday and Sunday with her. Many a time there are as many as sixty youngsters gathered at one time. The ice-cream and cake and fruit-juice situation is always handled by Shirley.

"For entertainment there are ball games, hide and seek, tag, and a variety of other games in which all the children join. Shirley has a wonderful time.

"Once in a while Shirley gives a luncheon and then she has a smaller group of friends. There are about eight youngsters with whom Shirley visits back and forth constantly.

■ "I have no special concern that Shirley will be taken in by the unkind people as she grows older. I believe the intuition which has made her a fine actress will serve her in sensing disloyalty and insincerity.

"Even now she automatically becomes casual with people who don't ring true. You know, there's an old saying that you can't fool a dog or a child.

"I believe Shirley will retain that unerring intuition into womanhood, and will avoid many heartaches thereby.

"I have no fears, no urgent anxieties for Shirley's future—no more, that is, than every mother feels for her child.

"We've done everything possible to make her adequate for life. I think she'll have no difficulty in making necessary adjustments to the world as it is, as she grows older.

"We can only see a certain distance into the future, of course. By giving Shirley a normal background and a solid family life, we have given her the equipment to help her solve adult problems.

"Playing in pictures has always been a game for her. It has been fun. But if, when she is fifteen or sixteen, it is no longer a thrilling adventure, she might want to turn to art or to music as her profession.

"Shirley is considerably advanced for her years. She'll be in Junior High School next year. 'Imagine,' her brothers remark, 'THAT in High School!' They think it's too funny for words.

"No matter how things work out as far as her career is concerned, Shirley will be given a comprehensive education. College, certainly. And other subjects—music, art, languages, dancing if she wants it.

"Money is never enough for happiness. It's what is in your head and your heart that counts.

"In every possible way, we are trying to equip Shirley for a happy and full life!"

I, who have known Shirley from the time she was a cuddly baby, believe her future is safe, because financially, she is protected, and emotionally and intellectually, she will be prepared to meet all problems as they arise.

Does that answer your questions?

Welcome Back, Shirley

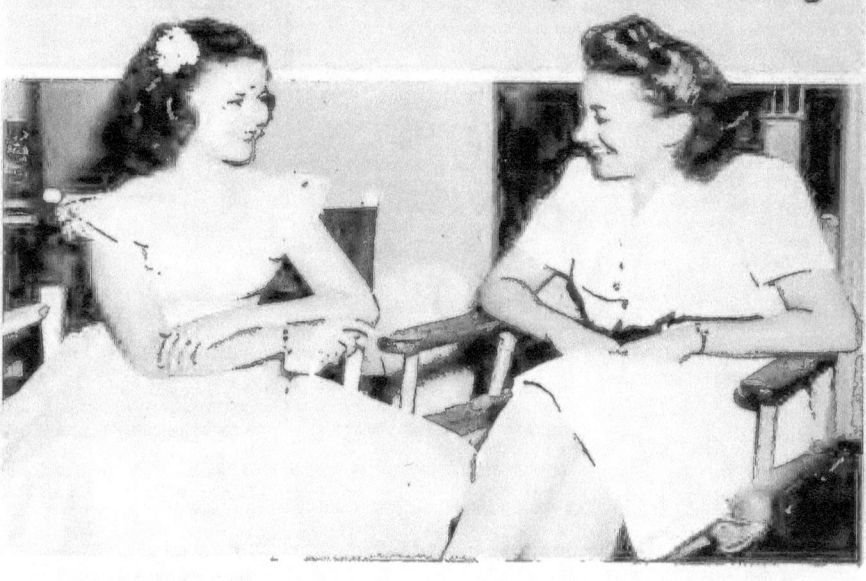

Shirley Temple's new film, *Girl on the Hill*, brings the little actress out of her mysterious 18-month retirement, and puts a stop to the various wild rumors which circulated about the talented child star when she left the screen. Shirley is shown above as she was interviewed by one of HOLLYWOOD'S ace reporters, Helen Hover

By HELEN HOVER

There was nothing, really, to distinguish this early California morning from any other. The same gray dawn with a hint of gold trying to break through, the same view of the swimming pool from the bedroom window, the same tangy morning air. But to the little girl with a riot of brown curls who tossed the blue coverlet quickly aside and bounced eagerly out of bed, this morning *was* different. It was a wonderful morning. A scrumptious one!

To Shirley Temple, it was the morning she was going back to work after having been away for eighteen months.

Her clock was set for 6:30, but when the alarm rang she was already up, showered and dressed and waiting impatiently for her mother.

"But darling," protested Mrs. Temple, "you're not due on the set before eight."

"I know, but—but, you know how it is, Mother."

Mrs. Temple did know. While everyone has been wondering about Shirley's "retirement," speculating as to whether the greatest child star of all was "through," making dinner conversation of the many rumored and fanciful reasons for her absence from the screen, Mrs. Temple knew how anxious Shirley was to face a camera again. Although Shirley has earned about two million dollars and has spent a happy, unprofessional "retirement" in a girls' school, like a champion race horse she was champing at the bit to go back to the scene of her victories.

So excited was she at the prospect of working on a movie set again that on her first day of *Girl on the Hill* at M-G-M, she was on the sound stage an hour early, even before the electricians were on hand. When Director Harold S. Bucquet arrived, he found her seriously studying her script.

"It's too bad you have to work on your school vacation," said Bucquet.

"Oh, no," beamed Shirley. "Coming back to work is like a vacation to me."

When Shirley and 20th Century-Fox called it quits two years ago, and when Shirley disappeared from picture-making into the recesses of a conservative girls' school, that seemed to put her definitely on the shelf. Baby Shirley, the child wonder, now knocked for a loop by the awkward years, people buzzed.

That wasn't it at all. Her parents thought it was about time Shirley let up and led a normal life in school and not on a movie set. That's all. Far from being a cinematic back number, every studio in town came forward with a huge contract. But all of them were turned down for the time being.

"She is going to be like other girls," said Mrs. Temple firmly. So Shirley was promptly enrolled in the Westlake School for Girls and quickly and deliberately lost her identity as a million dollar child star to become just another white-middied student, indistinguishable from the others. She shied away from any act which might

make her conspicuous, and became popular with the girls not because she was Shirley Temple, movie star, but because she convinced them by her attitude that she was one of them.

The first day in school, one of the girls rushed to her and asked, "Oh, tell us what it's like to work in pictures?"

Shirley wrinkled her nose distastefully. "Oh, skip it," she said quietly and moved on.

Another girl, watching this, called out approvingly, "Atta girl, Shirley," and Shirley's popularity was cinched.

Christmas time, Shirley was offered the lead in the school play, but she refused it in her effort to be un-actressy. However, she did want to participate in school events, so she accepted a tiny role as a Christmas angel along with ten other "angels."

She spent a happy, normal year and a half in school, attended school dances and teas, experienced the thrill of wearing silk stockings for the first time and went to properly chaperoned dances in long party dresses with socially approved young boys from military school. But she was still homesick for the sound stages, so when school was out in June, Shirley signed up with M-G-M to make a picture during her vacation. It was a $50,000 vacation!

At first it was announced that Shirley would appear with Wallace Beery in *Barnacle Bill*, then with Judy Garland and Mickey Rooney in *Babes on Broadway*. But she developed a mild whooping cough just before *Barnacle Bill* started, and the studio decided that Shirley's comeback picture should be a drama, which eliminated *Babes on Broadway*.

You should have heard the wild stories that started! Zowie! The rumors buzzed that (1) Shirley was getting high-hat, (2) she wouldn't work in a picture with Wallace Beery, (3) Beery wouldn't work in a picture with her, (4) Shirley wasn't as pretty now as she used to be, (5) and quite the silliest of all that she was taller than Mickey Rooney and couldn't work with him.

Hooey! All of it.

But the studio kept mum and scouted for a suitable story for Shirley's return. They found it in *Girl on the Hill*, which presents Shirley as a motherless little girl whose father is too occupied with his business affairs to give her more than fleeting attention. She reacts brattishly to his gold-digging fiancee (Gail Patrick) and eventually brings her father and her pretty nurse (Laraine Day) together and shows him that happiness can be his with his own daughter.

Shirley and Mrs. Temple loved the story. "In all her other pictures," said Mrs. Temple, "Shirley was busy saving the Indian Garrison or Great Britain or something. In *Girl on the Hill* she's a normal girl, not saving anyone except perhaps herself."

Her long absence hasn't changed Shirley's manner of work. She is still up to her old tricks. In the old days, Shirley used to confound directors by knowing not only her own lines but the dialogue of all the other actors. The first day of work Shirley had learned all but two sequences of the script and she knew most of the lines of the other players. In the opening scene, Shirley and her domineering nurse are having one of their frequent duels. When they made such progress on the opening day that they reached a scene not on the schedule it was Shirley who cued the older actress in her lines.

After the first such rehearsal, Director Bucquet turned to the script girl and said. "I guess you can go home. We have a star and script girl all in one." Which was exactly what Shirley's director on her last picture, *Young People*, said two years ago!

But physically, twelve-year-old Shirley Temple vaguely resembles the golden-haired cherub of years gone by. Her hair is chestnut brown—she is two inches taller, her baby fat has slid off and now she is a slim, poised young lady. The "awkward years" haven't touched her and she is blossoming into a lovely young lady.

Inwardly, Shirley feels more grown up too, and a little scene which took place on the *Panama Hattie* set is final proof that Shirley has forever said good-bye to the old days when she was America's most loved child star. On the *Panama Hattie* set this particular day, seven-year-old Jackie Horner, a precocious little actress, was performing. Little Miss Horner is a cute trick. She sings, dances, emotes. Shirley watched her with great admiration, then turning to her mother asked, "My goodness! Was I ever like that?" ∎

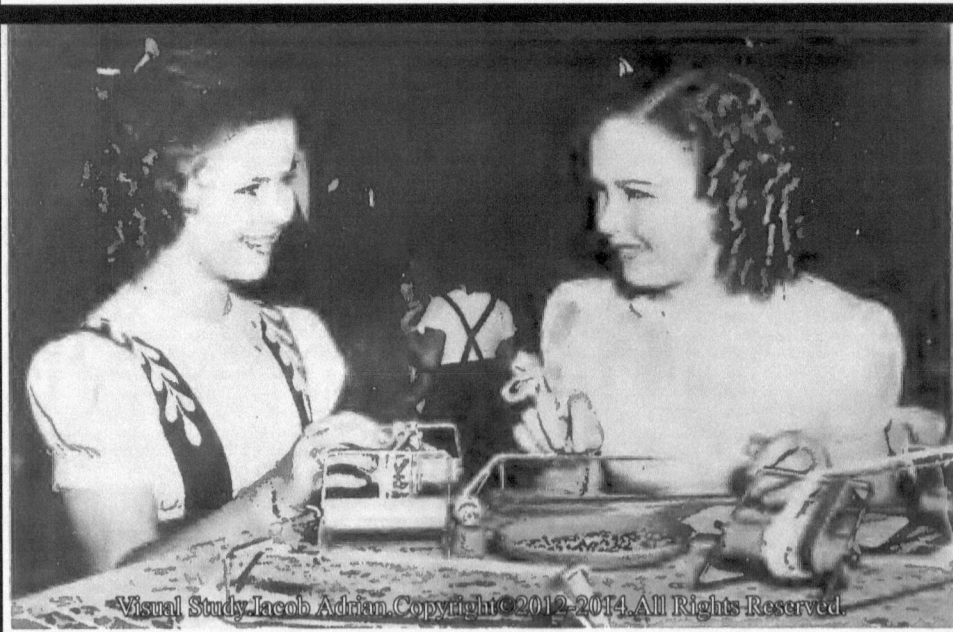

Shirley Temple went visiting the other day, and Gloria Jean entertained her distinguished guest by getting out her looms for Indian bead-work and showing Shirley how to make a belt. Shirley's last picture, before her temporary retirement from the screen, is *Young People*. Gloria Jean is seen currently in *A Little Bit of Heaven*. She completed her intricate bead belt during waits between scenes at the studio

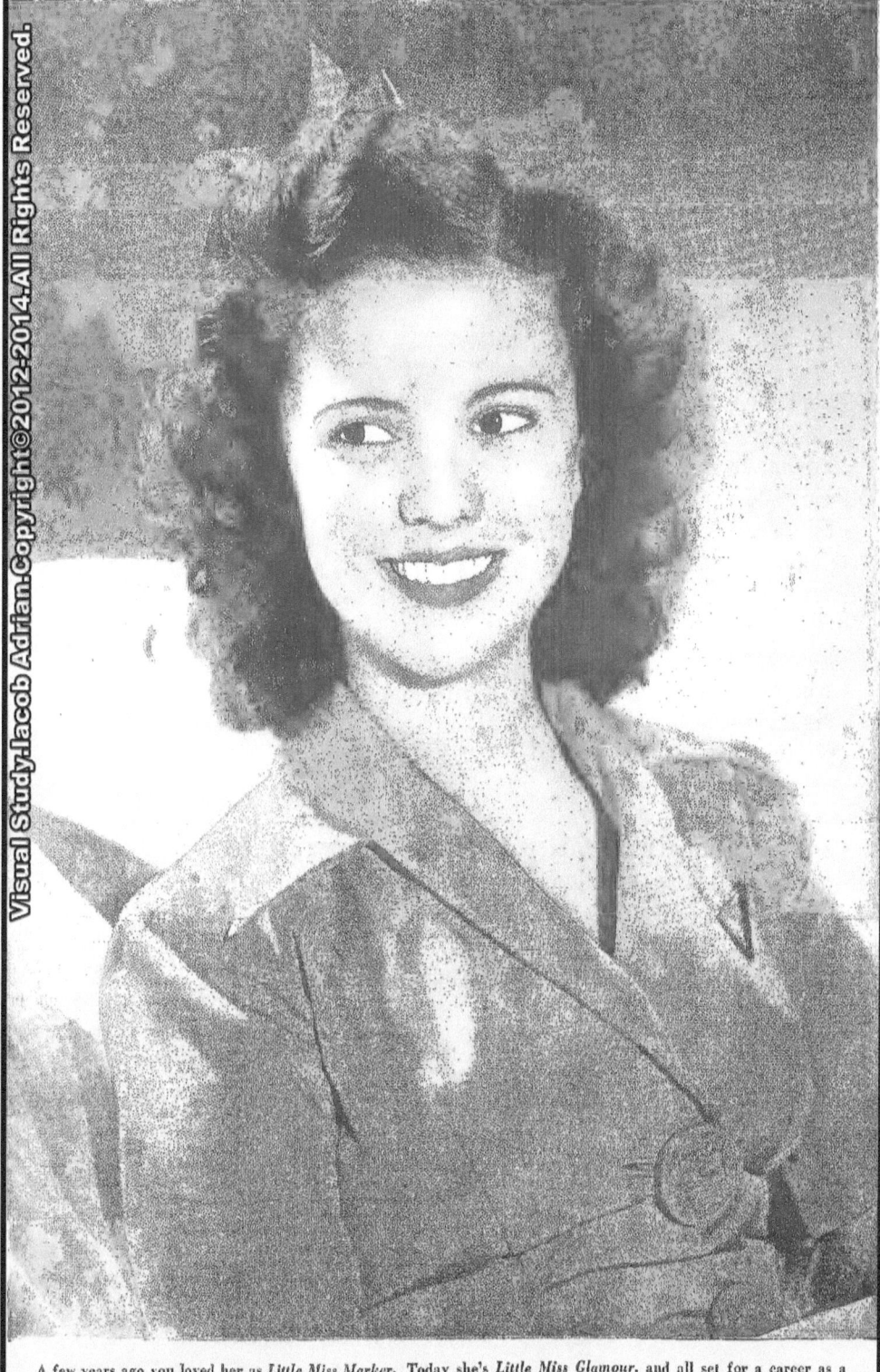

A few years ago you loved her as *Little Miss Marker*. Today she's *Little Miss Glamour*, and all set for a career as a lovely and talented young lady of the screen. You'll be seeing this "new" Shirley Temple soon in *Miss Annie Roouey*

Bibliographic sources :

Hollywood (1934-1943)
Publisher: Hollywood Magazine, inc. ; Fawcett Publications, inc.

This documentary study use,
combined in various proportions,
elements from the following categories,
forms and subsets :
- fair use
- documentary
- documentary photography
- feature
- journalism
- arts journalism
- visual journalism
- photojournalism
- celebrity photography
in order to :
- employ material as the object of cultural critique ,
- quote to illustrate an argument or point ,
- use material in historical sequence,
providing independent opinion,
using photos, press articles, advertisements,
opinions of fans etc. ...

Copyright©2012-2014 Iacob Adrian.All Rights Reserved.

www.ingramcontent.com/pod-product-compliance
Lightning Source LLC
Chambersburg PA
CBHW030809180526
45163CB00003B/1212